Butterflies *of the* World

First published in 2015 by Reed New Holland Publishers Pty Ltd
London • Sydney • Auckland

First published in the United States in 2018 by Johns Hopkins University Press, Baltimore

Johns Hopkins University Press
2715 North Charles Street
Baltimore, Maryland 21218-4363
www.press.jhu.edu

Library of Congress Control Number: 2018938219

ISBN 978-1-4214-2717-1
ISBN 1-4214-2717-6

Special discounts are available for bulk purchases of this book. For more information, please contact Special Sales at 410-516-6936 or specialsales@press.jhu.edu.

Johns Hopkins University Press uses environmentally friendly book materials, including recycled text paper that is composed of at least 30 percent post-consumer waste, whenever possible.

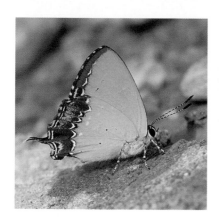
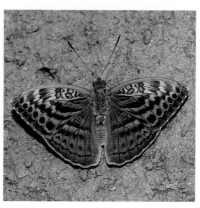

Butterflies *of the* World

ADRIAN HOSKINS F.R.E.S.

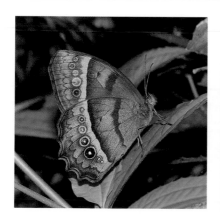
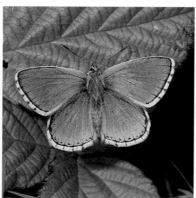
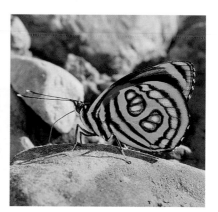

Johns Hopkins University Press
Baltimore

THE AUTHOR

Adrian Hoskins is a Fellow of the Royal Entomological Society, a rare honour shared with the likes of Charles Darwin, Henry Walter Bates, Alfred Russel Wallace and an elite group of modern day entomologists. His passion for butterflies stretches back to the age of four, when he spotted his first species, a Small Tortoiseshell, and wanted to learn more about it. That early fascination led to a lifetime devoted to the study of butterflies, developed in parallel with his enthusiam for travel and photography.

As a youth he explored most of Britain by motorbike, visiting the habitats of all the British species. Later he travelled around Europe, with a particular fondness for the French Alps. Soon afterwards he began organising and leading butterfly-watching tours to Europe for various friends. However, his dream was to visit the tropics, so he saved long and hard, and in 1991 participated in what he expected to be a once in a lifetime wildlife safari in Tanzania. The aim was to see and photograph the big game animals, but he found himself taking more photos of butterflies than of lions, cheetahs or elephants!

The urge to explore took him the following year to Trinidad, where he found himself 'awestruck by the rainforest and its infinite wonders.' There, he saw his first morphos, daggerwings and owl butterflies – species he had dreamt about since childhood. He found the whole rainforest experience overwhelming, noting in his diary that 'the hummingbirds and oropendolas, the haunting siren wail of cicadas, the high-pitched chirping of thousands of tiny frogs, and best of all my 'discovery' of the incredible moth *Siculodes aurorula*, will stay in my mind until the day I die – irreplaceable memories that make the material things in life pale into insignificance.'

As one of Britain's most active entomologists, Hoskins spent many years working voluntarily for Butterfly Conservation. During his time with the Hampshire branch of the organisation his roles included County Butterfly Recorder, Field Meetings Organiser, Conservation Officer and Editor of the Annual Butterfly Report. After 10 years he retired from the Committee, to turn his attention to tropical butterflies.

In 2006 he created his website www.learnaboutbutterflies.com, which is widely regarded as the most authorititive on-line resource on butterflies. His aim was to produce a receptacle for his photographs and knowledge, a means of archiving what he had seen and learnt, and passing it on to others. More importantly, he saw it as a tool to promote the conservation of butterfly habitats – particularly the irreplaceable rainforests of Amazonia, Africa, South-East Asia and Australia.

Hoskins now organises and leads entomological expeditions to numerous destinations around the world, giving others the opportunity to share his passion for butterflies and to learn about their fascinating lifecycles and behaviour.

DEDICATION

This book is dedicated to the memory of two of the world's finest naturalists – Henry Walter Bates (1825–1892) and Alfred Russel Wallace (1823–1913).

Together these two friends came up with the idea of mounting an expedition to the Amazon, which they funded by collecting specimens and shipping them back to museums and collectors in the UK. The purpose of their expedition was to 'gather facts towards solving the problem of the origin of species.' Wallace conceived the theory of evolution by natural selection. In 1858 his paper on the subject was jointly published with material written by Charles Darwin, prompting Darwin to publish *On the Origin of Species* the following year. Another of Wallace's theories was the concept of warning colouration. Bates worked independently and is best known for publishing the first scientific account of mimicry in animals, which he based largely on his observations of butterflies. He collected tens of thousands of butterflies, animals and plants, of which 8,000 were new to science. He published the story of his great adventure in *The Naturalist on the River Amazons* in 1863. Wallace also collected vast numbers of butterflies, but tragically his entire collection was lost in a fire on board ship during his homeward journey. Such a disaster would have broken a lesser man, but undeterred, Wallace quickly planned another expedition, this time to South-East Asia, where he spent eight years collecting specimens. Perhaps the best way to convey my own lifelong passion for butterflies is to quote the following passage from Wallace's classic work *The Malay Archipelago*:

'During my very first walk into the forest at Batchian, I had seen sitting on a leaf out of reach an immense butterfly of a dark colour marked with white and yellow spots. I could not capture it as it flew away high up into the forest, but I at once saw that it was a female of a new species of *Ornithoptera* or 'bird-winged butterfly', the pride of the Eastern tropics. I was very anxious to get it and to find the male, which in this genus is always of extreme beauty. During the two succeeding months I only saw it once again, and shortly afterwards I saw the male flying high in the air at the mining village. I had begun to despair of ever getting a specimen, as it seemed so rare and wild; until one day about the beginning of January, I found a beautiful shrub with large white leafy bracts and yellow flowers, a species of *Mussaenda*, and saw one of these noble insects hovering over it, but it was too quick for me, and flew away. The next day I went again to the same shrub and succeeded in catching a female, and the day after a fine male. I found it to be as I had expected – a perfectly new and most magnificent species and one of the most gorgeously coloured butterflies in the world. Fine specimens of the male are more than seven inches across the wings, which are velvety black and fiery orange, the latter colour replacing the green of the allied species. The beauty and brilliancy of this insect are indescribable and none but a naturalist can understand the intense excitement I experienced when I at length captured it. On taking it out of my net and opening the glorious wings, my heart began to beat violently, the blood rushed to my head, and I felt much more like fainting than I have done when in apprehension of immediate death. I had a headache the rest of the day, so great was the excitement produced by what will appear to most people a very inadequate cause.'

ACKNOWLEDGEMENTS

The information presented in this publication is based on over 40 years of personal observation by the author. It is supplemented by data accumulated from numerous books, journals and scientific papers; and from communications with entomologist colleagues. In order to make the text more accessible, citations are not included within the text. However, the author wishes to express his sincere gratitude to the following people, and recommends their works to anyone wishing to explore the subject more deeply:

André Freitas, Andrew Neild, Bernard d'Abrera, Bernaud Dominique, Blanca Huertas, Bob Robbins, Curtis Callaghan, Delano Lewis, Jason Hall, Jean-Marc Gayman, Jeremy Thomas, Jorge Bizzaro, Gerardo Lamas, Katie Lucas, Keith Brown, Keith Willmott, Kevin Tuck, Martin Honey, Martin Warren, Matthew Oates, Maurizio Bollino, Michael Parsons, Pat Haynes, Phil DeVries, Ronald Brabant, Stéphane Attal, Szabolcs Safian, Tomasz Pyrcz, Torben Larsen and Zsolt Balint.

I also wish to thank Dave Griffiths and Joe Schelling for kindly undertaking the initial proof-reading, and Simon Papps of Reed New Holland for his enthusiasm, encouragement and assistance during the production of this book.

PHOTOGRAPHIC CREDITS

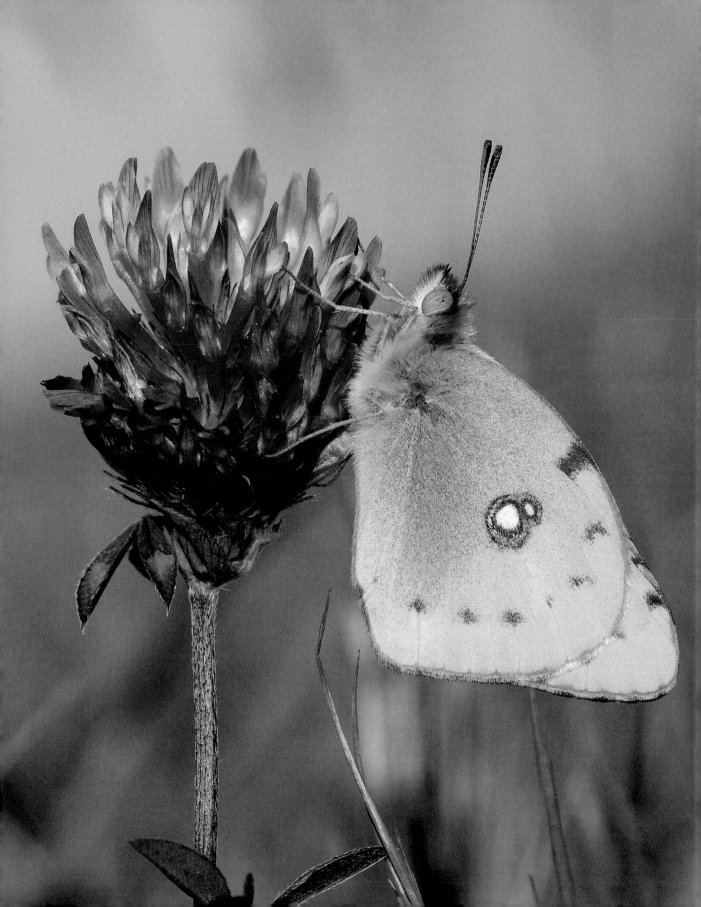

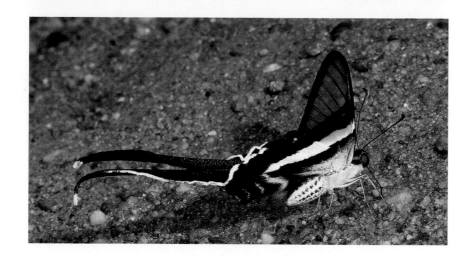

CONTENTS

Introduction ...10

SECTION 1 **ORIGIN AND EVOLUTION**12

SECTION 2 **BUTTERFLY BIOLOGY**
Anatomy ..18
Lifecycle ..33
Natural enemies ..59
Strategies for survival ..66
Migration and dispersal ..86

SECTION 3 **THE BUTTERFLY FAMILIES**
Overview of Butterfly families ..91
Hesperiidae ..96
Nymphalidae ..128
Lycaenidae ..222
Riodinidae ..246
Papilionidae ..266
Pieridae ..276
Hedylidae ..290

SECTION 4 **HABITATS AND CONSERVATION**292

SECTION 5
Glossary ..297
Index ..307

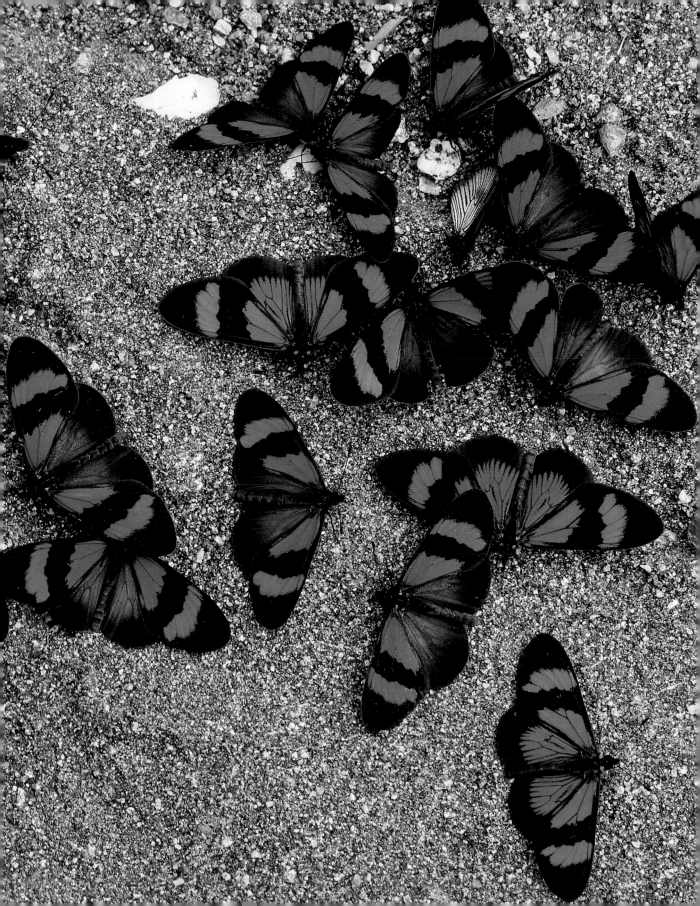

INTRODUCTION

This book is intended as a celebration of the immense beauty and great diversity of butterflies across the world.

The opening chapters in Sections 1 and 2 provide comprehensive coverage of their origin, evolution, anatomy, lifecycle, ecology and general behaviour. These are followed by chapters discussing predators, parasitoids and the diverse survival strategies that butterflies have evolved to deal with them. Section 2 ends with a chapter dealing with dispersal, providing insights into the origins of migratory behaviour.

Section 3 of the book is divided into seven chapters describing the characteristics that distinguish the various families, subfamilies, tribes and genera. It includes many fascinating accounts of butterfly behaviour, and is lavishly illustrated with over 350 images of living butterflies, photographed in their natural habitats.

The author hopes very much that this book will encourage more people around the world to discover and appreciate the myriad of beautiful butterflies on our planet. Above all is the hope that it will motivate its readers to become actively involved in the conservation of butterfly habitats, especially the immensely beautiful and incredibly species-rich tropical rainforests and cloud forests. These irreplaceable paradises are being destroyed at a rate that can only be described as catastrophic, yet it is well within our power to reverse this trend and to save butterflies from the tragedy that otherwise awaits them.

There are numerous ways in which each and every one of us can help. Donations, no matter how small, enable NGOs such as the World Land Trust and the Amazon Conservation Organisation to purchase and protect vital tracts of forest that act as biological corridors connecting national parks and other major wildlife refuges.

A huge contribution to conservation can also be made simply by adding your name to the on-line petitions orchestrated by www.rainforestportal.org, www.rainforest-rescue.org and various other conservation bodies. Such petitions are immensely valuable in applying pressure to governments to clamp down on the illegal logging and unauthorised development that causes so much devastation in the Amazon and Andes, in Africa, and particularly in Malaysia and Indonesia, where the tiny fragments of remaining forest are surrounded by vast expanses of oil palm that stretch to the horizon in every direction. By signing petitions you are sending a loud and very clear message to governments that preserving rainforests is better for their long term economies than cutting them down. Considerable areas of forest have already been saved as a direct result of the embarrassment caused to offending governments and multinational companies by these petitions. Please don't leave it to someone else.

Adrian Hoskins

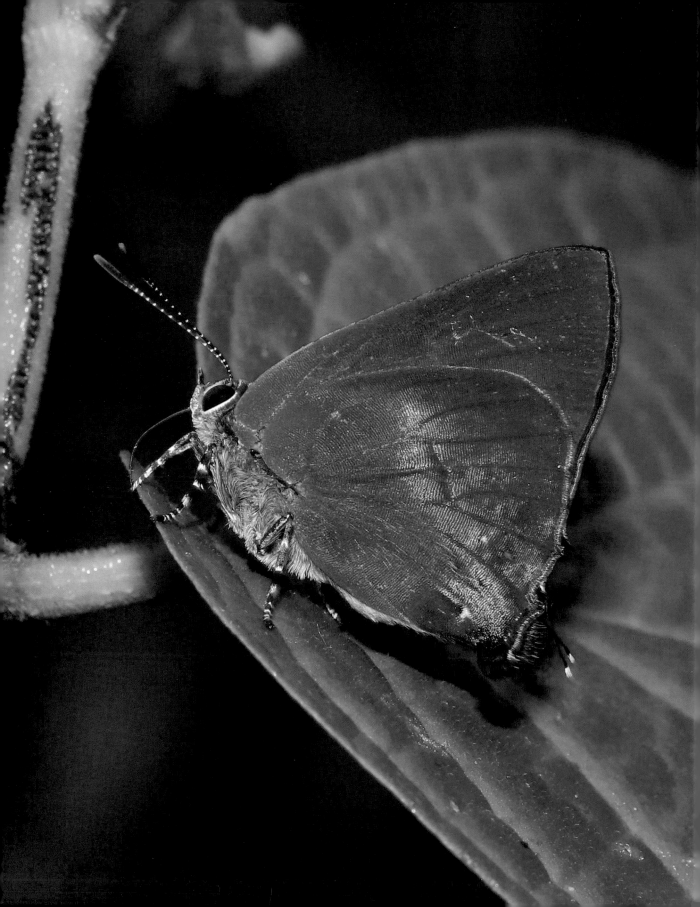

SECTION 1

ORIGIN AND EVOLUTION

THE ORIGIN OF BUTTERFLIES

The oldest fossilised insect so far discovered is *Rhyniognatha hirsti*, a silverfish-like creature that lived about 400 million years ago. However, insects are believed to have first appeared on Earth a while earlier, in the Silurian period, about 420 million years ago. The earliest winged insects appeared at a relatively early stage, about 350 million years ago.

250 million years ago the superorder Amphiesmenoptera emerged. It is from these primitive insects that the first Lepidoptera (butterflies and moths) and Trichoptera (caddisflies) evolved. Both groups share characteristics that are not found elsewhere in the insect world. Butterfly and caddisfly females, for example, have two different sex chromosomes, while in all other insects, females have two identical chromosones.

Other features common to butterflies and caddisflies include fundamentally similar wing venation and the ability of their larvae to produce silk. It is perhaps also no coincidence that the larvae of some modern day Lepidoptera, such as the Hawaian *Hyposmocoma* moths, are aquatic, like caddisfly larvae, spending their lives within similar protective cases, constructed from silk and fragments of wood or gravel. Some *Hyposmocoma* larvae even share the carnivorous habits of caddisfly larvae – they seize small snails, bind them with silk and then suck out their body fluids.

There are about 700 fossil records of Lepidoptera, some dating back to the early Mesozoic period, about 200 million years ago. Most of these refer to trace fossils, such as the larval leaf-mines of primitive moths. The earliest known lepidopteran is *Archaeolepis mane*, a member of the long extinct family Archaeolepidae. Its fossilised wings and scales were discovered in southern England and date back 190 million years to the Lower Jurassic, the era when dinosaurs ruled the Earth.

The extant butterfly families evolved at a time when the present-day continents were still partially linked. However, many of the subfamilies and tribes arose much later, after the break-up of the supercontinent Pangaea. Consequently their global distribution is limited. The Trapezitinae and Tellervini, for example, are restricted to the Australian/Papuan region. The Lipteninae only occur in Africa. Likewise, the Eudaminae, Pyrrhopyginae, Euselasiinae, Baroniinae and Ithomiini are found only in the Neotropics.

OPPOSITE: A new species of *Cyanophrys*, currently under description, discovered by the author at Rio Shima, Peru, in May 2014.

Most modern genera came into existence during the Paleogene era, between about 23–66 million years ago. The oldest known extant species is the Ancient Metalmark, *Voltinia danforthi*, from Sonora, Mexico. Its closest known relative *Voltinia dramba* is known only from specimens found fossilised in amber, on the Caribbean island of Hispaniola. Plate tectonics caused Hispaniola to separate from Central America about 40–50 million years ago, indicating the time when *V. dramba* and *V. danforthi* split from their ancestral parent species.

Whatever their origins, butterflies and moths have since diversified and spread to occupy almost every environmental niche on the planet. In total there are about 160,000 described species of Lepidoptera. Together, butterflies and moths account for about 9 per cent of all life forms on Earth.

There are currently just over 17,500 described species of butterfly. However, in the last 20 years, new species have been discovered at a rate of about 100 per year, so it is estimated that the eventual total will reach 19,000 or more.

Evolution

The concept of evolution was first introduced by the French biologist Jean-Baptiste Lamarck in 1800. He believed that animal anatomy and behaviour were not fixed, but could adapt to new circumstances. Lamarck considered that these adaptations could be transmitted to new generations, evolution being driven by two forces – one which drove animals from simple to complex forms; and another that adapted them to local environments.

Alfred Russel Wallace and Charles Darwin developed upon this, theorising that all animals evolved from more basic forms by a process of natural selection. In 1859, Darwin's book *On the Origin of Species* dramatically altered our perceptions of how species came into existence. After immense initial opposition, the scientific world accepted and expanded these theories,

concluding that life began billions of years ago when primitive entities arose in the 'primordial soup' of early oceans.

Natural variation

In simple terms, evolutionary theory recognises that mutations occur naturally in all populations. Some of these 'aberrations' are caused by freak climatic conditions but others are genetically controlled and can be passed to future generations. The forms that survive better as individuals are able to pass on their genes to further generations, while less beneficial traits tend to be bred out by natural selection.

Speciation

It is generally agreed that speciation is triggered when the habitat of an ancestral species undergoes a major climatic or geological upheaval. Over the millennia, natural barriers such as wide rivers, deserts or mountain ranges emerge, isolating populations from each other. The natural variation which exists intrinsically in all species ensures that new traits arise in each population. One type of biological or behavioural trait may work best in population A, while a different adaptation may be more successful in the environment occupied by population B. Consequently two 'subspecies' develop. Eventually a stage is reached when these races become so different from each other that they are no longer able to interbreed. They are then regarded as distinct species.

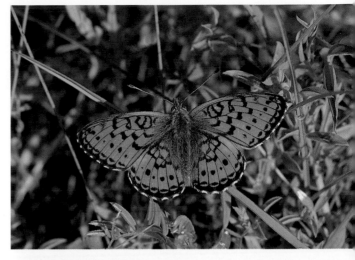

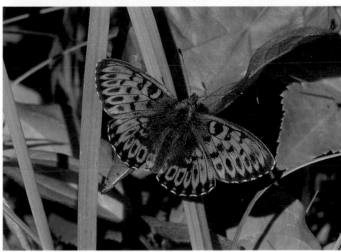

TOP: Lesser Marbled Fritillary, *Brenthis ino*, typical form, Saaremaa, Estonia.

BOTTOM: Lesser Marbled Fritillary, *Brenthis ino*, mutation, Saaremaa, Estonia.

The greatest opportunities for butterfly speciation occur in mountainous regions of the tropics. During interglacial periods when global temperatures increase, species that were previously widespread in the lowlands are forced to retreat to cooler habitats at higher elevations. Environmental differences on various mountains cause each isolated population to gradually evolve adaptations that increase its chances of survival. Thus new species are generated on each mountain. During ice ages each of these species is forced to move down to the warmer valleys. This process is repeated many times as cycles of ice-age and interglacial periods shift butterfly populations back and forth between the lowlands and mountains. Over millions of years, that single ancestral species thus diversifies, generating a multitude of new species.

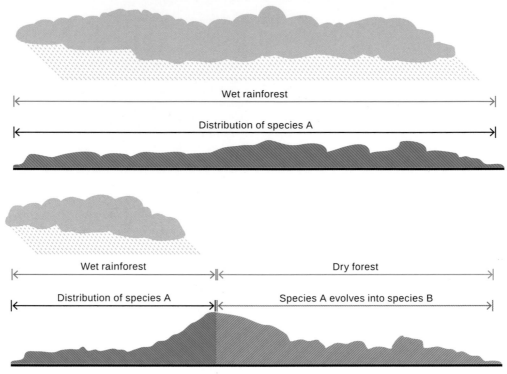

Wet rainforest

Distribution of species A

Wet rainforest

Dry forest

Distribution of species A

Species A evolves into species B

An emerging mountain range changes rainfall patterns and splits the range of species A, leading to the evolution of species B.

For a long time, scientists thought that speciation could only occur if precursor subspecies evolved in isolation from each other, thereby preventing interbreeding. However, recent research on the genetics of two 'sister species', *Heliconius cydno* and *H.melpomene*, which sometimes hybridise with each other, has indicated that such isolation may not necessarily be essential. It appears in fact, that adaptations to ecological niches may be a powerful enough force to instigate speciation.

Speciation is more frequent in the tropics than in temperate regions because there are more habitat niches and more generations per year. In subarctic regions some species take two or more years to complete their lifecycle. The moth *Gynaephora groenlandica* from Greenland, for instance, spends up to 14 years as a larva. In the tropics, most species produce six or more generations per year, providing them with many more opportunities to mutate and speciate.

Subspecies

Most scientists regard the species as the terminal taxon. Subspecies are perhaps best thought of merely as stepping stones, transitional taxa that are presumed to be a prerequisite of speciation. An individual species may have several described subspecies. The Silver-studded Blue, *Plebejus argus*, for example, has 18, including *P.a.corsicus* which is endemic to the Mediterranean island of Corsica and *P.a.caernensis* which is found only on the Great Orme's Head peninsula in north Wales. The Swallowtail, *Papilio machaon*, has no less than 42 described subspecies, distributed across almost the entire northern hemisphere.

A multi-brooded species, the Plain Tiger, *Danaus chrysippus*, Sri Lanka.

Such a proliferation of taxa leads many people to consider that more species and subspecies have been described than truly exist. The difficulty is that there is no universally accepted definition of the word 'species'. It is very much a matter of interpretation. Consequently taxonomists tend to fall into one of two camps – the 'splitters', who tend to frequently elevate the rank of subspecies to full species; and the 'lumpers' who tend to merge groups of what were previously regarded as closely related species, into a single species.

BUTTERFLY BIOLOGY

ANATOMY

The body of a butterfly has three sections: the head, which contains the eyes, antennae and proboscis; the muscular thorax that serves as an anchor for the legs and wings; and the abdomen, which houses the digestive, respiratory and reproductive systems.

HEAD

Eyes and vision

All adult butterflies have a pair of spherical compound eyes. Each contains several thousand individual light receptors or 'ommatidia' that work in unison to produce a mosaic view of the world around them. Each ommatidium consists of a cornea and cone. Together they function as a lens. Light travels down a rod behind each cone to reach a cluster of two to six sensory cells, each sensitive to a particular part of the visual spectrum.

Skipper butterflies are noted for their swift and precise flight. In these species the distance between the ommatidia and the sensory cells is greater than in other butterfly families. Consequently more light spills across onto neighbouring rods, increasing resolution and sensitivity. As a result, they can judge their flight paths with extreme accuracy. Many Skipper genera, such as *Tisias*, *Carystus*, *Lycas* and *Matapa*, have conspicuous red eyes. These butterflies are crepuscular in behaviour, flying at dawn and dusk. In them, the distance between the cones and sensors is even greater than in day-flying species. Sensitivity is thus increased even further, enabling them to see well enough to perform high precision flight manouevres even in twilight conditions.

ABOVE: Moore's Red Eye Skipper, *Matapa aria*, Ulu Gerok, West Malaysia.

OPPOSITE: Swallowtail, *Papilio machaon*, Saint Germain l'Herm, France.

The laws of optics show that it's likely that everything within a range from about 1cm (0.4in) to 200m (650ft) will be rendered in sharp focus by butterflies, due to the very short focal length of the ommatidia.

The butterfly's brain can detect whether the image formed by each ommatidium is dark or light. If a predator approaches, or if the butterfly moves its head a tiny fraction, the amount of light hitting each receptor changes instantly because of its very narrow angle of view. This sensitivity to changes in its surroundings means that butterflies are incredibly efficient at detecting movement and at gauging the distance of an approaching predator, enabling them to take immediate evasive action. Their high flicker-vision frequency of about 150 images per second may also help them to piece together the thousands of elements of the mosaic, merging them into a single image. If this is the case, it might be possible for them to distinguish patterns at close distances.

Most animals need to move their heads to scan their surroundings, but butterflies have an almost 360° field of vision. They can see everything at the same time, enabling them to accurately probe into flowers in front of them, while simultaneously devoting equal concentration to detecting threats from behind. They can also see polarised light, allowing them to determine the position of the sun, even if it is partly obscured by cloud. This lets them relate their position to the sun and use it as a compass when moving around their habitats.

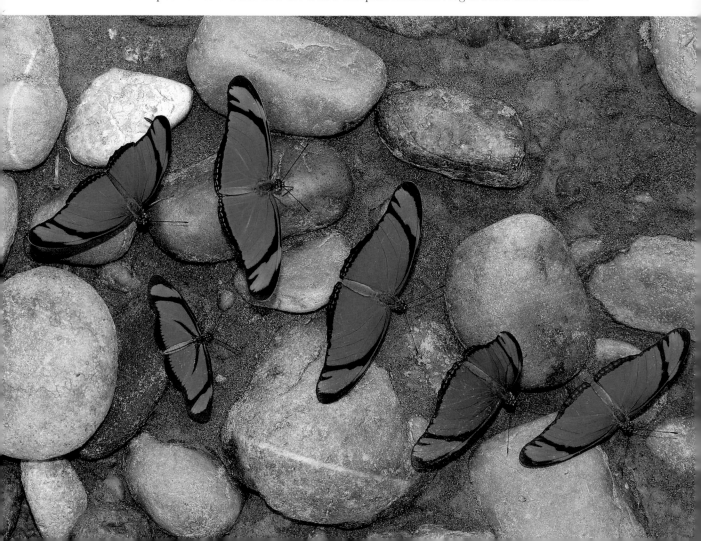

Humans and birds perceive colours in a different way to butterflies, as the latter are sensitive to ultraviolet as well as visible radiation. Flowers have UV patterns that are invisible to vertebrates but can be recognised by butterflies and guide them to the source of nectar, much as runway lights guide an aircraft in to land.

The visible patterns of butterflies serve primarily to convey survival-related signals such as camouflage or aposematic colouration to insectivorous birds. Additionally, visible and UV patterns enable them to detect and recognise members of their own species during the initial phases of mate location. Butterflies are also alert to the iridescent colours produced when sunlight refracts from the wings of their congeners. Experiments have also shown that many species have selective colour response, i.e. their brains are tuned to react to colours that are dominant in the wing-patterns of their own species.

The interpretation of visual signals by the brain also provides butterflies with a limited ability to distinguish various shapes – females of some species seem able to recognise plants from a distance, purely on the basis of leaf shape. Male butterflies seem less able to discern shape – they will generally chase after anything that is approximately the same size and colour as their own species, regardless of its shape.

Antennae

Emerging from between the eyes of butterflies is a pair of segmented antennae. These can be voluntarily angled at various positions, and are best thought of as a form of scent-radar. They are covered in thousands of microscopic sensors that are sensitive to sexual pheromones and to the scent of nectar and larval foodplants.

The antennae are also used for tactile communication. It is common for example, to see male Small Tortoiseshells, *Aglais urticae*, drumming their antennae on the hindwings of females during courtship, but it has not yet been proven whether they are using them to 'taste' pheromones, or to produce percussive signalling.

Traditionally, one of the ways of distinguishing between butterflies and moths has been to examine their antennae. In most butterfly subfamilies the shaft is narrow and straight, and is tipped with a prominent rounded club. In Ithomiini however, the antennae thicken progressively towards the tip. The antennae of Hesperiidae thicken in a similar way, but have a distinctive hook at the tip.

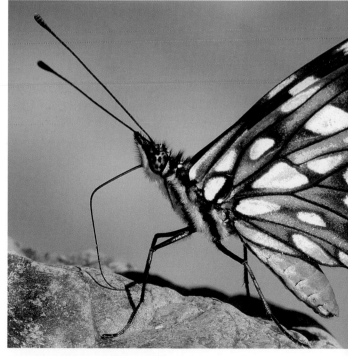

ABOVE Club-tipped antennae of *Dione juno* (Heliconiinae), San Ramon, Peru.

OPPOSITE The Julia, *Dryas iulia*, and Juliette, *Eueides aliphera*, are both attracted to anything coloured bright orange.

Among the moths, males of Lasiocampidae, Saturniidae and several other families have dramatically plumed or 'pectinate' antennae. They are covered in thousands of olfactory sensors that can detect the scent of females from distances of up to 2km (1.2 miles) away.

There is a popular misconception that moths never have club-tipped antennae, but there are several exceptions to this general rule. The day-flying Cane Borer moths (Castniidae), for example, have straight shafts with prominent clubs, very similar to those of Nymphalid butterflies.

Johnston's organ

At the base of each antenna is a Johnston's organ. This is covered in nerve cells called scolopidia, which are sensitive to stretch. They are used to detect the position of the antennae, as affected by gravity and wind. Thus, they can sense orientation and balance during flight, enabling butterflies to finely adjust their direction or rate of ascent/descent. Laboratory experiments with Monarchs, *Danaus plexippus*, have also revealed that these organs are able to detect magnetic fields, thereby assisting navigation during migration.

Palpi

Protruding from the front of the head is a pair of small projections called labial palpi, which are covered in olfactory sensors. Similar sensors are also located on the antennae, thorax, abdomen and legs. They are present in a variety of forms, so it's likely that each type serves a different purpose. Sensors on the antennae, for example, are probably tuned to locate sexual pheromones, while those on the legs are sensitive to chemicals exuded by larval foodplants. Those on the palpi and proboscis, due to their position, might be tuned to detect adult food sources. The palpi undoubtedly also have other, as yet unexplained functions. They may, for example, act as tactile sensors like a cat's whiskers, alerting butterflies when their eyes get too close to sticky food substances such as tree sap or putrefied fruit. If these came into contact with the eyes, the butterfly would be blinded and would very quickly fall prey to insectivorous birds.

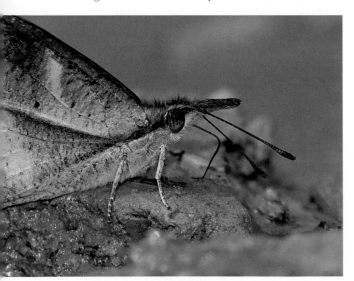

Palpi and proboscis of Oriental Beak, *Libythea myrrha*, Assam, India.

Proboscis

All butterflies have a proboscis. So do most moths, although it is absent in certain families such as Saturniidae, whose adults rely for sustenance entirely on fats and proteins accumulated during the larval stage. The proboscis consists of a pair of c-section channels, linked together to form a tube, which functions like a drinking straw. It can be coiled up like a watch spring for storage, or extended to enable the butterfly to reach deep into flowers to suck up nectar. If it gets clogged with sticky fluids, the two sections can be uncoupled and cleaned.

THORAX

The thorax consists of three body segments, fused together to form a chitinous cage which acts as an anchor point for the legs and wings. Within the thoracic cavity are powerful muscles that lever on the wings. The rapid expansion and contraction of the muscles causes the wings to rise and fall at rates of up to about 1,000 beats per second in bees and close to 200 beats per second in hawkmoths.

Amongst the butterflies, Skippers have the fastest wingbeats. Their wings whirr audibly at a rate of about 20 beats per second as they dash from place to place. Other, more 'fluttery' butterflies, such as Swallowtails and Satyrs, can only manage about five beats per second. Even slower are ithomiines, such as *Methona confusa*. These have very deep beats at about three per second. Slowest of all are the Morphos and the *Caligo* Owl butterflies. In normal flight they only achieve about two beats per second, although if alarmed they can temporarily double that frequency.

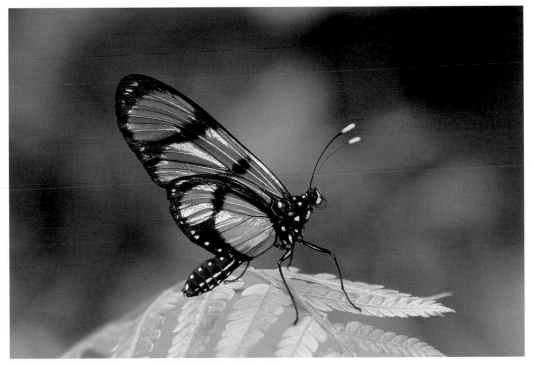

Giant Glasswing, *Methona confusa*, Rio Madre de Dios, Peru.

Legs

Most adult butterflies have three pairs of legs. In the Nymphalidae however, the front pair are reduced to brush-like stumps and modified as chemoreceptors. In the Riodinidae the forelegs of males are greatly reduced, but in females all the legs are fully functional, enabling them to more easily manoeuvre to oviposit under leaves. The males of certain genera of Lycacnidae and Hesperiinac have fully-formed but redundant forelegs that are often held 'kangaroo-style' and not used for walking.

The middle pair of legs has a subgenual organ, which detects and amplifies small vibrations. These alert butterflies to ground trembles caused by the approach of animals or birds, enabling them to respond instantly to danger.

Spurs on the legs can be used to puncture the cuticle of a leaf, causing it to bleed tiny quantities of sap. Olfactory sensors on the legs are then used to determine the chemical composition of the leaves, thereby ensuring that females lay their eggs on the correct species of plant. Females also sometimes dab their antennae onto leaves and then draw them through the spurs on their forelegs, transferring more chemicals on to the sensors for analysis.

ABDOMEN

The abdomen contains the digestive system, breathing apparatus, a long tubular heart and the sexual organs. The abdominal exoskeleton is comprised of 10 short segments, each composed of chitin. The segments are linked by flexible tissues, allowing the abdomen to bend, a necessity for copulation and egg-laying.

Spiracles
On the sides of each abdominal segment are tiny oval holes called spiracles, through which air enters and leaves the body. Slight rhythmic movements of the body, coordinated with the opening and closing of the spiracles, suck air into microscopic lung-like sacs, enabling the butterfly to breathe.

Digestive system
Butterflies feed exclusively on liquids. According to species, the diet may include fruit juices, tree sap, nectar, dissolved pollen, mineralised water, liquefied mammal or bird faeces, urine, sweat, or even bodily fluids oozing from decomposing animal corpses. After digestion and extraction of proteins and other minerals in the gut, the waste matter is expelled from the anus, either in liquid form, or as tiny faecal pellets.

Sexual organs
The genitalia are located at the tip of the abdomen. Each species has uniquely shaped genital structures – the male 'key' only fitting the correct female 'lock'. Because the structure of the organs is unique to each species, taxonomists have traditionally relied heavily on microscopic examination of genitalia to determine species and their relationship with other taxa. Females are also equipped with an ovipositor – a short flexible tube via which the eggs are released and deposited.

Sound producing organs
Insects such as cicadas and grasshoppers are well-known for producing courtship songs, but butterflies are normally only associated with incidental sounds, such as the whirring of wings. However, there is mounting evidence that they can produce auditory signals that fulfil specific functions. Most of these sounds can only be detected with specialised acoustical equipment. In some butterflies however, they are clearly audible.

Grey Cracker, *Hamadryas februa*, Yarinacocha, Peru.

In Europe, the Peacock butterfly, *Inachis io*, often rests on the ground with its wings closed. However, if alarmed, it suddenly flashes open its wings, displaying huge eye-like markings. As it does so, the butterfly stridulates with its wings, making a distinctive rasping 'alarm' sound that has been likened to the hissing of a snake.

Male *Hamadryas* Cracker butterflies in South America can produce a sound similar to the crackling of frying bacon. It is made by twanging together two hollow veins on the forewings, when the wings reach their highest position. The purpose of the sound is not fully understood. One theory is that it deters competing males from occupying the same territory. However, a tree trunk will often host three or four males perching in close proximity, so that seems unlikely. Furthermore, an apparently identical sound is also produced in the presence of females.

WINGS

Venation

All butterflies have two pairs of overlapping wings, each composed of a very thin double membrane, with rigidity supplied by a network of tubular veins that radiate from the base of the wings. The number of veins and the pattern formed by them varies according to family and genus. Wing venation is thus one of the primary characteristics analysed by taxonomists when classifying Lepidoptera.

In most butterflies the veins are obscured by the overlying scales, but in *Aporia* Black-veined Whites they are very obvious, being outlined in black. In ithomiine Glasswings, such as *Episcada hymenaea*, the near-absence of wing scales also allows the venation to be clearly seen.

ABOVE Venation of Swallowtail, *Papilio machaon* (Papilionidae).

BELOW Round-winged Glasswing, *Episcada hymenaea*, Rio de Janeiro, Brazil.

Scales

The wing membranes are transparent, but in most butterflies are covered in a dust-like layer of tiny, overlapping coloured scales. The scales generally take the form of flat rectangular or tear-drop shaped plates, each arising from a single cell on the wing surface. Many however, especially those near the base of the wings, are long, thin and hair-like.

In some species there can be as many as 600 scales per square cm (0.16 sq in) of wing surface, but in certain genera, such as *Parnassius* and *Acraea*, the density is much lower, giving the wings a translucent glassy appearance. In many tropical genera, including *Ithomia* Glasswings, *Lamproptera* Dragontails and *Cithaerias* Phantoms, the scales are absent from large areas of the wings, resulting in almost complete transparency.

The scales, where present, are laid out in neat rows like the tiles on a roof. Each row is comprised of alternating pigmentary and structural 'cover scales'. The latter are larger and semi-transparent so the colours of the pigmentary scales can be seen through them. In combination, they can produce any colour of the rainbow, ranging from the subtle browns of Satyrs, to the fiery reds and oranges of *Lycaena* Coppers and the dazzling blues of Morphos.

Butterflies can even display colours beyond the visible spectrum. In addition to the colours visible to humans and birds, they also have a private channel of ultraviolet patterns that can only be seen by other butterflies.

Pigmentary scales

The pigments account for the basic colours found in butterfly wings – black, red, yellow, orange and brown. The juxtaposition of the scales often creates the illusion of additional colours. In *Anthocharis cardamines*, for example, the green colour on the underside is an illusion created by the juxtaposition of yellow and black scales. Variations in pigmentation and density also create further illusions such as texture or shading, which help to give the wings of some butterflies a three-dimensional appearance.

Structural scales

The action of light, striking semi-transparent structural scales, produces metallic or iridescent colours. Diffraction causes light to be broken up into bands, after passing through a lattice of microscopic bubbles or slits within the scales. Refraction, on the other hand, occurs when light is broken up into its constituent rainbow colours, having passed through prismatic ridges on the surface of the scales. Interference patterns occur when light passes through clear layers of varying density.

The colours that we perceive are determined by the directional qualities of the light and the angle at which it strikes the scales. Thus, as a butterfly moves its wings, the colours often change very dramatically. The effect is particularly striking in the *Doxocopa* Emperors, where a band of colour can be transformed from deep purple to electric blue, vivid turquoise or dazzling silver, as sunlight strikes the wings at different angles.

Perhaps the most extreme example of iridescence is found in Madagascar, in the day-flying Rainbow Moth, *Chrysiridia rhipheus*. The slightest change of angle causes metallic green bands on its forewings to change to turquoise, while contrasting patches on the hindwings undergo an even more dramatic transformation, cycling through red, yellow, green, purple and blue

Turquoise Emperor, *Doxocopa laurentia cherubina*, Antioquoia, Colombia.

hues as the moth fans its wings in the sunlight. The extraordinary brilliance and iridescence is due to the unusual curved ribbon-like scales. Their structure causes light to bounce around between them, before being reflected back to the observer.

Androconia

This type of scale is found mainly in male butterflies. Tiny sacs at the base of the scales contain sex pheromones, which are released in the presence of females, to entice them to mate.

In many satyrines, such as the Gatekeeper, *Pyronia tithonus*, androconia occur as diagonal, mealy patches or 'sex brands' on the forewings. This is also the case with many hesperiines, such as *Ochlodes* and *Thymelicus*. In the Skipper tribes Pyrgini and Erynnini they are contained within a fold on the leading edge of each forewing.

Androconia on forewings of male Gatekeeper, *Pyronia tithonus*, England.

Androconial pocket on the hindwing of male *Tirumala septentrionis*, West Bengal, India.

The androconia of ithomiines such as *Mechanitis*, *Greta* and *Ithomia* occur as long hair-like scales on the leading edge of the hindwings. In danaines they also occur on the hindwings, but are contained in small pockets, as shown in the illustration of *Tirumala septentrionis*. During courtship the male gathers the pheromones by brushing a tuft at the tip of his abdomen against each pocket. The tuft is then expanded in the presence of a female, releasing the chemicals in front of her.

Sexually dimorphic wing-patterns

In addition to androconia, there are other ways to visually differentiate the sexes of butterflies. Males are generally slightly smaller and more brightly coloured than their female counterparts. Females usually have more rounded wings, and tend to have fatter abdomens, as they are laden with a cargo of eggs. In order to lay them all, they must remain undetected by predators for as long as possible, so in many species, females are secretive in behaviour, and less conspicuously coloured than males.

Although differences in colour and pattern between the sexes are generally very minor, there are a significant number of species in which the dimorphism is quite pronounced. In the genus *Polyommatus*, for example, males are generally bright blue, while females are dark brown.

Males of the Turquoise Emperor, *Doxocopa laurentia*, have dazzling turquoise bands on their

ABOVE Male Amanda Blue, *Polyommatus amandus*, Viidumae, Estonia.

LEFT Female Amanda Blue, *Polyommatus amandus*, Kuresaare, Estonia.

wings, but females are banded with white and orange, such that they bear a strong resemblance to *Adelpha* Sisters. Such mimicry of other genera by females also occurs in various *Papilio*, *Elymnias* and *Hypolimnas* species. This is discussed more fully in the Strategies for Survival chapter.

Hearing organs

Hamadryas Crackers and *Heliconius* Longwings have an 'ear' at the base of their underside wings. It takes the form of a funnel shaped sac, covered with a thin membrane. This vibrates in response to high frequency sound, stimulating nerve cells, which convey signals to the brain.

Nerve cells similar to those in the ears are found in enlarged veins at the base of the forewings in some butterfly genera. They are particularly well developed in Satyrs such as *Oressinoma*, *Maniola*, *Pararge* and *Hipparchia*, all of which react instantly to the sound made as dry leaves are crunched underfoot.

Some butterfy species, such as *Morpho helenor*, have been shown to be able to differentiate between high and low pitches. Potentially, this might enable them to distinguish between the beating of bird wings and the sound of birdsong, thereby enabling them to take evasive action when necessary.

The evolution of hearing

When butterflies first evolved they were probably nocturnal. Their ears may have originally served to detect and avoid predatory bats. Bats emit acoustic pulses as they fly, using their highly sensitive ears to detect the echo reflected back by solid objects. This way they can avoid hitting unseen obstacles and are able to locate moving prey in the dark. Owlet and Tiger moths are able to hear a bat's acoustic pulses. The frequency and volume enables them to work out how far away a bat is from them. The relative positions of a moth's hearing organs even enable it to triangulate and determine a bat's direction of approach. High-speed photography has shown that moths initially react by steering away, but instantly divebomb if a bat gets within striking distance.

Flight

The wide variety of wing-shapes and wing-to-body size ratios in butterflies give rise to multifarious flight styles. Skippers have small narrow wings and broad muscular bodies, resulting in a whirring moth-like flight. Hairstreaks and Metalmarks have broader wings and thinner bodies, so their wings beat more slowly, although they still fly quite rapidly. Leafwings have particularly robust wings. They tend to launch into flight very suddenly, swerve to confuse predators, and then abruptly resettle. Swallowtails have large but flimsy wings. Consequently they fly slowly, with gentle fluttering wingbeats. Sisters and Aristocrats fly by a combination of flitting and gliding. When gliding, they curve their wings so as to create a concave under-surface, producing a parachute effect which slows the rate of descent.

In the Neotropics, *Eurybia* butterflies and other Metalmarks habitually spend long periods perching upside down, with wings outspread, on the underside of foliage. Flight analysis has shown that by doing so they are able to launch into flight much more efficiently than they could if they rested the 'right' way up.

Thermoregulation

Butterflies are cold-blooded. If they are too cold they cannot fly. If they get too hot they become dehydrated and die. They have no internal means of regulating their body temperature, so they need to use behavioural strategies instead. In cool conditions they have to raise their

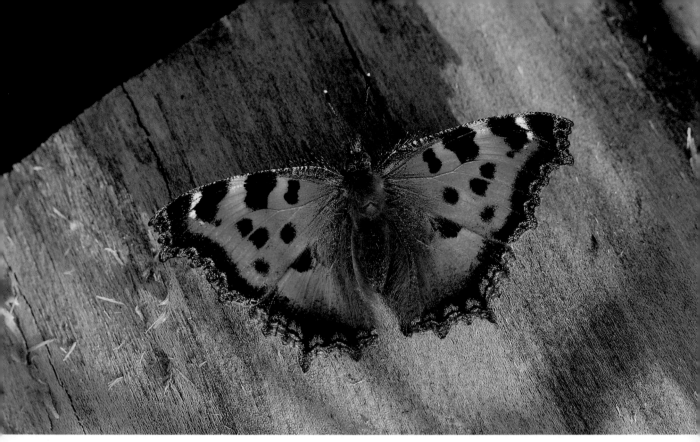

Yellow-legged Tortoiseshell, *Nymphalis xanthomelas*, Saaremaa, Estonia.

body temperatures before they can fly. Most species achieve this by basking, using their wings as solar panels to absorb heat and give them energy. To maximise absorbtion, they often bask on heat-reflecting substrates such as boulders, tree trunks, logs or patches of bare ground.

In temperate regions, many butterflies, such as *Colias* Clouded Yellows, *Hipparchia* Graylings and *Callophrys* Green Hairstreaks, keep their wings closed when at rest. In cool conditions they tilt their wings over to present the maximum possible wing area to the sun. Conversely, if they get too hot, they tilt in the opposite direction. Their wing surfaces are then parallel to the sun's rays, minimising heat absorbtion.

Whites, Blues and Coppers have wing surfaces which reflect rather than absorb solar energy. Consequently they bask with their wings half open, so that the heat produced by sunlight falling on the dark thorax is contained within the 'cage' of the half-open wings rather than being dispersed on the breeze. This behaviour is called reflectance basking.

Another method used to raise body temperatures is shivering. Peacocks, Commas and Tortoiseshells, for example, prepare themselves for flight by rapidly shivering their closed wings. Even on cold days, a couple of minutes of this activity will generate enough friction to heat up the thoracic muscles and enable them to fly short distances.

Butterflies can only operate within a limited temperature range. On hot days they are in danger of desiccation so they need to find ways to keep cool. Forest-dwelling species simply hide beneath leaves, while species that inhabit open areas often fly into bushes or enter animal burrows to seek shade.

LIFECYCLE

Insects first appeared on Earth in the late Silurian Period. The earliest insects had a simple two-stage lifecycle in which miniature versions of the wingless adults emerged from eggs. Such insects are called Apterygotes. Modern day examples include silverfish, springtails and bristletails.

Winged insects first appeared in the late Devonian or Lower Carboniferous Period when a three-stage Exopterygote lifecycle evolved in which wingless nymphs emerge from eggs. As the nymphs feed and grow they periodically moult their skins. The stages between the moults are called instars. During the later instars the nymphs develop wing buds, but it is only after the final moult that fully developed wings appear. Examples of Exopterygotes include mayflies, dragonflies, stick and leaf insects, katydids, mantises, earwigs, cockroaches, lice, termites and shield bugs.

The most advanced insects, those with a four-stage Endopterygote lifecycle, evolved in the late Carboniferous Period. Examples include lacewings, scorpion flies, caddisflies, true flies, bees, wasps, ants, beetles, butterflies and moths.

The lifecycle of butterflies was first unravelled in 1600 by Maria Sibyella Merian, who observed that they have four distinct phases of development: ovum, larva, pupa and imago.

OVUM (EGG)

The shape, size, colour and texture of butterfly eggs varies enormously according to family and subfamily. The Pyrginae and Satyrinae, for example, have eggs that are domed or barrel-shaped, with between 8–30 vertical ribs, linked by a series of tiny lateral ridges. In the Hesperiinae and Papilioninae, the eggs are smooth-surfaced and globular. Those of the Polyommatinae are shaped like flattened doughnuts and have a finely reticulated surface. The Limenitidinae produce spherical eggs dimpled with hundreds of hexagonal pits and tiny spikes, giving them the appearance of miniature sea urchins. Pierinae produce tall skittle-shaped eggs, with fine vertical ribbing. The variety is endless.

All butterfly eggs have a funnel-like depression at the top. At the centre of this is a hole called the micropyle, through which the sperm enters during fertilisation. The eggshell is also peppered with microscopic pores called aeropyles, which supply air to the developing larva.

Fertilisation

In most species, the eggs are already formed within the bodies of females when they emerge. They grow in size over a period of two or three days as they mature within the female's body. Egg-laying is triggered when they reach a certain size, at which time they pass from the ovariole to the egg chamber. They are fertilised just prior to egg-laying, the sperm having been stored until this time in a receptacle in the female's abdomen.

Oviposition

Most butterflies lay their eggs, either singly or in batches, on the foodplants that will be used by their caterpillars. Some species, however, lay their eggs away from the foodplant on tree trunks, dead leaves or bare soil. This strategy prevents them from being accidentally eaten by grazing animals.

Marbled Whites, *Melanargia galathea*, drop their eggs randomly as they fly among tall grasses. The vast majority of butterflies, however, are incredibly fussy about where they lay their eggs. Pearl-bordered Fritillaries, for example, glue them onto dead bracken or dry grass stems next to their larval foodplant *Viola*. White-letter Hairstreaks are even fussier, laying their eggs on elm twigs, at the precise point where the new and old growth meet. Silver-washed Fritillaries, *Argynnis paphia*, deposit their eggs in chinks in the bark of oak trees. Upon hatching, the baby larvae eat their own egg shells, but then go into immediate hibernation. In the spring, they awaken and descend the tree, to feed on the leaves of nearby violets.

Many species in the subfamilies Pierinae, Heliconiinae, Danainae and Papilioninae are able to visually or chemically detect eggs laid by other females. They reject any plants that carry the eggs of other butterflies, thereby preventing overcrowding and potential starvation of their offspring.

Foodplant selection

The larvae of most species will only eat the leaves of one or two types of plant. They will die if they find themselves on the wrong type of tree, bush or herb. Even oligophagous species – those that are able to feed on more than one type of plant – have a hierarchal order of foodplant preference, only accepting less nutritional species if they are unable to locate their preferred foodplant.

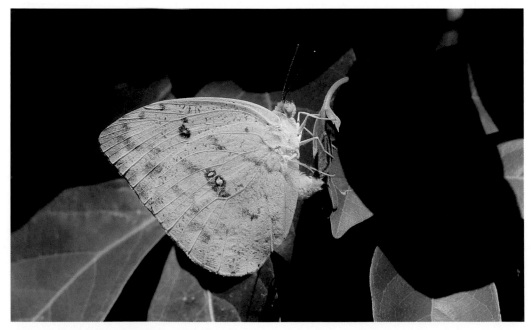

Apricot Sulphur, *Phoebis argante*, ovipositing on *Inga*, Rio de Janeiro, Brazil.

Butterflies, therefore, spend a great deal of time checking various leaves, to ensure they lay their eggs on the correct plant. They appear to initially narrow down the choice of plant visually. They then visit each in turn, alighting for a split second on various leaves to test the chemical properties of the plants, using olfactory sensors on their feet. This process enables them to locate the proper type of plant from amidst the myriad of species in their habitat. Females often visit dozens of plants and test hundreds of leaves before satisfying themselves that they have found the right larval foodplant.

It isn't just enough to locate the correct species of plant. The eggs usually have to be laid on tender young leaves or buds, as older leaves often contain toxins that can kill the larvae. They also have to be laid on plants that are growing in very precise conditions – just the right degree of shade, just the right conditions of temperature and humidity, and at a height on the plants where they will not be accidentally eaten by browsing herbivores.

Heliconius eggs are often laid on tendrils, or on the tips of buds, where they are less likely to be found by marauding ants. Hairstreaks such as *Thecla* and *Satyrium* often spend long periods probing about with the tips of their abdomens, taking extreme care about the positioning of each egg before finally choosing a particular fork in a twig.

It is often impossible to figure out what attracts a female to a particular twig, leaf, or bud, but it is quite common for more than one female to oviposit in the same place. By way of example, I once found a *Succisa* leaf with two separate Marsh Fritillary egg batches deposited on its undersurface, each laid by a different female.

This tendency to home in on a particular plant or leaf sometimes results in strange anomalies. The Brimstone, *Gonepteryx rhamni*, for instance, always lays its eggs singly, but I have counted up to 19 on a single leaf, and up to 100 on a tiny bush. This figure, however, pales into insignificance when learning about observations of certain *Capparis* feeding butterflies. In Kenya, in 1926, Somersen estimated that a single 1m (3.3ft) high bush held about 57,000 eggs and larvae of *Belenois aurota*. In Sydney, Australia, during a mass migration of *Anaphaeis java*, Waterhouse estimated that about 250,000 eggs were laid on a single 5m (16ft) high *Capparis*.

Laying in batches

Butterflies usually lay the bulk of their eggs within the first few days of their lives. Most species lay their eggs singly, but some lay them in batches. This reduces time spent searching for oviposition sites and ensures that as many eggs as possible are laid before the butterfly falls prey to a predator. As might be expected, there are also negative aspects to this strategy. An egg batch could make a nourishing meal for a frog or a small rodent. Just as likely, it could be accidentally eaten by a grazing animal. To reduce the likelihood of such catastrophes, butterflies choose their egg-laying sites with enormous care.

Several Nymphalidae genera, including

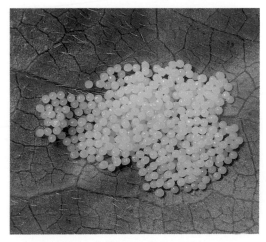

Egg batch of Marsh Fritillary, *Euphydryas aurinia*, Dorset, England.

Hamadryas Crackers, *Polygonia* Commas and *Araschnia* Map butterflies, lay their eggs in long vertical strands, dangling from the underside of leaves. *Hamadryas amphinome* sometimes lays strands of up to 15 eggs long. It is not known what advantage the butterflies gain by adopting this strategy – perhaps the eggs at the end of the string are less susceptible to leaf mould or attack by ants?

Egg parasitoids

In addition to the threats from predators and grazing animals already mentioned, eggs are frequently parasitised by microscopic wasps and flies. It might seem surprising that something as small as a butterfly egg has its own parasitoids, but these cause high losses, particularly in species that lay their eggs singly. The main culprits are wasps in the families Scelionidae and Trichogrammidae – as many as 60 of these minute insects can emerge from a single butterfly egg.

Maturing and incubation

The eggs of many species need to mature within the female for three to six days before egg-laying commences. Once this period has elapsed, her activity follows a rest-feed-fly-oviposit cycle, triggered by an inbuilt biological clock and modified by environmental cues such as temperature and light levels. The 'oviposit' part of the cycle, often referred to simply as an egg-laying run, typically lasts for about five minutes.

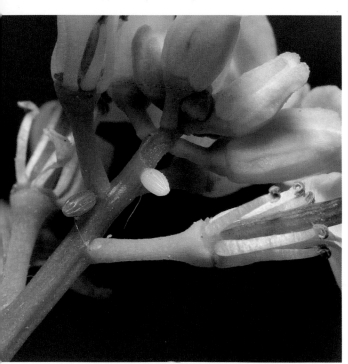

Eggs of Orange-tip, *Anthocharis cardamines*, Sussex, England.

The rate at which the larva develops within an egg varies from species to species. Eggs of tropical butterflies usually hatch within a week, but in temperate regions 10–14 days is more typical. There are, however, numerous species such as Purple Hairstreak, *Favonia quercus*, Chalkhill Blue, *Polyommatus coridon*, and High Brown Fritillary, *Argynnis adippe*, in which the eggs hibernate over winter. In some cases, the larva is formed within the egg, prior to hibernation, but doesn't hatch until the following spring.

Butterfly eggs often undergo colour changes as the young larvae develop within them. The eggs of the Marsh Fritillary, *Euphydryas aurinia*, for example, are bright yellow when first laid, but after a day or two turn pinkish, then deep crimson and finally dark grey just before the larvae hatch. The egg of the Orange-tip butterfly, *Anthocharis cardamines*, is pure white when first laid, but turns orange within 2–3 days, then becomes dull grey when hatching is imminent.

LARVA (CATERPILLAR)

A larva has only two functions during its life – to eat and survive. It is basically just an eating machine with large powerful jaws, a huge gut and an elasticated skin that stretches to accommodate the huge amount of food consumed.

Larvae do not possess external wings. However, even in the earliest stages, they have rudimentary wing-pads under their skin. These are initially extremely small, but by the time the larvae are full-grown these internal wing pads have developed veins and other structural features found in adult butterflies.

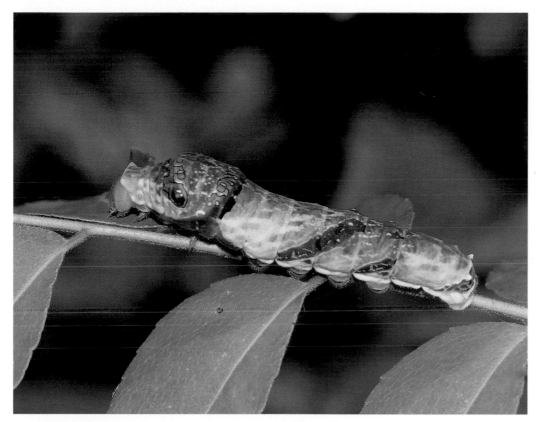

Larva of Common Raven, *Papilio castor*, Manas NP, Assam, India.

All larvae have six true legs located on the first three segments. These are used to hold and manipulate the leaves on which they feed. The abdominal segments of most species also have four pairs of sucker-like 'prolegs' which are used for locomotion. All larvae also have a pair of anal claspers, which are used to clamp them to stems or to the midrib or veins of leaves.

Caterpillars, pupae and adults breathe through oval spiracles, which open and close to allow gas exchange with the atmosphere. Each segment has two spiracles, one on each side of the body.

Hatching

When a caterpillar is ready to hatch, it bites a tiny hole out of the top of the egg. It nibbles away over a period of an hour or so, until the hole is large enough to allow it to crawl out. Some species use a different technique, chewing out a circle around the perimeter of the egg to create a lid, which is then pushed upwards to allow the caterpillar to make its exit.

After hatching, some larvae, such as that of the White-letter Hairstreak, *Satyrium w-album*, immediately rush away to burrow into a young leaf bud or flower. Those of most species, however, usually stay long enough to partly devour their eggshell, which contains important nutrients. Larvae deprived of the opportunity to eat their eggshell invariably perish.

Feeding

For the remainder of the larval stage, most species feed on the leaves, stems, flowers or seeds of particular plants. When small, they can usually only nibble at the leaf cuticle or petals, but larger larvae can devour an entire leaf within a couple of minutes. Some species are polyphagous, i.e. they are adapted to feed on a wide variety of plants from different botanical families. Most, though, are monophagous – limited to feeding on just one or two closely related plant species and incapable of surviving on anything else. Not all larvae feed on living flowers or leaves. Some African Liptenid larvae are known to feed on algae. In Amazonia, the larvae of *Calycopis* Groundstreaks and *Detritivora* Metalmarks feed on dead vegetation on the forest floor. Not all larvae are vegetarian either – it often surprises people to find out that the larvae of many Hairstreaks, Blues and Darkies from the family Lycaenidae are carnivorous.

The larval stage of many species tends to be compressed into the early part of the season. This is because the chemical make-up of plants changes seasonally. Plants often accumulate toxins in their leaves as a means of defence against herbivores. Older leaves are more strongly toxic and have less protein than younger leaves. Towards the end of the season, leaves may be so toxic that they can kill any caterpillar that eats them.

The balance of proteins, carbohydrates, minerals, alkaloids and essential oils in plant leaves varies throughout the day, so larvae tend to feed at specific times, when the foliage is most nutritional and least toxic. Many species only feed at night. This way, they are less likely to fall prey to insectivorous birds, which need daylight in order to locate their prey.

The duration of the larval stage varies according to climate and day length. It is also heavily influenced by the varying nutritional values of the foodplants. Larvae that eat foods with high nutritional value, and that live in hot climates, grow very quickly. They may go from egg to pupa in less than a month. Species that feed on grasses, bamboos, palms or roots, all of which are low in nutrients and difficult to digest, develop very slowly, commonly taking two or three months to reach maturity. In the case of species from temperate regions, growth is often so slow that larvae are unable to complete their development during the summer, having to hibernate and resume feeding the following spring. Larvae which live in the subarctic, or in cold, high-elevation habitats, sometimes take two or more years to mature.

Larval webs and shelters

Caterpillars of the Marsh Fritillary, *Euphydryas aurinia*, Peacock, *Inachis io*, Small Tortoiseshell, *Aglais urticae*, and many other species, live communally within silk shelters, where they are protected from the ravages of extreme weather such as heavy rain, flooding and high winds.

Species that live communally tend to moult synchronously and then move as a group to another clump of foliage where they spin a new web.

Many other species live solitary lives within individual shelters. These are usually constructed by folding over a leaf and binding it with silk. A typical example is the larva of the Tiger-with-tails, *Consul fabius*, which hides in a rolled leaf and plugs the entrance with its head. The head capsule is sclerotised and too hard to be pierced by the ovipositor of parasitoid wasps. The secrecy gained by hiding in the shelter also provides protection from birds and other predators.

Moulting

A larva may increase its body mass by a factor of between 60–200, depending on species, in the period between hatching and pupating. Accordingly, as it grows, its skin periodically becomes too tight. When this happens, it has to be moulted and replaced with a looser second skin that forms under the outer layer. Moulting is triggered by nerve cells, which detect stretch in the skin between the abdominal segments.

Two or three days before moulting, a larva will anchor itself to a small button of silk which it has spun on a leaf or twig, or to a silk web spun over the foodplant. During this period, the soft tissues within its head retract and a new head-capsule forms within the first thoracic segment. When moulting takes place, the old capsule slides forward and drops off. The old skin then splits just behind the head, allowing the larva to crawl out. At first the new skin is loose and soft, leaving the larva extremely vulnerable to attack by parasitoids. The larva slowly inflates its body by drawing in air through the spiracles. After a couple of hours its mandibles have hardened, at which point it will often eat its old skin. Another two hours or so later the skin has toughened sufficiently to allow it to walk about without injuring itself, and to resume normal feeding.

The stages between moults are known as instars. Larvae of the family Lycaenidae usually have four instars. Those of the Hesperiidae, Nymphalidae, Papilionidae and Pieridae usually have five instars. The Riodinidae have six to eight larval instars according to species.

Cannibalism

Some butterflies have cannibalistic larvae. Those of the Orange-tip, *Anthocharis cardamines*, for example, normally feed on the leaves and seeds of garlic mustard, but if they encounter another larva, they turn cannibal. Individual plants may only have enough foliage to sustain one or two larvae, so if more than one egg is laid it, cannibalism ensures the survival of at least one larva.

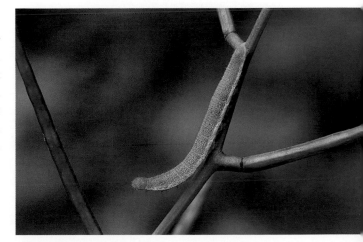

Larva of Orange-tip, *Anthocharis cardamines*, West Sussex, England.

Myrmecophagy and aphytophagy

Species that have dependent, mutually beneficial or symbiotic relationships with ants are called myrmecophiles. The act of feeding on ants is called myrmecophagy. The act of feeding on aphids or other homopteran bugs is called aphytophagy.

The larva of the Vicrama Blue, *Pseudophilotes vicrama*, is a myrmecophile. In the early instars it feeds on the flowers and leaves of *Thymus* or *Saturja*, but when it reaches the fourth instar it loses all interest in feeding, releases its grip on the foodplant and drops to the ground. It wanders about, calling to ants by stridulating tiny organs known as vibratory papillae. Eventually it is located by a *Myrmica* ant. The ant strokes the larva with its antennae, stimulating it to secrete a honey-like fluid from a nectary gland on its back.

After several milking sessions, the larva becomes immobile. It hunches its back, allowing the ant to seize it and carry it underground into the brood chamber of its nest. Once there, the larva becomes carnivorous, feeding on tiny ant grubs. During the several weeks it spends in the nest, it devours about 1,000 ant grubs. The larva placates the ants by emitting control pheromones from tentacle organs on its back, and by producing appeasement sounds with its vibratory papillae.

In Africa the larvae of *Lepidochrysops* have a similar association with *Camponotus* ants. Another species, *Euliphyra hewitsoni* lives in the nests of *Oecophylla* tailor-ants, also feeding on ant regurgitations and ant grubs. Its distant cousin D'Urban's Woolly Legs, *Lachnocnema durbani*, lays its eggs amidst colonies of membracids or coccids. The resulting larvae feed carnivorously throughout their lives, attacking and devouring the nymphs of these tiny insects.

Ant-attended larva of Vicrama Blue, *Pseudophilotes vicrama*, Macedonia.

In Borneo, the larva of Fruhstorfer's Darkie, *Allotinus apries*, feeds on coccids when it is small. As it grows bigger it develops protrusions on its body. These are used as grapples by an ant called *Myrmecaria lutea*, which carries the larva to its nest. Thereafter, the larva lives within the nest, feeding on ant grubs.

Another Oriental species, the Moth butterfly, *Liphyra brassolis*, has an even more extraordinary lifecycle. Its carnivorous larva lives inside the nests of weaver ants, *Oecophylla smaragdina*, attacking and devouring hundreds of ant grubs. It lays its eggs singly on the undersides of tree branches, often returning several times to a particular spot, so that several eggs are eventually laid in close proximity. The chosen tree can be one of several species, but only 'ant trees' are used, i.e. those which have been colonised by weaver ants. Each tree holds numerous ant nests, constructed from bunches of leaves stitched together with silk. The nests may each contain 50–200 workers, a queen ant and hundreds of developing ant grubs.

The *L.brassolis* eggs hatch after about three weeks. The early part of the larval stage is unrecorded, but it seems likely that during the first and second instars the larvae may feed on algae growing on the tree trunks, before ultimately being captured by ants and taken into the nests. A single nest can house as many as five or six *Liphyra* larvae.

Any insect unlucky enough to find its way into an *Oecophylla* nest would normally be attacked and eaten, but the *Liphyra* larva is protected by a tough chitinous carapace that is impervious to ant bites. The ants try to flip the larva over to reach its soft underparts. Their attempts invariably fail because the larva uses its sucker-like feet to pull the carapace down, sealing it limpet-like to the substrate, making it impossible for them to gain entry.

When the larva is hungry, it raises the carapace and snatches an ant grub in its mandibles. It instantly pulls the grub underneath, pierces its skin and sucks out its body fluids. Up to a dozen ant grubs can be killed and eaten per hour by a single *Liphyra* larva. Pupation takes place inside the nest.

When the butterfly emerges from its pupa, it cracks open the carapace and finds itself surrounded by a horde of aggressive ants. They attack, but are unable to kill the butterfly, because its body and wings are covered with loose sticky scales that become detached and clog their jaws. The butterfly then crawls out of the nest and finds its way to a safe spot to expand and dry its wings.

By associating with ants, larvae gain protection from other predatory insects that avoid ants in case they are attacked. For the same reason larvae are less likely to be attacked by parasitoids.

The lifecycles of many Lycaenid butterflies are still unknown, but all species so far investigated have been found to have specialised organs adapted for association with ants. These include a nectary gland on the back, alongside which is a pair of eversible tentacles. The gland secretes ant-attracting chemicals that are similar in composition to aphid honeydew. Each species secretes a slightly different chemical compound to ensure that it only attracts the appropriate species of ant. While the larvae want to attract ants, they also need to prevent themselves from being attacked by them, so in addition to the aforementioned organs they also have an epidermal gland which exudes chemicals that appease the ants.

SURVIVAL MECHANISMS

Caterpillars have soft bodies, making them extremely vulnerable to predation and parasitism. They are unable to escape if attacked. Consequently they have evolved many strategies to deal with their enemies. Skipper larvae simply hide out of sight, spending their lives within rolled-leaf tubes. Those from other families generally live and feed out in the open, sometimes nocturnally, but usually in broad daylight. Some rely on visually-directed strategies: aposematic patterns to deter predators, or concealment using camouflage or disguise. Others defend themselves physically, with irritating hairs, prickly spikes, head horns or other forms of armature.

Armature

Larvae from the subfamilies Nymphalinae, Heliconiinae and Limenitidinae are armed with rows of extraordinary multi-branched spikes and horns. These probably deter many birds from attacking, and undoubtedly also offer a degree of protection from predatory spiders, wasps and ants. They also have the added bonus of cushioning a larva against injury in the event of a fall. Spikes, hairs and horns are most pronounced in young larvae that feed communally, so it seems likely that another of their functions may be to protect them against cannibalism.

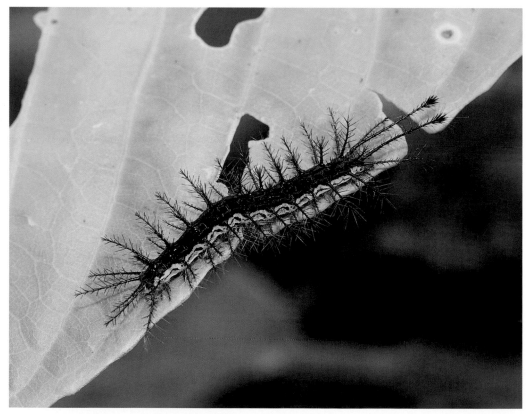

Unidentified Nymphalid larva, Pantiacolla, Peru.

Butterfly larvae do not sting, but the 'hairs' of certain moth larvae have irritating properties that can cause a minor skin rash. Species from temperate regions of the world are generally quite safe to handle, but in the tropics it is a very different story, and all hairy or spiky larvae should be treated with considerable caution. The fluffy caterpillars of moths in the families Megalopygidae and Apatelodinae almost invite you to handle them, but beware – there are sharp spines hidden beneath the soft hairs. If the larvae are handled, the spines break, releasing chemicals that can cause excruciating pain.

The spikes on the backs of some Saturniidae and Limacodidae moth larvae can also inflict a painful sting. Worst of all are the well-camouflaged spiky larvae of *Lonomia obliqua*, which are often found clustered on tree trunks in Brazil. There have been hundreds of cases where people have suffered dire consequences, including kidney failure and intercranial haemorrhaging, after unwittingly touching them.

Gregarious behaviour

Generally speaking, larvae that live solitarily tend to be palatable to predators. For defence, they rely primarily on camouflage – colours, patterns and textures that help them avoid detection. Larvae which feed gregariously tend to be unpalatable or noxious to predators. They often advertise their toxicity with bold aposematic colours: a seething mass of brightly coloured, wriggling larvae is far more likely to deter a potential predator than a single larva could. Gregarious behaviour also has other benefits, for example a group of larvae can quickly construct a communal silk shelter that provides them with a degree of protection from predators and parasitoids.

The battle for survival between plants and caterpillars

There is a constant battle between plants and the caterpillars which eat them, each evolving ways to try and stay ahead of the other in the struggle for survival. Many plants extract minerals from the soil and convert them into toxic alleochemics that discourage larvae from feeding. In response, larvae have found various ways to avoid being poisoned. One method they use is to bite through leaf veins or stems to allow the toxins to bleed out before eating a leaf. *Melinaea* Glasswing larvae, for example, cut circular trenches in leaves to cut off the flow of toxins prior to devouring the enclosed tissue. Other species simply restrict themselves to nibbling at the edges of leaves, where toxicity is minimal.

Some larvae, for example those of danaines and ithomiines, are immune to the poisons but store them in their bodies, using them to their own advantage to deter birds from eating them. Furthermore, the toxins sequestered from larval foodplants are inherited by the pupa and adult, providing them with protection too.

Once larvae evolve immunity to the toxins the plants become threatened again, so they have to find new ways to protect themselves. Some develop tough leathery leaves that are difficult to digest, or grow thorns on their stems, making it difficult for larvae to walk on them without becoming impaled. *Passiflora adenopoda* goes a step further. Its leaves are covered with sharp microscopic hairs that puncture the skin of browsing larvae, rendering them immobile and killing them by starvation.

Another *Passiflora* vine has found an equally novel way to defend itself against the larvae of *Parides* Cattleheart butterflies, by controlling the number of eggs that can be laid. If 'too

many' are laid, the leaf tissue around each extra egg dies and drops to the ground, carrying the egg with it.

The vines have also evolved a fascinating means of protecting themselves against *Heliconius* Longwings. Females of these butterflies normally lay just a single egg on each vine. Some *Passiflora* species, however, have 'learned' to take advantage of this, by producing tiny egg-mimicking structures on their leaves. If a *Heliconius* detects one of these false eggs, it is inhibited from ovipositing.

PUPA (CHRYSALIS)

The pupa, or chrysalis, is the diapaused phase in which a caterpillar undergoes the transformation into an adult butterfly. The word 'pupa' is Latin for doll and refers to the supposedly doll-like appearance, while 'chrysalis' is derived from the Greek word for gold – *chrysos*, a reference to the silvery or golden spots that adorn many butterfly pupae.

Pupation
Skipper larvae nearly always pupate on the plant on which they lived and fed, but the larvae of most other butterflies undergo a wandering phase, walking some distance before finding a suitable place to pupate. The Nymphalidae pupate openly, suspended by the tail, or cremaster. This is equipped with a rosette of microscopic hooks that hold it securely to a pad of silk spun by the larva on a leaf or stem. The pupae of Papilionidae and Pieridae are formed in an upright position, attached to a stem by the cremaster, and further secured by a silk girdle around the waist. The pupae of Lycaenidae and Riodinidae lack a cremaster. Most attach themselves to a leaf by a silk girdle, but some just pupate loosely on the ground.

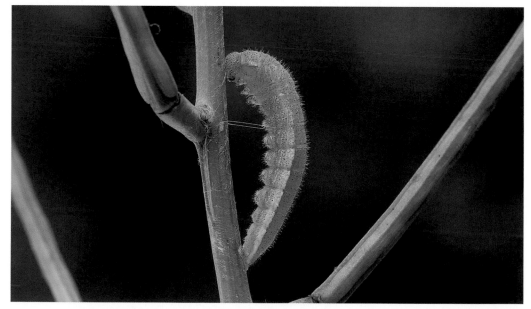

Pre-pupal larva of *Anthocharis cardamines* (Pieridae), Sussex, England.

After settling in position to pupate, a larva will remain motionless for two or three days. During this time the prolegs gradually shrink, the thoracic segments swell up and the larva adopts a hump-backed posture. When the final moult takes place, the skin splits behind the head and the pupa wriggles out. At first it is soft, limp and highly vulnerable to attack by wasps and flies. At this stage pupae often wriggle violently if touched, presumably as a defence against these parasitoids. Within a few hours, the skin hardens into a tough chitinous shell and the pupa is thereafter relatively immobile.

Anatomy

Many anatomical details of the adult butterfly can be seen on the pupa, including the antennae, legs, eyes, wing cases and palpi. It is usually possible to tell the sex of a pupa by examining the tip of its abdomen. A male pupa has two tiny bumps on the underside, close to its tail, corresponding with the anal claspers of the adult butterfly. On a female pupa the bumps are missing. Instead there is a short slit on the eighth abdominal segment.

Pupae come in many forms and colours. To protect themselves against predation they have evolved cryptic patterns and strange contorted shapes that disguise them as natural objects such as bits of wood, twisted and desiccated dead leaves, or bird droppings. Many pupae, such as those of *Apatura*, look like green leaves. Amongst the most unusual are those of the Ithomiini, which are chrome silver and look like glistening raindrops. Their protective resemblance makes it much harder for birds and small mammals to locate them, improving their chances of survival.

Protective resemblance is a passive form of defence, but some tropical pupae have evolved aggressive strategies. The pupa of the Broad-banded Flasher, *Astraptes apaustus*, for instance, has eye-like pips on the thorax, giving it the appearance of a snake's head. Even more convincing snake-like false eyes appear on the pupa of the Scarlet-eyed Skipper, *Cephise nuspesez* (pronounced 'new-species', indicating that taxonomists have a sense of humour). The pupae of both of these species are formed inside rolled leaves. Any creature prising open the leaves, hoping to find a tasty morsel, is in for a shock and is likely to leave the pupa alone.

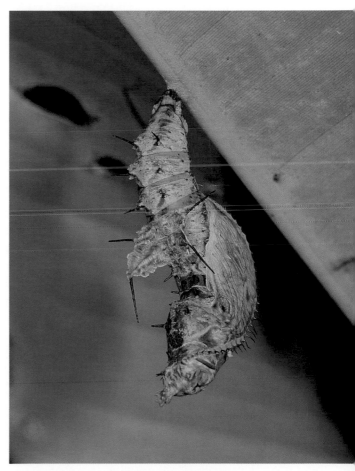

Pupa of *Heliconius melpomene*, Boca Colorado, Peru.

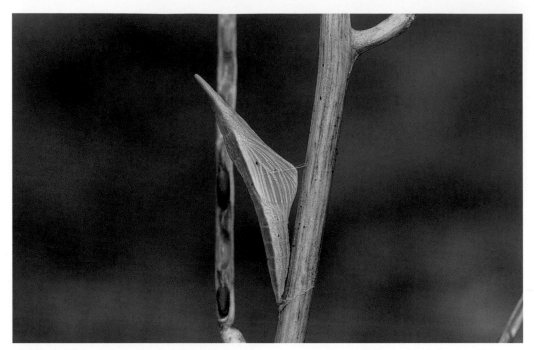

Pupa of Orange-tip, *Anthocharis cardamines*, Hampshire, England.

Some members of the Papilionidae and Pieridae can individually influence their survival prospects by producing pupae that match the colour of their surroundings. The Orange-tip, *Anthocharis cardamines*, is a well-known example. A percentage of its pupae are straw coloured to match dead stems, while others are pale green, matching living material. Laboratory experiments have shown that the larvae are able to detect the colour of surrounding vegetation, thereby triggering a genetic response that determines the colour of the pupa.

Diapause

In multi-brooded tropical species, the pupal stage may last less than a week. In temperate regions it usually lasts about two weeks, but in the case of species that overwinter as pupae it often lasts for several months. Some species occasionally delay their emergence and remain as pupae for two winters. This is a form of natural insurance. In a severe drought, or in an extremely wet summer, a butterfly might not be able to breed in viable numbers. By staggering its emergence over two years, it spreads the risk, ensuring that at least a few adults will appear and reproduce each year regardless of the weather.

Metamorphosis

The stem cells, from which the anatomical features of the adult butterfly develop, are present even in the eggs of butterflies. The cells replicate and diversify during larval development so that the wings and other anatomical features of the adult are quite well formed at the time of pupation. The metamorphosis begins slowly, but accelerates rapidly in the later stages. About three days before the butterfly is due to emerge, the pupa changes colour and the pattern of the wings can usually be clearly seen.

IMAGO (ADULT BUTTERFLY)

The morphological changes within the pupa and the approximate timing of adult's emergence are both regulated by a 'circadian' biological clock which operates at different rates according to species. In temperate regions the timing is heavily modified by day length. The exact timing of the final emergence or 'eclosure' is triggered by local weather conditions, i.e. humidity and temperature.

Some species emerge shortly after dawn, the time of day when foraging birds are most active and butterflies are most vulnerable. Large numbers are undoubtedly killed and eaten at this time, but the newly hatched butterflies keep very still to avoid detection until they are ready to fly. Other species emerge in late afternoon, giving them just enough time to expand and dry their wings before nightfall.

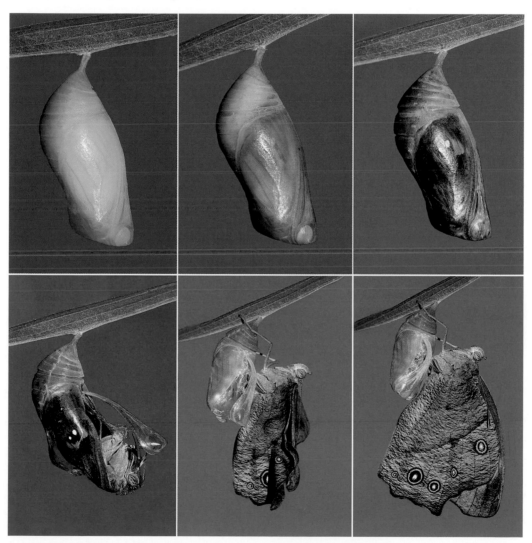

Evening Brown, *Melanitis leda*, emergence sequence, New South Wales, Australia.

Eclosure

The spiracles of the butterfly within the pupa are linked by trachea to spiracular 'port-holes' on the pupal shell. Just prior to eclosure, air is drawn in through these tubes, pumping up the butterfly's body and causing the shell to split just behind the head. The butterfly then breaks its way out and hauls itself free. If the pupa was formed within a silk shelter, as is the case with most Hesperiidae, the butterfly then ejects solvents from its proboscis to soften the silk and allow it to push its way out.

Having emerged and found a safe place to settle, it then spends several minutes hanging virtually motionless. During this time, it pumps blood into its wing veins, causing the wings to expand to their full size. After drying their wings, butterflies expel the metabolic waste product meconium from their abdomens, in the form of a pinkish fluid. Males usually fly off as soon as their wings are hardened, but females of many species tend to remain quiescent until mated.

Sex ratios

It is often claimed that male butterflies emerge in greater numbers than females. The most quoted example is Rajah Brooke's Birdwing, *Trogonoptera brookiana*, whose males are frequently stated to outnumber females by a ratio of as much as 10:1. These erroneous claims arise simply because males are far more visible than females to the casual observer, particularly in the case of *T.brookiana*, whose males aggregate in large numbers at sulphur springs in Malaysia. Females, on the other hand, are far more secretive in behaviour, so it follows that a much lower percentage of them are observed. Captive breeding of *T.brookiana* and numerous other species has proven that the sexes actually emerge in roughly equal numbers.

Males of most species emerge a day or two before females. One reason for this is that females lose their fecundity quickly and therefore need to mate on the day they emerge. Thus, it is advantageous if there are already plenty of fresh males available to them. Another reason is that prior to mating the males of many species need time to feed and accumulate alkaloids, which are used in the production of pheromones and defensive toxins.

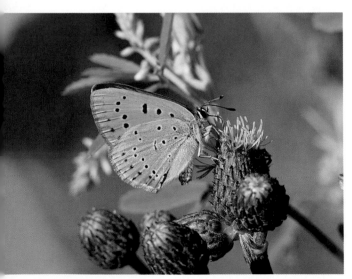

Feeding behaviour

In temperate regions, most butterflies obtain their sustenance by imbibing nectar from flowers. European meadows are often overflowing with Fritillaries, Coppers, and Blues, all attracted by the profusion of wild flowers.

Forest butterflies often feed on the aphid secretions or 'honeydew' which coats the upper surfaces of tree foliage in summer. Several of the larger species, including Purple Emperor, Large Tortoiseshell and Woodland Grayling, feed at sap oozing from tree trunks.

In the tropics, the feeding habits of male

Large Copper, *Lycaena dispar*, Laeva, Estonia.

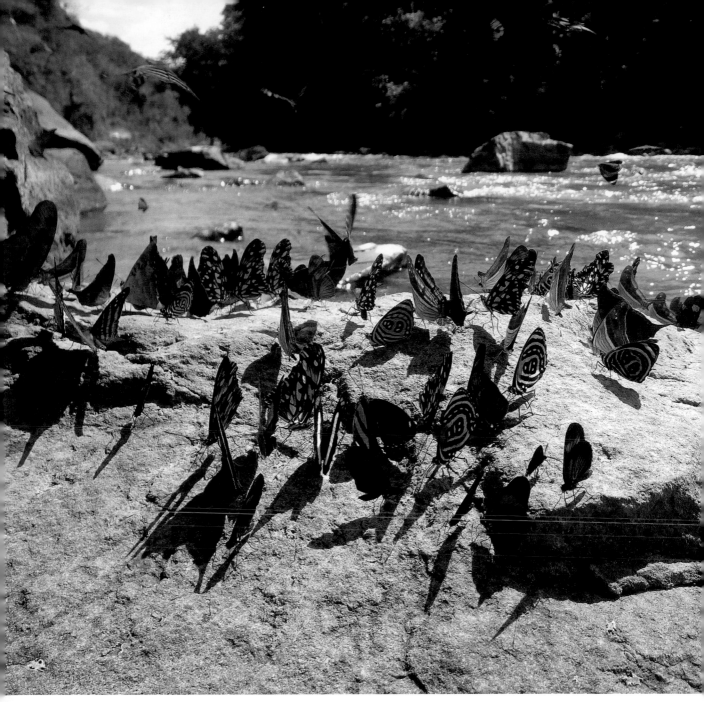

Aggregation of *Callicore*, *Dione* and *Marpesia* males in Peru.

butterflies are very diverse. In Amazonia, swarms of *Phoebis* Sulphurs, *Marpesia* Daggerwings and *Callicore* Numberwings aggregate on river beaches to imbibe dissolved minerals from damp sand. They constantly pump water through their bodies and then reimbibe it, to extract as many minerals as possible. This activity is known by several names – 'mineralising', 'mud-puddling' or 'filter-feeding'.

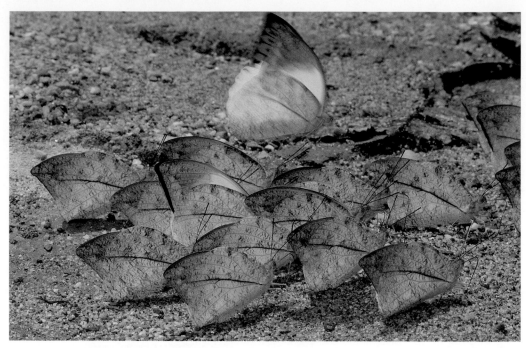
Great Orange-tip, *Hebomoia glaucippe*, Ultapani, Assam, India.

In breezy conditions, mud-puddling butterflies generally all face into the wind. This increases their stability, making it less likely that they will be blown over by strong gusts.

A river beach may have several hundred mud-puddling butterflies in attendance, but individuals of each species often form isolated clusters with others of their own kind. By concentrating together and then suddenly scattering in random directions when alarmed, they cause confusion to predators. A swirling mass of identical prey makes it very difficult for a predator to isolate and catch any individual.

Males of the gaudy orange Julia, *Dryas iulia*, often gather to imbibe at places where animals have urinated. They are also regularly observed sipping teardrops from the corners of the eyes of yellow-throated caiman in Brazil, and from the eyes of turtles in Peru.

Dazzling blue *Doxocopa* Emperors, superbly camouflaged *Memphis* Leafwings and many other tropical species, get the minerals they need from decomposing organic matter – mainly dung, rotting fruit or carrion. The carrion feeders vary enormously in their choice of foodstuff. In Peru, *Godyris zavaleta* Glasswings can often be seen feeding on the decomposing corpses of robber flies. In Venezuela I once watched a male Blue Doctor, *Rhetus periander*, sucking fluids from the corpse of a tarantula. At Pululuhua Crater in Ecuador, I found scores of *Lymanopoda*, *Lasiophila* and *Junea* feeding on a snake corpse; while in Sikkim I discovered a Pallid Nawab, *Polyura arja*, avidly feasting at the corpse of a bullfrog. In England I once found a group of six male Purple Emperors, *Apatura iris*, feeding at the carcass of a deer floating in a cesspit.

Male butterflies often need to acquire particular chemicals prior to mating. In the Neotropics, Skippers obtain the pyrrolizidine alkaloids (PAs) they need primarily from bird droppings. Glasswings and Tiger-mimics do the same, and also obtain them from *Eupatorium* flowers, at which they often aggregate in multi-species flocks. *Danaus* Tigers and *Euploea* Crows

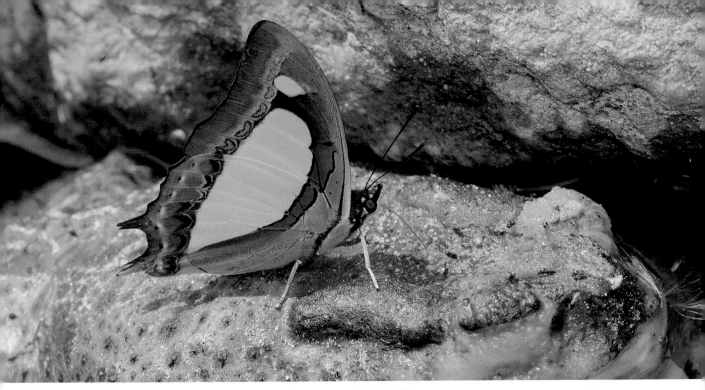

Pallid Nawab, *Polyura arja*, feeding on bullfrog corpse, Sikkim, India.

in the Oriental region acquire alkaloids from the decomposing stems of *Heliotropium* and other Boraginaceae.

In the Amazon and Andes, female *Heliconius* Longwing butterflies sequester pollen from *Psiguria* and *Gurania* flowers. They process the pollen to extract amino acids. These increase their longevity, enabling them to produce eggs for several months.

Mate location

Unlike *Heliconius*, most other butterflies have very short lives. Females of most species often have less than a week to find a mate, copulate, search for oviposition sites and lay their eggs. Rapid mate location and recognition are therefore vital. Butterflies can't afford to waste time on fruitless encounters with species other than their own.

Most butterflies are 'tuned' to recognise certain colours and are thus able to detect members of their own species from a short distance away. The smaller and drabber

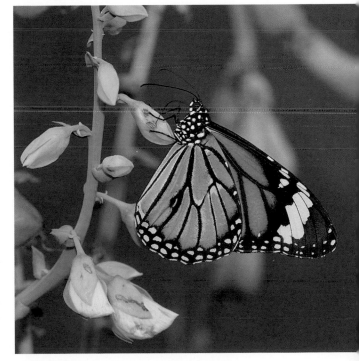

Brown Tiger, *Danaus genutia*, feeding on fluids oozing from a damaged flower bud, West Bengal, India

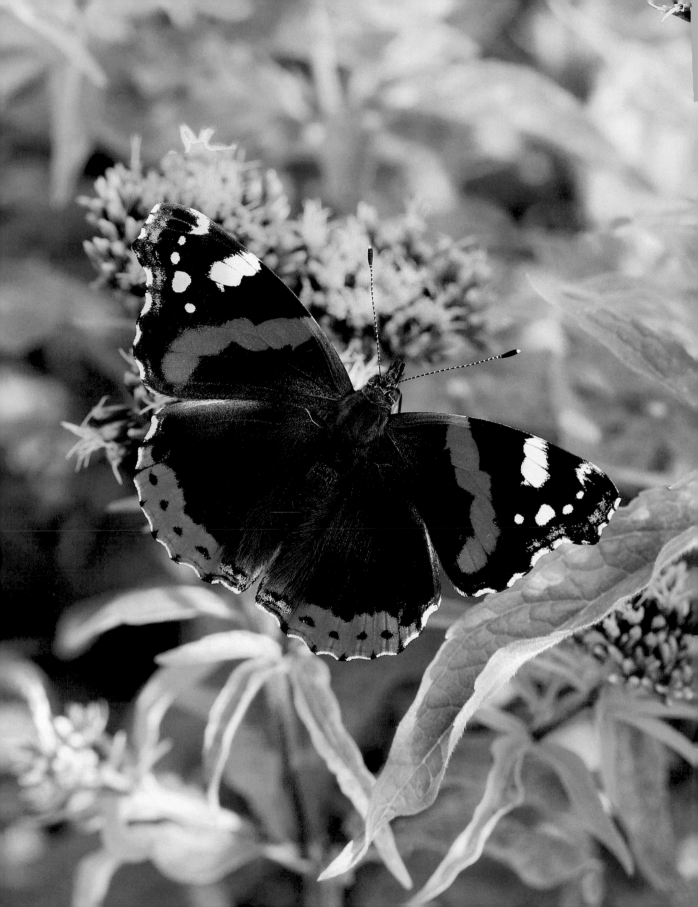

species may need to get to within 1–2m (3.3–6.6ft) of each other for this to happen. On the other hand, large and conspicuous butterflies such as the dazzling blue *Morpho* butterflies of Amazonia can spot each other from at least 10m (33ft) away.

The recognition of patterns, as opposed to colours, only seems to come into play when butterflies are in much closer proximity. Some patterns, such as the black and yellow patchwork of the Swallowtail, *Papilio machaon*, or the distinctive black, red and white of the Red Admiral, *Vanessa atalanta*, may be recognised at close distances, but it is obvious that subtle patterns cannot be.

To illustrate this point, imagine an alpine meadow populated by a variety of *Erebia* species. These are all very drab brown insects of similar size and shape, differing only in minute details that could not possibly be seen with the poor resolution of a butterfly's eyes. The same situation occurs with *Melitaea*, *Pyrgus*, *Polyommatus*, *Adelpha* and other genera, when several similarly coloured species share the same habitat. If butterflies relied solely on visual stimuli for mate recognition they would waste almost all of their short lives chasing after the wrong species. Reproduction success would be very low indeed. Consequently, they make use of chemical and tactile messaging, which is discussed later in this chapter.

Perching, patrolling, and territories

Entomologists have traditionally divided the prenuptial behaviour of butterflies into two groups, those that 'patrol' and those that 'perch'. However, in practice many species use both strategies. Patrolling refers to situations where the male actively flies along a regular

ABOVE Male *Doxocopa cyane* in typical perching territorial posture, Colombia
OPPOSITE Red Admiral, *Vanessa atalanta*, Sussex, England.

or random route through its habitat in order to locate a female. Perching involves a male establishing a territory, typically centred on a prominent projecting leaf, or on a particular rock, that is used as a vantage point from which to survey and intercept passing females.

Butterflies are usually thought of as benign creatures, but males will aggressively defend their territories against intruders. If two males meet, they twist and turn around each other in the air, sometimes clashing wings and often spiralling rapidly upwards until they are mere specks in the distance. The fight continues until one of them, usually a newly emerged insect that has not yet established a territory, is ousted. After the contest, the winning male invariably returns to exactly the same leaf or boulder from which the battle began.

Lekking

In Amazonia, male Glasswings and Tiger-mimics gather at ephemeral courtship sites known as leks. These normally form in damp sheltered pockets deep in the forest. They may exist for up to two months, during which time numerous individual males of various species come and go. After a while, the complex mixture of scents exuded by the various males attracts females to the lek. Different, aphrodisiac pheromones are then released, enticing the females to copulate.

Mate recognition, courtship and chemical messages

Male butterflies will usually launch into flight and chase almost any small moving object that could potentially be a female. Their poor eyesight often leads them to chase after bees, wasps and day-flying moths, as well as other butterflies. Rather amusingly, they sometimes

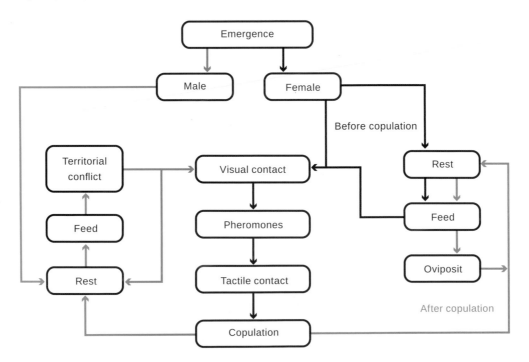

Prenuptial and postnuptial behavioural cycles.

even attack falling leaves. Once they get within a few centimetres of these objects they quickly recognise them as being of no interest, but real butterflies, regardless of species, are investigated closely. Ultraviolet patterns on their wings are invisible to humans, but butterflies can analyse them to confirm whether they are of their own species. When they get really close to each other, they switch from visual to chemical methods of recognition. Pheromones provide them with detailed information, confirming the species and sex.

If the pheromones indicate that the intruder is a male of the same species, the butterflies are usually stimulated into a territorial dogfight. On the other hand, if they indicate a conspecific female, the male is stimulated into initiating courtship.

In some species, exposing a female to male pheromones is sufficient to initiate instant copulation. In others, a courtship ritual, consisting of a series of visual, tactile and/or olfactory stimuli and responses, is an essential prerequisite.

Courtship rituals

Courtship typically begins with a visual stimulus, i.e. the male recognising a female from her pattern and colour. The male then approaches her and releases airborne pheromones. If the female has already mated, she will often dive into long grass to escape the male's advances or 'freeze' to signal frigidity. Alternatively she may settle on foliage, open her wings, and raise her abdomen to expose a 'stink-club' in the genital opening, from which she releases anti-aphrodisiacs.

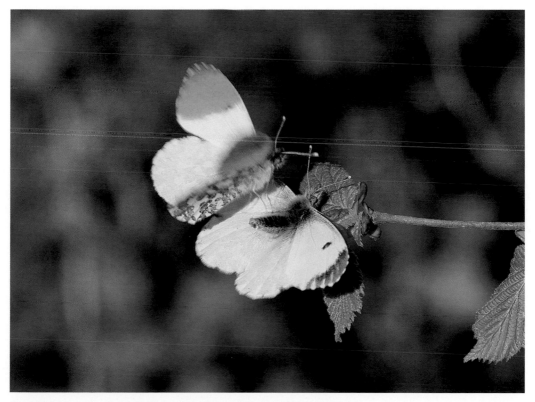

Female Orange-tip, *Anthocharis cardamines*, raising abdomen to reject male.

If she is a virgin, she generally settles calmly and awaits a new stimulus from the male. He might respond with a 'courtship dance', buzzing excitedly around her and wafting his pheromones across her antennae. At this stage, she might allow him to copulate, but in many cases she will require tactile stimuli before allowing him to proceed.

Tactile stimuli usually involve contact pheromones, i.e cuticular hydrocarbons. The male Grayling, *Hipparchia semele*, for example, begins by facing the female. He flicks his wings open and shut a few times and then leans forward as if bowing to her. Next he closes his wings, trapping her antennae between them, causing them to rub against the androconial scales on the upperside of his forewings. Thus seduced, she allows him to settle alongside her and curve his abdomen around to make sexual contact.

Another example of tactile communication is found in the courtship ritual of the Wood White, *Leptidea sinapis*. The male and female sit facing each other on a leaf. The male repeatedly flicks out his proboscis, whipping the female alternately on the underside of her left and right wings. If she is a virgin, copulation follows almost immediately. By mid-morning almost all females will have been mated, so after this time most rituals end with the male being rejected.

The Small Tortoiseshell, *Aglais urticae*, has a protracted courtship which can last for several hours. The male follows the female as she flies from place to place. Each time she settles and opens her wings, he settles behind her and then drums on her hindwings with his antennae. The process is repeated dozens of times in the course of an afternoon, during which time the male will chase away any other intruding males. Eventually, just before dusk, the female leads him to a sheltered and shady spot, typically beneath a small bush, where copulation takes place. They remain copulated until the following morning.

The male Brimstone, *Gonepteryx rhamni*, behaves similarly, but most encounters end when the female responds by inverting her wings and raising her abdomen – a signal that she has already mated and is rejecting his advances.

Brimstones normally copulate in very early spring. Males awaken from hibernation several days before the females. They patrol the woodlands until they find a female at rest under a leaf. Copulation then takes place almost instantly, without any pre-nuptial ritual. Most butterfly species remain copulated for only an hour or so, but Brimstones are quite remarkable in this respect – I once found a pair that remained copulated beneath a bramble leaf for 17 days before finally parting! The amazingly long copulation period is probably necessary because Brimstones mate at a cold time of year when night frosts are common and their metabolism is very slow.

Although most species undergo quite complex courtship rituals, there are a few in which copulation occurs without any observable preliminary process. Among these is the Black-veined White, *Aporia crataegi*, in which the male attacks the female, which instantly submits to copulation.

Males of most species will mate with several females during the course of their lives. Likewise, females of the Monarch, *Danaus plexippus*, and a few other species will mate with several different males. However, in the great majority of species, females only mate once. After mating, the genital opening of the some species, such as the female Apollo, *Parnassius apollo*, develops a structure called a sphragis, which physically prevents other males from copulating.

OPPOSITE Courtship of Small Tortoiseshell, *Aglais urticae*, Sussex, England.

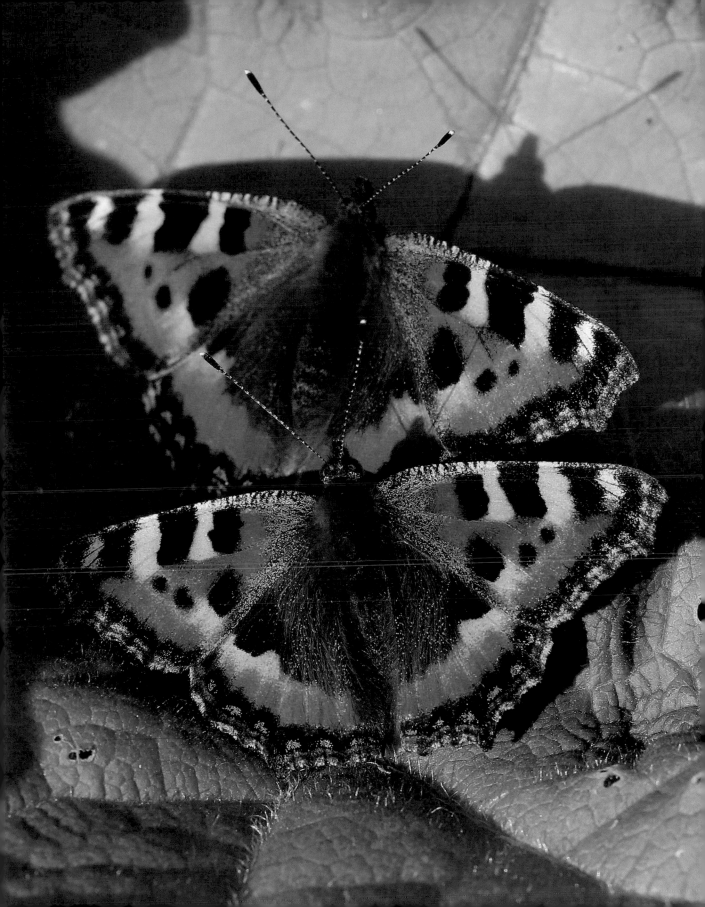

Black-veined White, *Aporia crataegi*, Saaremaa, Estonia.

Lifespan

The lifespan of adult butterflies varies considerably from one species to another. Captive butterflies, if fed regularly, can live for several weeks. Wild butterflies are subject to predation and the extremes of climate, so while some may have the potential to live longer, in practice the average lifespan is just seven or eight days. There are, however, several notable exceptions to this rule. Certain tropical species are capable of living for very long periods. In South America, some species are able to extend their lives by aestivating during the dry season, and can live for up to 11 months. In temperate regions, species that hibernate as adults also tend to have very long lives – the overwintering generations of Brimstone, Comma, Peacock and Small Tortoiseshell can live for several months.

NATURAL ENEMIES

Predators, parasitoids and parasites

Strictly speaking, predators and parasitoids should not be considered as enemies of butterflies. Rather, they should be thought of as nature's way of preventing butterfly populations from getting out of control. If they were not kept in check, the populations would rapidly expand and would quickly deplete all available food resources, ultimately leading to their own demise.

Some species are capable of laying up to 500 eggs. However, almost all females are killed by birds before they have had time to fulfil that potential. In practice, perhaps only a quarter of this number will actually be laid. After losses caused by predation, parasitism and disease, probably only about 10 per cent of the resulting larvae reach maturity. Studies have shown that roughly half of all wild pupae are eaten, or are killed by parasitoids or fungal diseases. When the adults emerge, many fall victim to predators before they have the chance to mate, let alone to lay any eggs. The net result is that, on average, despite the 500 eggs that could potentially have been laid, only two or three adults emerge from each brood and survive long enough to mate and produce another egg batch.

Avian predators

Throughout the world, adult butterflies are killed in colossal numbers by birds like sparrows, tits, thrushes, robins, orioles, jays, finches, flycatchers, tanagers and jacamars. Numerous studies have provided statistical data on bird predation. One, for example, revealed that 23 per cent of examined specimens of *Ascia monuste* bore beak marks on their wings, indicating that they had been attacked by birds, but had escaped or been rejected. This figure does not, of course, include the specimens that were actually eaten.

It is apparent from the many research projects carried out that at least half of wild butterflies are killed and eaten before they are able to mate and reproduce. Some are attacked when they are emerging or drying their wings prior to their first flight. Others fall victim when basking on the ground or visiting flowers, although many are lucky to escape with nothing more than a peck taken out of a wing.

Birds and other vertebrates rely almost entirely on sight to locate their prey, so butterflies have evolved numerous visually orientated defence strategies. Primarily these involve passive tactics such as camouflage, disguise, warning colouration or transparency. Although generally very effective, these defences sometimes fail, and a butterfly will then find itself under direct attack. At this stage, secondary active mechanisms come into play, as shown in the diagram on page 60.

Birds are intelligent and quickly discover ways to overcome the defence strategies employed by butterflies. They can also pass on learnt behaviour to their offspring. Therefore, their ability to locate butterflies and their larvae increases with each passing generation. Many birds also possess empathic learning abilities. Thus, an individual can learn to avoid toxic butterflies simply by observing that another bird suffers vomiting after eating one.

Luckily, butterflies have a couple of advantages over birds. Firstly, many of them produce several generations per year. This rapid rate of reproduction allows them to recover their

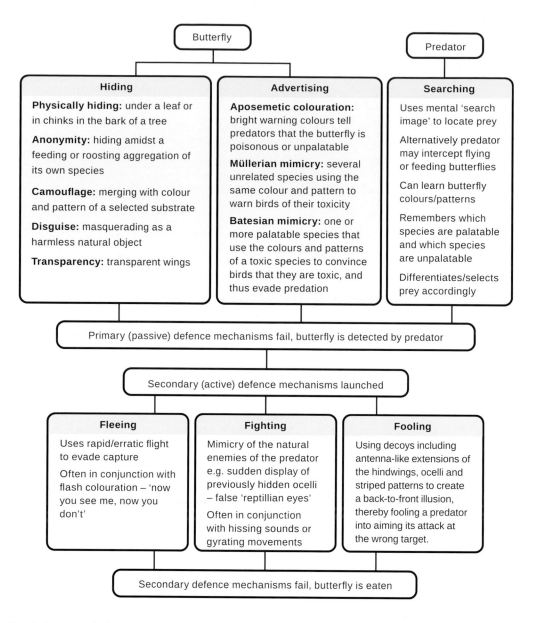

The deployment of primary and secondary defence mechanisms.

numbers quickly, even after major losses of population. Secondly, butterflies intrinsically produce high genetic diversity. These two factors enable them to rapidly evolve new defence mechanisms. The battle between butterflies and birds, therefore, is a closely run race. Birds catch enough butterflies and larvae to feed themselves and their offspring, but at the same time butterflies survive in enough numbers to enable predator and prey to coexist with reasonable population stability.

Spiders and predatory insects

Although birds are their main predators, butterflies are also attacked by spiders, wasps, dragonflies, robber flies and crickets. In tropical climates they also have to contend with mantises and numerous other arthropods.

Butterflies also often wander into the webs of orb spiders. Small, weak butterflies such as *Polyommatus* invariably become entangled and are quickly wrapped up in silk for later consumption. On the other hand, larger and stronger species, such as those belonging to the genera *Vanessa* and *Charaxes*, can often struggle free before the owner of the web is able to pounce on them. Examination of these species often reveals a telltale pattern of shiny lines across their wings. These mark the places where loose wing scales have become detached and left behind on the sticky threads of the web.

Crab spiders are also major predators of small butterflies. In Europe, species such as *Misumena vatia* will often spend several days sitting motionless on a flower head, waiting for a victim to fly in. The peripheral vision of crab spiders is so poor that a butterfly can settle alongside one without being noticed, but if it is unlucky enough to walk across its field of vision, the spider stealthily creeps up and seizes the butterfly. It grips it firmly with its powerful pincer-like forelegs and then bites it on the neck, injecting it with paralysing venom. The latter incorporates enzymes that liquefy the body tissues, which the spider then sucks out.

Misumena vatia attacking Chestnut Heath, *Coenonympha glycerion*, Viidumae, Estonia.

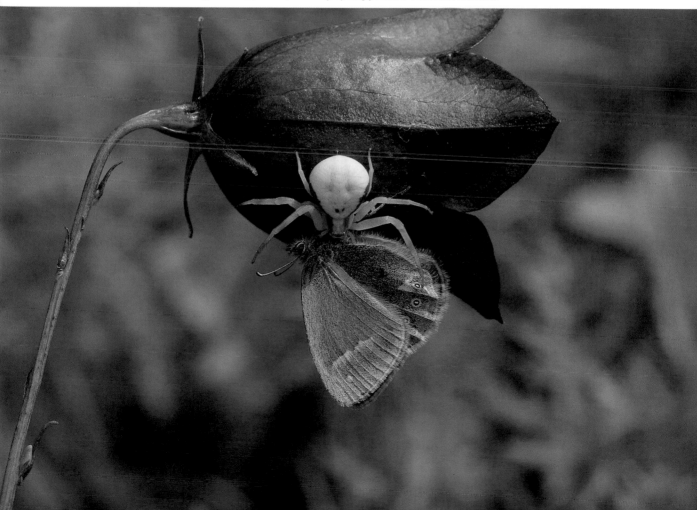

One of the commonest butterfly predators in England is *Enoplognatha ovata*. This small spider traps butterflies that fly into the sticky strands of its untidy web, which is spun on grass-heads and wild flowers. During research into butterfly predation at Magdalen Hill Down in Hampshire, I estimated that about 5 per cent of the population of the Chalkhill Blue, *Polyommatus coridon*, fell victim to this arachnid.

Butterfly larvae are also killed in vast numbers by predators. A study of predation on *Pieris rapae* estimated that half of first instar larvae and two-thirds of second instar larvae were attacked and eaten by invertebrates including spiders, carabid beetles, bugs and wasps. The same study estimated that almost a quarter of older *Pieris rapae* larvae were caught by birds.

Parasitoids

The larva of the King Page Swallowtail, *Heraclides thoas*, is highly palatable to birds and employs a bird-dropping disguise as its first line of defence. This strategy may be enough to prevent avian attacks but it is useless against parasitoid wasps and flies, which rely primarily on smell to locate their victims. Consequently, the larvae of *H.thoas* and other members of the Papilionidae such as *Parides anchises* have evolved a secondary defence that is specifically targeted at such enemies. In this instance, they turn to chemical warfare, everting an 'osmaterium' from behind the head. This fleshy organ discharges airborne isobutyric acids that have been shown to repel predatory insects and parasitoids.

Bird-dropping disguise of *Heraclides thoas* larva, San Cristobal, Venezuela.

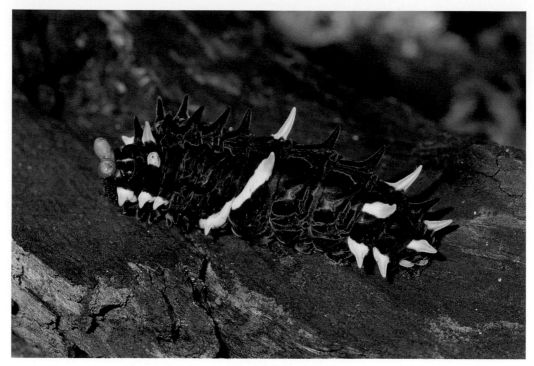

Parides anchises larva with orange osmaterium erected, Rio Pindayo, Peru.

All stages of the lifecycle are threatened by parasitoids, i.e. creatures that feed on other organisms and ultimately bring about their death. Many species fall victim to tiny wasps that inject their eggs into the soft, newly laid butterfly eggs. When the wasp grubs hatch, they feed on the organic matter within the egg. The adult wasps emerge a few days later and use their mandibles to cut minute exit holes in the eggs and make their escape. In some instances as many as 60 microscopic chalcid wasps can emerge from a single butterfly egg.

South American *Caligo* Owl butterflies are parasitised by a tiny trichogrammatid wasp that rides from place to place on the hindwings of females. When a butterfly settles momentarily to lay her eggs, the wasp drops off, injects its own eggs into those of the butterfly, and then flies back on to the butterfly's wing in time to hitch a lift to the next egg-laying site.

A surprisingly high percentage of butterfly and moth larvae fall victim to parasitoid wasps or flies. In the case of the Marsh Fritillary, *Euphydryas aurinia*, up to 95 per cent are parasitised by the wasp *Apanteles bignelli* in certain years. Wasps including *Apanteles*, *Amblyteles*, *Ophion*, *Protichneumon* and *Ichneumon*, and flies such as *Tachina*, *Gymnochaeta* and *Gonia*, spend their larval stage within the bodies of caterpillars. The adult wasps usually inject their eggs into their victims by means of a stinger-like ovipositor. In the case of flies such as *Sturmia bella*, the eggs are laid on leaves which are later ingested by the caterpillars.

The larva of the moth *Eumorpha fasciatus* illustrated overleaf has been parasitised by a wasp that injected its eggs into it. When the wasp grubs are full-grown, they break out through the skin of the larva and form papery white cocoons. The larva then shrivels and dies. A few days later, the adult wasps emerge from the cocoons and hunt for another larva to parasitise.

Some wasps will attack the newly formed pupa of a butterfly while its skin is still soft and

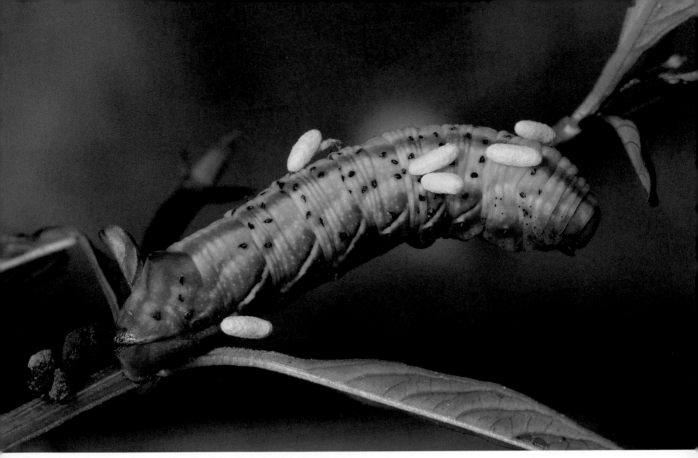

Parasitised larva of *Eumorpha fasciatus*, Rio Cristalino, Mato Grosso, Brazil.

easily punctured. The beautiful metallic green wasp *Pteromalus puparum*, for example, attacks newly formed pupae of the Large White, *Pieris brassicae*. The entire lifecycle of *Pteromalus* takes place within the butterfly pupa. Ultimately, the tiny wasps emerge in dozens after making exit holes in the pupal skin.

Parasites

Parasites are creatures which feed upon other organisms, but, unlike parasitoids, they don't cause the death of their hosts. In the case of butterflies, they generally affect the adults rather than the caterpillars.

Cerapogonid midges, for example, attack adult *Pteronymia* Glasswings in Central America, feeding on the blood in the butterfly's wing-veins and eyes. In Europe, Common Blues and Marbled Whites are infested by the tiny red larvae of the mite *Trombidium breei*. These usually attach themselves to the thorax of the butterfly, piercing its skin to feed on its blood. However, the mites appear to cause no real harm – the flight and lifespan of the butterflies are unaffected.

Pseudoscorpion hitchhikers

Close examination of butterflies sometimes reveals the presence of tiny scorpion-like creatures, clinging by their pincers to the legs or antennae. Pseudoscorpions, as they are known, are related to true scorpions, spiders and harvestmen. They are carnivorous, typically feeding

on mites, insect eggs and tiny larvae, but they are harmless to adult butterflies, merely using them as a means of transport to reach new habitats. A pseudoscorpion will sometimes attach itself to a larva, gripping it by its dorsal spines. When the larva pupates, the pseudoscorpion remains attached to the shed larval skin, which adheres to the base of the pupa. A few days later the adult butterfly emerges. The pseudoscorpion then grabs hold of it, usually by the legs or antennae, clings tightly, and hitches a ride to a new habitat.

Pathogens
Butterfly larvae are prone to infection by fungi including *Cordyceps*, *Beauvaria* and *Metarrhizium*. They are often attacked by nuclear polyhedrosis viruses, granulosis viruses and cytoplasmic polyhedrosis viruses. Affected larvae become limp, darken in colour, and produce liquid faeces prior to death. The condition is known as wilt disease and is highly infectious.

The Balance of Nature
The romanticised notion of a 'balance of nature' is largely unrealistic. Nature is in fact in a state of perpetual warfare. Host animals are involved in an ongoing battle with predators, parasites and pathogens, while plants fight an endless conflict with herbivores, including butterflies and other insects.

The weapon of this warfare is evolution. The lifeforms that evolve fastest survive, while the slower ones ultimately face extinction.

STRATEGIES FOR SURVIVAL

THE FUNCTION OF WING-PATTERNS

Butterflies occur in a myriad of different shapes, colours and patterns. These serve two distinct purposes. Firstly, they help them to recognise potential mates, and secondly, but equally importantly, they protect them from their natural enemies.

Dozens of different strategies are used to achieve this. Some species, for example, use camouflage or transparency to hide from their enemies. Others do exactly the opposite, using bright colours and easily memorised patterns to advertise to birds that they are unpalatable. Many species employ multiple strategies. They may, for example, have cryptic underside patterns that provide camouflage, but might back this up with a secondary tactic such as flash colouration, that only comes into play once the butterfly has been discovered.

Every wing design has evolved over countless millennia to reach its current stage, so it is tempting to believe that each tiny nuance of colour and pattern has arisen to serve a particular purpose. There doesn't, however, necessarily have to be a survival-related reason for everything – it can make little difference whether the legs of a butterfly are grey or brown. Nevertheless, it is obvious that a butterfly that has evolved effective camouflage is more likely to escape predation than one that has not.

Camouflage is just one of the strategies used by butterflies to conceal themselves from predators. Others include disguise, disruptive colouration and transparency.

CAMOUFLAGE AND DISGUISE

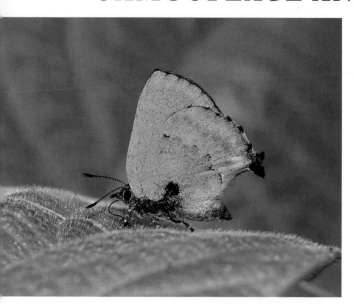

Mountain Greenstreak, *Cyanophrys longula*, Medellin, Colombia.

The term 'camouflage' is used here to describe colours and patterns that enable a creature to blend well against its natural background, which may be foliage, bare earth, lichen-covered boulders or the bark of a tree. Disguise, on the other hand, refers to the mimicry of another natural object, such as a dead leaf, a flower or even a bird dropping.

Examples of camouflage include the Mountain Greenstreak, *Cyanophrys longula*, whose green underside blends perfectly against living foliage; the Common Brassy Ringlet, *Erebia cassioides*, whose silvery-grey underside matches the colour of the boulders on which it settles; and the Grey Cracker, *Hamadryas februa*, which has a marbled upperside that renders it near-invisible when it is basking on tree trunks.

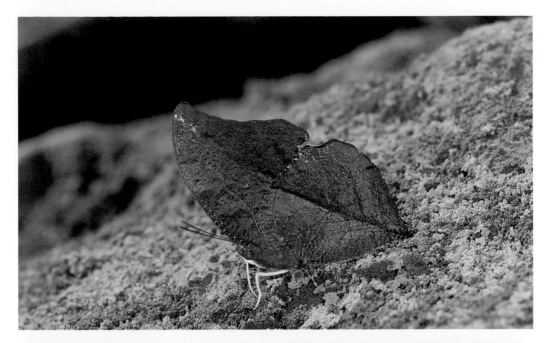

TOP Isodora Leafwing, *Zaretis isodora*, Rio Madre de Dios, Peru.

BOTTOM Marbled Leafwing, *Hypna clytemnestra*, Rio Sarapiqui, Costa Rica.

Disguise takes on several forms, the most common of which is dead-leaf mimicry. Examples include the Isodora Leafwing, *Zaretis isodora*, the Tiger-with-tails, *Consul fabius*, and the Marbled Leafwing, *Hypna clytemnestra*. The subtle colours, intricate patterns and convincingly leaf-like shapes of these butterflies provide an extremely effective disguise.

DISRUPTIVE COLOURATION

Birds use a 'search image' to identify butterflies, finding them by recognising their distinctive shape and symmetrical patterns. Many butterflies have evolved ways to make it harder for birds to find them by using disruptive patterns that break up their outline into a series of meaningless shapes, usually by means of mottling or prominent bands or stripes.

One example is the Malachite, *Siproeta stelenes*. The translucent green bands and spots on its dark brown wings break up its shape, making it difficult to spot when it basks in the dappled sunlight of its rainforest habitat. The Rock Grayling, *Hipparchia alcyone*, is another case. The dark mottled undersides of its wings are marked with jagged white bands that fragment its shape, making it almost impossible to detect, regardless of whether it settles on boulders, tree trunks or broken soil.

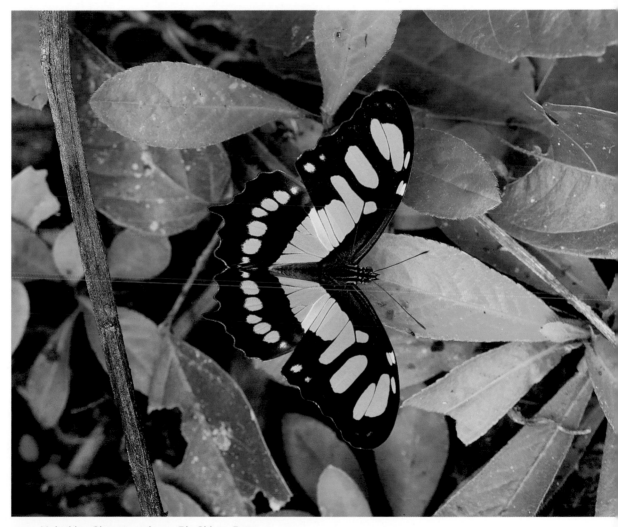

ABOVE Malachite, *Siproeta stelenes*, Rio Shima, Peru.
OPPOSITE Tiger-with-tails, *Consul fabius*, Rio Chanchamayo, Peru.

TRANSPARENCY

The colours of butterfly wings are produced by pigments and by the effects of light reacting with the structure of the scales. However, in many ithomiines, including *Hypoleria*, *Ithomia* and *Pteronymia*, large areas of the wings are devoid of scales, revealing transparent 'windows' or hyaline areas. These are found also in many genera of the Pyrrhopyginae, Pyrginae, Papilioninae and Riodinidae.

Transparency is rare among sun-loving butterflies because scaleless wings glint in sunlight and attract the attention of birds. The theme works extremely well though for sedentary ithomiines and for satyrine genera such as *Cithaerias*, *Dulcedo* and *Haetera*, which inhabit deeply shaded areas in the interior of rainforests.

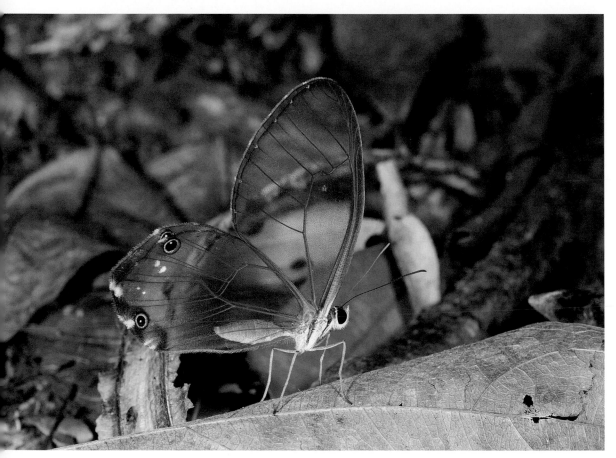

Amber Phantom, *Haetera piera*, Rio Cristalino, Mato Grosso, Brazil.

The small number of transparent species that do fly in open sunshine tend to be very active, fast-flying butterflies such as the Amazon Angel, *Chorinea amazon*, from Peru, or the Dragontail *Lamproptera meges* from Malaysia. Both of these species are usually found in the vicinity of waterfalls or streams, where they dart rapidly from spot to spot and can easily be mistaken for dragonflies.

APOSEMATIC COLOURATION

Most butterflies are palatable to birds, but a significant number of species are toxic or unpalatable. The term aposematic refers to colours and patterns that are used to advertise these toxic or dangerous qualities to other creatures.

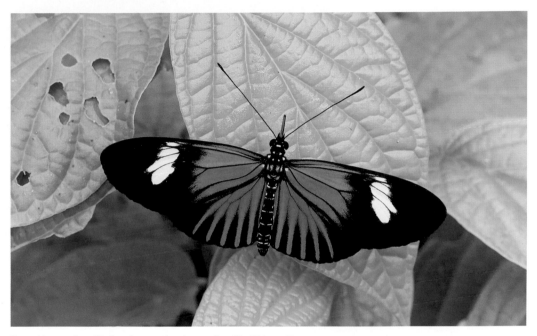

Bates' Longwing, *Heliconius xanthocles melior*, Rio Shima, Peru.

Examples of aposematic colouration include the yellow and black bands on the abdomens of hornets and wasps; the red, yellow and white bands of *Micrurus* coral snakes; and the gaudy patterns of *Dendrobates* poison arrow frogs. Unpalatable or toxic butterflies such as *Heliconius xanthocles* and *Altinote dicaeus* use similar colours and patterns to warn insectivorous birds that they are inedible.

Red-banded Altinote, *Altinote dicaeus callianira*, Rio Kosnipata, Peru.

Numerous studies have revealed that all vertebrates, including birds, intrinsically associate the colours green and blue with safety; while red, orange, yellow and white are regarded as signs of danger. In addition to their inherent recognition of 'danger' colours, birds have the ability to learn. They remember strong patterns but tend to forget plainer ones. If they associate a particular bright pattern or colour with an unpleasant taste, they will avoid eating similarly marked butterflies. Consequently, well-marked noxious butterflies, especially those with bright stripes or a high orange content, survive much better.

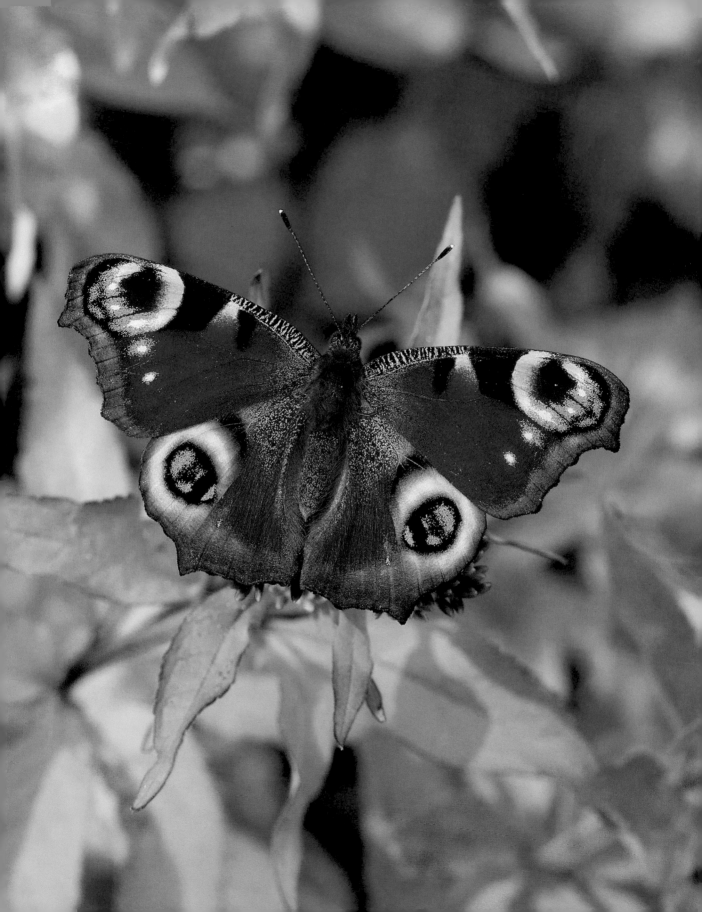

DIEMATIC PATTERNS

Diematic patterns are those which startle or scare potential predators. The most common form of diematic defence in Lepidoptera is the use of ocelli, or 'false-eye' markings, on the wings. If displayed suddenly, they can invoke fear in a predator, or at least startle it long enough for the insect to make its escape. The markings also tend to create the illusion that the insect is larger than is actually the case.

In silkmoths such as *Automeris io*, *Saturnia pavonia* and *Antheraea mylitta* these ocelli are very conspicuous. They appear to simulate the eyes of monkeys, snakes or raptors, although predators may not necessarily interpret the ocelli in the same way that humans do.

Many butterflies also have diematic ocelli. The best-known example is the Peacock, *Inachis io*, from Europe. It often rests with its wings closed, but if disturbed it suddenly flicks them open, revealing four huge ocelli. At the same time, it produces an alarming snake-like hissing sound. The combined visual and auditory display is often enough to deter a bird from attacking.

Birds may find the appearance of the Peacock frightening, but it usually has the opposite effect on humans, as many people consider it to be the most beautiful butterfly in the world. Its beauty was remarked upon as early as 1634, by Sir Theodore de Mayerne, physician to King Charles l, who noted that the eye-like markings on the wings 'shine curiously like stars, and do cast about them sparks of the colours of the rainbow.'

DECOYS

While large ocelli are usually regarded as diematic, the smaller ocelli on the wings of satyrs such as the Gatekeeper, *Pyronia tithonus*, are believed to function instead as decoys.

When a bird attacks it focuses its aim on an obvious target area such as a conspicuous spot. Many butterflies have prominent spots on the outer part of their wings. These decoys are highly effective at diverting attacks away from the body – a fact confirmed by the position of peck marks on the wings of butterflies that have survived attacks.

Decoy ocelli are especially prevalent in the Satyrinae. They are particularly well-developed in the Old World genera *Ypthima*, *Mycalesis*, *Bicyclus* and *Tisiphone*; and in the Neotropical *Chloreuptychia* and *Cissia*. It should be noted, however, that in certain genera, such as *Taygetis*, the ocelli serve an entirely different function, being mimetic of galls or spots of leaf mould.

ABOVE Gatekeeper, *Pyronia tithonus*, Hampshire, England.

OPPOSITE Peacock, *Inachis io*, Hampshire, England.

Zebra-striped Hairstreak, *Panthiades bathildis*, Medellin, Colombia.

The false-head illusion

A variation on the decoy theme is employed by Hairstreak butterflies. The Zebra-striped Hairstreak, *Panthiades bathildis*, and the Metallic Caerulean, *Jamides alecto*, for example, have distinctive patterns of bright stripes that function to direct the eyes of birds towards a target area on their hindwings. The target is comprised of a prominent orange and black 'eye-mark' at the tornus, and thin antenna-like tails that are deliberately jiggled when the butterflies are at rest. The effect is to create a false-head illusion that deceives birds into thinking that the butterfly is facing back-to-front. In the case of *Panthiades*, *Arawacus* and other similarly patterned hairstreaks, the deception is enhanced because the butterflies have a habit of immediately rotating to face the other way as soon as they settle.

Metallic Caerulean, *Jamides alecto*, Buxa, West Bengal, India.

An attacking bird always tries to anticipate the escape route of its prey. It expects a butterfly to fly forwards, so it aims its attack at a point just a fraction in front of what it perceives to be the real head. The false-head fools it into aiming at the rear of the butterfly, which then escapes in the opposite direction.

FLASH COLOURATION

Many butterflies employ a 'now you see me, now you don't' defence strategy in which a gaudy upperside alternates in flight with a dark, sombre underside. A spectacular example is the fabulous Sickle-winged Blue Morpho, *Morpho rhetenor*. Its dazzling blue wings seem to flash on and off like a beacon as it flutters gently along river courses in search of a mate. Unfortunately, the highly reflective blue wings sometimes attract the unwanted attention of birds. If the butterfly is chased, its lazy flight pattern suddenly changes to a wild, swooping, evasive manoeuvre, and it dives into the forest. The pursuing bird is still, of course, searching for an iridescent blue insect, but the instant it settles, the *Morpho* snaps its wings shut, foiling the bird's search program.

MIMICRY

As discussed previously, unpalatable butterflies often have conspicuous patterns. Experiments have shown that birds can memorise these and learn to avoid eating similar looking species in the future. Mimics take advantage of this fact, 'copying' the aposematic patterns of other species. There are two basic types of mimicry – Batesian and Müllerian.

Batesian mimicry

In 1862, Henry Walter Bates published a scientific paper in which he theorised that palatable butterflies occasionally produce mutations with visual characteristics that are similar to those of toxic species. He suggested that their similarity would make them less likely to be eaten by birds, and that their characteristics therefore would be inherited by their offspring. He proposed that certain palatable species thereby evolved to become almost identical to their noxious counterparts.

Batesian mimicry works because the noxious species far outnumber the palatable ones. If the situation was reversed so that most of the butterflies attacked were palatable, the bluff would fail. There are, however, a few cases where the mimics can outnumber the models by producing several different morphs, each mimicking a different species. *Eresia datis*, for example, produces about a dozen different forms, each mimicking a different species of ithomiine.

Müllerian mimicry

Fritz Müller studied butterflies in south-east Brazil. He realised that in addition to Batesian mimics, there were also groups of near-identical species in which ALL members were unpalatable to birds. He proved mathematically that this type of mimicry is biased in favour of the scarcer species, and that it is advantageous for there to be a large number of species involved in the mimicry complex because it increases the power of the warning signal. This type of evolutionary 'cooperation' is called Müllerian mimicry.

The genus *Heliconius* is a fascinating collection of Müllerian mimics. It consists of 39 species, each of which produces many different geographical colour forms. The Common Postman,

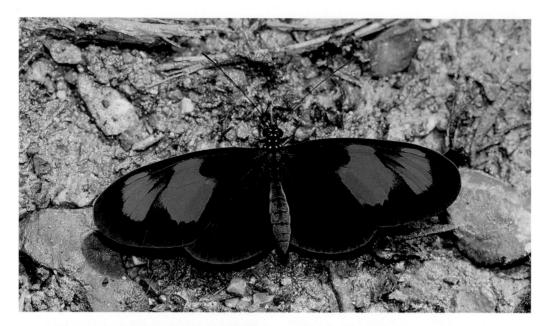

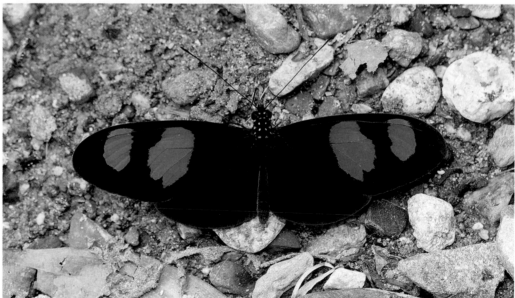

TOP Melpomene Postman, *Heliconius melpomene xenoclea*, Junin, Peru.

BOTTOM Common Postman, *Heliconius erato microclea*, Junin, Peru.

Heliconius erato, for example, produces 29 subspecies, each of which corresponds almost exactly in colour and pattern to a 'sister' subspecies of the Melpomene Postman, *Heliconius melpomene*, flying in the same area.

The genus also includes several species that mimic toxic ithomiines. One example is *Heliconius atthis*, which mimics *Elzunia humboldt*. Another is *Heliconius numata*, which is a member of the 'tiger complex'.

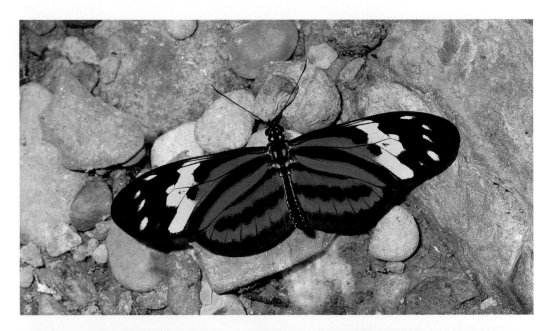

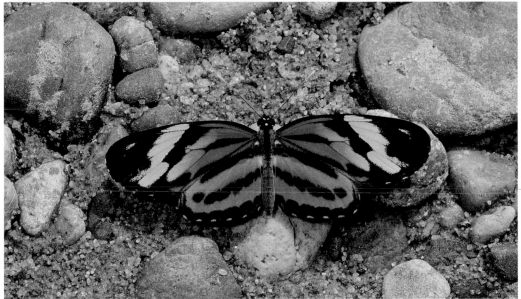

TOP Isabella Longwing, *Eueides isabella dissoluta* (Heliconiini), Junin, Peru.

BOTTOM Tiger Crescent, *Eresia eunice* (Melitaeini), Rio Pindayo, Peru.

The tiger complex

The tiger complex is a group of over 200 Neotropical butterflies and moths sharing a common theme of orange stripes on a black ground colour. It includes many toxic ithomiines such as *Tithorea harmonia* and *Mechanitis lysimnia*; the noxious danaine *Lycorea halia;* unpalatable heliconiines such as *Eueides isabella* and *Heliconius pardalinus*; and the swallowtail *Pterourus zagreus*. The complex also includes several noxious day-flying arctiine moths from the tribe Pericopini, and a palatable member of the Melitaeini – the Tiger Crescent, *Eresia eunice*.

Members of the tiger complex often aestivate commonally during the dry season. At such times, when they are lethargic and can easily fall prey to birds, mimicry is a valuable form of defence.

The tiger complex is the most well-known group of mimics and models, but there are also several other mimicry rings. The glasswing ring, for example, consists of about a dozen large transparent species, including unpalatable Müllerian models in the ithomiine genera *Methona* and *Thyridia*, together with the highly toxic danaine *Lycorea ilione*, and the palatable dismorphiine *Patia orise*.

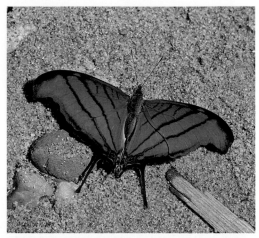

Another mimicry complex includes a number of bright orange butterflies, among which are the toxic heliconiines *Dryas iulia*, *Agraulis vanillae*, *Eueides aliphera* and *Dione juno*; and the palatable Red Daggerwing, *Marpesia petreus*. Although the latter has an entirely different wing-shape from the others, it is easily confusable in flight with its noxious models.

RIGHT Red Daggerwing, *Marpesia petreus*, Volcan Orosi, Guanacaste, Costa Rica.

BELOW *Agraulis vanillae* and *Dione juno*, Oxapampa, Peru.

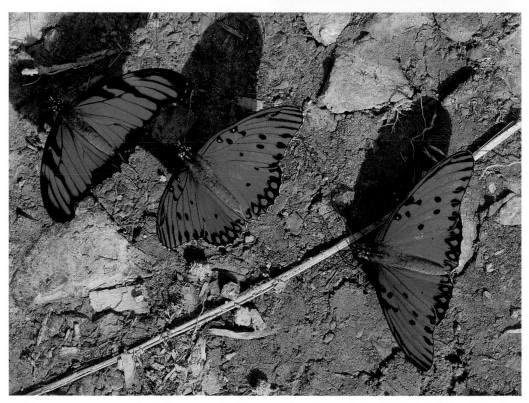

POLYMORPHISM

Polymorphism is defined as the ability to produce multiple varieties within a given species. It has evolved in several butterfly families, most notably among the Papilionidae. In species where polymorphism occurs, males are always consistent in colour and pattern. Females, on the other hand, produce several forms, one of which sometimes resembles the male, while the others are Batesian mimics of other species.

The best-known example is the African Mocker Swallowtail, *Papilio dardanus*. The tailed male never varies in colour or pattern, but the female produces no less than 14 different forms corresponding with various noxious models, including the Friar, *Amauris niavius*, the Glassy Acraea, *Acraea poggei*, and the Plain Tiger, *Danaus chrysippus*.

Another example of polymorphism is *Papilio polytes*. The male is always constant in appearance, but the female produces several different forms mimicking various unpalatable *Atrophaneura* species. These forms include *Papilio polytes romulus* 'form *polytes*', which is a near-perfect double of the Crimson Rose, *Atrophaneura hector*; and *Papilio polytes romulus* 'form *theseus*', which is a superb mimic of the Common Rose, *Atrophaneura aristolochiae*.

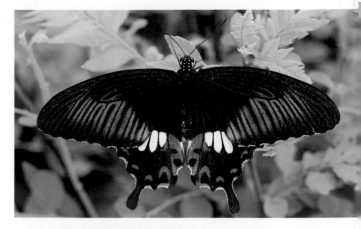

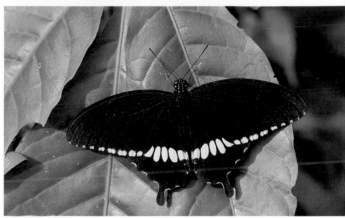

TOP Common Mormon, *Papilio polytes romulus*, female form *theseus*, Assam, India.

BOTTOM Common Mormon, *Papilio polytes romulus*, female form *cyrus*, Assam, India.

Seasonal dimorphism

In temperate regions, the spring and summer generations of butterflies are often different in appearance. The Comma, *Polygonia c-album*, for example, produces a brightly coloured form called *hutchinsoni* in early summer, but the overwintering brood have darker undersides and a more ragged wing-shape that provides them with a more effective camouflage when hibernating amongst dead brown leaves.

A more extreme example is the Map butterfly, *Araschnia levana*. The spring brood is orange with black spots, and resembles a miniature Comma. The summer brood, however, is very different in appearance, with white bands on a black background, like a miniature White Admiral, *Limenitis camilla*. It is not known what advantage the butterfly gains from this dimorphism, but clearly it must benefit in some way.

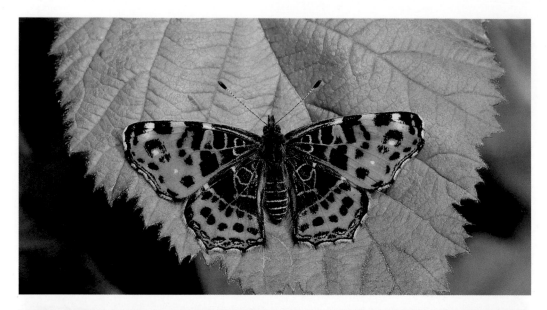

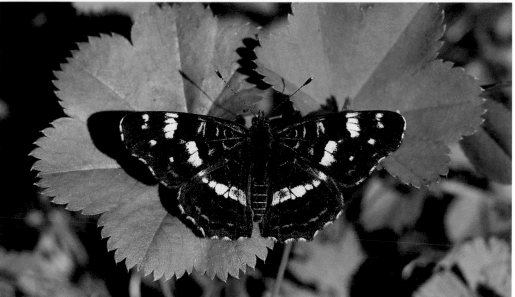

TOP Map butterfly, *Araschnia levana*, spring brood, Saint Germain l'Herm, France.
BOTTOM Map butterfly, *Araschnia levana*, summer brood, Laeva, Estonia.

In the case of tropical butterflies, such as the Virgilia Wood Nymph, *Taygetis virgilia*, the advantage gained by having seasonal forms is more obvious. Wood Nymphs spend long periods at rest, settled among leaf litter on the forest floor. In the dry season, when the leaves are desiccated and russet in colour, *T.virgilia* produces a russet form with falcate wings, simulating the appearance of a dead leaf. In the rainy season it produces a two-tone, earthy brown form that provides more effective camouflage at a time when the foliage is dense and the shadows are darker.

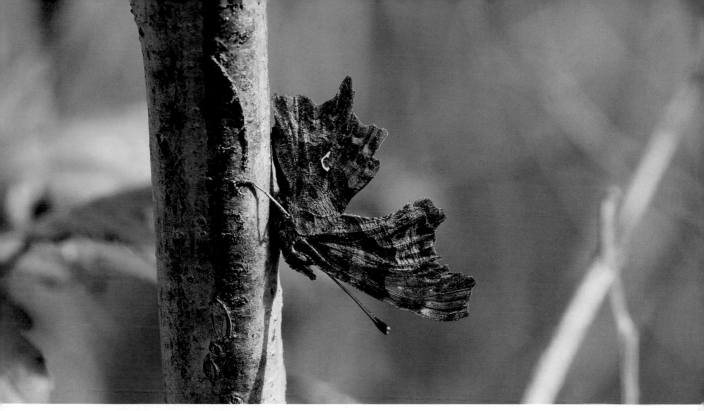

Comma, *Polygonia c-album*, West Sussex, England.

ROOSTING BEHAVIOUR

In Europe, many butterflies roost overnight in open situations. Most have evolved cryptic undersides and have adopted specialised roosting behaviours in order to escape predation. The Orange-tip, *Anthocharis cardamines*, for example, blends superbly with the garlic mustard flowers on which it roosts. Likewise, the Comma, *Polygonia c-album*, looks remarkably like a crumpled dead leaf when roosting in a head-downward posture on twigs or tree branches.

One of the most fascinating examples of roosting behaviour is found in the Dingy Skipper, *Erynnis tages*, which wraps its cryptically patterned wings tightly around dead knapweed flower heads, where it is almost impossible to detect – unless you are a very determined entomologist!

Some butterflies, such as the Chalkhill Blue, *Polyommatus coridon*, and the Marbled White, *Melanargia galathea*, habitually roost in a head-downward posture at the top of grass-heads. In such a highly visible position they would seem to be vulnerable to predation, but because the grasses are constantly swaying in the breeze it is difficult for birds to snatch them. By roosting at the top of grass-heads they are also less likely to be discovered at night by foraging mice or shrews.

In tropical areas most species roost under leaves, where they are safe from heavy overnight rains. Beneath leaves, they are also well hidden from birds and other predators.

The image on page 83 shows a mixed-sex group of Social Skippers, *Hyalophrys neleus*, roosting communally under a leaf in the Peruvian Amazon. With several million leaves to choose from, why did they settle beneath this particular one? It seems almost certain that a single butterfly initially settled there and that pheromones or other stimuli then attracted the

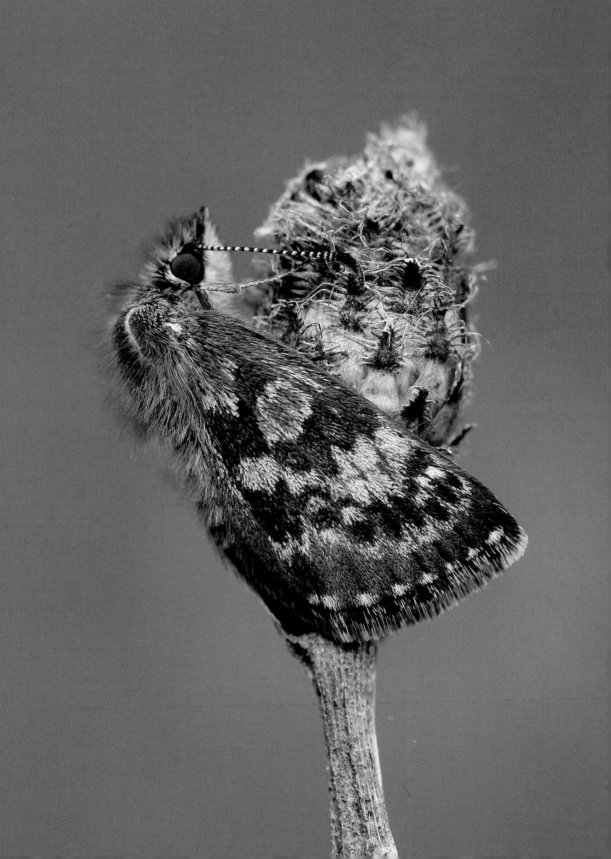

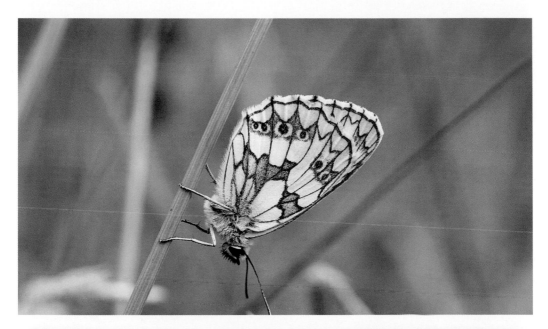

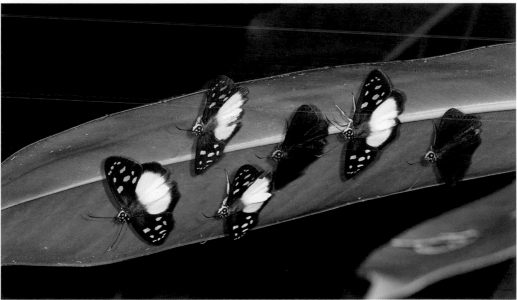

ABOVE TOP Marbled White, *Melanargia galathea*, Berkshire, England.
ABOVE BOTTOM Male and female Social Skippers, *Hyalothyrus neleus*, Rio Madre de Dios, Peru.
OPPOSITE Dingy Skipper, *Erynnis tages*, Hampshire, England.

others. Communal roosting probably evolved as a defence strategy. The more pairs of eyes there are, the easier it is to detect approaching predators. The tiniest disturbance causes the entire assemblage to suddenly take flight. The scatter-burst of alarmed butterflies is certainly enough to startle any foraging bird. Once airborne, the rapidly swirling mass of butterflies, some with white patches, would cause great confusion to a bird and allow most to escape.

HIBERNATION AND AESTIVATION

Butterflies are cold-blooded. If they get too cold they cannot fly. If the weather is too hot and dry they become dehydrated and die. Consequently, during times of extreme heat, cold or drought, they have to enter a state of diapause, a condition in which the metabolism is so low that normal activities such as flying, feeding and breeding are suspended.

Hibernation

Hibernation occurs at different stages of the lifecycle according to species. Most overwinter as larvae and reawaken when fresh foliage reappears in the spring. Some hibernate as eggs or pupae. A few, such as the Small Tortoiseshell, *Aglais urticae*, overwinter as adults. This strategy ensures that their energy is not wasted on futile searches for nectar in mid-winter. Reawakening is synchronised with the appearance of spring flowers and fresh larval foodplants.

To successfully overwinter, butterflies need to find a place to hide where they are protected from the worst of the wind, rain and snow. They may be in diapause for several months and throughout this period they must remain undetected by birds. Accordingly, they have evolved cryptic colours, patterns and unusual wing-shapes that combine to provide them with effective camouflage or disguise.

The Brimstone, *Gonepteryx rhamni*, for example, has wings that are leaf-like in shape and colour, with a rough texture and prominent raised veins, rendering the butterfly almost invisible when roosting or hibernating beneath leaves.

Brimstone, *Gonepteryx rhamni*, West Sussex, England.

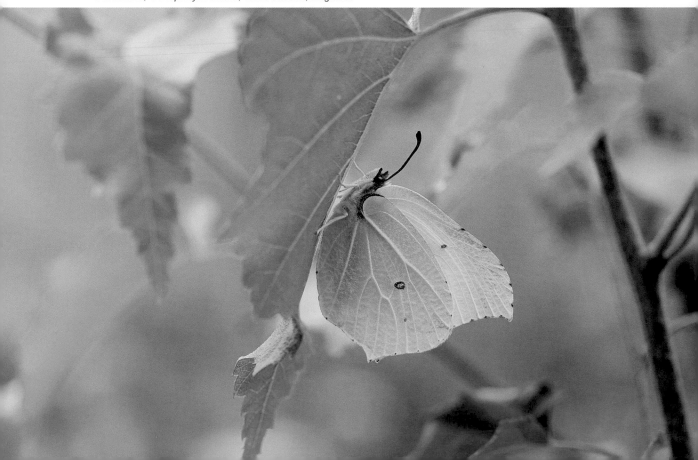

Camberwell Beauties, *Nymphalis antiopa*, Large Tortoiseshells, *N. polychloros*, and Peacocks, *Inachis io*, hibernate in hollow tree trunks, caves and other dark places. These species have very dark undersides, making it almost impossible for foraging birds to locate them in their gloomy surroundings.

Aestivation

Butterflies need to maintain their body temperatures within operational limits. They quickly become dehydrated if conditions become too hot. Consequently, they cool themselves by seeking shade or by drinking water from puddles or the edges of streams. However, there are times when even these measures are insufficient to prevent desiccation. In tropical regions of India, Australia, Africa and Amazonia the dry season can be extremely hot and dry. Nectar sources and larval foodplants shrivel and die. Sources of moisture become very scarce. To avoid death in such circumstances butterflies have only two choices. They must either migrate or they must go into a state of diapause known as aestivation.

In Amazonia, the Daggerwing *Marpesia berania* aestivates communally in densely packed clusters of 60 or more adults, hanging from branches. By clumping tightly together in this way they are less prone to desiccation.

Glasswings such as *Ithomia agnosia*, and Tigers including *Melinaea*, *Mechanitis* and *Hypothyris*, often aggregate at dried out riverbeds in deeply shaded areas within their rainforest habitat. There they hide amidst tangles of palm rootlets where a few traces of moisture remain. They occasionally awaken to imbibe pyrrolizidine alkaloids oozing from nearby withered plants, but soon return to their dens, only becoming fully active again when the first rains of the wet season fall.

Not all tropical butterflies aestivate in the dry season. Many, particularly members of the Pieridae and Papilionidae, escape the dry conditions by migrating. Some species migrate to cooler climates high in the mountains, while others follow river courses to reach distant areas where rain still falls.

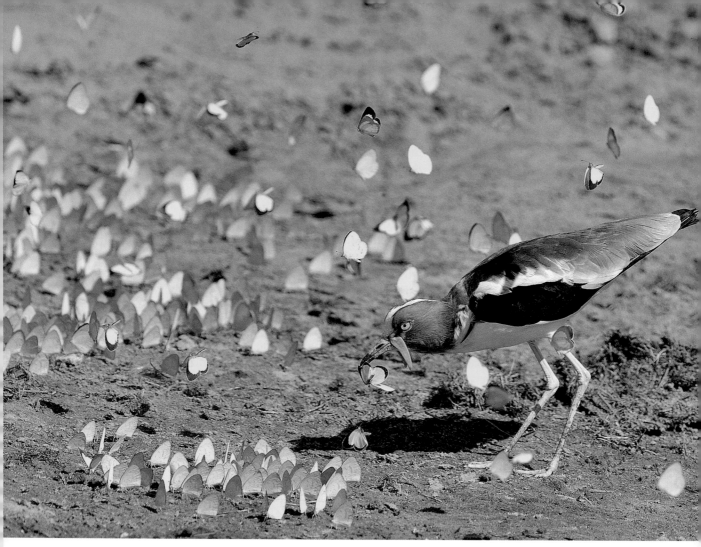

White-crowned lapwing attacking mud-puddling *Eurema brigitta*, Chobe, Botswana.

During migrations, large swarms of butterflies often break their journey to descend and imbibe moisture from damp ground. Males in particular often gather in huge numbers at favoured spots.

The image above of *Eurema brigitta* was taken by wildlife photographer Veronica Cöetzer, who vividly recalls watching the butterflies at Chobe in Botswana: 'The highlight of the trip was the extraordinary sighting of many thousands of tiny yellow butterflies at Elephant Valley and the fascinating behaviour of animals and birds towards them. White-crowned lapwings looked like they didn't really enjoy eating the butterflies – they would first dip them into water before swallowing them. A little egret was in a feeding frenzy running frantically around and in its typical way stalked its prey. Strangely enough it ignored all the thousands of yellow butterflies and only picked out brown ones. What we enjoyed most were the baboons. They ran through them, played between them, tried to catch them and just sat and stared at this phenomenon. Elephants, warthogs and kudu also ran through them. It was just such a magical sight – this yellow confetti dancing all around them.'

Seasonal migration

Outward migrations usually begin in hot and dry regions when foodplants shrivel and die, stimulating butterflies to migrate to more humid locations to find fresh vegetation. Successive generations migrate progressively away from the source population until less favourable climatic conditions deter them from continuing. Eventually, as the seasons change and weather conditions deteriorate, a return migration occurs, but the numbers involved are always much lower than in the outward phase.

In mountainous regions, the climate is often drastically different on either side of a range. Butterflies migrating from one side to the other seek the easiest route. By following streams upriver they find their way to high mountain passes. From there they continue down the opposite slope to forests and grasslands where the onset of rains has triggered the growth of fresh vegetation.

In 2012, I witnessed such a migration while hiking in the Chanchamayo valley in Peru. At one stage over 100 *Marpesia furcula* Daggerwings were passing me every minute, as I walked along an old logging trail running beside the Rio Shima. The migration continued for over four hours, during which time at least 10,000 butterflies passed by, all flying in the same direction. About 20 species were involved, about half of which were *M. furcula*. Upon arrival at our campsite I found another 2,000 or more *M. furcula* swarming around the edges of two large pools.

Route finding

The Monarch, *Danaus plexippus*, is the most accomplished migrant in the butterfly world. In North America, the butterflies migrate annually in millions, covering a distance of over 3,200km (2,000 miles) between their breeding territories in Canada and their southern wintering grounds in Mexico.

Laboratory experiments and field studies have shown that their migrations are triggered by a biological solar compass, which is activated by light receptors, and regulated by a circadian clock built into the Johnston's organ at the base of their antennae. Another research project resulted in the discovery that Monarchs have two types of photoreceptor proteins which not only allow them to see UV light, but also enable them to detect the Earth's magnetic field. Collectively, these studies have demonstrated that Monarchs are able to process detailed information about sun position, magnetic fields, time of year and other factors, and use it to calculate migration routes.

The origin of migratory behaviour

Butterflies first came into existence at a time when the present day continents were united to form the giant land mass Pangaea. Huge seasonal extremes of climate must have occurred on this massive supercontinent. Consequently, butterflies would have needed to find some way to survive when their larval foodplants and nectar sources wilted in summer, or when temperatures were too high or too low for normal activity.

One option would be to hibernate or aestivate *in situ*, but in a diapaused state large numbers would perish due to predation. A better alternative would be to fly to another location, perhaps close to a river, where foodplants would continue to be available long after the surrounding land had dried out. Further foodplants would then be found by migrating up or down river.

Butterflies that survived as a result of such actions would be able to pass on the migratory trait genetically. It is perhaps no coincidence that so many species in the tropics still use rivers and streams as migration paths.

In subsequent geological periods, migratory patterns must have changed when tectonic activity caused mountain ranges and seas to appear, splitting up areas of formerly contiguous breeding terrain. As the ranges got higher and the oceans got wider, the journeys would have become more difficult. However, by this time the migratory trait was deeply ingrained, and many species continued their seasonal journeys, crossing mountain ranges via low passes, and hopping from island to island to cross seas and oceans.

THE BUTTERFLY FAMILIES

THE RELATIONSHIP BETWEEN BUTTERFLIES AND MOTHS

There are about 160,000 described species of Lepidoptera. Approximately 17,500 of these are members of families that are traditionally classified as butterflies. This classification, however, is rather unscientific. It is based on the erroneous concept that species with club-tipped antennae are biologically separate from those with tapered antennae. Equally erroneous are the notions that all butterflies are brightly coloured day-flying insects, and that all moths are drab nocturnal creatures. In reality, there are hundreds of very colourful moth species and thousands of dull brown butterfly species, many of which fly only in the dim light of dawn and dusk.

The relationship between 'butterflies' and the various 'moth' superfamilies is shown in Table 1. The superfamilies at the top of the table are regarded as the more basal ones, while those towards the bottom are considered to be the more highly evolved and specialised. The butterfly section has been expanded to show the two butterfly superfamilies, Hesperoidea and Papilionoidea, highlighted in orange. It can be seen from the table that butterflies are not separate from moths. More accurately, they should be thought of as a sub-group of Lepidoptera, that in evolutionary terms lies between the geometer and the hook-tip moths.

The Hesperoidea contains only one family – Hesperiidae. The remaining six families are all placed in the Papilionoidea. These are Papilionidae, Pieridae, Lycaenidae, Riodinidae, Nymphalidae and Hedylidae. The Nymphalidae was formerly split into 10 smaller families – Nymphalidae, Satyridae, Morphidae, Brassolidae, Acraeidae, Amathusiidae, Danaidae, Heliconiidae, Ithomiidae and Libytheidae. Subsequently, phylogenetic research revealed that these 'families' were very closely related. In recognition of this all were consolidated within the single family Nymphalidae.

Table 1 Lepidoptera

Sub-order	Superfamily	Common name
Zeugloptera	Micropterigoidea	Mandibulate moths
Aglossata	Agathiphagoidea	Kauri moths
Heterobathmiina	Heterobathmoidea	Valvidian Archaic moths
Glossata	Eriocranioidea Lophocoronoidea Neopseusroidea Mnesarchaeoidea Hepialoidea	Archaic Sun moths, Australian Archaic Sun moths, Archaic Bell moths, New Zealand Primitive moths, Amazon Primitive Ghost moths, Australian Primitive Ghost moths, African Primitive Ghost moths, Ghost moths, Miniature Ghost moths
Monotrysia	Andesianoidea Nepticuloidea Tischerioidea Paleaphatoidea Incurvarioidea	Valvidian Forest moths, Pygmy moths, Eye-cap moths, Trumpet Leafminer moths, Gondwanaland moths, Leaf-cutter moths, Gall moths, Yucca moths, Longhorn Fairy moths, Shield-bearer moths
Ditrysia	Tineoidea Gelechioidea Copromorhoidea Yponomeutoidea Immoidea Pyraloidea Pterophoroidea Sesioidea Zygaenoidea Cossoidea Castnioidea Tortricoidea Calliduloidea Geometroidea	Tube moths, Fungus moths, Spiny-winged moths, Bagworm moths, Tropical Lattice moths, Double-eye moths, Bristle-legged moths, Ribbed Cocoon-maker moths, Leafminer moths, Concealer moths, Tropical Longhorn moths, Grass Miner moths, Lance-winged moths, Twirler moths, Scavenger moths, Case-bearer moths, Mompha moths, Palm moths, Cosmet moths, Flower moths, Many-plumed moths, Fruit-worm moths, Fringe-tufted moths, Cereal Stem moths, Shiny Head-standing moths, Sedge moths, Diamond-back moths, Ermine moths, Lyonet moths, Sun moths, Imma moths, Teak moths, Picture-winged Leaf moths, Snout moths, Plume moths, Little Bear moths, Clearwing moths, Metalmark moths, Burnet moths, Long-tailed Burnet moths, Flannel moths, Wood-borer moths, Parasite moths, Slug-Caterpillar moths, Giant Butterfly-moths, Leaf-roller moths, Parnassian moths, African Skipper-moths, Swallowtail moths, Crenulate moths, Geometer moths
BUTTERFLIES Hesperioidea Papilionoidea	Hesperiidae Papilionidae Pieridae Lycaenidae Riodinidae Nymphalidae Hedylidae	Skipper butterflies Swallowtail butterflies White butterflies Hairstreaks, blues and coppers Metalmark butterflies Brush-foot butterflies Butterfly-moths
	Drepanoidea Bombycoidea Sphingoidea Noctuoidea	Gold moths, False Owlet moths, Hook-tip moths, Sackbearer moths, Silkworm moths, Giant Lappet moths, Lappet moths, Glory moths, Owl moths, Andean Moon moths, Emperor moths, Hawk moths, Prominent moths, Tuft moths, Owlet moths, Tiger moths, Tussock moths

THE BUTTERFLY FAMILIES

The seven butterfly families are subdivided into 38 subfamilies, as shown in Table 2:

Table 2 The Butterfly Families

Family	Subfamilies	Common names
Hesperiidae	Pyrrhopyginae	Firetips, Swifts
	Pyrginae	Spreadwings, Flats
	Megathyminae	Giant Skippers
	Trapezitinae	Australian Skippers
	Coeliadinae	Policemen, Awls
	Hesperiinae	Grass Skippers, Darts
	Heteropterinae	Gold-spot Skippers
	Euschemoniinae	Regent Skipper (1 species)
Papilionidae	Papilioninae	Swallowtails, Swordtails, Dragontails, Cattlehearts, Birdwings
	Parnassiinae	Apollos, Festoons
	Baroninae	Baron (1 species)
Pieridae	Pierinae	Whites, Orange-tips, Jezebels, Ravens
	Coliadinae	Yellows, Sulphurs, Brimstones
	Dismorphiinae	Mimic Whites
	Pseudopontiinae	Paradox Whites
Lycaenidae	Lycaeninae	Coppers, Sapphires, Silverlines
	Polyommatinae	Blues, Caeruleans
	Miletinae	Brownies, Darkies
	Lipteninae	Liptenas, Telipnas, Epitolas
	Poritiinae	Gems
	Liphyrinae	Moth-butterflies
	Curetinae	Sunbeams
	Theclinae	Hairstreaks, Oakblues
Riodinidae	Euselasiinae	Euselasias
	Riodininae	Metalmarks, Underleafs
Nymphalidae	Apaturinae	Emperors
	Biblidinae	88s, Callicores, Banners, Perisamas, Red-rings, Crackers
	Calinaginae	Freaks
	Charaxinae	Leafwings, Pashas, Preponas, Agrias, Pallas, Nawabs
	Cyrestinae	Mapwings, Maplets, Daggerwings
	Danainae	Tigers, Crows, Tiger-mimics, Glasswings, Hamadryads
	Heliconiinae	Longwings, True Fritillaries, Acraeas
	Libytheinae	Beaks
	Limenitidinae	Sisters, Gliders, Sailors, Foresters, Cymothoes
	Morphinae	Morphos, Antirrheas, Owl butterflies, Jungle Glories
	Nymphalinae	Aristocrats, Pansies, Checkerspots, Eggflies, Mother of Pearls
	Pseudergolinae	Popinjays, Constables, Tabbies
	Satyrinae	Satyrs, Ringlets, Phantoms, Heaths, Evening Browns, Palmflies
Hedylidae	(no subfamilies)	Butterfly-moths

Distribution

Butterflies evolved during an era when the supercontinent Pangaea was splitting. Consequently the various families, subfamilies and tribes are not evenly distributed across the modern day continents. The Pyrrhopyginae and Ithomiini, for example, are only found in the Neotropical region; the Trapezitinae and Euschemoniinae only occur in Australia; and the Lipteninae are found only in Africa.

Taxonomic revision

Phylogenetics is a relatively new but rapidly advancing field of science. Modern techniques, including molecular analysis and detailed study of larval morphology, are taking the place of older methodology, which relied heavily on characteristics such as genitalic structure and wing venation to establish relationships between taxa. The upshot of these changes is that butterfly taxonomy is under constant revision. Consequently a subspecies might be elevated to the rank of full species, or a species might be split into several subspecies. Much to the annoyance of the non-scientific community, taxonomists often find it necessary to reassign a species to a different genus. Higher level reclassifications occur less frequently, but it also occasionally happens that an entire tribe or subfamily is uprooted and moved to a different family altogether.

Take the case of *Bia actorion*, a butterfly that was first described by Linnaeus in 1763 as *Papilio actorion* and placed in the then all-embracing family Papilionidae. The name *Papilio* was later reserved for a particular group of Swallowtails, so in 1819 Hübner created a new genus *Bia* to accommodate *actorion*. He placed it in the family Satyridae. The latter was later reduced in status to become a subfamily of the Nymphalidae. For a while, *actorion* was retained in this new subfamily, but further studies resulted in it being transferred to another subfamily – Brassolinae. In turn, this was reduced in status to become a tribe, namely the Brassolini, which is currently placed within the Nymphalid subfamily Morphinae.

Admittedly, *Bia actorion* is an extreme example, but virtually all butterflies have had their scientific names changed at least once in recent decades; and hundreds of them have been reassigned to different genera, tribes or subfamilies.

Changes in classification and nomenclature now happen at such a rapid rate that it is virtually impossible to keep track of them. During the six months it took to write this book, over 100 butterfly species have been renamed or reassigned. Therefore, any figures quoted here regarding the number of species in a genus, the number of genera in a family, or the total number of species on the planet, should only be regarded as an approximation and may differ from those quoted elsewhere.

OPPOSITE Uncertain Owlet, *Bia actorion*, Pantiacolla, Peru.

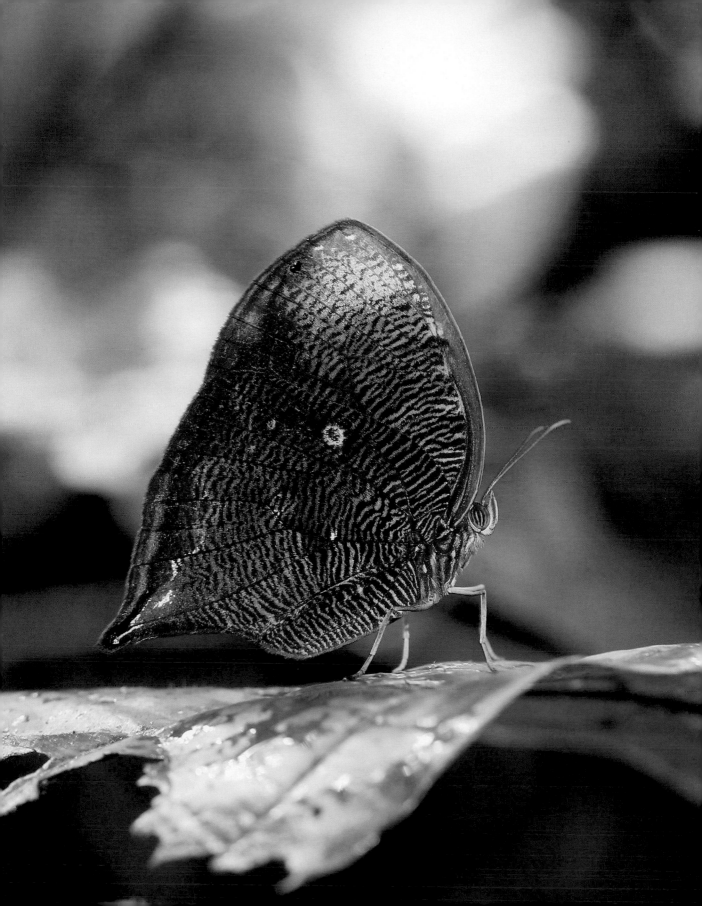

HESPERIIDAE

The Hesperiidae is the most basal of the butterfly families. It contains about 4,200 species worldwide. It attains its highest diversity in the Neotropical region, where 2,365 species occur.

The butterflies are commonly known as Skippers, due to their rapid darting flight. In this family all the veins on the forewings are unbranched. Other characteristics include large smooth eyes, stout bodies and widely spaced hook-tipped antennae.

The taxonomy of Skippers is not yet fully resolved. Some authorities consider the Eudaminae and Pyrrhopyginae to be distinct subfamilies, while others regard them as being tribes within the Pyrginae. Likewise, the Megathyminae are relegated to tribal status and included in the Hesperiinae by some workers. The subfamilies Coeliadinae, Euschemoniinae, Hesperiinae, Heteropterinae and Trapezitinae are all widely accepted.

PYRGINAE

Until recently, about 1,500 species were included in this subfamily, but revisionary work published in 2009 resulted in many being transferred to the Eudaminae. At the time of writing, about 1,100 remain in the Pyrginae. There are six, or arguably seven, pyrgine tribes, namely Celaenorrhini, Achlyodidini, Carcharodini, Tagiadini, Pyrgini, Erynnini and Pyrrhopygini. The latter is so distinctive that I am treating it here as a subfamily.

The Pyrginae probably originated in the Neotropical region, reaching the temperate regions of the Holarctic millions of years later. Nowadays, they are found virtually worldwide, occupying every region except the Arctic and Antarctic. They occur in a wide range of habitats, including temperate woodlands, alpine grasslands and sub-arctic tundra, but are most abundant and diverse in Amazonia and the Andes.

The vast majority of pyrgines (excluding the pyrrhopygines) are small butterflies, with wingspans typically between about 25–50mm (1–2in). Many are dull earthy brown in colour, with just a few indistinct paler markings, but others have conspicuous white patterns, a dusting of blue scales or an overall purplish sheen. The males of many genera have a distinctive fold on the costa of the forewing. Hidden within the fold are hundreds of androconial 'scent' scales. During courtship, males vibrate their wings rapidly, releasing pheromones from the scales, to entice females to copulate.

All pyrgines lay their eggs singly. The range of larval foodplants used is very broad. The larvae vary in appearance according to genus, but are typically smooth-skinned, plump and green or brown in colour. Most only have light markings but some are spotted or striped. Each larva lives solitarily within a shelter constructed by silking together leaves of the foodplant, or by rolling or folding a single leaf and fastening it with silk. After each moult, it constructs a new larger shelter. Pupation takes place in the final larval shelter. Pyrgine pupae are generally green, brown or black. However, there are exceptions to this rule – one fascinating species, *Pellicia arina* from Central America, has a bright red pupa covered in white spots, with a pair of false eyespots that simulate the eyes of a snake.

Pyrgini

With the exception of *Pyrgus*, the 22 genera currently allocated to this tribe are all confined to the Neotropical region. The 48 *Pyrgus* species are distributed widely across North America, Europe, temperate Asia and the Neotropics. The commonest and most widespread is the Orcus Checkered Skipper, *Pyrgus orcus*, which occurs from Mexico to Argentina.

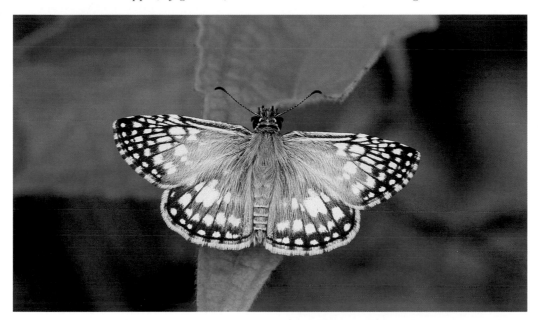

Most members of the tribe are smallish butterflies with squarish forewings. They vary considerably in colour and pattern. Among the most well-known species are *Xenophanes tryxus*, *Heliopetes arsalte*, *Carrhenes bamba*, *Spioniades abbreviata*, *Anisochoria pedaliodina* and the very beautiful Glorious Blue Skipper, *Paches loxus*, which is distributed from Mexico to Bolivia.

The pretty Variegated Skipper, *Diaeus lacaena*, is endemic to south-east Brazil. There are three other almost identical *Diaeus* species – *D.ambata*, *D.varna* and *D.variegata*; all of which are native to the Neotropical region.

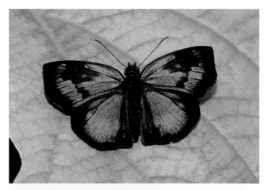

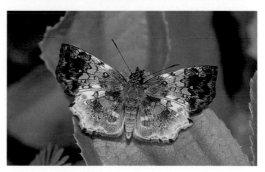

TOP Orcus Checkered Skipper, *Pyrgus orcus*, Tatama NP, Colombia.

MIDDLE Glorious Blue Skipper, *Paches loxus*, Rio Tambo, Peru.

BOTTOM Variegated Skipper, *Diaeus lacaena*, Serra da Bocaina, Brazil.

The nine *Antigonus* species are known as Spurwings, due to the projecting spur found at the apex of their hindwings. They have dark velvety wings, peppered with grey, brown or cream scales according to species. One of the most attractive species is the Powdered Grey Spurwing, *Antigonus erosus*, which is found in open, disturbed forest from Panama to Bolivia. Males are often seen imbibing mineralised moisture from muddy patches, amidst aggregations of other Skipper genera.

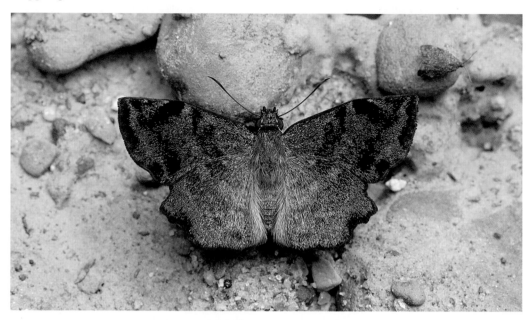

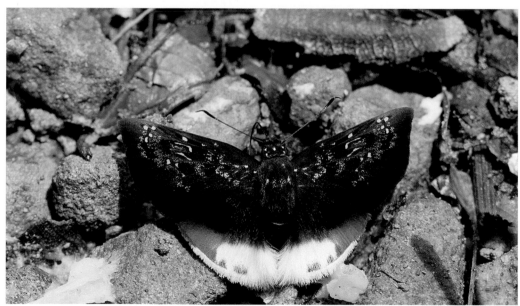

TOP Powdered Grey Spurwing, *Antigonus erosus*, Boca Colorado, Peru.
BOTTOM Pied Piper, *Spioniades abbreviata*, Tatama NP, Colombia.

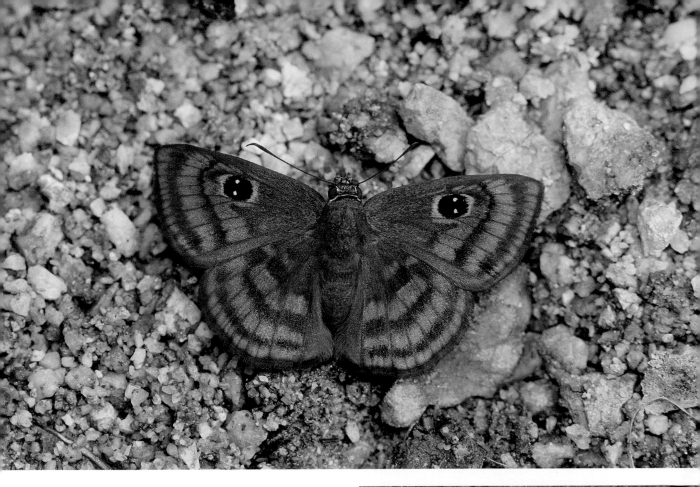

Carcharodini

The Carcharodini contains two Palearctic genera, *Carcharodus* and *Muschampia*; and one primarily African genus, *Spialia*. The remaining 27 genera are Neotropical in distribution, with just a handful of species reaching the southern USA. Among the best known are the *Bolla*, *Gorgopas* and *Staphylus* Sootywings. As their name implies, they generally have blackish wings, but several species arc adorned with metallic golden or green scales on their heads.

Perhaps the most fascinating members of the tribe are the *Ocella*, *Myrinia*, *Morvina* and *Cyclosemia* Eyed Skippers. It is possible that the conspicuous ocelli on their forewings act as decoys to divert bird attacks away from the body, but this seems unlikely as they are positioned centrally on the forewings rather

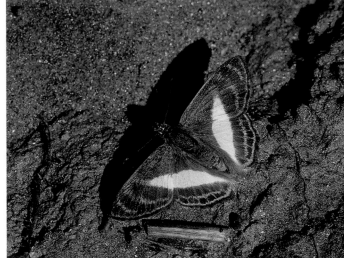

TOP Eyed Skipper, *Cyclosemia leppa*, Medellin, Colombia.

BOTTOM Aristotle's Skipper, *Sophista aristoteles*, Itatiaia, Brazil.

than at the edge. A more rational explanation might be that they evolved as a diematic defence, to scare predators. They certainly have a mesmersing effect on human observers.

The attractive and unusually marked Aristotle's Skipper, *Sophista aristoteles*, is impossible to mistake for any other species. It is one of only two members of the genus, the other being *S. latifasciata*. In the latter, the wings are far more rounded and the white bar on the forewing extends to reach the costa. *S.aristoteles* is distributed from Colombia to Bolivia, Argentina and south-east Brazil.

Erynnini

This large tribe is represented in the Holarctic region by the genus *Erynnis* and in the Neotropical region by 29 genera including *Anastrus*, *Camptopleura*, *Chiomara*, *Cycloglypha*, *Ebrietas*, *Gesta*, *Gorgythion*, *Grais*, *Helias*, *Mylon*, *Potomanaxas*, *Sostrata* and *Theagenes*. The butterflies are easy to recognise as a group, as the earthy brown ground colour of most species is overlaid with an intricate pattern of wavy lines, formed by a speckling of pale brown, greyish or blue scales. As usual, there are a few exceptions to the rule. *Mylon*, for example, are beautifully marbled with brown or greyish on an off-white ground colour; *Anastrus* are generally plain brown with a subtle blue sheen; and most of the *Potomanaxas* species are marked with broad white or yellow vertical bands.

Cryptic Mylon, *Mylon cajus*, Rio Kosnipata, Peru.

Many of the Erynnini adopt unusual postures when basking or roosting. *Theagenes*, *Cycloglypha*, *Helias* and *Camptopleura*, for instance, bask with the apexes of their forewings curved downwards; hence their popular name Bent-Skippers. In North America, *Erynnis* Duskywings often roost overnight on twigs or branches, adopting a moth-like posture with their wings folded roof-wise over their backs. Their close relative the Impostor Duskywing, *Gesta gesta*, on the other hand, goes to roost on dead vegetation, hanging by its forelegs, creating the impression of a dangling dead leaf.

The Mercurial Skipper, *Theagenes albiplaga*, is one of the most distinctive skippers in the Neotropics, easily recognised by the pure white circular patches on its hindwings; and by the cryptic forewings, which are angled downwards when the butterfly is basking. The adults are usually found singly and are only active in hot sunshine. They have a very rapid zigzag flight, just above ground level.

The exaggerated 'Bent-Skipper' posture of *Helias cama*, and the pattern formed by its metallic scales, give this pretty species a three-dimensional appearance. The male sets up a territory at a chosen spot in the forest. It defends it vigorously, instantly intercepting other passing insects, zigzagging and whizzing about in tight circles before suddenly returning to its original perch.

The genus *Cycloglypha* contains six small species, each about 35mm (1.4in) in wingspan. The ground colour is almost black in freshly emerged individuals, overlaid with a characteristic wavy pattern of metallic bluish markings. In older individuals the colour fades to brown. Males often settle on river beaches or sunlit forest trails to imbibe moisture.

RIGHT TOP Mercurial Skipper, *Theagenes albiplaga*, San Ramon, Peru.
RIGHT MIDDLE Squared Bent-Skipper, *Helias cama*, Rio Claro, Colombia.
RIGHT BOTTOM Möschler's Bent-Skipper, *Cycloglypha enega*, Rio Claro, Colombia.

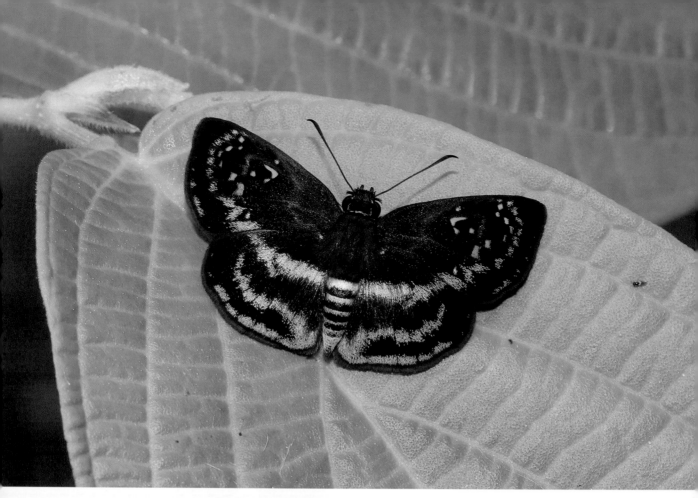

Achlyodidini

All members of this tribe are native to the Neotropics, with only two species reaching the southern states of the USA. The Achlyodidini includes 15 genera. Some, such as *Charidia*, *Paramimus* and *Milanion*, are blackish-brown, with large white spots on the forewings and white bands on the hindwings. Others, including *Pythonides*, *Gindanes* and *Quadrus*, have hyaline windows in the forewings and suffused pale bluish areas on the under surface of the hindwings. In many of the *Pythonides* and *Quadrus* species there are also blue bands on the upperside hindwings. Another species that features metallic blue markings is the Sapphire Spreadwing, *Ouleus narycus*.

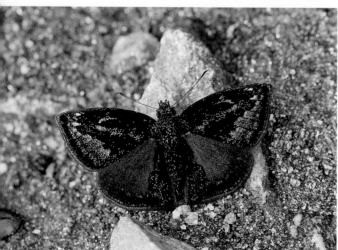

TOP Blue-banded Spreadwing, *Quadrus contubernalis*, Tatama NP, Colombia.

BOTTOM Sapphire Spreadwing, *Ouleus narycus*, Rio Kosnipata, Peru.

Southern Sicklewing, *Eantis thraso*, Rio Shima, Peru.

One of the most attractive species is the Orange-spotted Skipper, *Atarnes sallei*, a distinctive white and brown butterfly with an orange spot on the inner margin of the forewing. A particularly intriguing species is the Lipstick Skipper, *Haemeactis sanguinalis*, which, as its name implies, has bright red markings that are a perfect simulation of a lipstick mark.

The *Aethilla*, *Eantis* and *Achlyodes* species are larger than other members of the tribe, and different in appearance. When at rest, the tips of their forewings are usually angled downwards, helping to create the illusion of a dead twisted leaf.

The Golden Batwing, *Achlyodes pallida*, is distributed from Mexico to Bolivia. It is a common species, found at elevations between about 200–1,600m (655–5,250ft) in disturbed forest-edge habitats.

The genus *Zera* is comprised of 10 species. Most occur in Central America or in the northern part of South America, although one species, *Z.nolkeni*, can be found as far south as Bolivia. Most members of the genus are very similar in appearance, but can be distinguished by examining the underside hindwings, which have suffused patches of white, pale blue, yellow or brown, according to species. There are also minor differences in the configuration of the hyaline spots on the forewings.

ABOVE Golden Batwing, *Achlyodes pallida*, San Ramon, Peru.

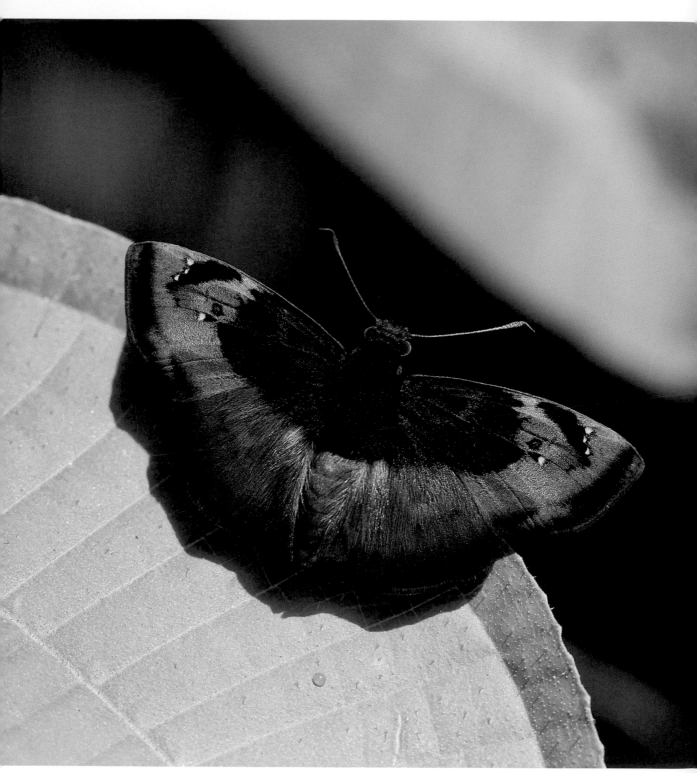

Hosta Spreadwing, *Zera hosta*, Medellin, Colombia.

Tagiadini

Some of the 27 genera in the Tagiadini, including the *Eagris* Flats, *Abantis* Paradise Skippers, *Netrobalane* Buff-tips and *Leucochitonea* White-cloaked Skippers, are found only in Africa. The bulk, however, are native to the Oriental region, where 18 genera occur, including *Chamunda*, *Coladenia*, *Caprona*, *Gerosis*, *Mooreana*, *Odina*, *Odontoptilum*, *Pintara* and *Seseria*. The most widespread genus is *Tagiades*. It contains 17 species, distributed across Africa, the Oriental region and Australia.

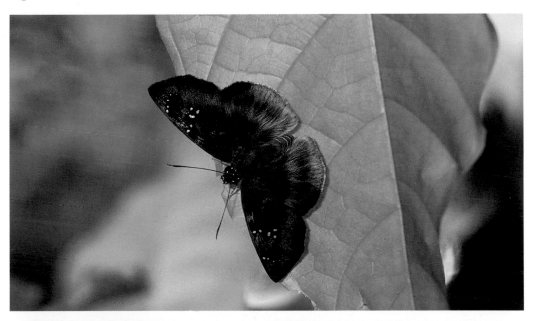

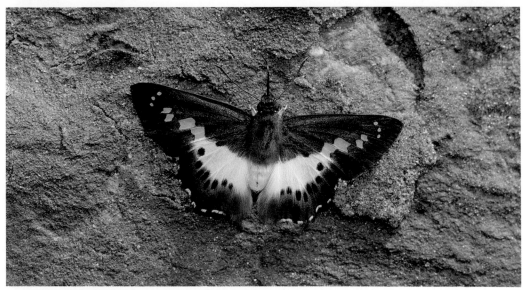

TOP Clouded Flat, *Tagiades flesus*, Lipke hills, Ghana.

BOTTOM Himalayan Snow Flat, *Seseria dohertyi*, Sikkim, India.

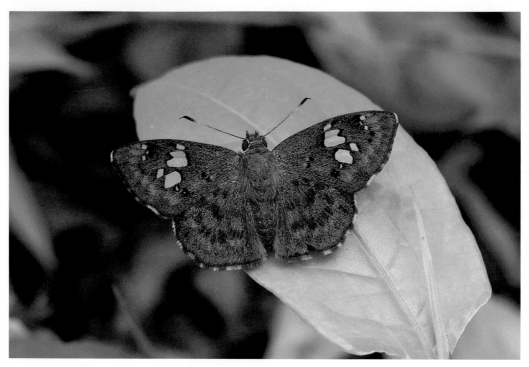

Fulvous Pied Flat, *Pseudocoladenia dan*, Manas NP, Assam, India.

Celaenorrhini

This tribe is composed of seven genera, of which *Alenia*, *Katreus*, *Loxolexis* and *Eretis* are all native to Africa. *Pseudocoladenia* and *Sarangesa* were both formerly included in the Tagiadini, but are now known to have descended from a different lineage. The *Pseudocoladenia* Pied Flats are native to the Oriental region, while the *Sarangesa* Elfins are represented in Africa and on the Indian subcontinent.

The largest genus is *Celaenorrhinus*. Most of its 120 species are found in the Old World tropics – 45 in Africa and 50 in the Oriental region. The remaining 25 are native to Central or South America. The forewings of most species are marked with a broken semi-transparent diagonal band.

The commonest African species is the Orange Sprite, *Celaenorrhinus galenus*, which is distributed from Senegal to Cameroon. It is an extremely active insect, whizzing around bushes at phenomenal velocities before suddenly disappearing beneath a leaf as if playing hide-and-seek. Males in particular are incredibly alert, shooting out instantly from their hideaways to chase after passing insects. Encounters with fellow males invariably result in ferocious high-speed aerial battles that can last for several minutes. After each sortie, the winner of the battle refuels on nectar for a few moments and then dashes back under another leaf, instantly flipping upside down and facing outwards ready for the next intruder. A true master of high-speed aerobatics.

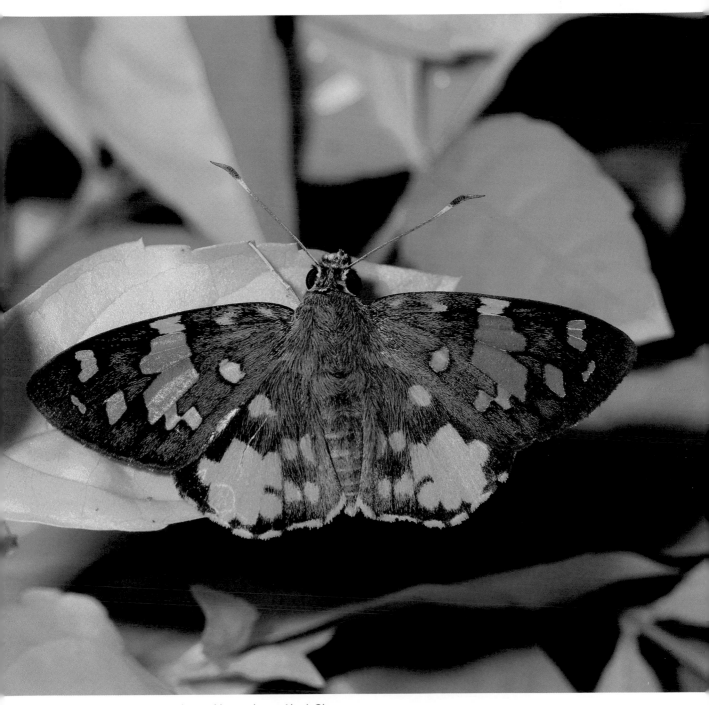

Orange Sprite, *Celaenorrhinus galenus*, Aburi, Ghana.

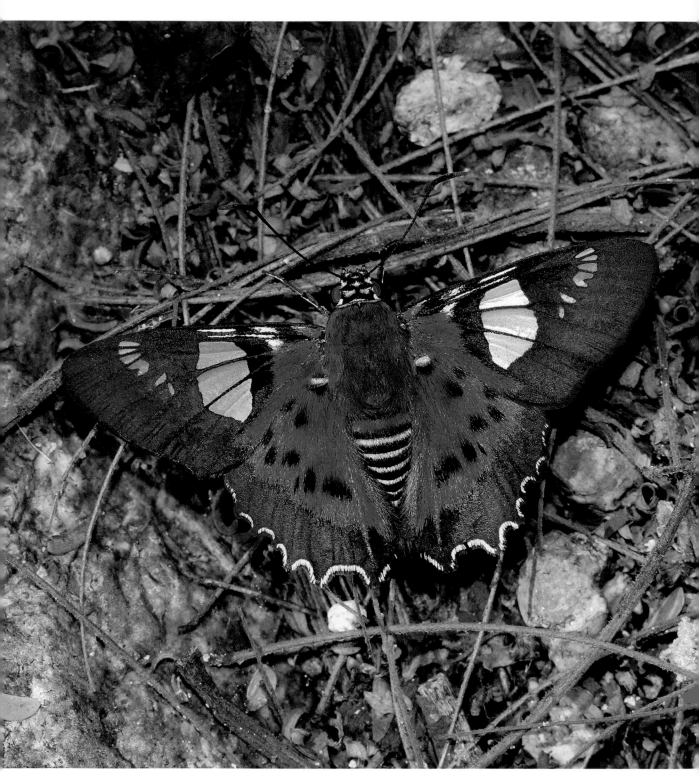

Pardalina Glory, *Myscelus pardalina*, San Ramon, Peru.

Pyrrhopygini

There are about 130 species in this tribe, divided among 27 genera. Collectively, they are known as Firetips on account of the red-tipped abdomens found in many species, particularly in the genus *Pyrrhopyge*. Most members of this genus have black wings, usually with a bluish sheen and white fringes, although some, such as *P.telassina* and *P.telassa* are bronzy with orange fringes.

TOP Telassa Firetip, *Pyrrhopyge telassa*, Rio Kosnipata, Peru.
BOTTOM Sejanus Firetip, *Mysarbia sejanus*, Rio Cristalino, Brazil.

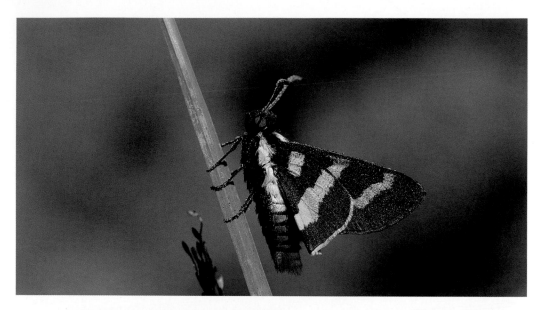

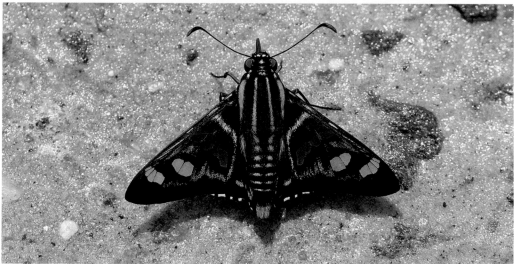

TOP Itatiaia Firetip, *Sarbia damippe*, Itatiaia, Brazil.

BOTTOM Versicolor Firetip, *Mimoniades versicolor*, Serra da Bocaina, Brazil.

The Atlantic coast rainforests of south-east Brazil have long been isolated from the Amazon, and have thus evolved many endemic species. Among these is the very attractive black and yellow Itatiaia Firetip, *Sarbia damippe*, which rockets back and forth across forest glades on hot sunny days. At dusk it settles to roost on grass stems in sheltered areas, and it can be found covered in dew early the next morning.

Another stunning butterfly found in the Atlantic rainforests is the huge Versicolor Firetip, *Mimoniades versicolor*. Males of this spectacular multi-coloured species can be found imbibing moisture from damp ground near rivers. Females are observed less often, but can sometimes be seen nectaring at *Eupatorium* flowers.

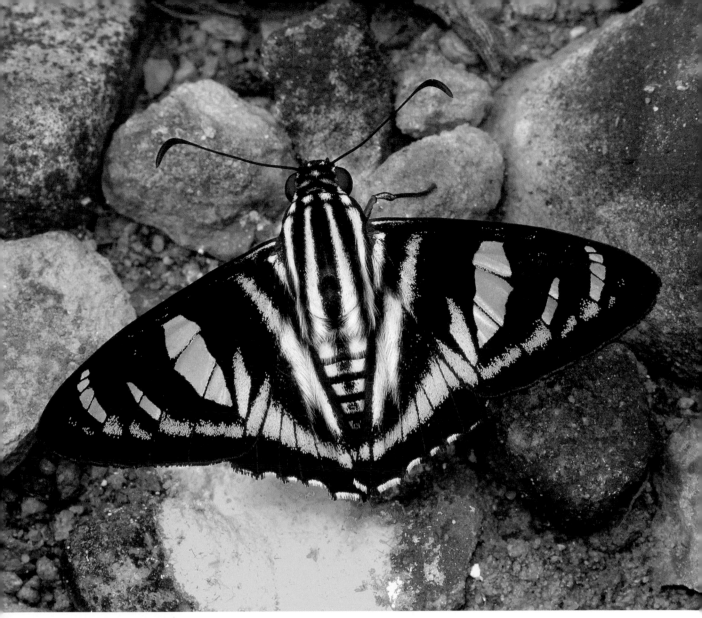

Dot-collared Sabre-wing, *Jemadia pseudognetus*, Rio Shima, Peru.

Most *Elbella*, *Parelbella* and *Jemadia* species have blue-striped thoraxes and blue-banded abdomens without red tips. Their black wings have a strong blue sheen and are beautifully marked with diagonal hyaline bands and striking metallic blue stripes.

Males of the very attractive Dot-collared Sabre-wing, *Jemadia pseudognetus*, can often be found in groups of three or four, imbibing moisture on sandbanks. They tend to settle in semi-shaded spots near the river's edge. Once settled and feeding they are reluctant to move, but they are capable of erupting into the air with incredible speed, charging about in short rapid bursts, circling and weaving around treetops so quickly that they are impossible to follow by eye.

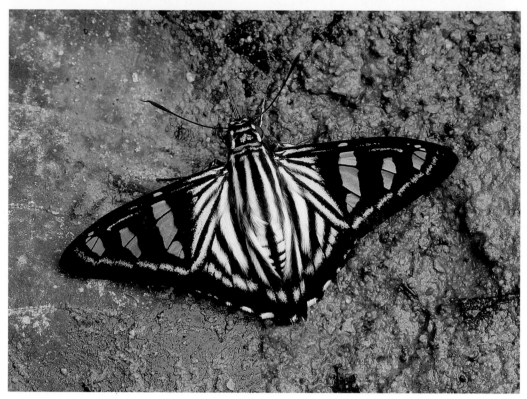

Bell's Paradise Skipper, *Phocides metrodorus*, Catarata Bayoz, Peru.

EUDAMINAE

The Eudaminae were formerly regarded as a tribe of the Pyrginae, but taxonomic revision has now elevated them to subfamily status. There are about 410 species and between 55 and 63 genera. The exact number is subject to conjecture, as the taxonomy of many is unresolved. Until such time as this is settled, I am treating all as being members of a single tribe Eudamini.

Eudamini

Almost all genera of the Eudamini are Neotropical in distribution, although a few extend their range into North America. One puzzling genus is *Lobocla*, which only occurs in eastern Asia, presumably having arrived there via the Bering land bridge that once joined Alaska to Asia.

Many species are superficially similar to the Pyrrhopyginae, being dark in colour, with prominent hyaline windows. The 23 *Phocides* species for example, are similar to *Jemadia*, but with the metallic blue stripes radiating from the base of the wings, rather than running vertically.

Other interesting genera include *Phanus*, which have distinctive transparent streaks across their wings; *Phareus*, which have brilliant metallic blue uppersides but are bright yellow underneath; and *Entheus*, which are brown with conspicuous yellow or orange bands. The bright yellow day-flying males of *Cabiris* are Batesian mimics of noxious pericopine and dioptine moths. Females, however, are predominantly white and appear to be members of

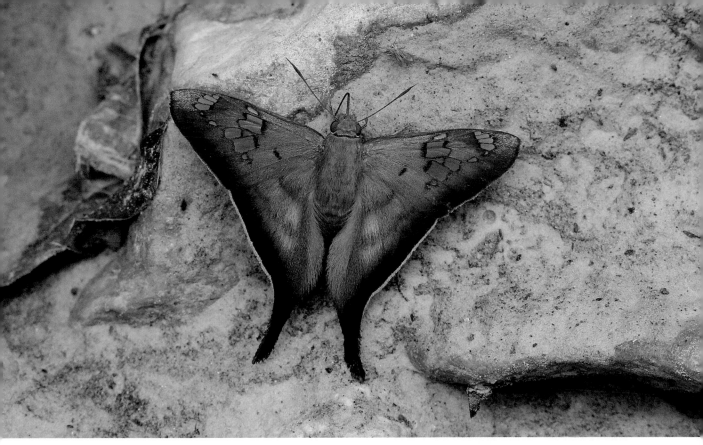

Gyges Longtail, *Polythrix gyges*, Rio Shima, Peru.

a mimicry complex that includes several geometrid moths and ithomiine butterflies.

Several of the Eudamini genera are crepusular in behaviour, for example *Porphyrogenes, Bungalotis, Sarmientoia, Dyscophellus* and *Nascus*. These large moth-like insects have a very fast erratic flight, whizzing low over the ground at dusk. Often four or five species can be found together imbibing fluids from dung, or from urine-tainted patches of soil on forest tracks. During the daytime they hide under leaves, always keeping their wings fully outspread.

There are several genera of long-tailed skippers including *Urbanus, Chioides, Polythrix, Typhedanus* and *Aguna*. Together they total about 95 species. Most of them are only active in bright sunshine, but *Polythrix* fly mainly at dawn.

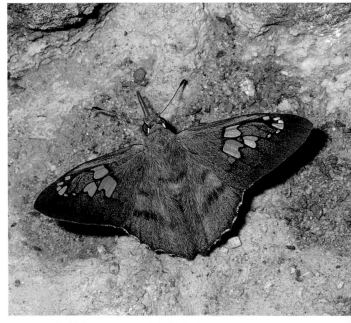

Cramer's Nightfighter, *Nascus phocus*, Satipo, Peru.

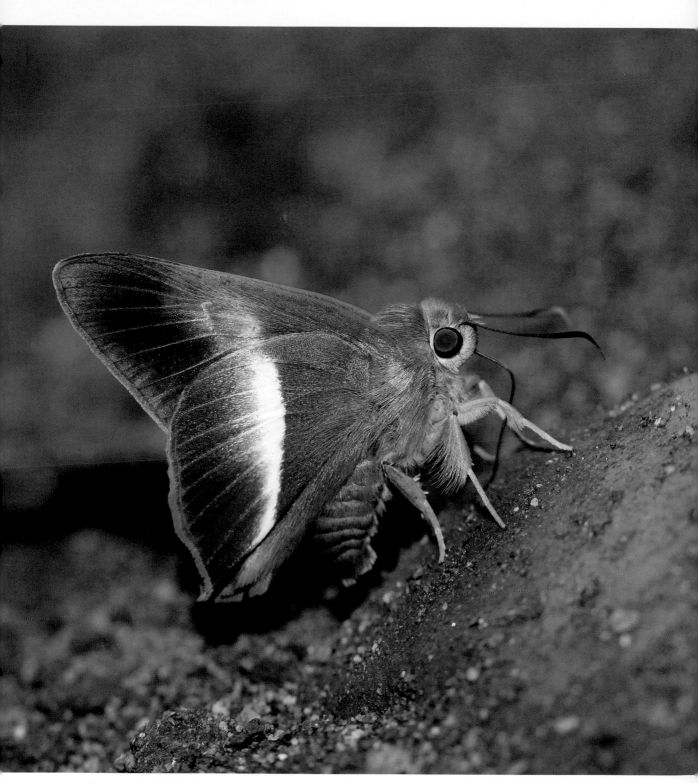

Orange-tail Awl, *Bibasis sena*, Ultapani, Assam, India.

COELIADINAE

This subfamily consists of about 150 species, all of which are restricted to the Old World tropics. There are eight genera – *Coeliades*, *Pyrrhiades* and *Pyrrhochalcia* from Africa; *Choaspes* and *Bibasis* from South-East Asia; *Allora* from the Australian/Papuan region; and *Badamia* and *Hasora* which both occur from India to Australia. The butterflies are primarily inhabitants of lowland rainforest, although *Hasora* occur at elevations as high as 2,000m (6,560ft) in Malaysia.

The Coeliadinae are popularly known as Awls or Policemen. They are the most basal of the skippers, distinguished by their palpi in which the second segment is erect and heavily scaled, while the third segment is narrow, devoid of scales and projects out in front of the face like a tiny prong. The adults vary in size, with wingspans of between about 25–50mm (1–2in). The wings are generally brown or olivaceous in colour, although many species have a metallic green, blue or purplish sheen. The tornus of the hindwing is extended to form a lobe.

Awls and Policemen are extremely rapid and aerobatic on the wing. Their flight is almost impossible to follow by eye. When they settle to feed, it is often only for a second or two, after which they instantly rocket into the air, hurtling around the vicinity before returning, moments later, to their original feeding spot.

The colourful larvae feed on a wide variety of trees and bushes including Moraceae, Combretaceae, Euphorbiaceae, Malpighiaceae, Fabaceae, Malvaceae, Connaraceae and Barringtoniaceae. Most are yellowish with a dark dorsal stripe and black rings around each segment. The head, according to species, can be either yellow or red, marked with black stripes or spots.

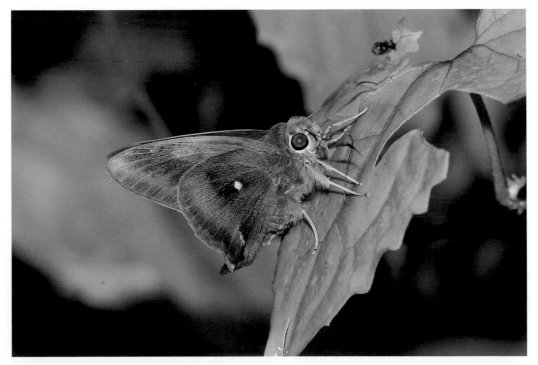

Common Awl, *Hasora badra*, Ultapani, Assam, India.

EUSCHEMONIINAE

This subfamily contains a single species, the Regent Skipper, *Euschemon rafflesia*. In this unique butterfly, males possess a frenulum – a wing-coupling spine on the hindwing that engages with a hook on the forewing called a retinaculum. This structure is absent from *E.rafflesia* females and from both sexes of all other known butterflies, but is present in most moths.

The Regent Skipper is endemic to the rainforests of eastern Australia. It measures about 50mm (2in) across and has jet black wings with bright yellow patches. Its body is black with yellow bands, while its abdomen is tipped in bright red. The antennae are proportionately the longest of any butterfly species, reaching almost to the wing tips.

HESPERIINAE

The Hesperiinae are represented in all regions of the world. There are over 2,100 known species. Following recent revision, these are now split into nine tribes, namely Aeromachini, Anthoptini, Baorini, Calpodini, Erionotini, Hesperiini, Moncini, Taractrocerini and Thymelicini. The greatest diversity occurs in the Neotropics, home to at least 1,040 species. A high percentage of them are found in grassy habitats, but there are also many that only occur in rainforests.

The butterflies are generally known as Grass Skippers because their larvae feed primarily on grasses, bamboos, sedges, gingers and other monocotyledons. The eggs are laid singly or in strings of up to a dozen, on the leaves, stems or sheaths of the foodplants. The larvae are crepuscular or nocturnal and live solitarily, hiding during the day within a shelter made by rolling a leaf into a tube; or by gathering together a few grass blades and fastening them with silk.

Calpodini

This tribe is comprised of 33 genera, all native to the Neotropical region. They are small to medium-sized butterflies, with wingspans varying from about 30mm (1.2in) in *Panoquina*, to about 55mm (2.2in) in *Saliana*. Most genera have a pattern of semi-hyaline spots on the forewings, although these are greatly reduced in *Panoquina* and absent in *Aroma*. In the latter genus, the wings are dark chocolate brown, with iridescent blue-turquoise scales at the base of the wings and on the thorax.

Thracides are similar but with hyaline spots. Some species have a red-tipped body, reminiscent of the Pyrrhopyginae. *Lychnuchus*, *Nyctus* and *Megaleas* have orange bands on the forewings. *Sacrator* have orange markings on the hindwings as well. Most genera are diurnal, but some, such as *Tisias*, *Tromba*, *Synale* and *Carystus*, fly at dusk. These crepuscular species have red eyes and are commonly known as Ruby-eyes, a term that is also applied to other red-eyed species from other tribes.

One of the most familiar genera to those exploring dark rainforest trails is *Saliana*. The underside hindwings of most species have a distinctive pale basal area and a pair of hyaline spots within the darker outer area of the wings. The butterflies are noted for their extremely long proboscises which enable them to probe into deep-throated flowers for nectar. Males also visit bird droppings, a source of important alkaloids. When attending excrement, they adopt

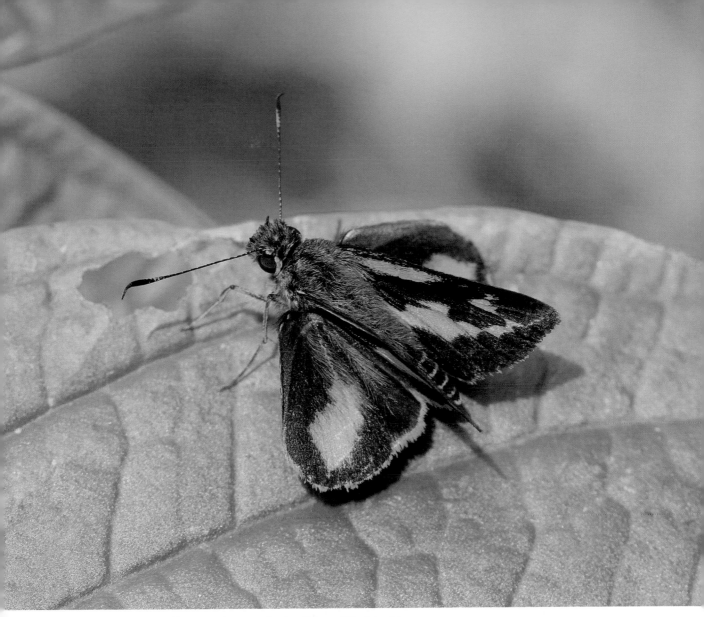

Male Trailside Skipper, *Anthoptus epictetus*, Tatama NP, Colombia.

a characteristic feeding posture, positioned over the pabulum, with the long proboscis curved back underneath the body to reach it.

Anthoptini

This is another exclusively Neotropical tribe. It contains about 55 species within 8 genera. All are small butterflies, measuring about 25–30mm (1–1.2in) across the wings.

The Trailside Skipper, *Anthoptus epictetus*, is sexually dimorphic. The female is dull brown on both wing surfaces. The male is marked with yellow streaks on the upperside, but has a straw-coloured underside. The butterfly is widespread and abundant in the Neotropical region, occuring in all grassy habitats between sea level and at least 1,700m (5,580ft) elevation.

Delicate Skipper, *Apaustus gracilis*, Tatama NP, Colombia.

Moncini

The Moncini contains no less than 500 species within 80 genera. Most are native to the Neotropical region, although a few *Lerodea* and *Nastra* species extend their ranges into North America. There are also a handful of *Amblyscirtes* species that are endemic to the southern states of the USA.

Most members of the tribe are plain, dull brown butterflies; although some genera including *Lento* and *Zariaspes* have bright yellow markings on their uppersides. Many of the *Pheraeus*, *Artines*, *Monca*, *Nastra*, *Cymaenes* and *Vettius* species have a pattern of small hyaline spots on the forewings, similar to those found in Calpodini. The configuration of these spots is distinctive for each genus, making them a useful identification characteristic.

There are several Moncini genera in which the veins on the undersides are picked out in a contrasting paler shade. These include *Callimormus*, *Lento*, *Flacilla*, *Peba*, *Ludens*, *Parphorus*, *Phlebodes*, *Radiatus*, *Venas*, *Virga*, *Vehilius* and *Apaustus*. The Delicate Skipper, *Apaustus gracilis*, is one of the most familiar, occuring commonly in grassy habitats from Nicaragua to Peru.

Large Skipper, *Ochlodes sylvanus*, Frankfurt, Germany.

Hesperiini

The Hesperiini are known as Branded Grass Skippers because the males of all species have a prominent black diagonal 'sex brand' of androconial scales on their forewings. This tribe is in urgent need of revision. Only two genera are currently assigned to it – *Ochlodes* and *Hesperia* – but others are likely to be included as phylogenetic studies progress.

The Large Skipper, *Ochlodes sylvanus*, is found throughout Europe and temperate Asia. It can be found in almost any grassy habitat but favours damp sunny spots such as woodland glades, humid heaths, hay meadows and riversides. In common with the Anthoptini and Thymelicini, the Hesperiini adopt a characteristic posture when basking, with the forewings raised at an angle of 45° and the hindwings held flat.

Large White-spots Skipper, *Osmodes laronia*, Bobiri, Ghana.

Aeromachini and Erionotini

The Aeromachini consists of about 40 Oriental genera including *Aeromachus*, *Ampittia*, *Erionota*, *Gangara*, *Iambrix*, *Matapa*, *Notocrypta*, *Pyroneura* and *Psolos*. Some taxonomists also include the African genera *Acada*, *Acleros*, *Andronymus*, *Ceratrichia*, *Chondrolepis*, *Fresna*, *Kedestes*, *Osmodes*, *Paracleros*, *Parosmodes*, *Pteroteinon* and *Zophopetes* in the Aeromachini, while others place them in the Erionotini.

The Large White-spots, *Osmodes laronia*, is a widespread species found from Liberia to Kenya. It is often seen nectaring at flowers or basking on bushes in forested habitats.

The Blue Red-eye, *Pteroteinon laufella*, from West Africa is a particularly interesting butterfly. Its main period of activity begins at dusk, when it can be seen whizzing about in forest glades like a tiny hawkmoth. It searches until it finds an *Ipomoea* plant, whereupon it crawls deep inside the pink trumpet-like flower to reach the nectaries. It remains inside until the petals close around it, providing it with a safe haven for the night. At daybreak, the flowers reopen and the butterfly flies out to seek a hiding place in the shade of the forest.

Thymelicini

These butterflies are known as Skipperlings in North America, denoting that they are among the smallest members of the Skipper family. Genera currently placed here include the 11 Holarctic *Thymelicus* species and the Nearctic *Copaeodes* and *Oarisma* Skipperlings. Taxonomic revision will undoubtedly lead to further genera being transferred to the Thymelicini. At this point in time the exact number of species in the tribe is unknown because many that should probably be placed in it are temporarily assigned to the *incertae sedis* group.

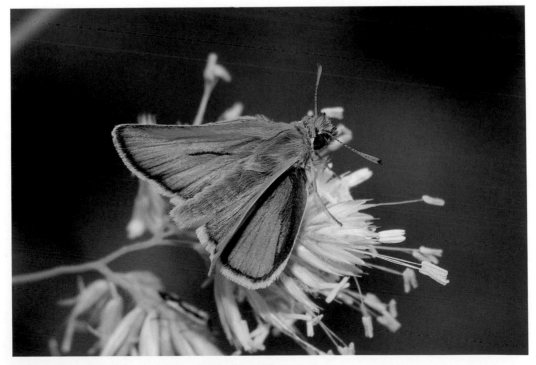

Small Skipper, *Thymelicus sylvestris*, Wiltshire, England.

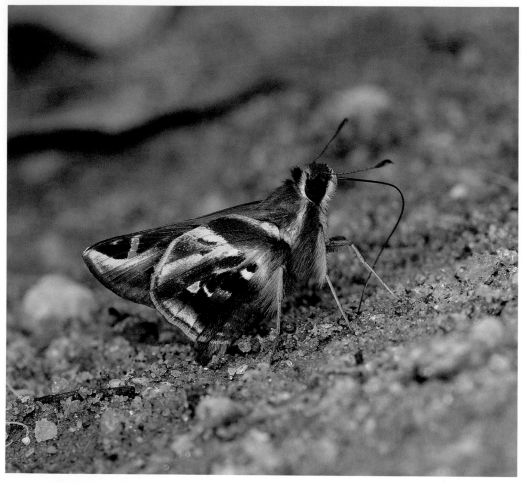

Ethemides Skipper, *Thespeius ethemides*, Serra da Bocaina, Brazil.

INCERTAE SEDIS

Currently there are about 200 genera which have not yet been assigned to any tribe. These are temporarily placed in the 'convenience' category *incertae sedis* – a term meaning 'of uncertain status.'

One of the largest genera among this group is *Thespeius*. It contains 32 species, distributed across Central and South America. The genus is easily recognised from the distinctive underside markings. Another giveaway is the androconial brand on the forewings, which, in most species, is edged in white. *Thespeius* are extremely fast-flying butterflies, darting incessantly from place to place. Males often settle on damp ground to imbibe dissolved minerals, but are always extremely alert, dashing off at the slightest disturbance. Likewise, females dash from flower to flower and are almost impossible to track by eye. The illustrated species, *Thespeius ethemides*, is found in cloud forests in Argentina, Paraguay and south-east Brazil, at elevations between about 600–1,400m (1,970–4,595ft).

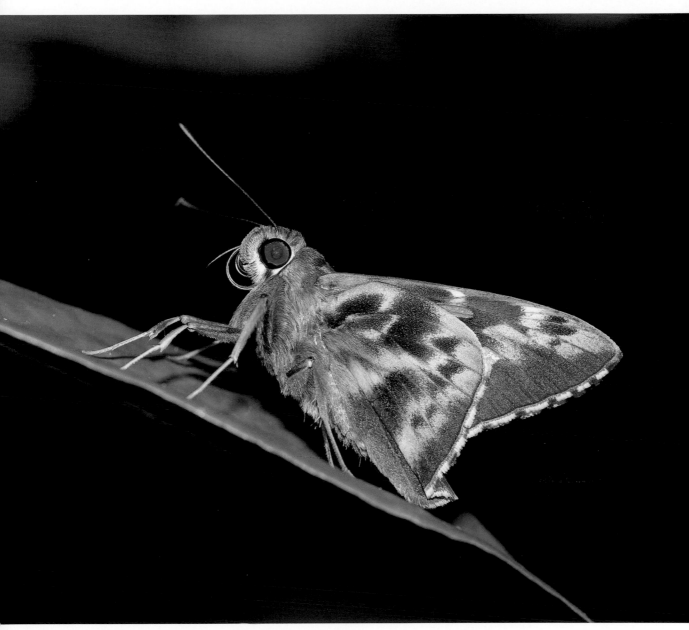

Evans' Ruby-eye, *Perichares aurina*, Rio de Janeiro, Brazil.

There are 16 *Perichares* species, occurring variously from Mexico to Paraguay and south-east Brazil. In this genus the forewings have three or four conspicuous transparent windows, although the configuration varies according to species. The undersides of the wings are dark brown, marked with suffused paler areas, giving the butterflies a silky or satin-like appearance. The ruby-coloured eyes of *Perichares aurina* are a common feature of crepuscular skippers. Evans' Ruby-eye, *Perichares aurina*, is known only from southern Brazil and Paraguay.

TRAPEZITINAE

The subfamily Trapezitinae contains 69 species in 16 genera. They occur only in Australia and New Guinea, where they are found in a diverse range of habitats, including heathlands, grasslands, *Eucalyptus* forest, cliff faces, coastal sand dunes, swamps and temperate rainforests.

The adults are superficially similar to hesperiines, but can be distinguished from them by the venation on the hindwings. In Trapezitinae, the discocellular veins are directed towards the apex, but in Hesperiinae and other Skipper subfamilies they are either vertical or directed towards the base of the wings.

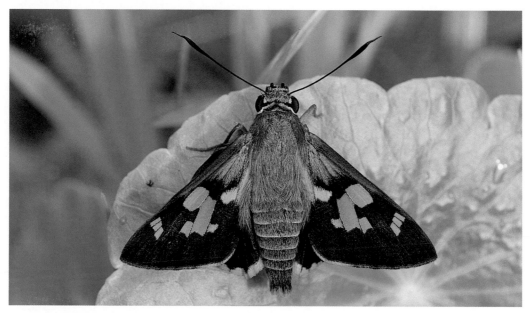

Splendid Ochre, *Trapezites symmomus*, New South Wales, Australia.

The females lay their eggs singly on a wide variety of monocotyledons, including *Patersonia* irises, *Gahnia* sword-grasses, *Lomandra* mat-rushes, *Carex* and *Cyperus* sedges, *Heteropogon* tangleheads, *Triodia* spinifexes and various grasses. The larvae are green or straw-coloured, with narrow stripes along the back and sides. They feed at night, resting during daylight hours within a shelter made by silking together leaves of the foodplant.

MEGATHYMINAE

This small group, known as the Giant Skippers, consists of about 18 species found in the USA and Central America, where they inhabit dry woodland, arid scrubland and deserts. As their common name suggests, they are among the largest of the Skippers, measuring between 45–75mm (1.8–3in) in wingspan. The wings are heavily scaled and dark brown in colour, with suffused yellow or orange markings. Unlike members of other Skipper subfamilies, their antennae are not hooked, but end in a substantial pointed club.

The eggs of *Megathymus* and *Stallingsia* are laid singly or in loose groups of three or four on the leaves of the larval foodplant *Yucca*, while those of *Agathymus* are dropped loosely into *Agave* clumps. The larva of *Megathymus yuccae* is bright red when newly hatched, but later becomes straw-coloured and grub-like in appearance. Like all members of the subfamily, it spends the entire larval period inside silk-lined tunnels within the leaves or stems of the foodplant. When fully grown it exits the plant through the stem or roots, and pupates within a tent constructed from soil, leaf fragments and silk at the centre of the plant.

HETEROPTERINAE

There are approximately 150 species in the Heteropterinae. The 16 genera include the *Carterocephalus* Skippers, which are found in damp grassy areas across most of the Holarctic region; the very attractive *Metisella* Sylphs from the forests and grasslands of central Africa; and *Hovala* which are endemic to Madagascar.

The largest genus is *Dalla*. The 96 species, known collectively as Gold-spots, are native to the cloud forests of Central America and the Andes. Males can often be found at damp patches on forest roads, constantly reimbibing moisture to filter-feed on dissolved minerals.

Hayward's Gold-spot, *Dalla spica livia*, Rio Kosnipata, Peru.

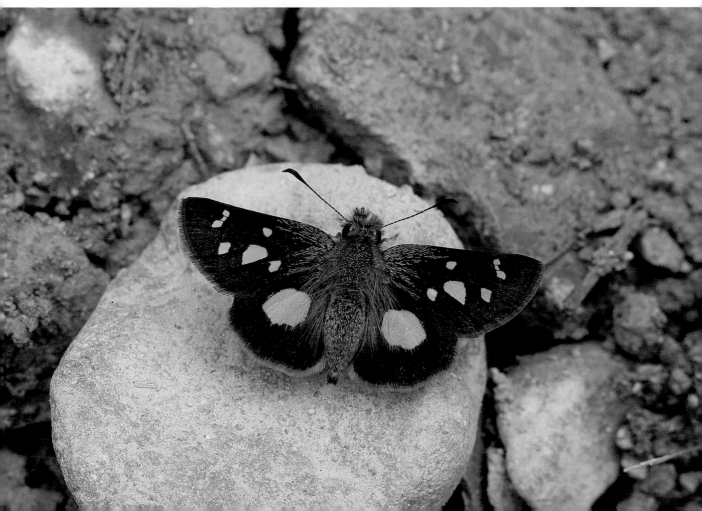

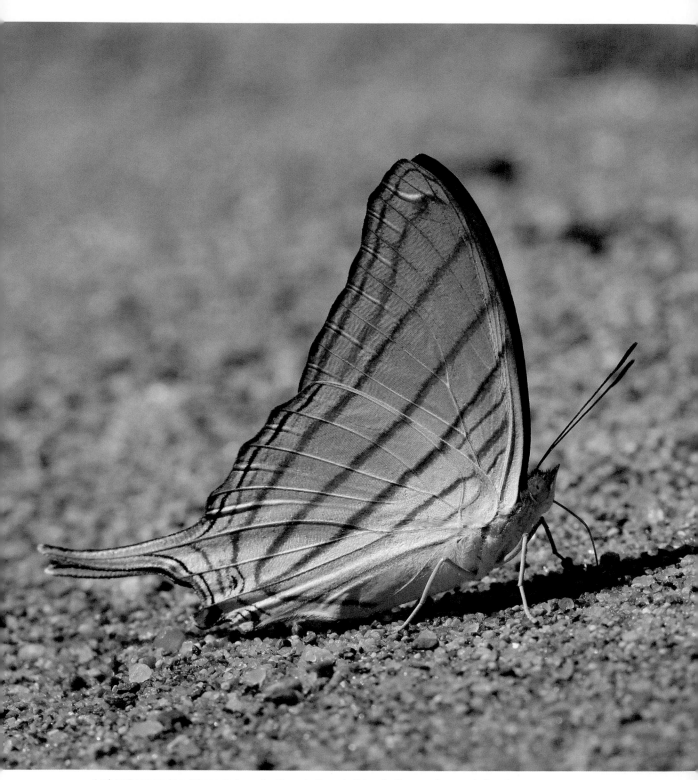

Amber Daggerwing, *Marpesia berania*, Peru. In Nymphalidae, both sexes have only four legs.

NYMPHALIDAE

The Nymphalidae is the largest butterfly family, with 542 genera encompassing just under 6,000 species worldwide. Many of its constituent taxonomic groups were formerly regarded as distinct families, but in recognition of the close relationship between them they are now consolidated under the Nymphalidae. The 12 currently recognised subfamilies are Apaturinae, Biblidinae, Calinaginae, Charaxinae, Cyrestinae, Danainae, Heliconiinae, Libytheinae, Limenitidinae, Morphinae, Nymphalinae and Satyrinae.

The single feature that unites these subfamilies is the fact that the forelegs of both sexes are non-functional for walking, being reduced to brush-like stumps, hence the butterflies are popularly known as brush-foots. The forelegs of females have four tarsal joints, while those of males have only two tarsal joints. The venation of the hindwings is variable, particularly in the Ithomiini, but in all Nymphalid genera the forewings have 12 veins.

APATURINAE

The Apaturinae are collectively known as Emperors. There are about 90 species within 20 genera worldwide. Most are largish butterflies measuring from about 60–100mm (2.4–4in) in wingspan. They are powerful flyers, capable of impressive high speed aerobatics. Females generally obtain their sustenance from chemicals passed to them by males during copulation. Males regularly settle on forest tracks to imbibe mineralised moisture. They also feed at various sources of organic fluids including carrion, rotting fruit, tree sap and carnivore dung.

Males of *Apatura* and *Doxocopa* are dark brown, often banded with white, but the underlying pigments are largely obscured by iridescent turquoise, purple or blue scales. Females of *Apatura* are similar to the males but lack the iridescence. *Doxocopa* females have a white and orange band across their wings, and strongly resemble *Adelpha* species.

Males of the Eastern Courtier, *Sephisa chandra*, from India are totally devoid of any iridescence. Nevertheless, they are among the most magnificent butterflies in the Oriental region, patterned in black, orange and white.

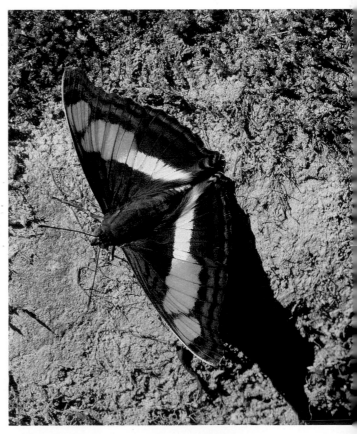

Immaculate Emperor, *Doxocopa laure griseldis*, Rio Shima, Peru.

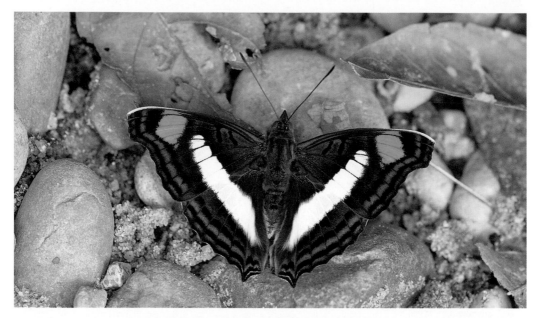

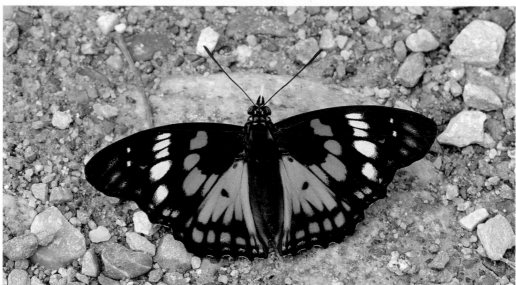

TOP Linda's Emperor, *Doxocopa linda*, Boca Colorado, Peru.

BOTTOM Eastern Courtier, *Sephisa chandra*, Ultapani, Assam, India.

Females are arguably even more beautiful – their black forewings are marked with blue, pink and white spots; while the hindwings are metallic azure blue with the veins highlighted in black.

Sephisa males visit damp ground to imbibe moisture. They are quite extraordinary in flight, hurtling back and forth along forest tracks at incredible speed, twisting and turning with amazing agility. Oddly, after taking a minute or two to familiarise themselves with human intruders, they become remarkably tolerant, remaining on the ground for long periods and returning repeatedly to the same spot if disturbed.

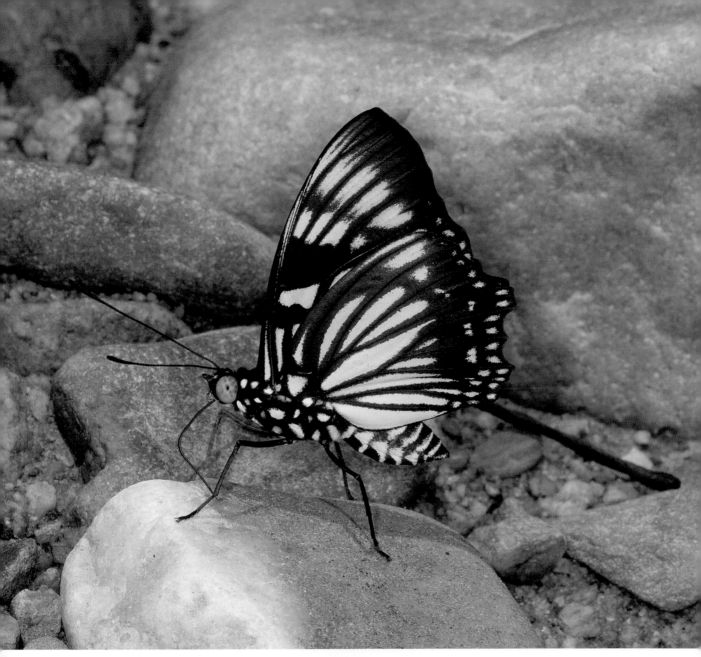

Courtesan, *Euripus nyctelius*, Taman Negara, West Malaysia.

The eggs of Apaturini are generally laid singly on the upper surface of leaves, although *Asterocampa* and *Sasakia* lay in clusters. The foodplants of many species are still unknown, but *Apatura* feed on Salicaceae, *Doxocopa* feed on Ulmaceae and *Euripus* use Cannabaceae. The larvae are cryptically patterned in shades of green and strongly resemble the leaves on which they are found. The pupae are also very leaf-like and are extremely mobile, wriggling like wet fish if touched.

BIBLIDINAE

This subfamily of tropical butterflies contains about 350 species. Until recently all were placed in the tribe Biblidini, which itself was split into seven subtribes. Most of the latter have now been elevated in status to full tribes, but the taxonomy remains in a state of flux.

Biblidini

The Biblidini contains the Afrotropical genera *Neptidopsis*, *Mesoxantha*, *Eurytela* and *Sallya*; the Oriental genus *Laringa*; and the widespread genera *Byblia* and *Ariadne*, which are represented in Africa, India and South-East Asia. As a result of recent taxonomic revision, the only Neotropical species currently remaining in this tribe is the Red Rim, *Biblis hyperia*.

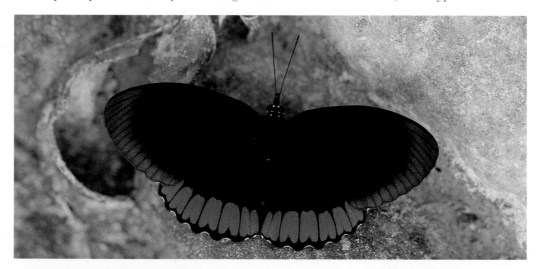

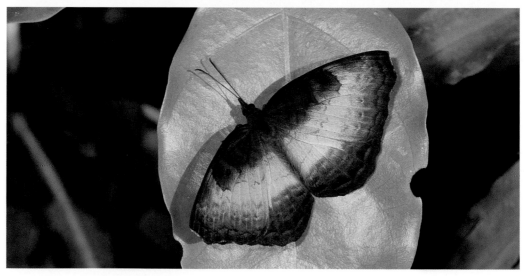

TOP Red Rim, *Biblis hyperia*, Tingo Maria, Peru.
BOTTOM White-banded Castor, *Ariadne albifasciata*, Bobiri, Ghana.

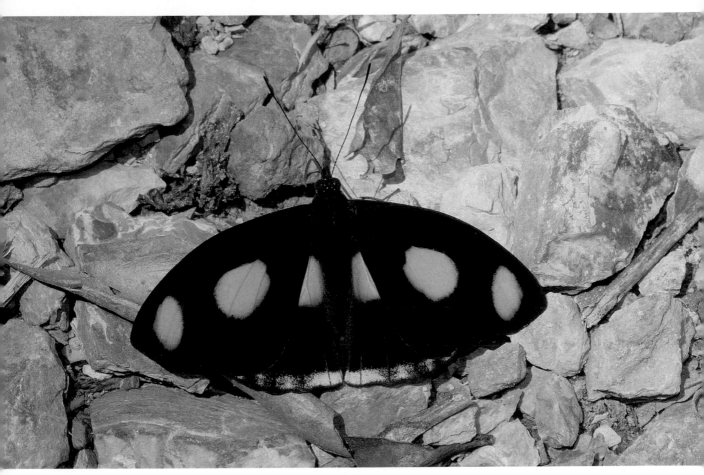

Blue-frosted Banner, *Catonephele numilia*, Tatama NP, Colombia.

Catonephelini

There are six genera in this Neotropical tribe – *Cybdelis*, *Eunica*, *Myscelia*, *Nessaea*, *Sea* and *Catonephele*.

Males of the Blue-frosted Banner, *Catonephele numilia*, are dark brown with luminous orange patches and blue-edged hindwings. Females are very different in appearance, being earthy brown, marked with a large cream patch in the median area of the forewing, and with the basal and submarginal areas of the hindwings deep red.

The genus *Eunica* contains 40 species. They are commonly known as Purplewings due to the purple or blue sheen found on the upperside of most males. A few species lack the iridescence – in *E.carias*, for example, the upper surface is chestnut brown with a suffused golden sheen. The undersides of most species are marbled in shades of brown and possess distinctive ocelli.

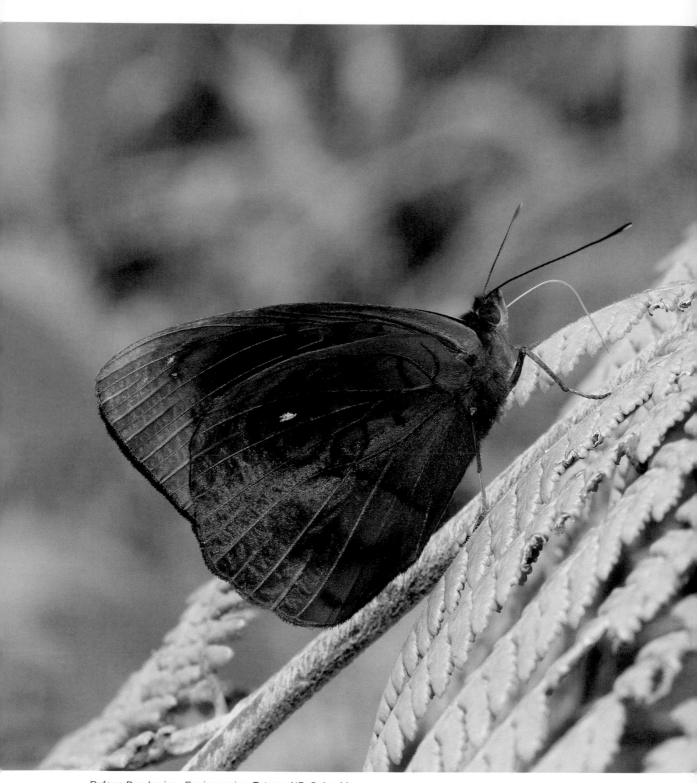

Rufous Purplewing, *Eunica carias*, Tatama NP, Colombia.

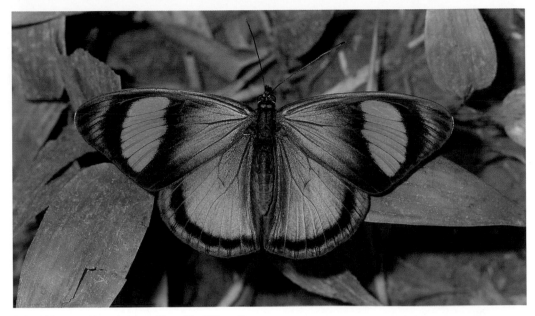

Painted Beauty, *Batesia hypochlora*, Rio Shima, Peru.

Ageroniini

This tribe contains 31 species, assigned to the genera *Batesia*, *Ectima*, *Hamadryas* and *Panacea*. All are entirely Neotropical in distribution.

Hamadryas butterflies habitually bask in a head-downward posture. They are well known for the strange crackling noise made by males during territorial conflicts, hence they are commonly known as Cracker butterflies. Some species, including *H. feronia* and *H. februa*, have beautiful calico-like markings that provide them with very effective camouflage when they bask on tree trunks. Others, including *H. laodamia*, *H. velutina* and *H. belladonna*, have stunning patterns of 'starry night' blue spots on a velvety black ground colour. The undersides vary from species to species, being predominantly white in *H. februa* and *H. atlantis*, dark brown with red spots in *H. laodamia* and *H. velutina*, yellow in *H. fornax* and bright red in *H. amphinome*.

The Red Flasher, *Panacea prola*, is another species featuring a blue upperside and a bright red underside. Males often congregate

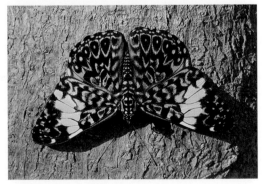

ABOVE TOP Starry Night Cracker, *Hamadryas laodamia*, Pozuzo, Peru.

ABOVE BOTTOM Red Cracker, *Hamadryas amphinome*, Yarinacocha, Peru.

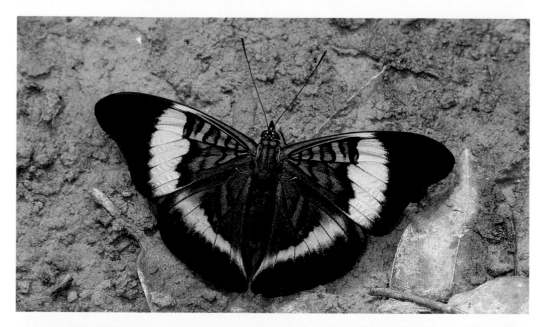

TOP Red Flasher, *Panacea prola*, Junin, Peru.

BOTTOM Red Flasher, *Panacea prola*, Rio Madre de Dios, Peru.

on river beaches in groups of up to 50, basking with wings outstretched. When one individual detects a threat from an approaching bird or animal, it responds by fanning its wings to display its vivid red underside. This acts as a warning signal to its nearby companions, triggering them to flash their own wings. Within two or three seconds, the whole group is alerted to the danger and is poised to fly up into the trees to escape.

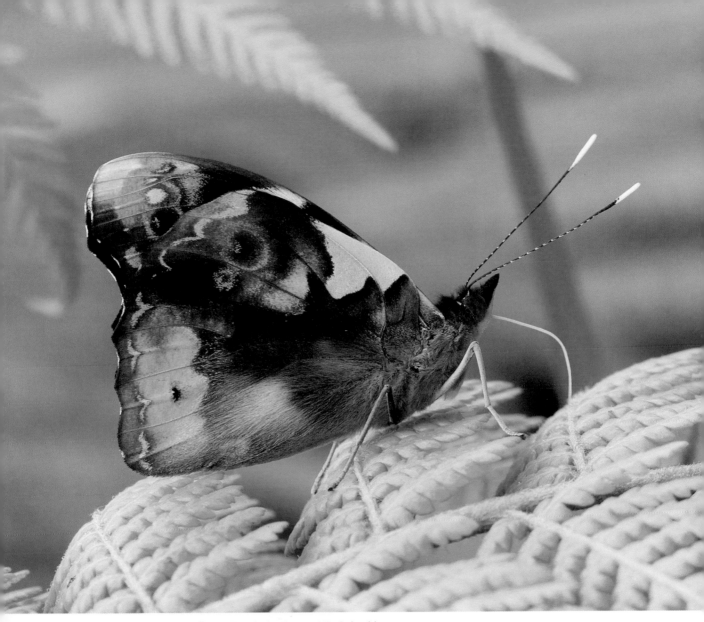

White-striped Banner, *Epiphile eriopis*, Tatama NP, Colombia.

Epiphilini

This tribe includes the genera *Asterope, Bolboneura, Epiphile, Lucinia, Nica, Peria, Pyrrhogyra* and *Temenis.*

The 16 *Epiphile* species are found variously from Mexico to Bolivia. Most have a pattern consisting of bright orange or red bands on a dark brown ground colour. In males of *E.hermosa, E.boliviana* and *E.grandis,* this is overlaid with a faint purplish sheen. The beautiful Colombian Banner, *E.epimenes,* has a blue iridescence that almost completely obscures the underlying colours. In *E.iblis* and *E.orea* the iridescence is confined to large sapphire blue patches on the hindwings. Both sexes of *E.eriopis* and *E.epimenes,* and the females of several other species, feature a diagonal white outer band on the forewings.

TOP White-striped Banner, *Epiphile eriopis*, Tatama NP, Colombia.

BOTTOM Pansy Banner, *Epiphile orea*, Itamonte, Brazil.

The undersides of all *Epiphile* species have a marbled brown leaf-like pattern, with a cream 'tooth' mark on the hindwing costa. The White-striped Banner, *E.eriopis*, is distributed from Nicaragua to Colombia, while the Pansy Banner, *E.orea*, has a more extensive range, being found from Costa Rica to Argentina and south-east Brazil.

Tomato, *Temenis laothoe*, form *violetta*, Rio Madre de Dios, Peru.

The Tomato butterfly, *Temenis laothoe*, is found from Mexico to Bolivia. It occurs in two colour morphs. The most common morph is bright orange in colour, except for the forewing apexes which are dark brown. In Peru, a small percentage of each brood is of the very beautiful *violetta* form, which has bright red forewings and metallic blue hindwings. The butterflies often bask on foliage, logs, fallen branches or tree stumps. Males imbibe mineralised moisture from damp sand on riverbanks, flitting from spot to spot while fanning their wings. This aposematic display warns birds that they are unpalatable – their bodies contain toxins derived from their larval foodplants Sapindaceae.

The undersides of the seven *Asterope* species are metallic greenish-blue, marked with a series of concentric black bands that are broken into dashes or dots. Most have a conspicuous patch of red or orange at the base of the wings. The distinctive white proboscis is common to all species. Females are rarely seen, but males occasionally mud-puddle on river beaches. The least disturbance will cause a feeding male to instantly fly up and settle on foliage about 3m (10ft) above the ground. From this vantage point it surveys its surroundings until any perceived threat has passed. It then makes a reconnaissance flight, circling the vicinity several times at high speed before returning to its original feeding place.

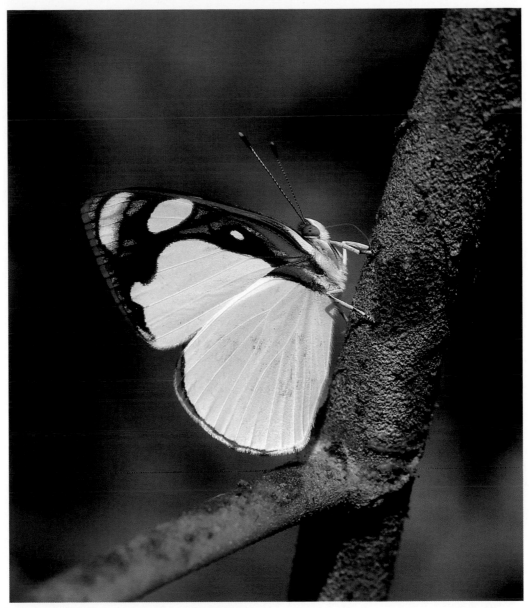

ABOVE White Sailor, *Dynamine coenus*, Rio Perene, Peru.

OPPOSITE Leprieur's Glory, *Asterope leprieuri*, Atalaya, Peru.

Eubagini

The Eubagini is comprised of a single genus *Dynamine*, which contains 40 species. Most have metallic bluish or turquoise uppersides, with a dark apex and a series of suffused white spots. Some species, however, are white with black markings. The undersides in most cases are white, with narrow orange bands on the hindwings. Several species, including *D.dyonis* and *D.postverta*, are also marked with dark ocelli and small patches of metallic blue scales. Males can often be seen imbibing at wet patches on roads, flitting incessantly from place to place.

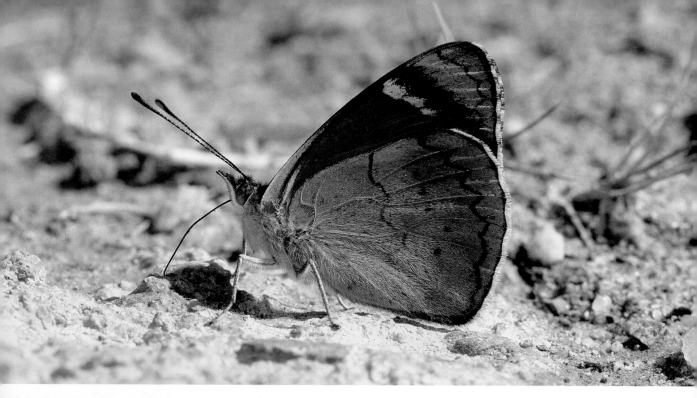

Callicorini

This tribe contains the genera *Antigonis*, *Callicore*, *Catacore*, *Diaethria*, *Haematera*, *Mesotaenia*, *Orophila*, *Paulogramma* and *Perisama*.

There are 32 *Perisama* species, all of which are native to the cloud forests of the Andes. They are medium-sized butterflies with blackish uppersides marked with diagonal bands of metallic green or turquoise on the forewings. Many species also have a band of the same colour around the hindwing-margins. Males spend the early mornings high up in trees, but at about 9am they suddenly become very active, dashing repeatedly back and forth between the treetops and the

TOP Hewitson's Perisama, *Perisama clisithera*, Bosque de Sho'llet, Peru.

MIDDLE Humboldt's Perisama, *Perisama humboldtii*, Tatama NP, Colombia.

BOTTOM Humboldt's Perisama, *Perisama humboldtii*, Tatama NP, Colombia.

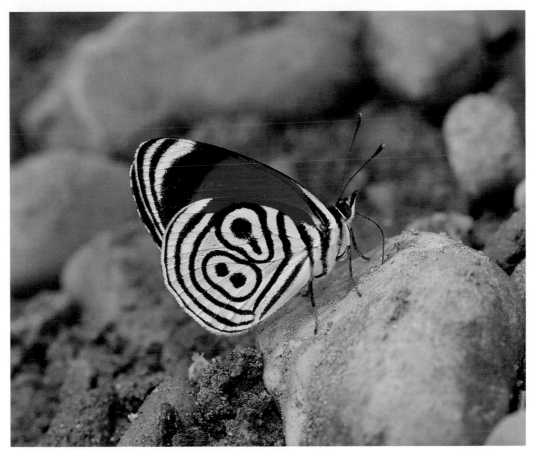

Cramer's '89' butterfly, *Diaethria clymena*, Pantiacolla, Peru.

ground. They usually keep their wings closed while feeding, but in cloudy or hazy conditions they will bask on foliage, or on the ground, with wings outspread.

The genus *Diaethria* is composed of 12 species, characterised by the strange '88' or '89' markings on their undersides. The uppersides are black, marked on the forewings with a diagonal band of metallic blue or green. In some species this colour is repeated on the hindwings in the form of a submarginal band. One of the commonest species is Cramer's '89', *Diaethria clymena*. It is usually seen in twos or threes but males sometimes gather in larger numbers at favoured spots. They are often found in the vicinity of habitations, for example on river banks close to jetties, at places where laundry is washed, at campfire ashes or at urine-tainted patches of ground. When not feeding, they habitually perch on leaves, often facing head downwards, to await passing females.

There are about 20 *Callicore* species. In common with *Diaethria* their undersides bear distinctive and graphic patterns, often resembling numerals or letters of the alphabet. The uppersides of all species are black, with bright red or orange bands on the forewings. In most species the hindwings have a blue sheen, or a large patch of iridescent blue-green scales. *Callicore* larvae are strange-looking creatures – typically green in colour, with three or four yellow bars across the back; and a brown head armed with enormous antlers.

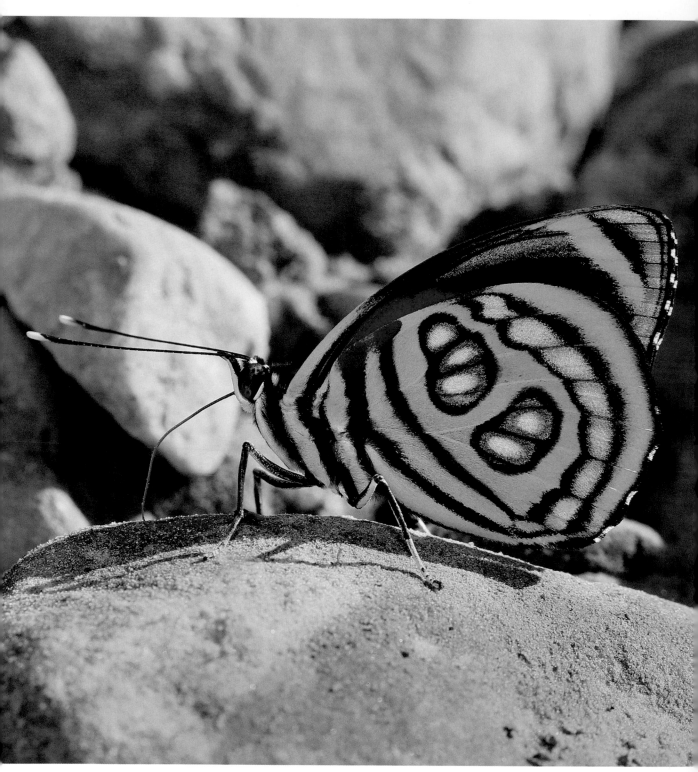

Beautiful Numberwing, *Callicore pygas*, Rio Tambo, Peru.

CALINAGINAE

This is the smallest of the Nymphalidae subfamilies, comprised of 8–10 species found in the temperate and subtropical forests of Assam, Burma, Tibet, Thailand, China, Vietnam, Bhutan and Taiwan.

All members of the Calinaginae are placed in the genus *Calinaga*. The exact number of species is uncertain, as the status of certain taxa is contested. *Calinaga* are largish butterflies, measuring from 85–100mm (3.5–4in) in wingspan. Their wings are thinly scaled and greyish, with suffused white spots and streaks. The costa of the hindwing is very straight. Other characteristic features include reddish hairs on the thorax and very short antennae.

Males can sometimes be found imbibing mineralised moisture from damp ground in forest edge habitats. Females are seen less often, usually when visiting flowering shrubs. They lay their eggs singly on the underside of *Morus* leaves and possibly on other Moraceae. When young, the larva feeds at the tip of a leaf but leaves the central vein intact. It rests on the protruding midrib, where it is less likely to be molested by ants or other predatory insects. When older, it makes a shelter by cutting and folding over a segment of leaf, then securing it with silk. The fully grown larva is a strange looking creature. Its body is green with a dense coat of short stiff yellow setae, while its head is bright red and armed with a pair of large black cactus-like thorny clubs. The pupa can be either green or brown, mottled with darker specks, and looks very much like a seed or nut.

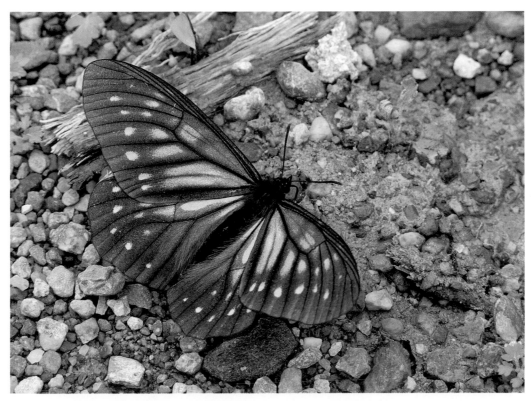

Oberthür's Freak, *Calinaga davidis*, Sichuan, China.

CHARAXINAE

The Charaxinae are a group of robust, medium to large butterflies, represented in most tropical and subtropical regions of the world. In total there are about 350 species split into 20 genera, within the six tribes Charaxini, Euxanthini, Pallini, Prothoini, Preponini and Anaeini.

In most genera, the larva is green and slug-shaped with a flattened head that is adorned with a spectacular crown of four long horns. The larvae feed on the foliage of various trees and shrubs in the families Melianthaceae, Euphorbiaceae, Fabaceae, Rhamnaceae, Sapindaceae, Ochnaceae, Lauraceae, Tiliaceae and Meliaceae.

Charaxini

There are two genera in this tribe – *Polyura* and *Charaxes*. The vast majority of the 198 *Charaxes* species are Afrotropical in distribution. The genus is also represented by one species, *C.jasius*, found around the Mediterranean coast of Europe; 23 species in the Oriental region; and the species *C.latona*, which inhabits New Guinea and the far north of Australia.

The Oriental species are commonly known as Rajahs, but in Europe they are called Pashas, and in Africa they are known as Emperors or simply as Charaxes. Most are rainforest butterflies but several are adapted to savannah and thorn scrub habitats. All are noted for their very rapid, powerful flight, and for their habit of feeding at carrion or dung. In Africa it is possible to find aggregations of 30 *Charaxes* of three or four species feeding together at these unsavoury foodstuffs.

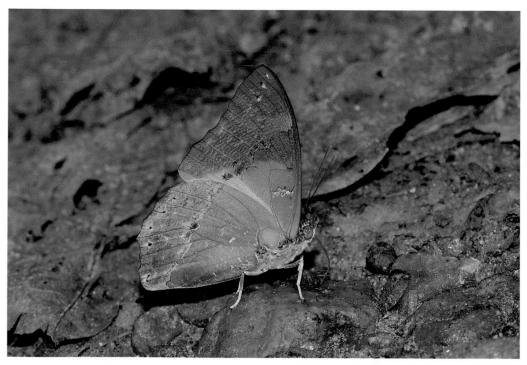

Green Charaxes, *Charaxes eupale*, Bobiri, Ghana.

Charaxes are usually black on the upperside, with bands of white, orange or blue. The bands in some species are broad and suffused, but in others they are narrow, well-defined and broken into a series of small spots. Many species have either a short dagger-like tail, or a pair of thin tails, at the tornus of the hindwings. The underside of *Charaxes eupale* from Ghana is green, while that of the Variegated Rajah, *C.kahruba*, from India is cryptically patterned to resemble dead leaves. Other species, such as the Two-tailed Pasha, *C.jasius*, are strikingly marked with red, black and white stripes.

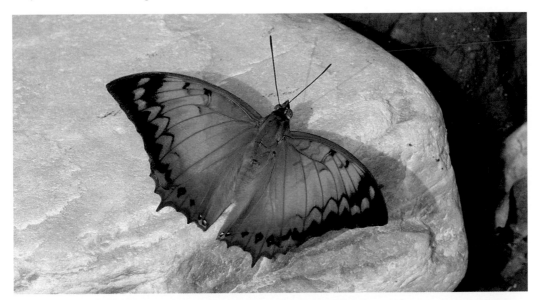

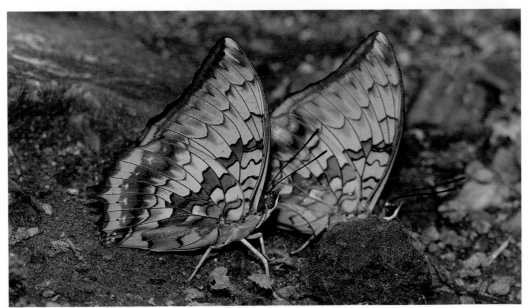

TOP Variegated Rajah, *Charaxes kahruba*, Ultapani, Assam, India.
BOTTOM Variegated Rajah, *Charaxes kahruba*, Ultapani, Assam, India.

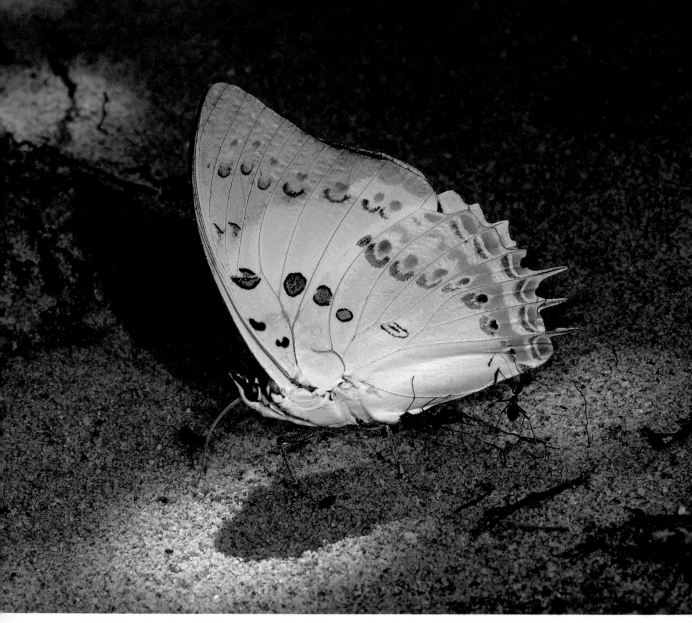

White Nawab, *Polyura delphis*, Taman Negara, West Malaysia.

The genus *Polyura* consists of 24 species. Most are native to the Oriental region but several are endemic to various islands in the South Pacific, while one particularly widespread species, *P.pyrrhus*, reaches Queensland. *Polyura* are similar in wing-shape to *Charaxes*. Most have dark brown uppersides with bright creamy white bands that vary in size and shape from one species to another. In most species, including the beautiful Common Nawab, *Polyura athamas*, the bands are repeated on the underside in a delicate shade of pearly green. An exception is the stunning White Nawab, *P.delphis*, which has a white underside marked with orange, yellow and grey spots and lunules. It is a scarce but widely distributed species, found in primary rainforests from Assam to Borneo, Palawan and Java.

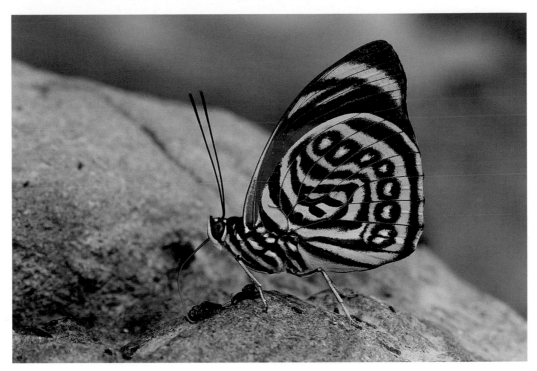

White-spotted Agrias, *Prepona (Agrias) amydon*, Rio Shima, Peru.

Preponini

This is an exclusively Neotropical tribe, comprised of three genera – *Archaeoprepona*, *Prepona* and *Anaeomorpha*. As a result of molecular analysis, the former genera *Noreppa* and *Agrias* have now been consolidated with *Prepona*. The adults of all Preponini are large, powerful and fast-flying. They spend most of their lives high in the canopy, although *Archaeoprepona* sometimes descend to feed at fermenting fruit or sap runs.

The five species that were formerly placed in the genus *Agrias* are rarely seen. The magnificent White-spotted Agrias, *Prepona amydon*, for example, is normally only observed if it is baited with rotting fish or other carrion laid along forest tracks or trails. When it settles it usually keeps its wings firmly closed, but if alarmed it flashes them open briefly, displaying the vivid scarlet and blue patches on its glorious upperside.

The six 'true' *Prepona* species, together with *Archaeoprepona*, *Anaeomorpha* and *Noreppa*, are larger insects. They have curvaceous forewings with very concave outer margins. On the upperside they are blackish-brown, with broad swathes of metallic blue or turquoise across both wings. The undersides are very different to those of the former *Agrias* species, being cryptically patterned in shades of brown.

Males of *Prepona* and *Archaeoprepona* often perch on tree trunks a few metres above the ground, adopting a characteristic head-downward posture, and holding their wings half open. They descend from the treetops in a series of hops, pausing for a few minutes at various points on the tree trunk. Once they reach ground level they generally become so engrossed in feeding that they are oblivious of human presence, but if alarmed they can fly off with amazing speed.

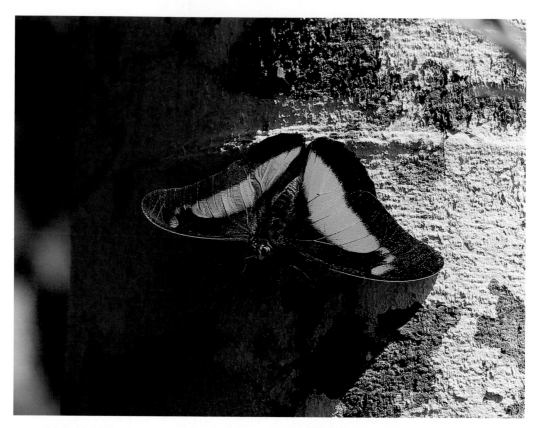

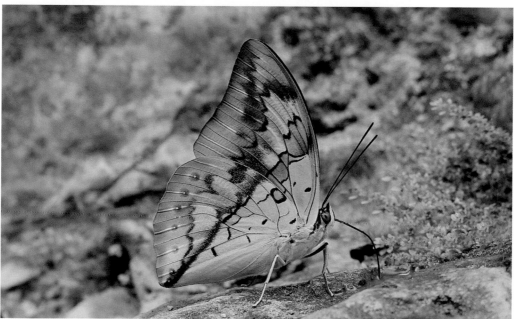

TOP Blue-banded Shoemaker, *Archaeoprepona licomedes*, Rio Madre de Dios, Peru.
BOTTOM Blue-banded Shoemaker, *Archaeprepona licomedes*, Rio Tambo, Peru.

Anaeini

The Anaeini are considered worthy of subfamily status by some taxonomists, but are currently retained as a tribe within in the Charaxinae. There are about 90 species, all of which are native to the Neotropics.

The largest genus is *Memphis* which contains 62 species. The uppersides of most species are black, with a metallic blue sheen over the basal half, and often a few small blue spots or streaks at the apex and outer margins. The wing-shape varies from species to species. The inner margins of the forewings of *M.anna*, *M.dia* and *M.laura*, for example, are very straight; while those of *M.forreri*, *M.leonida* and several others are strongly S-shaped, with a pronounced hook at the tornus. Females of *M.forreri*, *M.proserpina* and *M.kingi* possess short clubbed tails on the hindwings. In *M.arginussa* and *M.philumena*, tails are present in both sexes. Conversely, in *M.polyxo* and *M.wellingi* neither sex is tailed.

In the closely related genus *Fountainea,* both sexes have tails, although those of *F.sosippus* and certain races of *F.ryphea* are very short. Most *Fountainea* species have extensive areas of orange on the upperside, but in the very beautiful *F.nessus*, *F.centaurus* and *F.nobilis* this is almost completely obscured by a stunning iridescent deep purple/pink sheen.

All species in the Anaeini have cryptic 'dead leaf' undersides. The wing-shapes and markings of *Hypna*, *Consul* and *Zaretis* are particularly convincing in this respect, but most impressive of all is the Archidona Leafwing, *Coenophlebia archidona*. This butterfly is truly the grand master of disguise. It is shaped and coloured exactly like a desiccated fallen leaf, complete with fake midrib and veins. Furthermore, the wings have clusters of tiny irregularly shaped spots that perfectly simulate holes nibbled by insects. The impeccable disguise of this species is unsurpassed by any other butterfly, although *Hypna clytemnestra* and *Consul fabius* both come close.

RIGHT TOP Noble Leafwing, *Fountainea nobilis*, Tatama NP, Colombia.

RIGHT BOTTOM Superb Leafwing, *Fountainea nessus*, Rio Tambo, Peru.

OVERLEAF Archidona Leafwing, *Coenophlebia archidona*, Rio Shima, Peru.

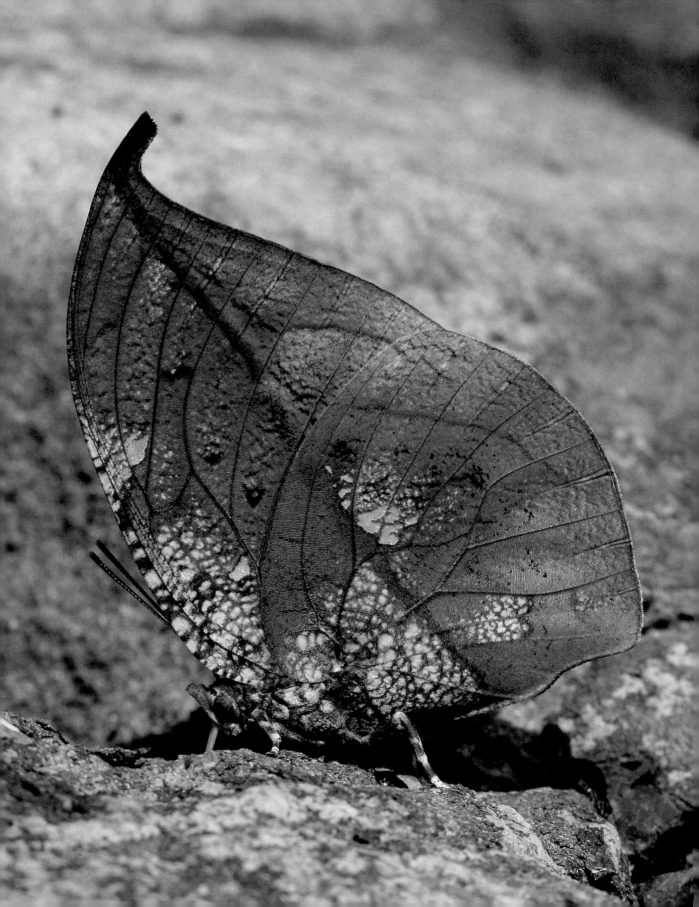

CYRESTINAE

For many years there was conjecture as to whether the tribe Pseudergolini should be included within the Cyrestinae, but molecular analysis has clarified the position and the tribe has now been reclassified as a distinct subfamily Pseudergolinae. The only currently recognised genera in the Cyrestinae are *Marpesia*, *Chersonesia* and *Cyrestis*, all of which are placed in the tribe Cyrestini.

The 17 *Marpesia* Daggerwings are medium-sized butterflies, distributed variously from Texas to Bolivia and Brazil. They possess distinctive tails and are sometimes confused with Swallowtails, but can easily be distinguished from them by their straight antennae. The uppersides of *Marpesia* species are typically dark brown, orange or red, patterned with fine dark vertical stripes. Some species, such as *M.marcella*, *M.corita* and *M.corinna*, have patches of metallic purple on their hindwings, giving them a pansy-like appearance.

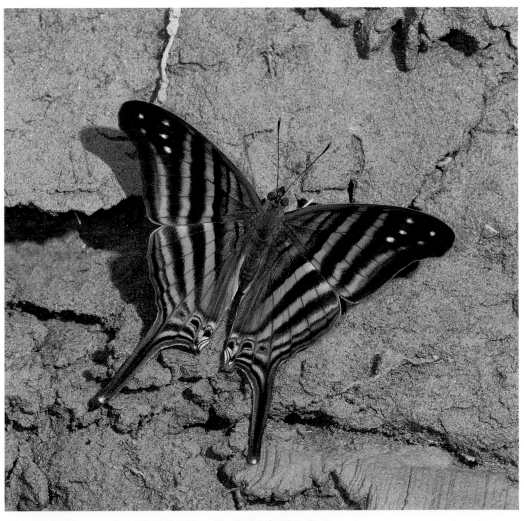

Many-banded Daggerwing, *Marpesia chiron*, Rio Madre de Dios, Peru.

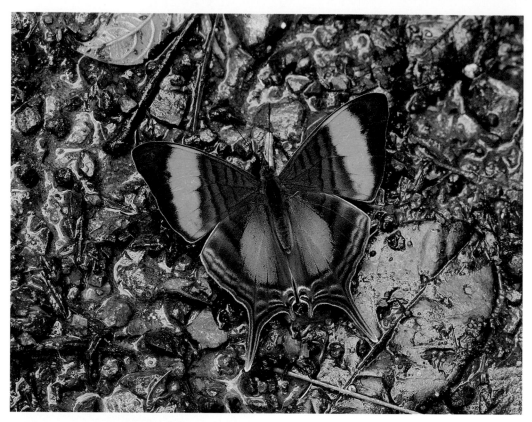

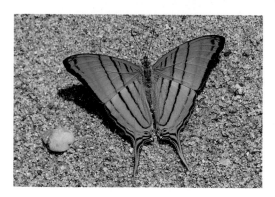

ABOVE Pansy Daggerwing, *Marpesia corinna*, Otún Quimbaya, Colombia.

LEFT Waiter, *Marpesia zerynthia*, Antioquoia, Colombia.

BELOW LEFT Amber Daggerwing, *Marpesia berania*, Rio Pindayo, Peru.

During migrations, males of *Marpesia furcula* and *M.chiron* are often encountered in dozens, hundreds or even thousands, swarming on river beaches or at the edges of stagnant pools. Certain *Marpesia* species also gather in large communal roosts – in Venezuela, for example, I was shown a group of about 100 aestivating *M.berania* clustered tightly together, suspended from an overhanging branch.

The *Cyrestis* Mapwings mostly have a white or yellowish ground colour, marked with many fine black lines reminiscent of

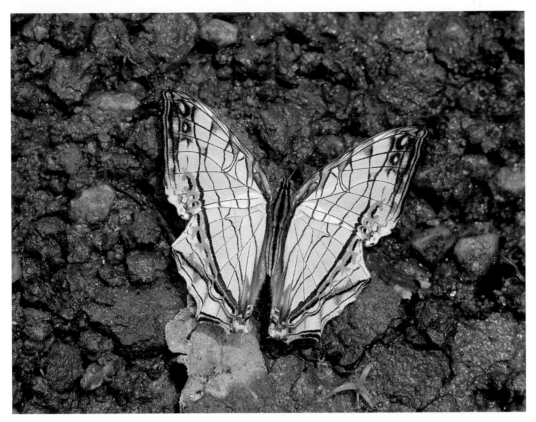

Common Mapwing, *Cyrestis thyodamas*, Buxa, West Bengal, India.

map contours. They are usually seen in twos or threes, basking on the ground with wings outspread and held flat against the substrate. They often shelter under leaves, keeping their wings fully outspread. Most of the 22 members of the genus are native to the Oriental region, although one species, *C. camillus*, is widespread in Africa and Madagascar.

The Wavy Maplet, *Chersonesia rahria*, is a delightful species found from Malaysia to Sulawesi. Like other species in the genus it is a dainty butterfly that can sometimes be spotted at rest on the underside of a high leaf with its wings outspread. It will often remain in this position for several minutes before gently fluttering down to settle on top of a sunlit leaf at eye-level. It is commonest in the wet season and is most active in the hot sunny spells between downpours.

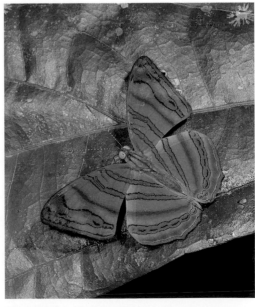

Wavy Maplet, *Chersonesia rahria*, Taman Negara, West Malaysia.

DANAINAE

The Danainae is comprised of about 540 species worldwide. It is subdivided into three tribes. The Danaini contains about 160 species distributed variously across most of the warmer regions of the world. The Ithomiini is composed of 370 known species, but more are likely to be discovered in the next decade. The Tellervini consists of a single genus, *Tellervo*, containing about a dozen species.

Danaini

The caterpillars of Danaini feed on plants in the families Apocynaceae, Caricaceae, Asclepiadaceae and Moraceae. Chemicals sequestered from these plants confer them with noxious qualities, protecting them from bird predation. The toxins are inherited by the adult butterflies, which further boost their toxicity by feeding on pyrrolizidine alkaloids secreted from the stems of *Heliotropium* and various other plants.

Most members of the Danaini have evolved aposematic patterns to advertise their poisonous nature. The best known examples are members of the 'tiger complex', a large group of Batesian and Müllerian mimics, all of which have black, orange and yellow patterns.

The Tiger-mimic Queen, *Lycorea halia*, acts as the model for many mimics including noxious ithomiines such as *Mechanitis lysimnia* and *Placidina euryanassa*; toxic heliconiines such as *Eueides isabella*; and a smaller number of palatable species including the melitaeine *Eresia eunice* and the dismorphiine *Dismorphia amphione*. The closely related Clearwing-mimic Queen, *Lycorea ilione*, is a member of a Müllerian mimicry complex involving several large glasswing ithomiines in the genera *Patricia*, *Methona* and *Thyridia*.

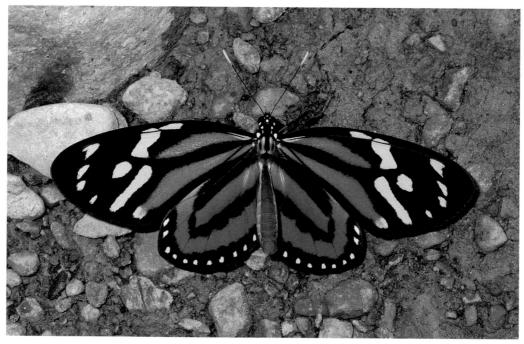

Tiger-mimic Queen, *Lycorea halia* (Danaini), Rio Napo, Ecuador.

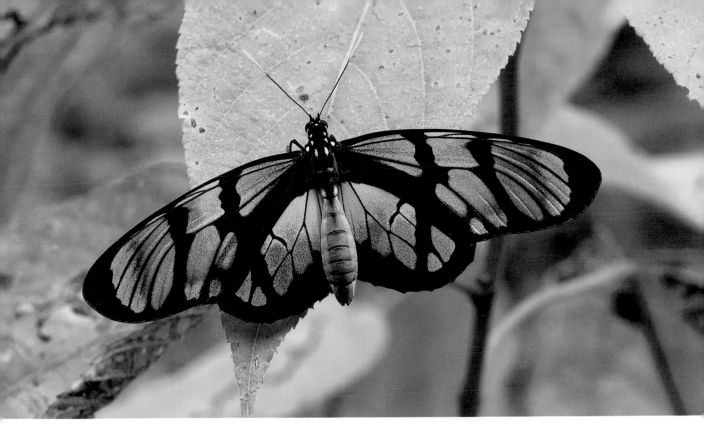

Clearwing-mimic Queen, *Lycorea ilione*, Rio Perene, Peru.

Another danaine-based mimicry group involves the Oriental genera *Tirumala* and *Parantica*. These dark brown butterflies with whitish or bluish streaks and spots arc unwary models for mimics such as the apaturine *Hestina nama* and the swallowtail *Papilio clytia*. Another swallowtail species, the Great Blue Mime, *Papilio paradoxa*, mimics a different danaine – the Striped Blue Crow, *Euploea mulciber*. The latter genus is comprised of about 24 species. Most are dark brown and have sombre undersides, but their uppersides display a strong blue iridescence.

The largest and most enchanting danaines are the beautiful *Idea* Tree Nymphs of India and South-East Asia. They are enormous butterflies with rounded translucent white wings, patterned with black veins and numerous oval black spots. They are noted for their relaxed and very graceful flight, which gives them the appearance of white

Common Crow, *Euploea core*, Chilapata, West Bengal, India.

Monarch, *Danaus plexippus*, Turrialba, Costa Rica.

handkerchiefs floating gently on the breeze. In the morning, they ascend to the treetops to feed at *Syzygium* or *Eugenia* flowers. Later, towards the end of the afternoon, they gracefully 'parachute' down in groups of up to half a dozen, gently weaving and circling until they alight on foliage 4–5m (13–16.4ft) above ground level.

Many danaines are migratory in behaviour. The most famous migrant of them all, of course, is the Monarch, *Danaus plexippus*. Its powers of migration are so great that it has been able to spread across the Americas from Canada to Peru. The first known record outside America was of three specimens which crossed the Atlantic to arrive in Britain in 1876. Since then, the Monarch has spread to reach North Africa, Europe and India. It has also crossed the Pacific Ocean to Australia, New Zealand and Papua New Guinea.

Ithomiini

The Ithomiini occur only in Central and South America. There are 43 recognised genera, split between 8 subtribes – Tithoreina, Oleriina, Melinaeina, Mechanitina, Napeogenina, Ithomiina and Dircennina.

Ithomiine characteristics include small eyes, slender abdomens and long drooping antennae that lack distinct clubs. They also have exceptionally long stilt-like legs, in which the femur is longitudinally striped with black and pale yellow or white. Males possess a plume of androconial scales or 'hair pencils' on the costa of their hindwings. These are hidden from view when the butterflies are at rest, but are displayed when the wings are held open during courtship.

Itatiaia Tiger, *Placidina euryanassa*, Itatiaia, Brazil.

There are basically two types of ithomiine – the Tiger-mimics, which are black with orange patches and creamy spots; and the Glasswings, which as their common name implies, have largely transparent wings. Most ithomiines produce several subspecies and forms, and it is often the case that one form or sex of a species will be tiger patterned, while another will be of the Glasswing type.

The various Tiger-mimics can be distinguished from each other fairly easily by their differing patterns, but the Glasswings are harder to tell apart. Males in the genus *Ithomia* can be easily recognised by the presence of a black blister of androconia on the underside costa of the hindwing. Some genera are much harder to identify, requiring close study of the venation, antennae, eye size and body length, and by the hues reflected from the transparent glassy wing

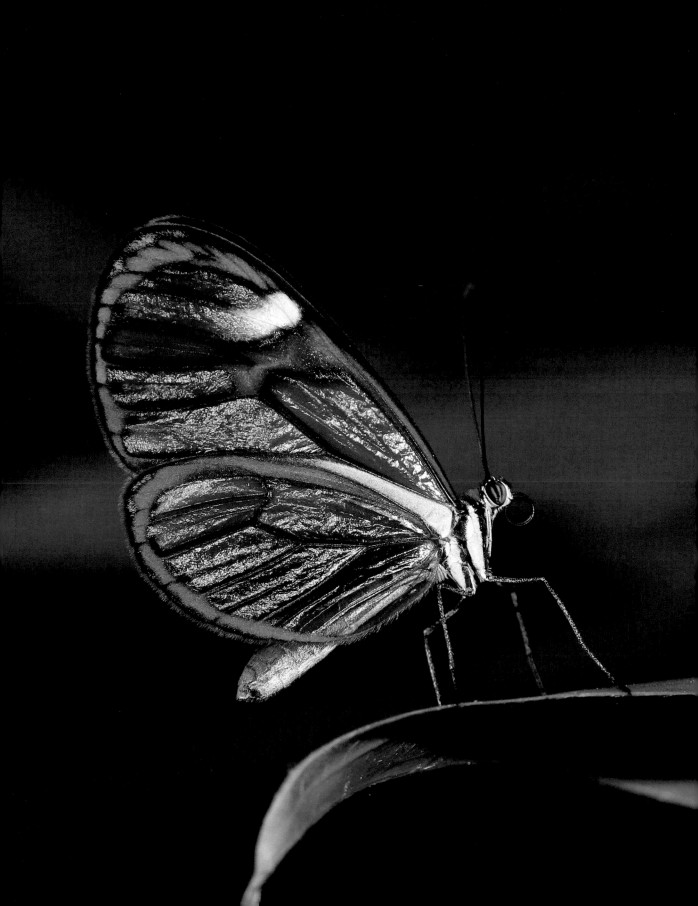

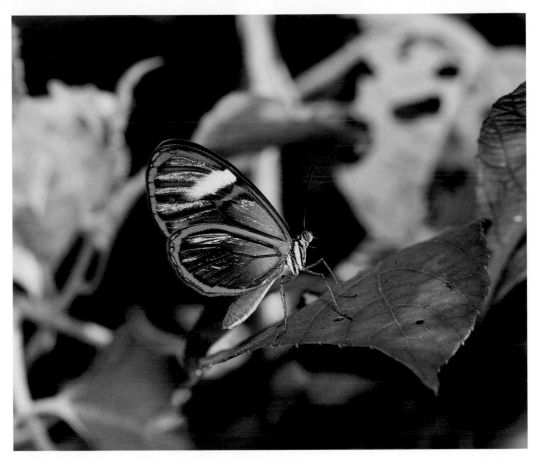

ABOVE Edessa Glasswing, *Heterosais edessa*, Pantiacolla, Peru.
OPPOSITE Blue Glasswing, *Ithomia agnosia*, Itamonte, Brazil.

membranes. Other giveaways include the colour of the legs, the presence or otherwise of tufts of orange scales on the thorax; and the precise locations of the submarginal white spots on the underside wings.

Ithomiines have a slow flight with characteristic deep wingbeats. They spend long periods at rest on the foliage of saplings, in the darkness of their forest habitats. They are extremely nervous, fluttering off instantly at the least disturbance, only to quickly resettle on another nearby leaf. Chasing after them is not recommended as they have a tendency to lure the pursuer away from the security of forest trails, deeper and deeper into the jungle, where it is easy to become disorientated and lost, or to be bitten by a snake or venomous spider.

In common with those of danaines, the larvae of ithomiines sequester toxins from their foodplants – mostly nightshades from the family Solanaceae. These chemicals are inherited by the adults, conferring them with noxious qualities that deter bird attacks. The butterflies additionally procure pyrrolizidine alkaloids from flowers such as *Eupatorium*, *Heliotropium*, *Tournefortia* and *Epidendrum*; and from fluids that ooze from the stems of wilting plants. These are then processed internally to produce further toxins, and are also used in the production of sexual pheromones.

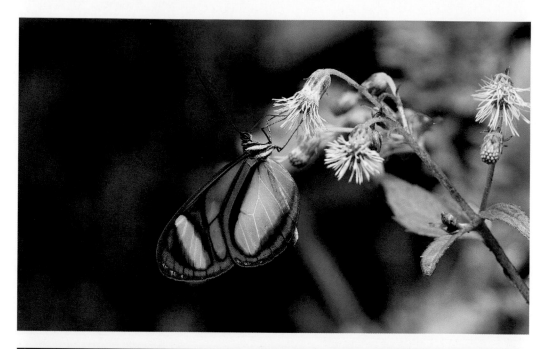

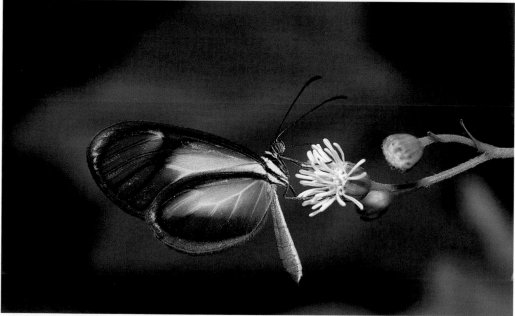

TOP Quintina Glasswing, *Oleria quintina*, Rio Kosnipata, Peru.

BOTTOM Canary Glasswing, *Episcada doto*, Itatiaia, Brazil.

Male ithomiines often form communal leks, where they release these pheromones from androconial plumes on their hindwings. Passing females are attracted to the leks by the strong fragrance, which can be detected by humans. The presence of the females stimulates the males to release additional, aphrodisiac pheromones that entice them into copulation.

Tellervini

The Tellervini was originally thought to consist of just a single Australasian species, *Tellervo zoilus*. Subsequent research led to many of its subspecies being elevated in rank to become distinct species. Just over a dozen species are now recognised. The butterflies are characterised by having long straight antennae, large orange or yellow eyes and conspicuous black and white markings on their wings. They are found variously in Queensland, West Irian, Papua and the Solomon Islands.

HELICONIINAE

This subfamily is currently divided into four tribes – Heliconiini, Argynnini, Vagrantini and Acraeini.

Heliconiini

The Heliconiini, commonly known as Longwings, contains 89 species, of which 76 are restricted to Central and South America. The Neotropical genera are *Agraulis, Dione, Dryadula, Dryas, Eueides, Heliconius, Neruda, Philaethria* and *Podotrichia*. Additionally, there are 13 *Cethosia* species distributed from India and South-East Asia to Australia.

Gulf Fritillary, *Agraulis vanillae*, San Ramon, Peru.

Montane Longwing, *Heliconius clysonymus*, Medellin, Colombia.

Heliconius are characterised by their slow graceful flight and elongated wings. Most have a blackish ground colour, marked with simple but striking patterns featuring streaks or patches of red and cream, or of blue and cream. Some orange and black striped species, such as *H.numata* and *H.ismenius*, are Müllerian mimics of ithomiines. Distinguishing them from the latter is easy as ithomiines have drooping antennae that thicken gradually towards the tip, whereas *Heliconius* antennae have long straight shafts and distinctly clubbed tips.

The 39 *Heliconius* species are much studied by geneticists and taxonomists. Many of them produce a staggering variety of colour forms. The Common Postman, *H.erato*, and the Red Postman, *H.melpomene*, for example, both produce 29 subspecies, each differing very noticeably in colour and pattern

Common Postman, *Heliconius erato chestertonii*, Medellin, Colombia.
Tiger Longwing, *Heliconius hecale shanki*, Rio Shima, Peru.

A few hours prior to emergence, female pupae of *Heliconius erato* exude sexual pheromones to attract males. Consequently, it is common to find female pupae with up to a dozen males clustered around them, poised to leap on the female the moment she ecloses. As soon as she does, a frantic battle ensues, as they all struggle to copulate with her. The mating pair then has to endure continued aggravation from the remaining males, which are often extremely persistent, trying to prise them apart. Eventually, as dusk approaches, the unsuccessful males disperse, allowing the pair to remain copulated until the next morning.

All *Heliconius* species lay their eggs singly on the leaf tips or tendrils of *Passiflora* vines. These plants contain toxins which are sequestered by the larvae, rendering them and the

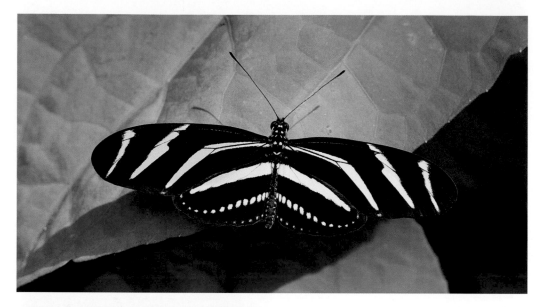

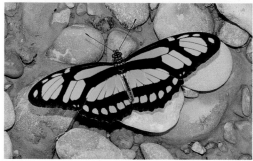

TOP Zebra Longwing, *Heliconius charithonia*, Medellin, Colombia.

BOTTOM Dido Longwing, *Philaethria dido*, Rio Madre de Dios, Peru.

resulting pupae and adults noxious to birds. The larvae are variable in colour and covered with branched black spines. Pupae of all species have sharp spikes on the abdomen and along the costal margin of the wing cases. They also have a pair of long, twisted palpal shrouds extending from the head. The overall impression is of a dead, decaying, twisted leaf, hanging from a stem.

Unlike other butterflies, *Heliconius* females feed on pollen as well as nectar. Pollen from *Psiguria*, *Anguria* and *Gurania* flowers provides them with amino acids which cannot be obtained from nectar or other sources. Laboratory studies of *H.ethilla* have shown that females deprived of pollen produce fewer eggs than those permitted access to it. Other studies have shown that individual butterflies can memorise the locations of pollen sources, larval foodplants and roosting sites; and can learn the most efficient route by which to visit them.

The Dido Longwing, *Philaethria dido*, is among the most beautiful and graceful of Neotropical butterflies. Less experienced observers often confuse this species with the Malachite, *Siproeta stelenes* – a much commoner insect found in open forest and around the edges of forest clearings. The wing-shapes of the two genera are completely different however. Males of *P.dido* are elusive but occasionally descend from the canopy to imbibe mineral-rich moisture from river beaches, fluttering constantly as they dance over the ground and probe for nutrients.

Males of the beautiful Oriental *Cethosia* species have scarlet or orange uppersides with broad black margins and a white diagonal bar across the forewings. Females are paler but are similarly marked. The undersides of both sexes have intricate lace-like markings, hence their common name Lacewings.

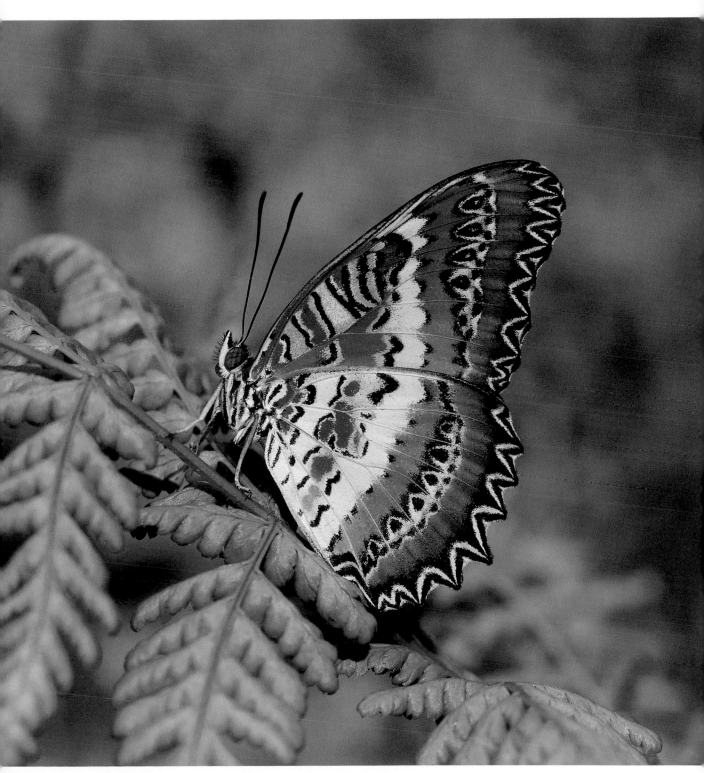

Red Lacewing, *Cethosia biblis*, Kinabatangan, Sabah, Borneo.

Lesser Marbled Fritillary, *Brenthis ino*, Kuresaare, Estonia.

Argynnini

The Argynnini includes 98 medium to large Fritillary butterflies in the Holarctic genera *Argynnis*, *Brenthis*, *Clossiana*, *Euptoieta* and *Issoria*; plus six Neotropical *Yramea* species. All have orange uppersides marked with numerous small black spots arranged in wavy columns across the wings. The undersides of most species are patterned with metallic silver or white spots.

One of the most beautiful species is the Silver-washed Fritillary, *Argynnis paphia*. Its courtship ritual is one of the most endearing and iconic sights of the English summertime. The female flies in a straight line along woodland tracks, wafting an aphrodisiac scent from the tip of her abdomen. The male responds by following her closely, repeatedly looping under and over her, showering her with pheromones released from the androconial scales which run along the veins of his forewings. In many cases this tantalising display fails to entice the female into mating, but if she is receptive she leads the male to a clump of leaves high in an oak tree where copulation takes place.

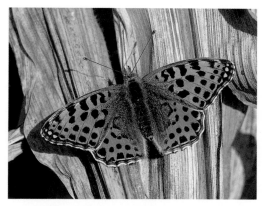

ABOVE Queen of Spain Fritillary, *Issoria lathonia*, West Sussex, England.

OPPOSITE Silver-washed Fritillary, *Argynnis paphia*, Sussex, England.

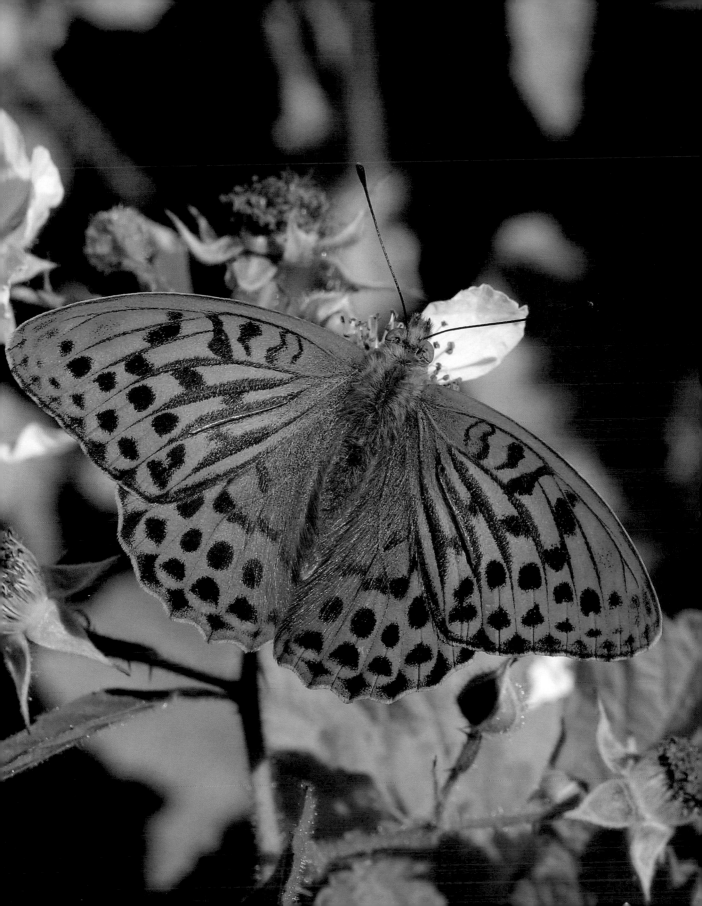

TOP Malay Yeoman, *Cirrochroa emalea*, Ulu Gerok, West Malaysia.

BOTTOM Cruiser, *Vindula dejone*, Bukit Tapah, West Malaysia.

Vagrantini

Most of the butterflies in the Vagrantini are orange, spotted to a greater or lesser degree with black. Among them are the *Cirrochroa* Yeomen, *Cupha* Rustics and *Vindula* Cruisers of the Oriental region; and the widespread Common Leopard, *Phalanta phalantha*, which is found across Africa, the Oriental region, New Guinea and the Northern Territory of Australia.

The genus *Terinos* is unusual in that the uppersides of both sexes are flushed with deep purple. There are eight species, some of which are restricted in distribution, but the Royal Assyrian, *T.terpander*, is widespread, being found from Myanmar to Java. The butterflies are active mainly in the mornings when they flit from leaf to leaf, basking here and there for a moment or two before moving on.

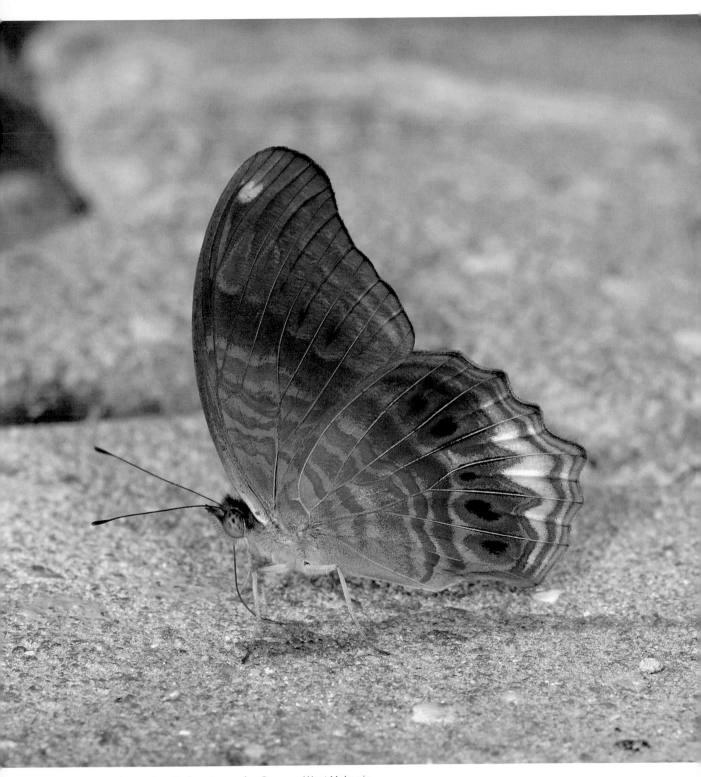

Royal Assyrian, *Terinos terpander*, Gopeng, West Malaysia.

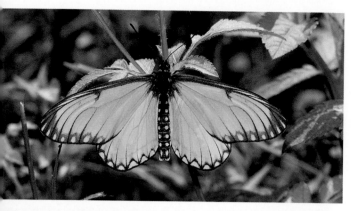

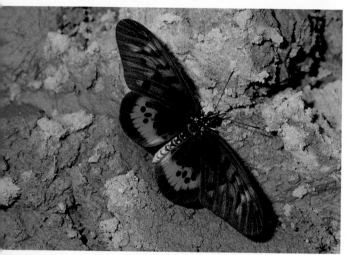

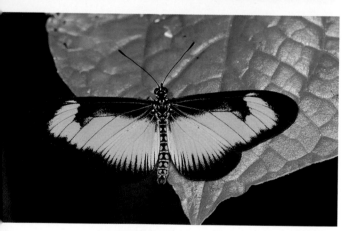

TOP Yellow Coster, *Acraea issoria*, Sikkim, India.

MIDDLE Ward's Acraea, *Acraea pharsalus*, Boabeng-Fiema, Ghana.

BOTTOM Hewitson's Acraea, *Acraea alciope*, Lipke hills, Ghana.

Acraeini

Acraeines can be found in tropical habitats worldwide, including rainforest, cloud forest, dry woodland, *Acacia* scrub and open savannah.

In total there are about 230 species in the genus *Acraea*, almost all of which are confined to the Afrotropical region. Beyond Africa, a further five species occur in the Oriental region, and another is found in Australia/New Guinea.

The wings of most *Acraea* species are thinly scaled or semi-transparent. The scales wear off very easily, so insects more than a couple of days old invariably develop a glassy appearance. The predominant colour is usually orange or brown, although some species are largely transparent, marked only with suffused white bands and blackish patches. The undersides of most have a distinctive pattern of black spots at the base and margins of the hindwings. Many species are sexually dimorphic – females generally being less colourful than males.

Three genera, namely *Actinote*, *Altinote* and *Abananote*, are native to the cloud forests of Central and South America. The five *Abananote* species have brown wings with suffused, broad diagonal orange bands across the forewings. The 17 species in the genus *Altinote* have black wings, sometimes with a slight bluish sheen, and are marked with large orange or bright red patches. It is common in the Andes to see swarms of up to 100 *Altinote dicaeus* and *Altinote negra* mud-puddling together on unmetalled road surfaces. The butterflies stay all day at these spots and are totally oblivious of approaching vehicles, with the unfortunate result that vast numbers are accidentally crushed every day by passing cars.

The remaining genus *Actinote* contains 36 species. They are very reminiscent of *Acraea*, with thinly scaled brownish wings marked

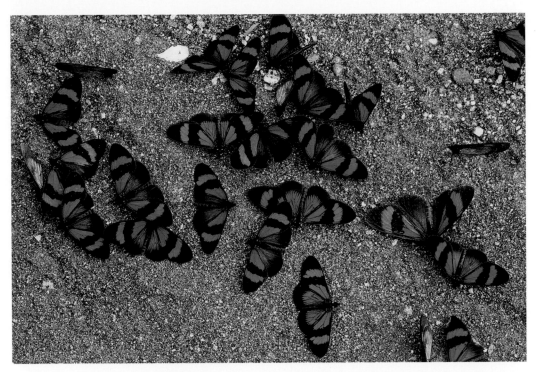

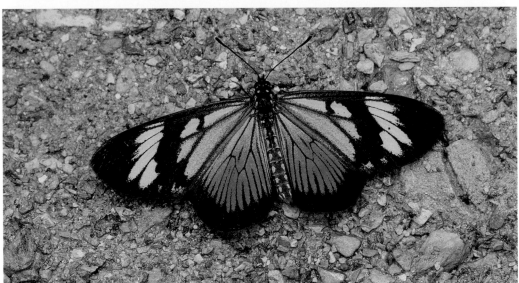

TOP Red-banded Altinote, *Altinote dicaeus* and Gaudy Altinote, *Altinote negra*, Rio Kosnipata, Peru
BOTTOM Common Actinote, *Actinote anteas*, Tatama NP, Colombia.

with bands and patches of white or pale orange. The aposematic patterns of these noxious species are mimicked by three genera of palatable Melitaeini – *Eresia*, *Gnathotriche* and *Castilia*. The easiest way to tell them apart is to look at the discal cell on the hindwing – in Acraeini this is closed, but in Melitaeini it is open-ended.

Oriental Beak, *Libythea myrrha*, Ultapani, Assam, India.

LIBYTHEINAE

The Libytheinae is regarded as the most basal subfamily of the Nymphalidae. It is comprised of only 13 species worldwide. There are four *Libytheana* species, namely *L.motva*, *L.terena* and *L. fulvescens* which are all endemic to Caribbean islands; plus the widespread *L.carinenta* which is found across much of North and South America.

The Old World libytheines are all assigned to the genus *Libythea*, which includes one species on Mauritius, one on mainland Africa, two on Madagascar and one on the Marquesas Islands in Polynesia. The most widespread species is the Nettle-tree butterfly, *L.celtis*, which has an almost contiguous distribution from Portugal to Japan.

Libytheines are commonly known as Snouts or Beaks, on account of the elongated labial palpi that project from between the antennae. The palpi are sensory organs. They are probably tuned to detect food sources such as nectar, carrion or tree sap, but are thought to also have additional functions such as shielding the eyes from contamination by dust, mud, nectar or rotting fruit.

During migrations, swarms of males commonly gather to imbibe dissolved minerals from muddy patches on forest trails. Both sexes occasionally bask open-winged on foliage, but normally rest on twigs with their wings held erect. They often adopt a forward-tilting posture, with the snout in contact with the twig, thereby creating the illusion that their wings are a dead leaf, with the snout forming the petiole.

LIMENITIDINAE

Estimates of the total number of butterflies in the Limenitidinae vary, but there are at least 810 species worldwide. The true total may even exceed 1,000 if the various taxa that are currently classified as subspecies of *Euphaedra*, *Bebearia* and *Neptis* eventually prove to be distinct species. The highest diversity occurs in West Africa, followed closely by the Oriental region. The subfamily is currently split into four tribes – Neptini, Limenitidini, Parthenini and Adoliadini.

Neptini

This tribe is centred on the temperate and subtropical regions of eastern Asia, but is also well represented in Africa and the Indian subcontinent. Only four species reach Australia and only two species penetrate Europe. The genera include the *Phaedyma*, *Neptis* and *Aldania* Sailors, all of which have black wings, marked with white spots, streaks and bands. The pattern is repeated on the underside, but against a pale orange ground colour. The *Pantoporia* and *Lasippa* Lascars are similar in pattern, but have dark brown uppersides, marked with orange or yellow. All members of the Neptini are forest dwellers, as are the following tribe Limenitidini.

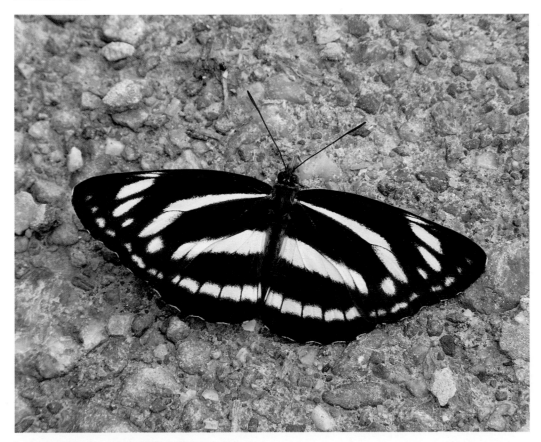

Long-streak Sailor, *Neptis philyra*, Sichuan, China.

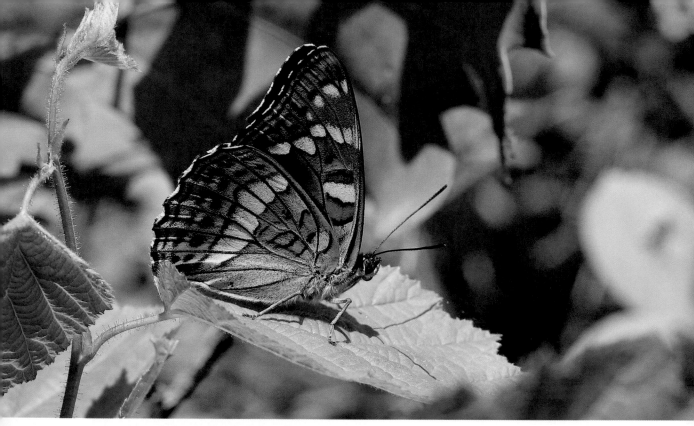

Poplar Admiral, *Limenitis populi*, Viidumae, Saaremaa, Estonia.

Limenitidini

The Limenitidini contains 300 species within 19 genera, the most well-known being *Adelpha* and *Limenitis*. The latter genus is confined to the Holarctic region and includes the very impressive Poplar Admiral, *Limenitis populi*, a magnificent species found in the larger forests of eastern Europe and temperate Asia. Its underside is like that of most other *Limenitis* species, with an orange ground colour traversed by white bands.

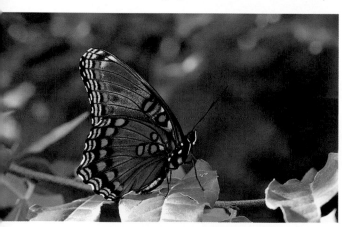

Red-spotted Purple, *Limenitis arthemis astyanax*, Indianapolis, USA.

Another interesting species is *Limenitis arthemis* from North America. It produces four subspecies. The northern races *L.a.arthemis* and *L.a.rubrofasciata* are typical of the genus. Their uppersides are black with white bands. The southern races *L.a.astyanax* and *L.a.arizonensis* are markedly different in appearance, lacking the white bands, instead having conspicuous red spots on the underside and a beautiful blue sheen across both surfaces of the wings. They are undoubtedly Batesian mimics of the noxious Pipevine Swallowtail, *Battus philenor*, which flies in the same region.

The 90 *Adelpha* species are commonly known as Sisters. The vast majority are native to the Neotropics, but there are a few exceptions, including *A.eulalia* from the southwest United States, *A.abyla* from Jamaica and *A.lapitha* from Hispaniola. *Adelpha* are instantly recognisable as a genus by the white and/or orange bands on their dark brown wings.

The Smooth-banded Sister, *Adelpha cytherea*, is a common species, found across much of Central and South America. Unlike most other *Adelpha* species it rarely imbibes moisture from the ground, preferring instead to nectar at *Cephaelis* flowers.

Many of the Oriental species in the genera *Moduza*, *Athyma*, *Parasarpa*, *Sumalia* and *Auzakia* are very handsome. The gorgeous Commodore, *Auzakia danava*, is a prime example. It inhabits heavily forested areas in the Himalayan foothills. Its flight is swift and skittish, with rapid wingbeats alternating with spurts of gliding. Males patrol regular beats back and forth along rivers and streams, periodically settling to imbibe moisture from damp boulders. Females are scarcer but can sometimes be seen basking on foliage or forest tracks.

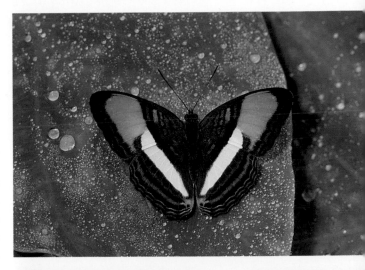

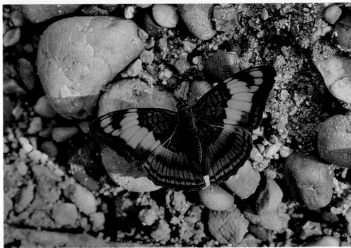

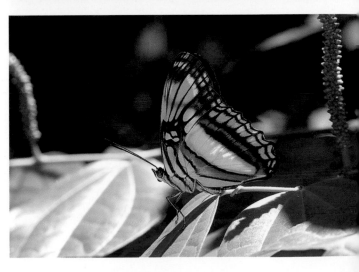

TOP Smooth-banded Sister, *Adelpha cytherea*, Maquipucuna, Ecuador.

MIDDLE Mesentina Sister, *Adelpha mesentina*, Rio Madre de Dios, Peru.

BOTTOM Celerio Sister, *Adelpha serpa*, Rio de Janeiro, Brazil.

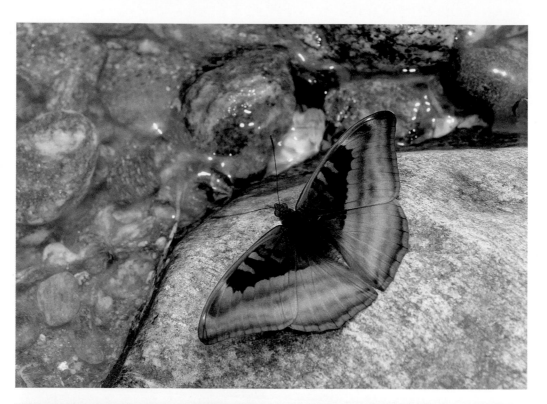

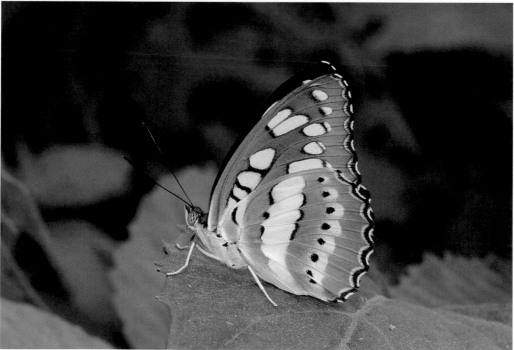

TOP Commodore, *Auzakia danava*, Sikkim, India.

BOTTOM Common Sergeant, *Athyma perius*, Manas NP, Assam, India.

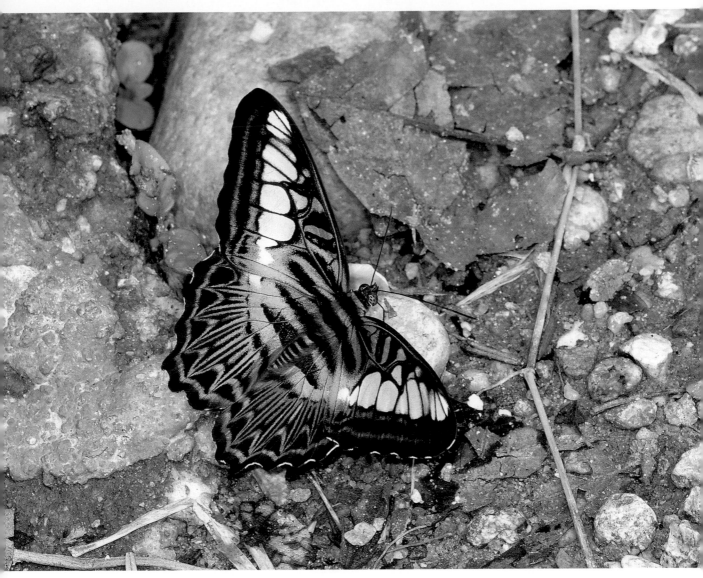

Clipper, *Parthenos sylvia*, Kinabatangan, Sabah, Borneo.

Parthenini

This tribe holds only two genera. *Bhagadatta* contains just a single species *B.austenia*, distributed from Burma and China. *Parthenos* is comprised of three species – *P.sylvia*, which occurs throughout tropical Asia, plus two New Guinea endemics, *P.tigrina* and *P.aspila*.

The beautiful Clipper, *Parthenos sylvia*, is a powerful, fast-flying butterfly. Its flight consists of short periods of gliding, alternating with shallow but rapid flickering wingbeats. On the Kinabatangan river in Borneo, hundreds of these magnificent butterflies circle and glide around treetops along several kilometres of the river edge. Both sexes commonly nectar at *Lantana*.

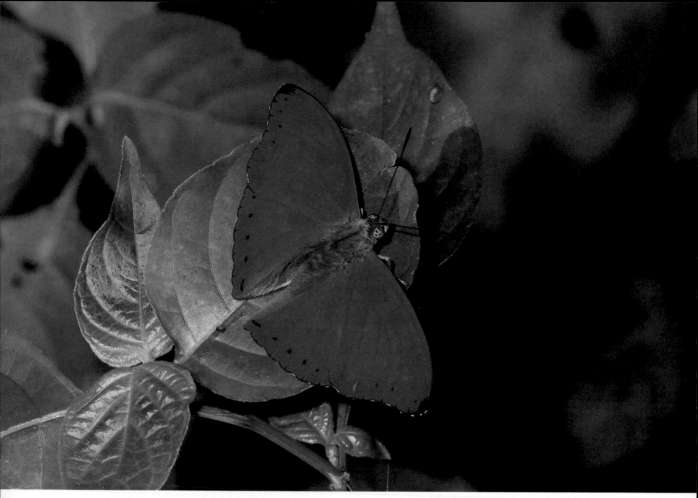

Mabille's Red Glider, *Cymothoe mabillei*, Bunso, Ghana.

Adoliadini

The Adoliadini are a diverse group of forest butterflies. In the Oriental region they are represented by genera including the *Euthalia* Dukes, the *Tanaecia* Earls and Counts, and the magnificent *Lexias* Archdukes. The females of the latter are dark brown with numerous prominent white spots. The males are black, except for a broad iridescent outer border which changes colour from turquoise to deep blue, according to the angle at which sunlight reflects from the wings.

The numerous African genera of Adoliadini include the *Cymothoe* Gliders, which spend most of their lives high in the forest canopy. Although most have quite plain patterns, they are often very gaudily coloured – *C.egesta* for example, is deep ochreous yellow, *C.sangaris* is blood-red, and *C.mabillei* is lurid metallic orange.

Beauty is in the eye of the beholder, but there can be few butterflies in the world equal in beauty to the *Euphaedra* Foresters which are so characteristic of the African rainforests. Hence I make no excuses for illustrating several of them here. These stunningly elegant butterflies have dark brown wings graced with large suffused patches of powder blue, bottle green, velvety orange or bright scarlet. There are somewhere between 100–200 species. The exact number is unknown, as many are very similar and frequently hybridize.

The Perseis Mimic Forester, *Euphaedra perseis*, inhabits primary rainforests from Guinea to Ghana. It is one of several red *Euphaedra* species that mimic the day-flying geometrid moth *Aletis helcita*. Both sexes fly close to the ground, patrolling forest paths in search of fermenting figs, of which they are very fond. They rarely settle in the open, instead preferring places where dappled sunlight filters through the foliage to reach the forest floor.

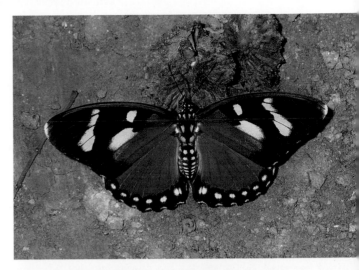

The beautiful Janetta Forester, *Euphaedra janetta*, is black above with a deep blue sheen and orange patches at the forewing apexes. The basal area of the wings is covered in iridescent scales that reflect golden, green or blue hues according to the angle at which sunlight strikes the wings. The underside is typical of a sub-group of *Euphaedra* species that also includes *E.sarcoptera*, *E.themis* and *E.splendens*. All are bright yellow beneath, marked with black spots and a vivid crimson patch at the base of the wings.

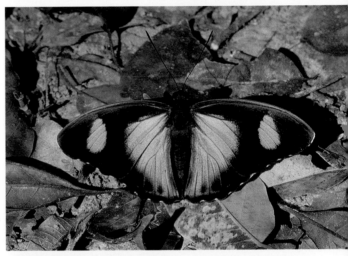

The Widespread Forester, *Euphaedra medon*, is the commonest member of the genus, being found across much of Africa from the Gambia to Tanzania. In males, almost the entire wing surface, apart from the orange bars, is covered in metallic blue-green scales. In females the latter colour is replaced by a powdery violet-blue. Both sexes fly close to the ground, elegantly weaving their way in and out of the undergrowth with great adeptness, and are very graceful in flight. They can often be found in groups of a dozen or more, aggregating at fallen fruits.

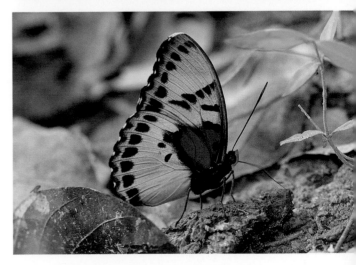

TOP Perseis Mimic Forester, *Euphaedra perseis*, Bobiri, Ghana.

MIDDLE Janetta Forester, *Euphaedra janetta*, Bobiri, Ghana.

BOTTOM Janetta Forester, *Euphaedra janetta*, Bobiri, Ghana.

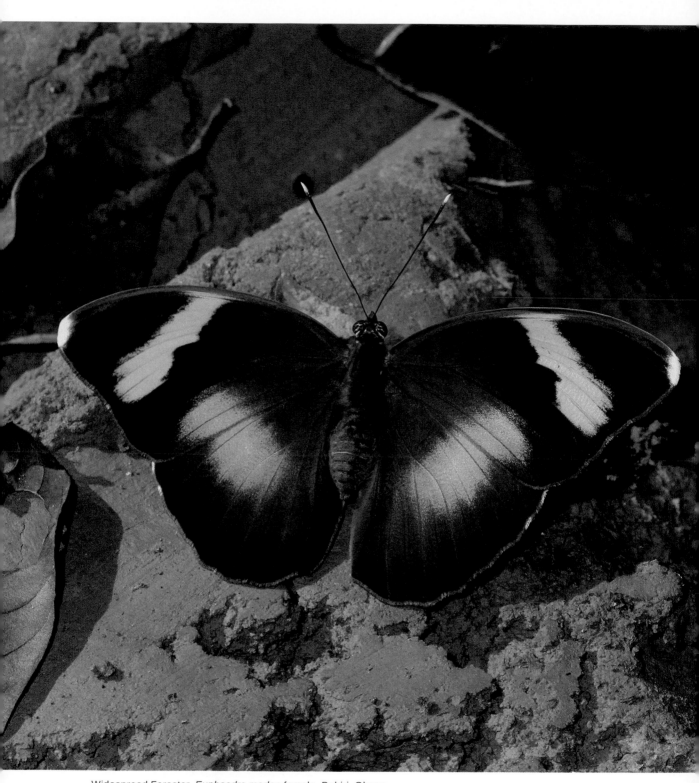

Widespread Forester, *Euphaedra medon* female, Bobiri, Ghana.

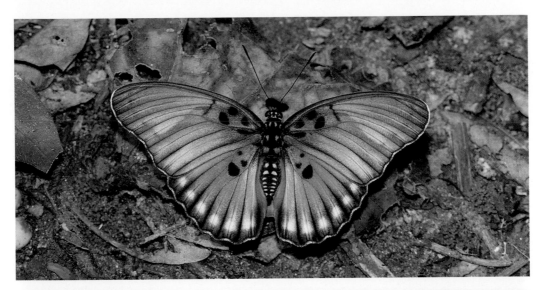

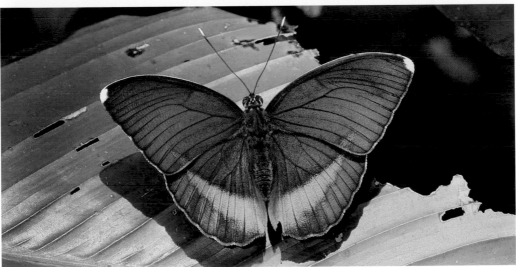

TOP Edward's Forester, *Euphaedra edwardsi*, Boabeng-Fiema, Ghana.

BOTTOM Blue-banded Forester, *Euphaedra harpalyce*, Wli Falls, Ghana.

The pattern and colouration of Edward's Forester, *Euphaedra edwardsi*, is unique. The butterfly is usually seen singly, patrolling along a short stretch of forest path, pausing occasionally to feed at fallen fruits. When settled, it fans its wings slowly, displaying shades of iridescent olive green, gold, blue and orange.

Very closely related to *Euphaedra*, and also commonly known as Foresters, are the 105 *Bebearia* species. The males of many, including *B.oxione* and *B.tentyris*, have a fritillary-like pattern of black spots on an orange or brown ground colour. Females of these and several other species have similar patterns to the males, but have an earthy ground colour and a wide cream bar across the hindwings. In some species however, such as *B.cutteri* and *B.phantasina*, the females are devoid of black spots and bear a strong resemblance to *Euphaedra* species.

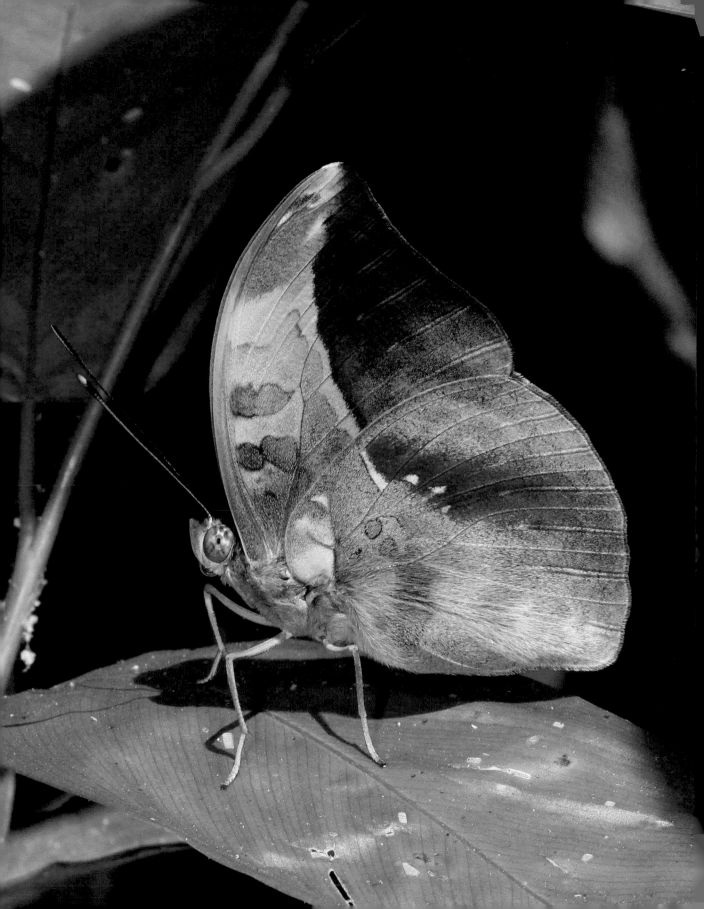

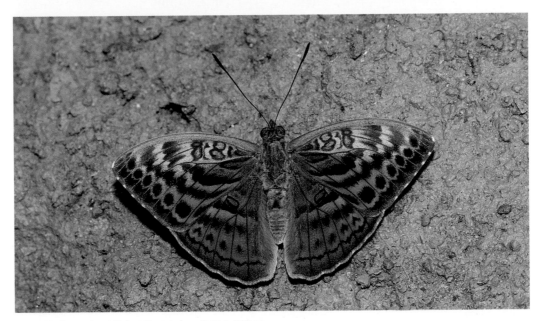

ABOVE Undetermined *Bebearia* species, Bobiri, Ghana.

OPPOSITE Beautiful Forester, *Bebearia sophus*, Wli Falls, Ghana.

The Tentyris Forester, *Bebearia tentyris*, normally inhabits areas where shafts of sunlight filter through the trees, creating a mosaic of sunspots on the forest floor. Males have a dull reddish-brown ground colour with a blue sheen over the leading edge of the forewings. The Ghanaian specimen depicted here is believed to be a new-to-science species, but in the absence of a specimen it remains undescribed. Its markings are similar to *B.tentyris* but it differs very markedly in colour, being an almost luminous bright pink, with khaki colouration replacing the blue of *B.tentyris*.

One of the most familiar butterflies in the African rainforests is the pretty Forest Glade Nymph, *Aterica galena*. Both sexes habitually bask with the forewings swept back while feeding at figs or other decomposing fruit. They have a rapid flight over short distances and usually fly close to the ground.

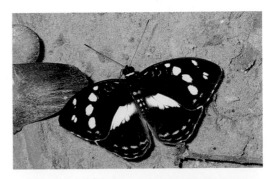

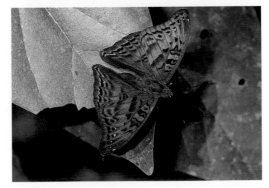

TOP Forest Glade Nymph, *Aterica galena*, Wli Falls, Ghana.

BOTTOM Common Commander, *Euryphura chalcis*, Bunso, Ghana.

MORPHINAE

This subfamily is regarded by some taxonomists as a tribe within the Satyrinae. It is treated here as a subfamily with three tribes – Morphiini, Brassolini and Amathusiini. Most are large or very large butterflies with blue uppersides, and dark undersides marked with conspicuous ocelli.

Morphini

The dazzling electric blue *Morpho* butterflies of Amazonia are probably the most well-known butterflies in the world. They are among the largest butterflies on the planet, measuring from 75–190mm (3–7.5in) across the wings, according to species. There are almost 80 *Morpho* species, distributed variously from Mexico to Uruguay and northern Argentina.

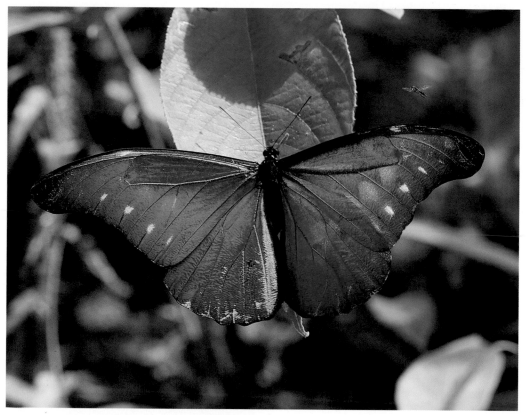

Sickle-winged Morpho, *Morpho rhetenor*, Rio Shima, Peru.

The wings of *Morpho* butterflies are enormous relative to their body size, resulting in a very distinctive slow, bouncy flight pattern. Their iridescent blue wings seem to flash like beacons as they alternate in flight with their dark undersides. Although the vast majority of species are metallic blue, there are a few exceptions. Several, including *M.lympharis*, *M.epistrophus* and *M.athena*, are brilliant white with an iridescent mother-of-pearl sheen. Others, including the females of *M.rhetenor* and *M.cypris*, are dark brown with broad orange-yellow bands.

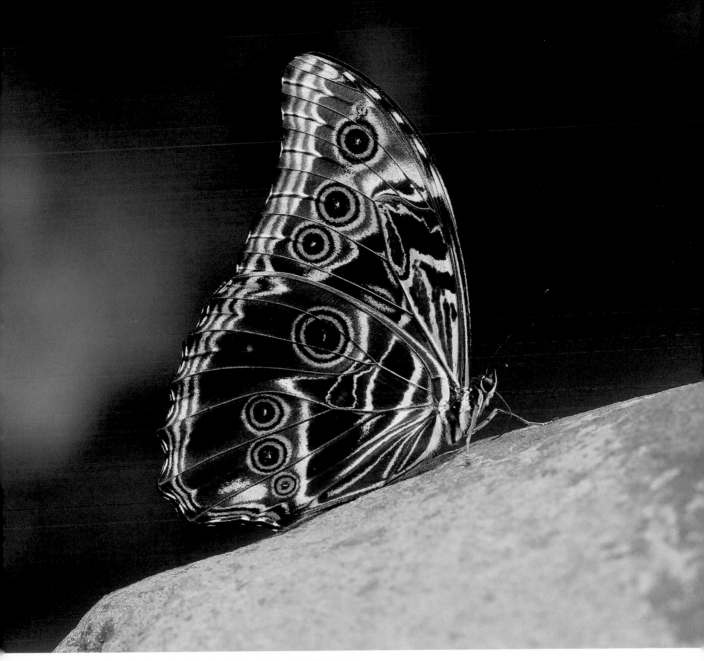

Hübner's Morpho, *Morpho deidamia*, Tingo Maria, Peru.

In addition to *Morpho*, the tribe Morphini includes two other genera – *Caerois* and *Antirrhea*. Both are generally dark brown in colour, usually with a faint blue sheen or patches of blue on their tailed hindwings. They fly mainly in the early evenings. Consequently, *Antirrhea philoctetes* is known in Trinidad by the delightful local name Queen of the Night.

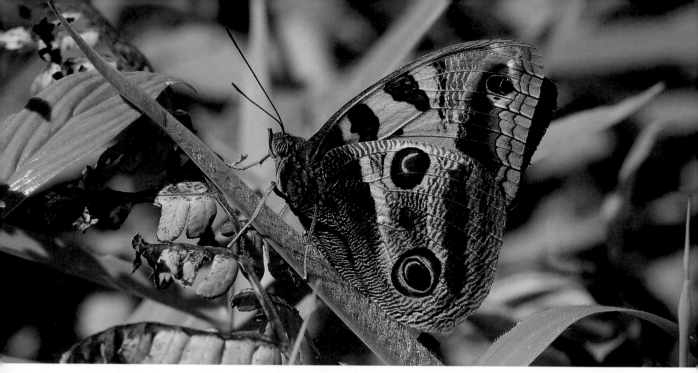

Sunshine Owlet, *Blepolenis batea*, Serra da Bocaina, Brazil.

Brassolini

There are 86 species in the tribe Brassolini, split among 17 genera. The smallest species, from the genera *Bia* and *Narope*, only measure about 55mm (2.2in) in wingspan, but the larger *Caligo* Owl butterflies can measure up to about 150mm (5.9in) across. The undersides of brassolines have feathery or bark-like patterns, often incorporating conspicuous ocelli on the hindwings.

Most brassolines are only active at dawn and dusk, but *Blepolenis batea* bucks the trend and only flies in bright sunlight. The upperside of this magnificent species is blackish, with broad suffused bright orange bands. It is found in south-east Brazil, Paraguay and northern Argentina.

Itatiaia Owlet, *Dasyophthalma rusina*, Itatiaia, Brazil.

The Itatiaia Owlet, *Dasyophthalma rusina*, is endemic to the endangered Atlantic coast rainforests of south-east Brazil. These wonderful forests, renowned for their high biodiversity and outstanding endemism, are perilously close to the gargantuan cities of Rio de Janeiro and Sao Paulo, which between them house 70 per cent of Brazil's burgeoning population of 190 million. Almost 80 per cent of the original forest has already been lost to logging, agriculture, cattle ranching and urban expansion.

The 21 *Caligo* species are popularly known as Owl butterflies due to their feathery appearance and the owl-like 'eyes' on the underside hindwings. Various theories

have been proposed to explain the presence of the eyespots, the most popular being that the butterflies are simulating owls. When at rest however, only one side of the wings can be seen at a time and the butterfly's appearance then is not owl-like.

A more rational likelihood is that the eyespot acts as a decoy. Owl butterflies are huge and have a slow clumsy flapping flight, so a bird could easily follow one to its resting place. Once it has settled, the butterfly's mottled pattern provides it with superb camouflage against the bark of a tree, although the eyespot remains easily seen. Birds don't direct their beaks aimlessly. They focus their aim on the most obvious feature. By diverting an attack away from its vulnerable body and towards the decoy eyespot, a butterfly avoids a fatal peck and is often able to escape, leaving the bird with nothing but a piece of wing in its beak.

Owl butterflies are usually encountered as singletons, flying just before dusk along narrow trails. They are strongly attracted to tree sap and decomposing fruits. If alarmed, they fly off in an ungainly panic, with the swooshing of their wings clearly audible. They only travel short distances at a time and usually settle on narrow tree trunks. If they attempt to land on foliage, they often fail to maintain their grip and are forced to fly off again and resettle elsewhere.

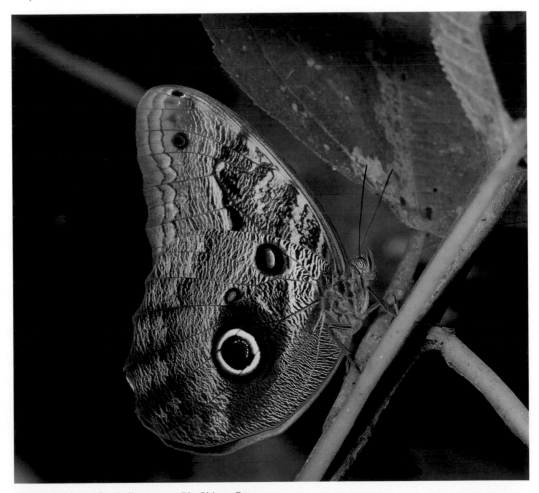

Teucer Owl butterfly, *Caligo teucer*, Rio Shima, Peru.

Amathusiini

The Amathusiini is the South-East Asian sister tribe to the Neotropical Morphini and Brassolini. It is comprised of 109 species, split into 15 genera.

The *Faunis* Fawns measure about 75mm (3in) in wingspan and are plain brown in colour with indistinct dark lines and small ocelli on the hindwings. At the other extreme, the *Zeuxidia* Saturns can measure almost 150mm (5.9in) across the wings. The males are black with diagonal metallic blue bands across their forewings, while the females are brown with white or orange bands. The undersides are pale brown with darker lines and have a pair of prominent ocelli on the hindwings. The 27 *Taenaris* species are extremely distinctive, their undersides being white with a pair of huge orange-ringed ocelli on the hindwings.

Most amathusiines are crepuscular. Those such as *Melanocyma* and *Zeuxidia* which fly in the daytime, rarely venture into open areas, preferring instead to remain in the denser parts of the jungle. Occasionally small groups gather at fallen fruit, but they are always very alert, flying up instantly if disturbed. If chased by a bird, they charge into dense undergrowth and settle on the ground among leaf litter.

NYMPHALINAE

There are six tribes in the Nymphalinae – Coeini, Victorinini, Junoniini, Kallimini, Nymphalini and Melitaeini. Additionally, there are a few genera such as *Rhinopalpa*, *Kallimoides* and *Vanessula* whose taxonomy is unresolved and thus have not yet been assigned to any tribe.

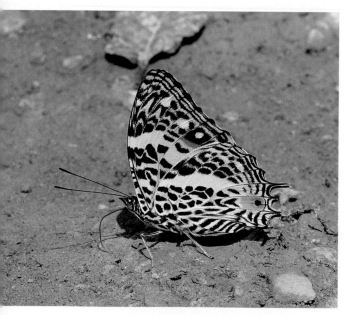

Leopard-spotted Beauty, *Baeotus deucalion*, Boca Colorado, Peru.

Coeini

The Coeini contains only three genera: *Pycina*, *Historis* and *Baeotus*. All are Neotropical in distribution. They are strongly built, powerful flyers; reminiscent of Charaxinae. One of the most familiar species is the Stinky Oakleaf, *Historis odius* – a large and impressive creature with an underside wing-pattern that simulates a dead leaf.

The four *Baeotus* species are sexually dimorphic. Males are black above with bands of metallic blue, while females are banded instead with orange. The undersides of both sexes are very attractively patterned with black spots and dashes on a pure white ground colour. The adults are always encountered singly, usually near rivers and often close to jetties or human habitations.

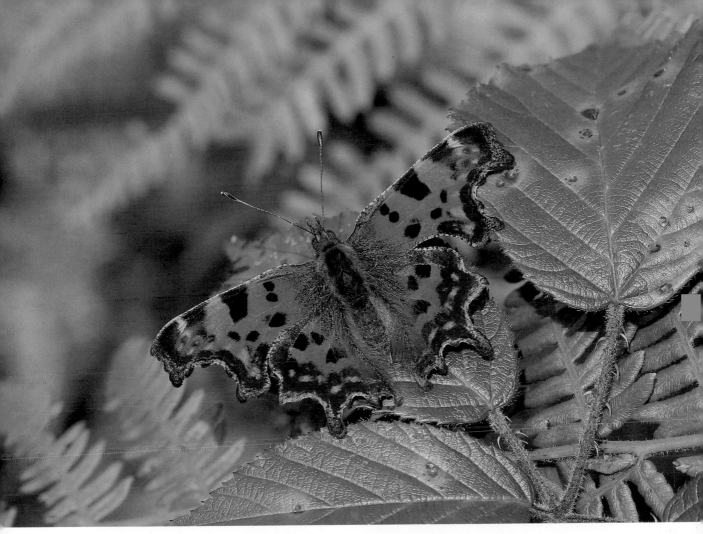

Comma, *Polygonia c-album*, Sussex, England.

Nymphalini

The Nymphalini is represented in all regions of the world and contains about 100 species split into 13 genera.

This cosmopolitan tribe includes many familiar butterflies, for example the Peacock, *Inachis io*, and the *Polygonia* Question-marks and Commas, which are named after the white 'punctuation marks' on the underside of their jagged wings. It also contains the well-known Red Admiral, *Vanessa atalanta*, and its close relative the Painted Lady, *V.cardui*, which is the most widely distributed butterfly in the world.

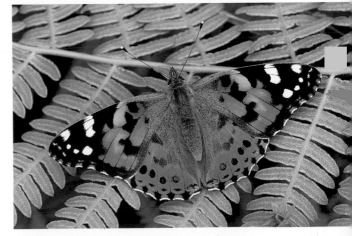

Painted Lady, *Vanessa cardui*, Wiltshire, England.

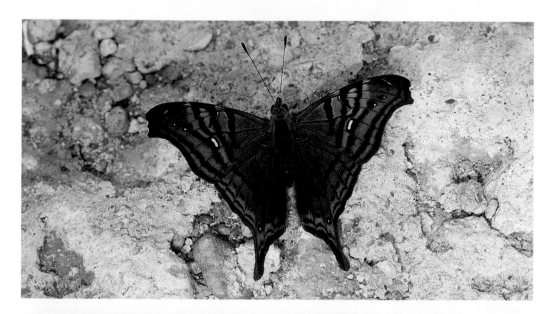

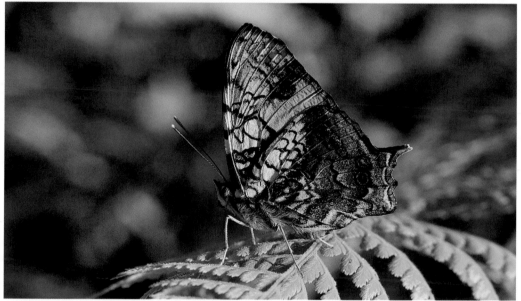

TOP False Daggerwing, *Hypanartia dione*, Rio Kosnipata, Peru.
BOTTOM Orange Admiral, *Hypanartia lethe*, San Ramon, Peru.

The 14 *Hypanartia* species are commonly known as Mapwings due to the markings on their undersides, which supposedly resemble the contours of physical maps. The False Daggerwing, *H.dione*, is often encountered in Andean cloud forests. Males habitually visit damp patches along roadsides, where they flit nervously from place to place until they find a spot rich in dissolved minerals. The closely related Orange Admiral, *H.lethe*, is the commonest and most widespread member of the genus. It is found in cloud forest habitats from Mexico to Bolivia.

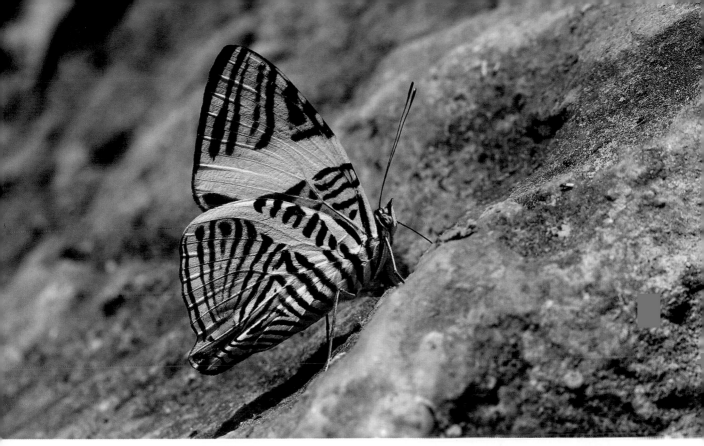

Mosaic, *Colobura annulata*, Rio Shima, Peru.

The beautiful Mosaics, *Colobura dirce* and *C.annulata*, are iconic rainforest butterflies found from Mexico to Argentina. They commonly perch on tree trunks, adopting a head-downward posture while feeding at sap runs. They are normally oblivious of humans, but sometimes try to evade observers by dashing squirrel-like around to the opposite side of the tree. If followed, they run back to their original position – quite literally forcing the pursuer to run around in circles after them.

There are 14 *Symbrenthia* species distributed across the Oriental region. They are similar to *Pantoporia* in colour and pattern, but have a more angular wing-shape. The Common Jester, *Symbrenthia lilaea*, is found in well-forested regions of India, Myanmar, Cambodia, China, Taiwan, Malaysia, Sumatra, Borneo and Sulawesi.

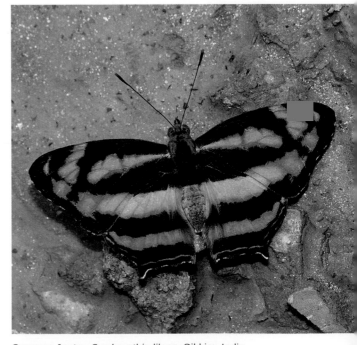

Common Jester, *Symbrenthia lilaea*, Sikkim, India.

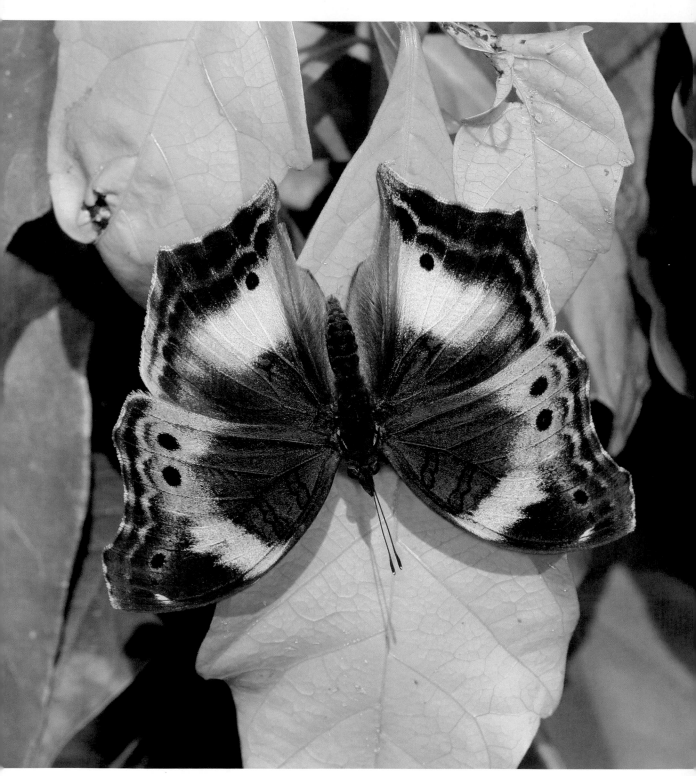

Western Blue Beauty, *Protogoniomorpha cytora*, Bobiri, Ghana.

Junoniini

The Junoniini is represented in all regions except the Palearctic. Among the 57 African species is the beautiful Mother of Pearl, *Protogoniomorpha parrhassus*, which when seen in flight is quite sensational, with flashes of pink, purple, gold and green reflecting from its jagged white wings. Its close relative, the Western Blue Beauty, *P.cytora*, is one of the most beautiful butterflies in Africa. It often basks in a head-downward posture on forest bushes.

The 17 *Precis* species are found only in Africa. They are known as Pansy butterflies because the colours and patterns of many species are reminiscent of *Viola* flowers. Closely related and very similar in appearance are the 33 *Junonia* species, which occur variously in Africa, the Oriental region, Australia and the Americas. Both genera are found in forest clearings and other open, disturbed habitats. They are nervous in disposition and have a rapid flitting flight, always close to the ground.

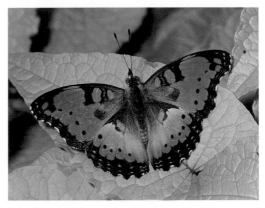

There are 31 species in the pan-tropical genus *Hypolimnas*. The butterflies are commonly known as Egg Flies. The name refers to the remarkable behaviour of the Asian species *H.antilope*, whose female is reputed to sit over her batch of eggs, protecting them from attack by parasitoid wasps. She is said to remain in position until the eggs hatch, after which she dies *in situ*.

Gaudy Commodore, *Precis octavia*, dry season form, Aburi, Ghana.

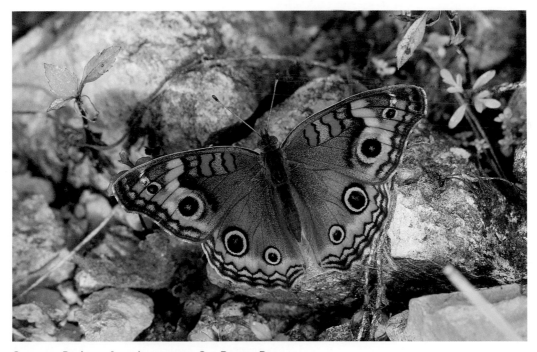

Genoveva Buckeye, *Junonia genoveva*, San Ramon, Peru.

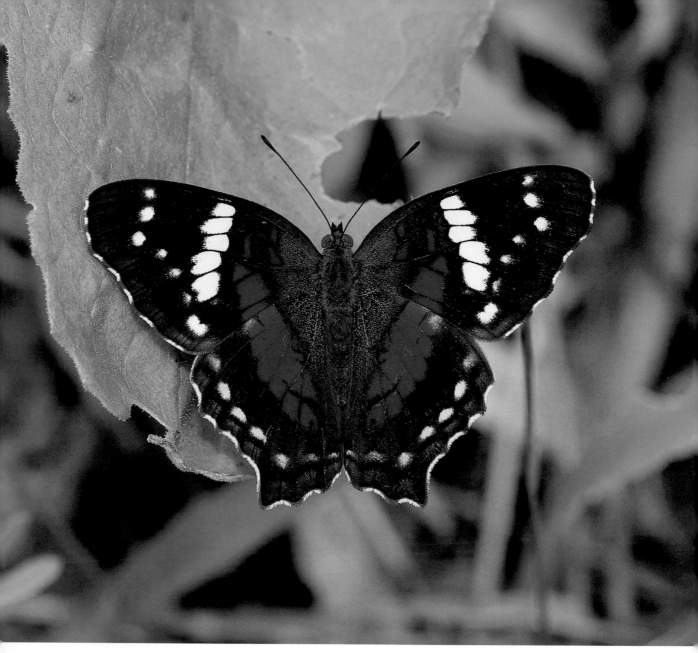

Red Peacock, *Anartia amathea*, Itatiaia, Brazil.

Victorinini

The Victorinini contains four Neotropical genera – *Metamorpha*, *Anartia*, *Siproeta* and *Napeocles*. The Red Peacock, *Anartia amathea*, also known as the Coolie, is a very common species found on both sides of the Andes from Colombia to northern Chile. Its ubiquitous nature and contiguous populations result in regular exchanges of genetic material. Consequently, variation in colour and pattern is virtually non-existent. The butterfly is found in disturbed habitats including gardens, forest clearings, roadsides and fields, but it probably originated in rainforest, where it still commonly occurs along riverbanks and in glades.

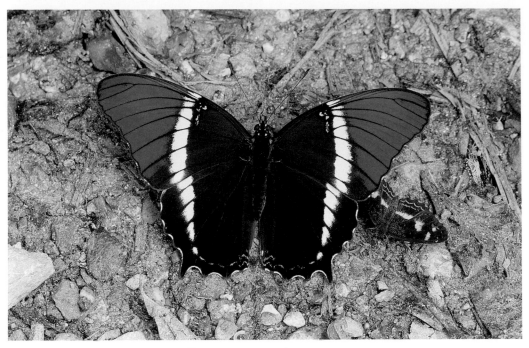

Rusty-tipped Page, *Siproeta epaphus*, Maquipucuna, Ecuador.

The impressive swallowtail-like Rusty-tipped Page, *Siproeta epaphus*, is a common species in the Andes but is usually seen singly. Males flit gently from spot to spot, settling frequently to bask on low foliage, or to imbibe mineralised moisture from damp roads or muddy riverbanks. Females make egg-laying runs back and forth along forest edges where they can be found nectaring at the flowers of shrubs such as *Croton*, *Lantana* and *Cordia*.

The gorgeous green Malachite, *Siproeta stelenes*, is very different in appearance to its relative *S.epaphus*. It is distributed from the southern states of the USA to Peru, Bolivia and south-east Brazil. It looks particularly beautiful when seen at rest, with sunshine streaming through the translucent green windows on its wings. Males feed mainly at fermenting fruit, while females can often be seen nectaring at the flowers of *Lantana*. The butterflies go to roost in late afternoon, hanging beneath the leaves of trees or bushes.

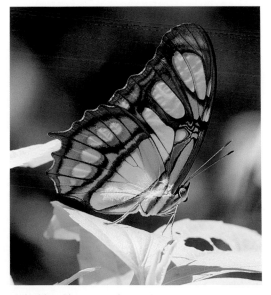

Malachite, *Siproeta stelenes*, Catarata Bayoz, Peru.

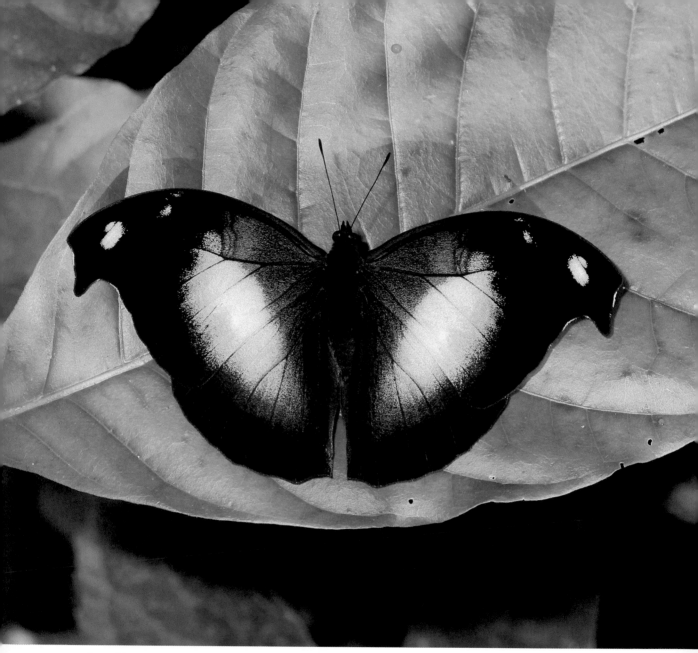

Great Blue Hookwing, *Napeocles jucunda*, Rio Shima, Peru.

The Great Blue Hookwing, *Napeocles jucunda*, inhabits rainforest at the foothills of the eastern Andes, at elevations between about 400–800m (1,310–2,620ft). This large magnificent butterfly spends most of its time high in the canopy, but sometimes descends to imbibe moisture from the ground. When at rest it holds the wings erect, displaying its cryptic 'dead leaf' underside, but when temperatures drop in the late afternoon it will sometimes bask on foliage with its wings outspread.

Kallimini

The Kallimini is comprised of 25 species, found variously from Africa to the Indian subcontinent, Malaysia, Indonesia and north-east Australia. There are four genera – *Kallima*, *Doleschallia*, *Catacroptera* and *Mallika*.

All members of the tribe have very leaf-like undersides. The disguise is most highly developed in the Indian Dead Leaf, *Kallima inachus*, also known as the Orange Oakleaf. Its falcate wing-shape and cryptic underside colouration create the illusion of a dead leaf, complete with a fake midrib. This defence strategy is highly effective because *K.inachus* exhibits considerable variation in the underside pattern, making it very difficult for a bird to form a reliable search image. Neverthless, the butterflies are regularly attacked by birds, as evidenced by the many adults found with chunks pecked out of their wings.

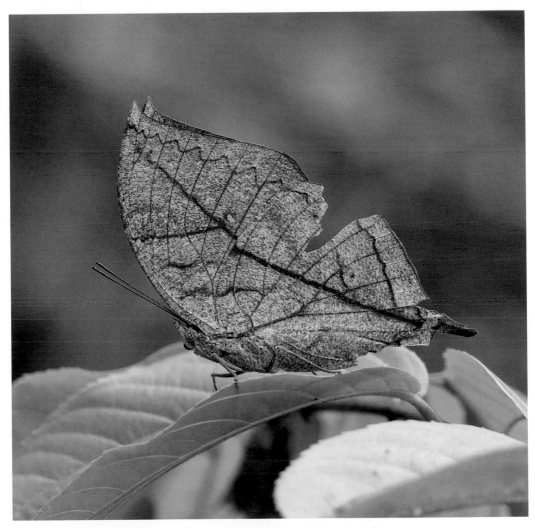

ABOVE AND OVERLEAF Indian Dead Leaf, *Kallima inachus*, Manas NP, Assam, India.

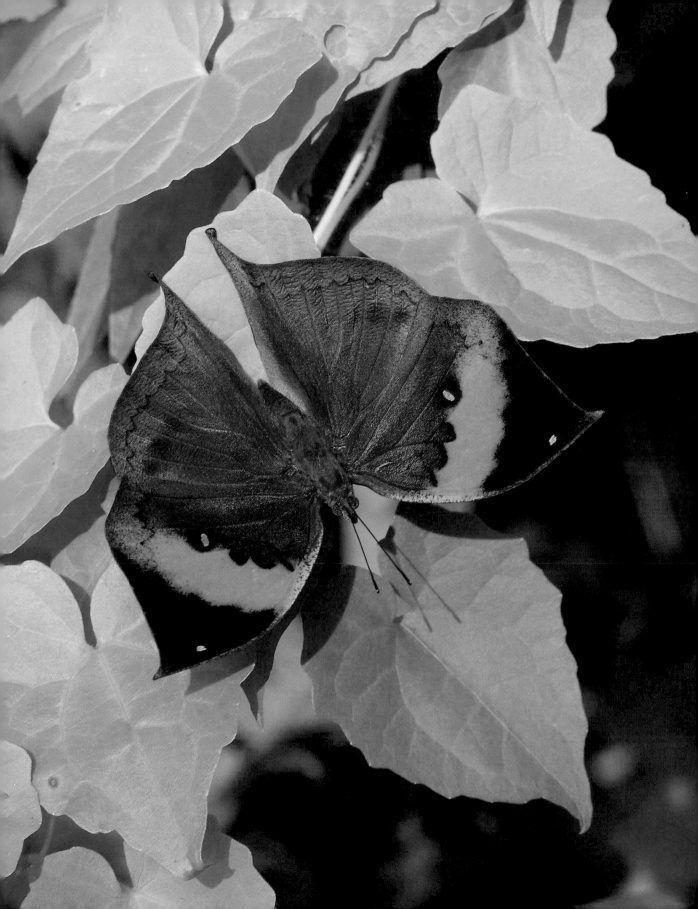

Melitaeini

There are 260 species in the Melitaeini, a tribe which is regarded by many as being worthy of subfamily status.

In Europe, North Africa and temperate Asia the tribe is represented by two genera, *Euphydryas* and *Melitaea*. The latter now incorporates *Mellicta*, which was formerly regarded as a distinct genus. In the Palearctic region melitaeines are commonly known as Fritillaries; a rather misleading name, as it is also applied to certain unrelated heliconiine genera such as *Argynnis*, *Speyeria* and *Clossiana*.

North American genera include *Euphydryas*, *Poladryas*, *Phycioides*, *Anthanassa*, *Chlosyne* and *Dymasia*. The last four also occur in the Neotropics, as do *Microtia*, *Gnatotriche*, *Higginsius*, *Phystis*, *Telenassa*, *Dagon*, *Ortilia*, *Tisona*, *Tegosa*, *Eresia*, *Castilia*, *Janatella*, *Mazia* and *Texola*. The Caribbean islands of Jamaica, Hispaniola and Cuba account for two genera, *Antillea* and *Atlantea*. The New World genera are popularly known as Crescents, Patches and Checkerspots.

TOP Cloudforest Crescent, *Anthanassa acesas*, Medellin, Colombia.

BOTTOM Orange Crescent, *Tegosa claudina*, Tatama NP, Colombia.

Marsh Fritillary, *Euphydryas aurinia*, Dorset, England.

One of the most attractive and variable European species is the Marsh Fritillary, *Euphydryas aurinia*. It is a rapidly declining butterfly, suffering greatly from habitat loss as a result of land drainage and urbanisation. In some years it can be still be abundant at certain sites, but in other years climatic conditions favour its natural enemy, the wasp *Apanteles bignelii*, which parasitizes its larvae. In such years the populations of *E.aurinia* crash dramatically, causing local extinctions. The isolation of the few remaining colonies means that natural recolonisations are virtually non-existent, so the range of the butterfly continues to shrink. It seems possible that the butterfly will face global extinction within the next 30 years.

Several of the Neotropical melitaeines are Batesian mimics of danaines, ithomiines or heliconiines. The Tiger Crescent, *Eresia eunice*, for example, mimics unpalatable tiger-complex species such as *Mechanitis polymnia* and *Eueides isabella*. Another very interesting example is Hewitson's Mimic, *Eresia datis*. This butterfly produces at least 40 different morphs, each of which mimics a different species. Examples include *Eresia datis phaedima* which is a mimic of *Actinote anteas*; and *Eresia datis corybassa* which mimics *Heliconius melpomene* and *Heliconius erato*.

Hewitson's Mimic, *Eresia datis phaedima*, San Ramon, Peru.

Constable, *Dichorragia nesseus rileyi*, Sichuan, China.

PSEUDERGOLINAE

Some taxonomists place this confusing group of butterflies within the Cyrestinae. Others consider them to be distinct enough to warrant them being elevated to the rank of a subfamily, i.e. Pseudergolinae.

There are four genera in the group, all of which are Oriental in distribution. The genus *Amnosia* contains only a single species, *A.decora*. The taxonomies of *Stibochiona* and *Pseudergolis* are contentious, with each containing somewhere between 2–5 species. Similarly, *Dichorragia* may only contain two valid species, *D.nesimachus* and *D.ninus*, but some workers split each of these into a number of subspecies.

The beautiful iridescent blue-green Constable, *Dichorragia nesseus*, is regarded by some as a subspecies of *D.nesimachus*. It occurs from India to Japan and has at least 11 geographical forms. It is normally restricted to dense forests, but males are occasionally observed mud-puddling in more open situations in valley bottoms.

SATYRINAE

The systematics of the Satyrinae is volatile and contentious. Some taxonomists, for example, regard the Morphini, Brassolini and Amathusiini as being tribes within the Morphinae. Others place them in the Satyinae, alongside Dirini, Eritini, Elymniini, Haeterini, Melanitini, Ragadini, Satyrini and Zetherini. The composition of several tribes is also open to conjecture, with some authorities including the sub-tribes Zetherina and Lethina within Elymniini, while others place them in Zetherini and Satyrini respectively. This confusion currently makes it virtually impossible to keep track of the number of satyrine genera and species, but it is estimated that there are at least 1,270 species worldwide.

Elymniini

This tribe contains a single genus *Elymnias*. Its 45 species are commonly known as Palmflies. The majority of species are native to Indonesia, but the genus is also represented in Africa, India and South-East Asia. One species, the Papuan Palmfly, *E.agondas*, reaches northern Queensland.

Palmflies are palatable to birds, but escape predation by mimicking toxic butterflies that inhabit the same areas. The Common Palmfly, *Elymnias hypermnestra*, for example, has a cryptic dead-leaf pattern on its underside, but the upperside of the female closely resembles a noxious danaine – the Plain Tiger, *Danaus chrysippus*. Another example is the female of *Elymnias agondas* from New Guinea, which is white with conspicuous ocelli. It is a mimic of the Silky Owl, *Taenaris catops*, an unpalatable amathusiine whose larvae feed on noxious cycads. In several cases *Elymnias* males and females mimic entirely different species. Males of *E.kuenstleri*, for instance, mimic the Striped Blue Crow, *Euploea mulciber*; while females mimic another noxious danaine, the Tree Nymph, *Idea leuconoe*.

Haeterini

The Haeterini consists of five genera, all confined to the Neotropical region. They are crepuscular in behaviour and inhabit the darker recesses of the forest.

The most commonly encountered genus is *Pierella*. There are 11 species. Most are dark brown in colour, although several have blue, orange or red markings on the hindwings. They fly mainly at dawn, always keeping close to the ground. They skip lazily from spot to spot, twisting and turning as they settle, in a style reminiscent of the movements of a ballroom dancer's feet. Hence they are popularly known as Lady's Slipper butterflies.

The other genera – *Cithaerias*, *Haetera*, *Pseudohaetera* and *Dulcedo* – are known as Phantoms, due to their crepuscular behaviour, transparent ghost-like wings and skulking flight. They spend the majority of their time hiding, motionless, in dense undergrowth. When they fly it is always close to the ground and only over very short distances. Upon settling they snap their wings shut, turn quickly around and tilt slightly forward, drawing attention to the small but conspicuous ocellus on the hindwing. In these genera, the function of this 'false-eye' is debatable. It may be an element of a diematic pattern, in which the hindwing simulates the head of a snake; or it may simply be a decoy to divert bird attacks away from the body.

Melanitini

This tribe is composed of five genera. The three *Cyllogenes* species are denizens of the Himalayan foothills. *Parantirrhoea* contains a single species, *P.marshalli*, which is endemic to Kerala in India, while there are three *Gnophodes* species, all native to Africa.

The genus *Melanitis* is comprised of 12 species, the most widespread of which is the Common Evening Brown, *M.leda*. It can be found throughout the entire Oriental region, across most of Africa and in the rainforests of Australia. The rainy season morph is marked on the underside with very fine striations and a series of conspicuous ocelli on the hindwings. There are several dry season morphs. Some are very plain, while others are highly variegated, but all are devoid of ocelli. As implied by their common name, *Melanitis* species are active mainly at dusk. They often enter houses, attracted by artificial lighting.

ABOVE Great Evening Brown, *Melanitis zitenius*, Sikkim, India.

OPPOSITE Lady's Slipper, *Pierella lamia chalybaea*, Rio Tambopata, Peru.

In 2006 Wahlberg published a paper on the higher level phylogeny of satyrines, resulting in the unexpected transferral of a Neotropical species, *Manataria hercyna*, to this tribe. Despite its current placement in the Melanitini, it is superficially more similar to the Oriental *Lethe* Treebrowns – members of the Satyrini.

Dirini

The six genera in this tribe are all native to Africa. The best-known is the Table Mountain Beauty, *Aeropetes tulbaghia*. This magnificent South African butterfly has dark brown wings with yellow bands and spots, and a series of blue-centred ocelli on the hindwings.

Eritini

The Eritini is an Oriental tribe containing only eight species, of which three are assigned to the genus *Coelites*, while the other five are placed in *Erites*. The latter are scarce and highly localised butterflies, found in swampy areas of rainforest. The Elegant Satyr, *Erites elegans*, is found in West Malaysia, Sumatra and Borneo.

Elegant Satyr, *Erites elegans*, Taman Negara, West Malaysia.

Zetherini

There are five genera in this tribe, all Oriental in distribution. Most of the species are Batesian mimics. The Blue Kaiser, *Penthema darlissa*, for example, is a convincing mimic of noxious *Parantica* and *Tirumala* species, while *Ethope diademoides* mimics another danaine *Euploea core*. The four *Neorina* species are among the largest Satyrs in the world. The oddly-shaped Malayan Owl, *Neorina lowii*, can measure as much as 120mm (4.7in) across. In size and pattern it is very reminiscent of the Black and White Helen, *Papilio nephelus*.

Satyrini

The Satyrini are represented in all zoogeographical regions of the world; and in all vegetated habitats including mountain peaks, tundra, rainforests and desert oases. Their larvae feed on grasses, sedges or bamboos. The adult butterflies are all believed to be palatable to birds. Most species rely on camouflage to escape predation.

There are at least 2,300 species in the tribe, split between a total of 217 genera including the *Coenonympha* Heaths, *Lethe* Treebrowns, *Erebia* Mountain Ringlets, *Melanargia* Marbled Whites, *Hipparchia* Graylings and numerous genera within the Neotropical euptychiine and pronophiline complexes.

Valentina Ringlet, *Pseudodebis valentina*, Rio Madre de Dios, Peru.

Marbled White, *Melanargia galathea*, Sussex, England.

Unlike most Satyrs, which tend to be fairly drab brown insects, the Marbled Whites, *Melanargia*, have beautiful black and white checkerboard markings. Such distinctive patterns are easily remembered by birds. Some biologists believe they are a form of aposematic colouration, indicating that Marbled Whites have noxious qualities. Others believe that the butterflies are palatable, but that they are Batesian mimics of toxic pierines.

One of the most attractive Palearctic satyrines is the Woodland Brown, *Lopinga achine*. It is a localised species, found in damp sunny glades in mature beech or oak woodland where *Carex* sedges are profuse. Females sometimes visit *Ligustrum* flowers but obtain their sustenance primarily from aphid secretions on foliage. Males cavort in twos and threes around hazel bushes and can sometimes be found in small groups imbibing mineralised moisture from bare ground.

The *Hipparchia* Graylings are found on

Woodland Brown, *Lopinga achine*, Saaremaa, Estonia.

Grayling, *Hipparchia semele*, Cumbria, England.

heaths, cliffs, limestone plateaux and other habitats where grasses grow sparsely. There are 27 species, distributed across Europe, Asia and North Africa. The adults spend long periods at rest. The disruptive patterns on their undersides provide them with superb camouflage whether they settle on tree trunks, bare earth, shingle or rocks. When disturbed, they instantly take flight, twisting and looping rapidly just above the ground. Upon landing they snap their wings shut but keep the forewings raised, so that the eyespot near the apex is visible. This way, any bird which spots where a butterfly has settled, and then attacks, is likely to aim at the eyespot instead of the body. The instant the butterfly feels safe it lowers the forewings to conceal the eyespots.

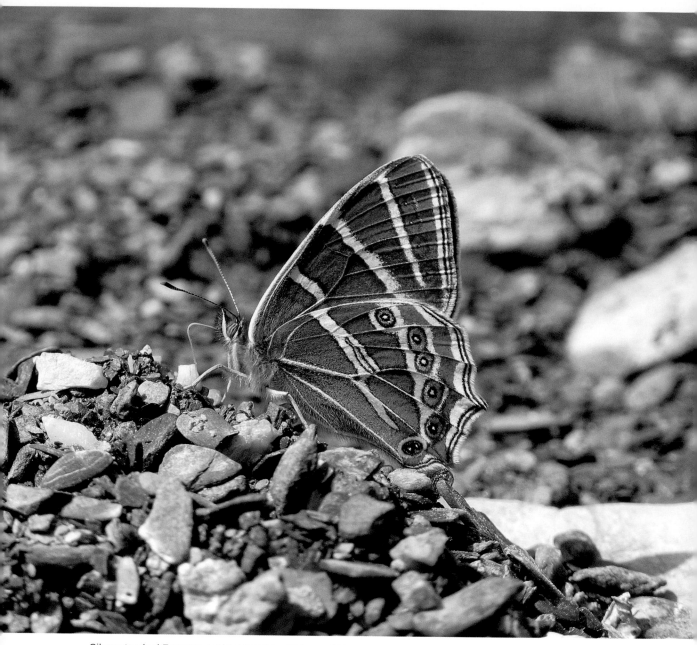

Silver-streaked Forester, *Lethe argentata*, Sichuan, China.

The 112 species of *Lethe* Treebrown are variously distributed across temperate and subtropical Asia from India to Sulawesi and Java. Some species are highly localised and confined to the forests of particular mountains, but others are widespread. The adults typically have sombre earthy brown uppersides, although some have white diagonal bands on their forewings. The underside hindwings feature a series of seven ocelli, which in several species such as *L.europa* and *L.verma* are very conspicuous.

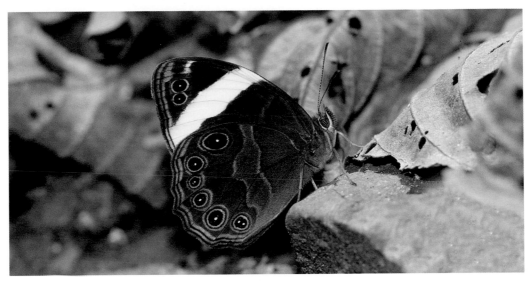

Straight-banded Treebrown, *Lethe verma*, Sikkim, India.

Most species are encountered in twos or threes but the Straight-banded Treebrown, *Lethe verma*, is often found in much larger numbers, flying in the dappled sunlight of small forest glades or along semi-shaded trails. Males often settle in a head-downward posture on tree trunks, using them as lookout stations from which to survey and intercept passing females. The rounded wings of *L.verma* are unusual for this genus – most *Lethe* species have lobes or stubby tails on their hindwings.

There are seven species in the Australian genus *Heteronympha*. The most widespread is the Common Brown, *H.merope*. It is found in open grassy habitats in the south of Western Australia, and in southern Queensland, Victoria, New South Wales and Tasmania.

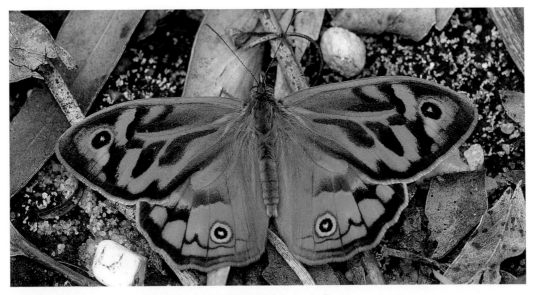

Common Brown, *Heteronympha merope*, New South Wales, Australia.

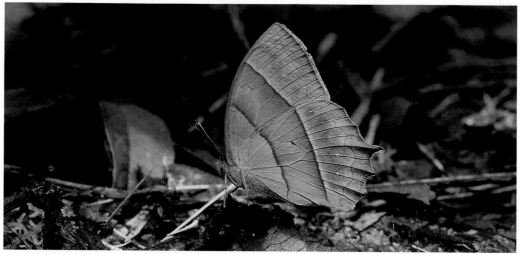

Chrysogone Wood Nymph, *Taygetis chrysogone*, Tatama NP, Colombia.

The Satyrini are extremely well represented in the Neotropics, where over 1,200 species occur. They are tentatively divided among four subtribes – Euptychiina, Erebiina, Hypocystina and Pronophilina.

The Euptychiina contains somewhere between about 400–500 species. They are understudied, so consequently the systematics of the whole group remains very confused. They are currently divided among 43 genera, including *Euptychia, Cissia, Chloreuptychia, Forsterinaria, Hermeuptychia, Magneuptychia, Oressinoma, Pareuptychia, Taygetis* and *Posttaygetis*.

There are 29 known *Taygetis* Wood Nymph species. Most are denizens of the forest understorey and tend to fly close to the ground. They avoid sunlight, preferring to fly at dawn or on overcast days. The forewings are usually falcate or angular, and the hindwings often have scalloped margins. The undersides are very effectively disguised as dead leaves and in most species are embellished with a series of small ocelli that are mimetic of insect galls or spots of leaf mould.

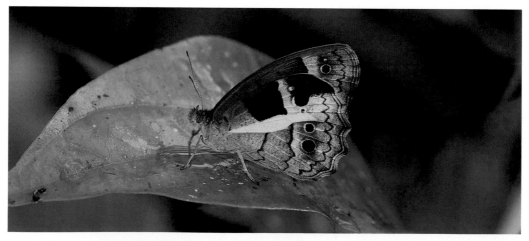

ABOVE Yellow-spiked Satyr, *Posttaygetis penelea*, Pantiacolla, Peru.
OPPOSITE Andromeda Wood Nymph, *Taygetis thamyra*, Rio Claro, Colombia.

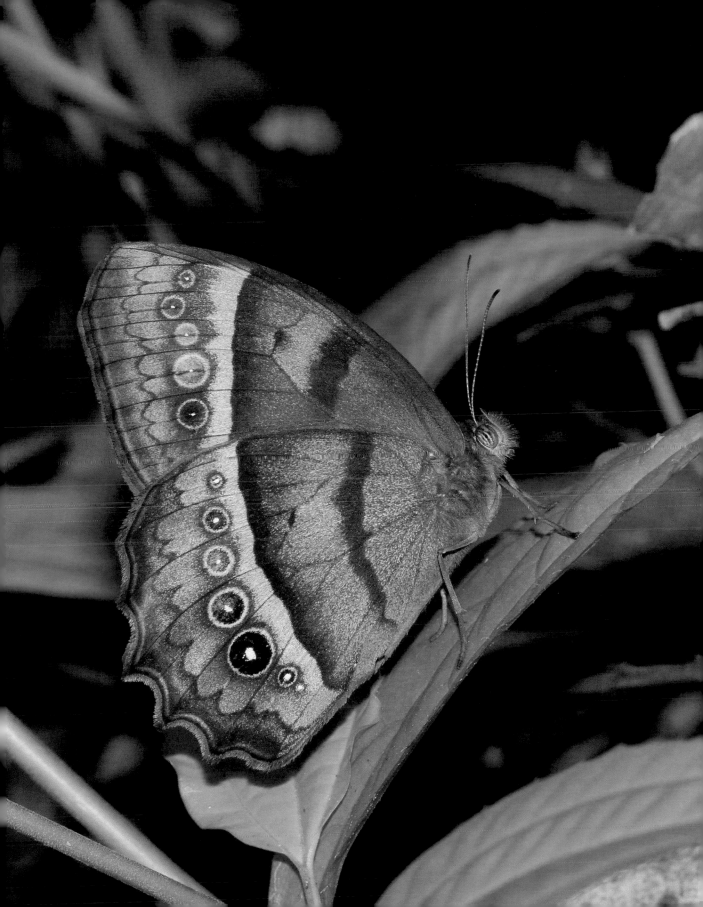

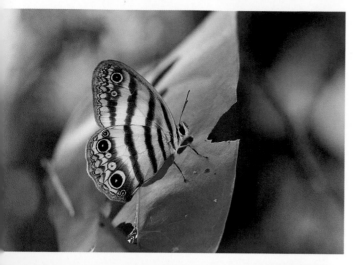

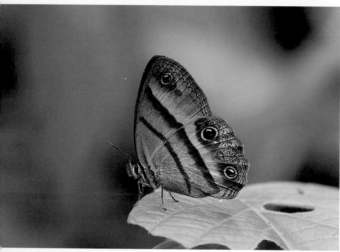

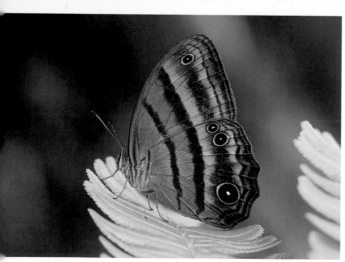

Under current classification the genus *Euptychia* contains about 30 species. One of the most attractive is *E.jesia*, which is found in lowland forests from Mexico to Peru. The 15 *Cissia* species are larger and feature twin-pupilled ocelli. Most also have a suffused orange patch below the ocellus on the underside forewing. Even larger are the 40 *Magneuptychia* species, which can measure up to 55mm (2.2in) in wingspan.

Most of the 12 *Chloreuptychia* species have a blue or violet sheen on both surfaces of the wings. On the underside, they are adorned with conspicuous orange-ringed ocelli. The ocellus in space two is always much larger than the others, while those in spaces three and four are silvery and elongated. One of the most beautiful species is the Tolumnia Blue Ringlet, *C.tolumnia*, found in Ecuador, Peru and Brazil.

An unusual butterfly, which should perhaps be assigned to another subtribe, is the White Satyr, *Oressinoma typhla*. The underside of this very graceful species has a mottled, almost feathery appearance, with suffused broad white bands and strange wavy orange borders on the hindwings. It is usually found near streams or swampy areas in cloud forests.

LEFT TOP Jesia Ringlet, *Euptychia jesia*, Rio Claro, Colombia.

LEFT MIDDLE Penelope Satyr, *Cissia penelope*, Rio Shima, Peru.

LEFT BOTTOM Tiessa Ringlet, *Magneuptychia tiessa*, Tatama NP, Colombia.

OPPOSITE TOP Tolumnia Blue Ringlet, *Chloreuptychia tolumnia*, Pantiacolla, Peru.

OPPOSITE BOTTOM Lobelia Blue Ringlet, *Cepheuptychia lobelia*, Pantiacolla, Peru.

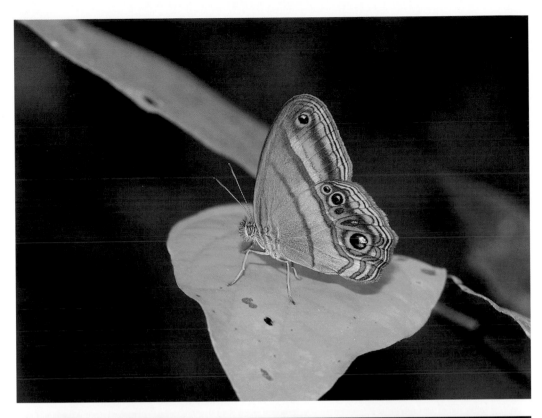

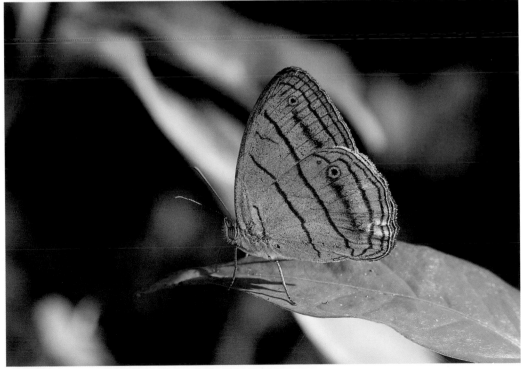

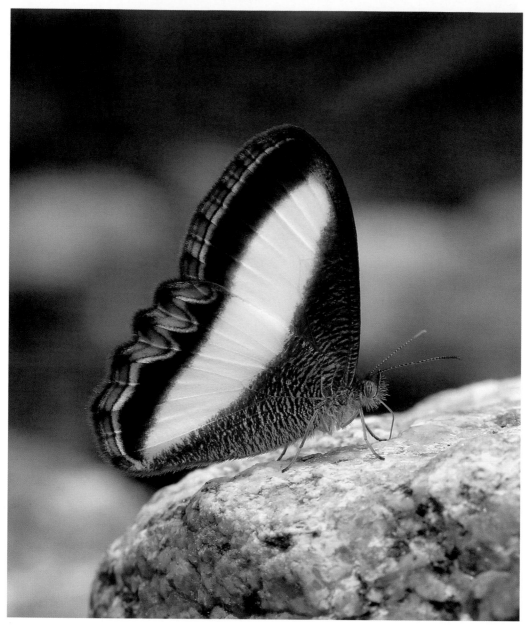

White Satyr, *Oressinoma typhla*, San Ramon, Peru.

The 562 species in the subtribe Pronophilina are classified within 67 genera, among which are *Pedaliodes*, *Corades*, *Eretris*, *Lasiophila*, *Lymanopoda*, *Oxeoschistus*, *Pronophila* and *Steremnia*. Most are high-elevation Andean cloud forest species. However, there are six species that are endemic to Guatemala, Costa Rica or Mexico and about 20 in the Atlantic coast forests of south-east Brazil. More oddly, there is one genus, *Calisto*, which is restricted to Cuba, Hispaniola and the Bahamas.

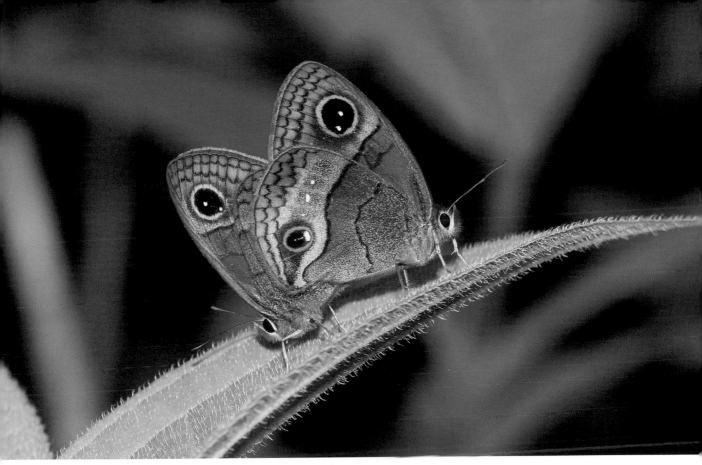

Cuban Calisto, *Calisto herophile*, Cuba.

At the time of writing, there are over 260 known *Pedaliodes* species. More are discovered every year, as their remote cloud forest habitats become better explored. No less than 114 new species were discovered between 1999 and 2004, and the eventual total is forecast to exceed 600 species. *Pedaliodes* are medium-sized butterflies. Most have plain blackish uppersides, although several, including *P.peruda*, *P.praxithea* and *P.triaria*, are banded with orange. The undersides of all species are black or brown, mottled to a greater or lesser degree with white. Some, in addition, have cream bands or marbling. The great majority of species are highly localised, having evolved on remote Andean peaks, isolated from their congeners. Hewitson's Mountain Satyr, *P.pausia*, is one of the more widespread species, being found in transitional elfin cloud forest/paramo habitats in Peru, Bolivia and Argentina.

Hewitson's Mountain Satyr, *Pedaliodes pausia*, Wayqecha, Peru.

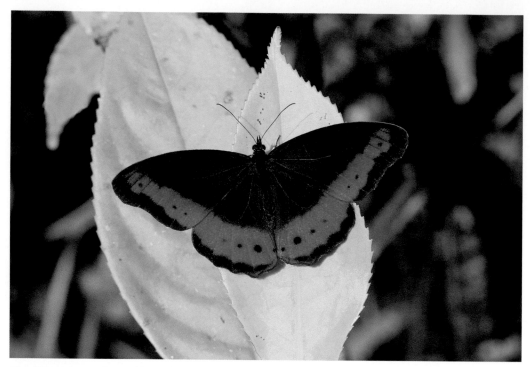

Cloudforest Argus, *Oxeoschistus simplex*, Otún Quimbaya, Colombia.

The genus *Oxeoschistus* is comprised of 13 largish species, distributed variously from Mexico to Bolivia. There are two subgroups within the genus. The *simplex* group are characterised by having dark brown uppersides with a suffused orange outer band that usually contains a complete set of ocelli. The *cothon* group have blackish uppersides that are marked with large white patches. *Oxeoschistus* butterflies can often be seen basking or resting on ferns that grow along cloud forest roadsides. They are found at elevations between about 1,000–2,000m (3,280–6,560ft) according to species.

There are 57 small species in the genus *Lymanopoda*. Some have white or metallic blue patches on the upperside, but most are dark brown. The undersides of many are quite plain, but others are beautifully marbled in shades of brown, yellow and white. The majority have an undulating series of ocelli on the underside hindwings. *Lymanopoda* species are sometimes seen singly, but are more often encountered in mixed-species aggregations, mud-puddling at roadsides.

Rusty Mountain Satyr, *Lymanopoda ferruginosa*, Rio Kosnipata, Peru.

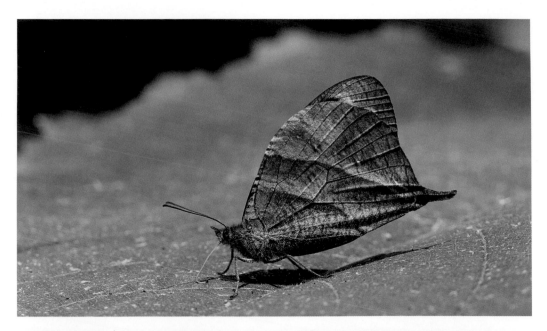

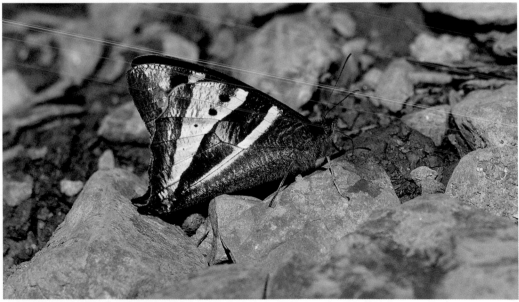

TOP Enyo Falcon, *Corades enyo*, Medellin, Colombia.

BOTTOM Striped Falcon, *Corades ulema*, Wayqecha, Manu, Peru.

The genus *Corades* contains 23 described species. They are easily recognised by their large size and very distinctively shaped hindwings. The undersides of most species are a unicolorous brown, peppered and striated with grey and black. Some, however, such as the very attractive Striped Falcon, *C.ulema*, have contrasting white or cream bands. One of the most widespread species is the Enyo Falcon, *C.enyo*, which can be found at elevations between about 1,400–3,000m (4,595–9,845ft) over much of the eastern Andes.

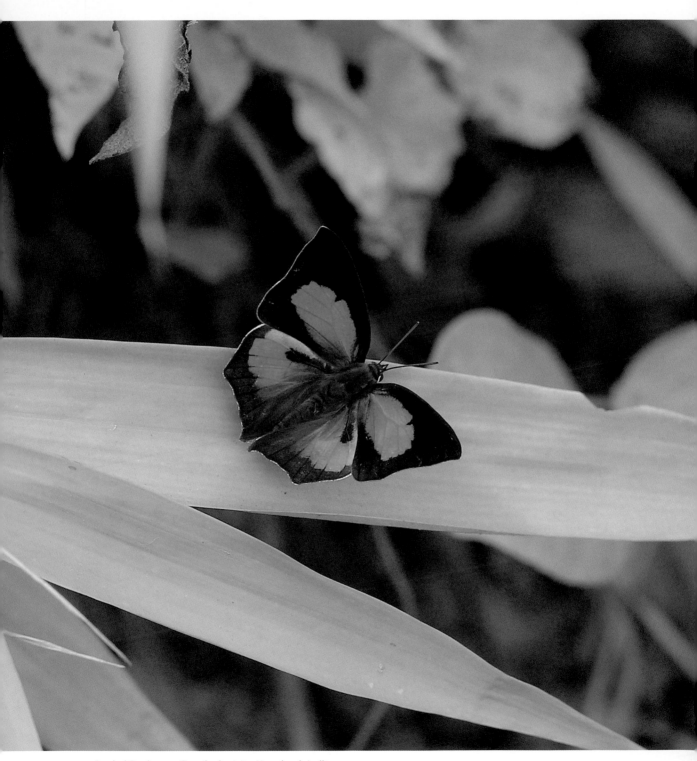

Angled Sunbeam, *Curetis dentata*, Nagaland, India.

LYCAENIDAE

The Lycaenidae, or Gossamer-winged butterflies, are a vast family containing over 4,700 known species worldwide. Many more undoubtedly remain to be discovered as most of the tropical species spend their entire lives undetected in the rainforest canopy.

All genera have six fully functional legs, although those of males are usually reduced in size. The eyes are often surrounded by a ring of white scales. The wings have reduced venation, with vein eight typically absent. Males often have reflective blue or coppery scales over the upper surface of their wings, while females tend to be quite drab and brown. The caterpillars of most species are myrmecophiles, having a parasitic, beneficial or symbiotic association with ants.

Currently the Lycaenidae is divided into eight subfamilies – Curetinae, Liphyrinae, Lipteninae, Lycaeninae, Miletinae, Polyommatinae, Poritiinae and Theclinae. As a result of DNA analysis, *Styx infernalis*, the sole member of the now defunct subfamily Styginae, was transferred to the Riodinidae in 2005.

CURETINAE

All members of this subfamily are placed in the genus *Curetis*. In total there are 18 species, distributed from India to China, Japan, the Philippines, Malaysia, Sumatra, Borneo, Sulawesi, Papua New Guinea and the Solomon Islands.

Males have brilliant fiery copper uppersides that glint in the sunshine, hence the popular name Sunbeams. They probably spend most of their lives in the treetops, but are occasionally spotted perching on the foliage of saplings in places where shafts of sunlight pierce through the canopy. They also sometimes settle on the forest floor to imbibe mineralised moisture.

Females are earthy brown with large suffused white patches and can easily be mistaken in flight for small Pierids. They can sometimes be seen flying around bushes in forest-edge habitats.

Curetis larvae feed on the foliage of trees and shrubs in the family Fabaceae, including *Pongamia*, *Pueraria*, *Millettia* and *Sophura*.

LIPHYRINAE

The subfamily Liphyrinae contains 31 species, of which 25 are placed in the African genus *Aslauga*. Members of this genus are easily recognised by the shape of the forewing, which has a very convex outer margin and an acute apex. The males of most species are dark earthy brown with a metallic blue sheen. Females are either plain brown or have a pale coppery sheen. The larvae are carnivorous, feeding on the nymphs of small Homopterans – coccids, psyllids and membracids. They are usually tended by ants, which provide them with a degree of protection from predators.

Another three African species are placed in the genus *Euliphyra*. They are fairly large butterflies by Lycaenid standards, averaging about 60mm (2.4in) in wingspan. Both sexes are dark brown with large silvery-white patches on the forewings. *Euliphyra* larvae live inside the nests of *Oecophylla* tailor-ants, feeding on ant regurgitations.

There are three *Liphyra* species. Two species, *L.grandis* and *L.castnia*, are endemic to New Guinea. The third species, *L.brassolis*, is found from India to the Philippines and from Malaysia to Papua and north-east Australia. It is one of the largest members of the Lycaenidae in the world, with a wingspan of about 75mm (3in). All *Liphyra* species are heavily built insects with furry bodies and a rapid, haphazard moth-like flight, hence they are popularly known as Moth butterflies. The extraordinary lifecycle of *Liphyra brassolis* is discussed in the 'caterpillar' section of the Lifecycle chapter.

LIPTENINAE

The 560 species in the Lipteninae are all native to Africa. Many, such as the pale yellow *Liptena xanthostola*, are tiny and quite plain in appearance. Others, including *Mimeresia libentina* and *Telipna semirufa*, have undersides beautifully patterned in red, orange, black and white. The majority have metallic blue uppersides. *Epitola posthumus* has almost blindingly reflective blue wings, so bright in fact that the butterfly can quite easily be spotted from a distance of 200m (655ft) away.

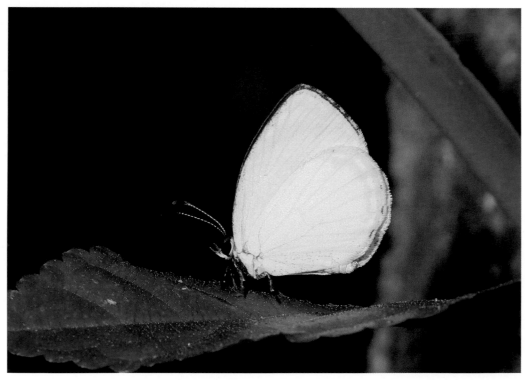

Yellow Liptena, *Liptena xanthostola*, Bunso, Ghana.

The Lipteninae are often encountered in the vicinity of 'ant trees', i.e. trees which support colonies of *Crematogaster* ants. Liptenid larvae browse on the tree trunks, feeding on lichens and blue-green algae. They have glands on their backs which secrete a sugary substance that is milked by the ants. The presence of ants is beneficial to the larvae, because they deter parasitoid wasps and flies.

The genus *Epitolina* contains five tiny, fast-flying species with dark brown uppersides, which in the case of males usually have a faint blue sheen. The undersides are pale earthy brown, overlaid in most species with an intricate pattern of small reddish-orange markings. Males habitually settle on tendrils or thin dry twigs and are very reluctant to fly unless disturbed. The Common Epitolina, *Epitolina dispar*, is found in rainforest and secondary growth from Sierra Leone to Angola, Congo and Uganda.

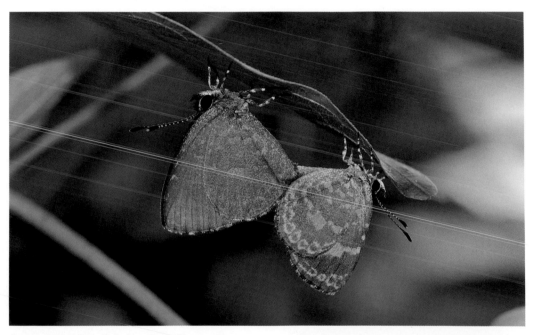

Common Epitolina, *Epitolina dispar*, Bunso, Ghana.

In Ghana, small mixed-sex groups of the Western Pearly, *Eresiomera bicolor*, can often be found feeding at extrafloral nectaries on the stems of Marantaceae. The nectaries are also attended by *Crematogaster* ants. The butterflies seem intolerant of each other, as well as of ants. They behave in a nervous and agitated manner, running backwards, spiralling rapidly down stems, or scurrying around them while flicking their wings open and shut.

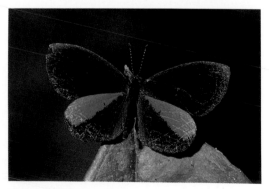

Western Pearly, *Eresiomera bicolor*, Wli Falls, Ghana.

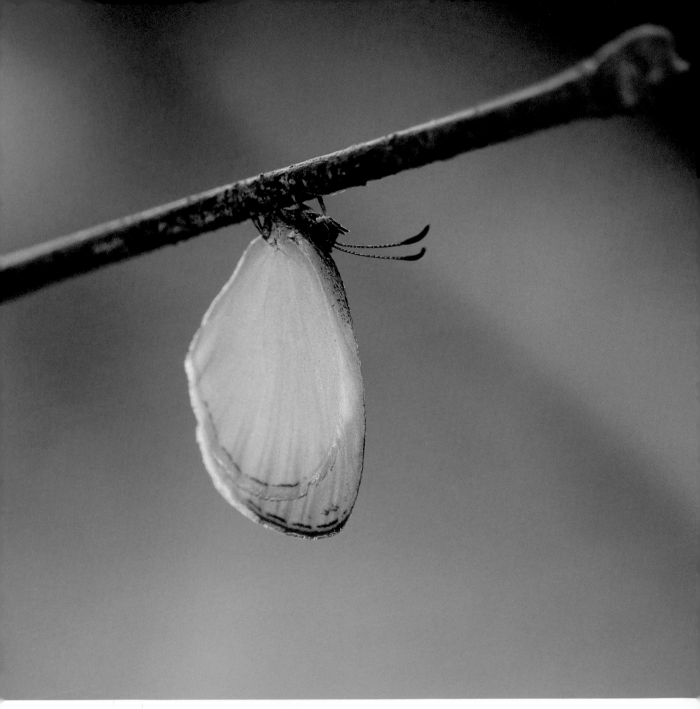

Pallid Liptena, *Liptena albicans*, Bobiri, Ghana.

Most Liptenids spend long periods at rest on spindly dry twigs, often aggregating in small groups to roost for the night. Some species, such as the Red-spot False Dots, *Liptena helena*, and the Nigerian Pierid Blue, *Larinopoda aspidos*, choose twigs only a few centimetres above the ground. Others, including the Silvery Epitola, *Cerautola ceraunia*, and the Pallid Liptena, *Liptena albicans*, rest much higher up, often several metres above the ground.

LYCAENINAE

There are two tribes within the Lycaeninae: the Lycaenini, which are distributed worldwide; and the Heliophorini, which have a disparate distribution that includes India, China, New Guinea and Guatemala.

Lycaenini

The Lycaenini are popularly known as Coppers due to the fiery orange iridescence on the uppersides of most species. All 70 species are currently placed in the genus *Lycaena*, although several were formerly assigned to subgenera including *Heodes*, *Palaeochrysophanus* and *Thersamonia*.

One of the most beautiful species is the Purple-shot Copper, *Lycaena alciphron*. The nominate race *L.a.alciphron* inhabits flowery sites at low to moderate elevations from Estonia to southern France. In the other six races, which are found variously across Europe and temperate Asia, the black spots are larger and the purple iridescence is reduced, allowing the underlying orange-red base colour to dominate.

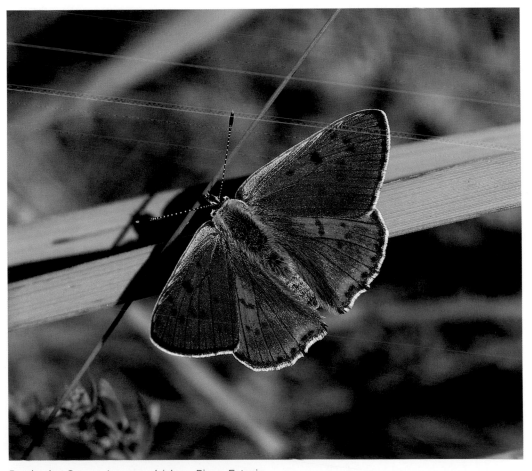

Purple-shot Copper, *Lycaena alciphron*, Piusa, Estonia.

Another very attractive species is the Sichuan Copper, *Lycaena pang*, found in Tibet and western China. In common with all other *Lycaena* species, its larvae feed on Polygonacaea – the plant family that includes docks, bistorts and knotweeds.

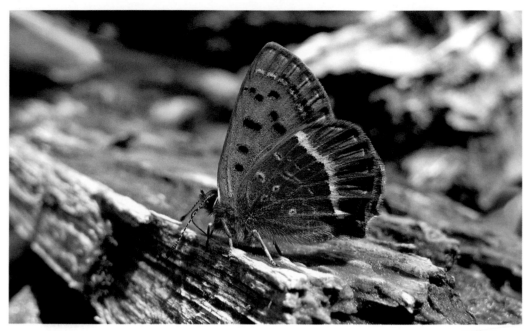

ABOVE Sichuan Copper, *Lycaena pang*, Sichuan, China.
OPPOSITE Purple Sapphire, *Heliophorus epicles*, Sikkim, India.

Males of many *Lycaena* species are strongly territorial and aggressive towards other butterflies. If two males meet a frenetic battle often ensues in which they spiral into the sky until one of them accepts defeat and flies off. Virgin females are mated almost immediately, without any observable ritual.

In the case of the Small Copper, *Lycaena phlaeas*, if a previously mated female is intercepted, she often signals her rejection of an unwanted male with an amusing ritual. When approached, she flutters her wings rapidly and then spirals timidly backwards down a stem to hide at the base of a plant. The flummoxed male then seems unable to relocate her and flies off in dismay.

Heliophorini

There are 10 *Heliophorus* Sapphires, of which *H.androcles*, which occurs from Sikkim to western China, is the most dramatic. It has a bright yellow underside with a red border. The male is dark brown on the upperside, splashed with iridescent blue in the wet season form or shimmering metallic green in the dry season form.

The commonest member of the genus is the exceedingly pretty Purple Sapphire, *Heliophorus epicles*, which is found across most of the Oriental region. As implied by its common name, the upperside of its wings are flushed with deep purple. In another species, *H.brahma*, the upperside is splashed with metallic golden-orange. Sapphires are normally found flying around bushes and herbage in full sunlight in forest edge habitats.

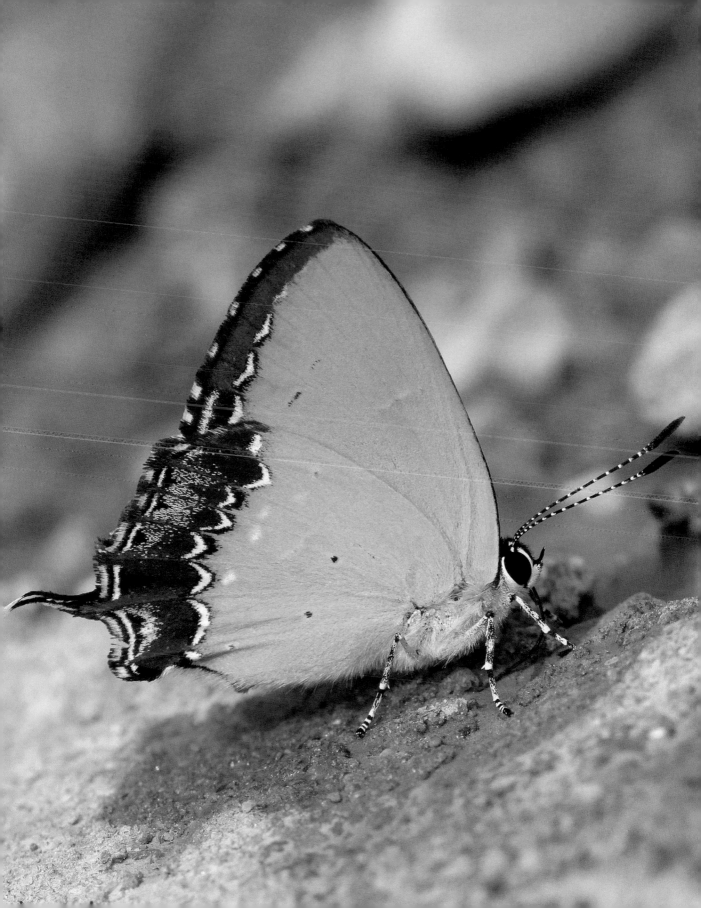

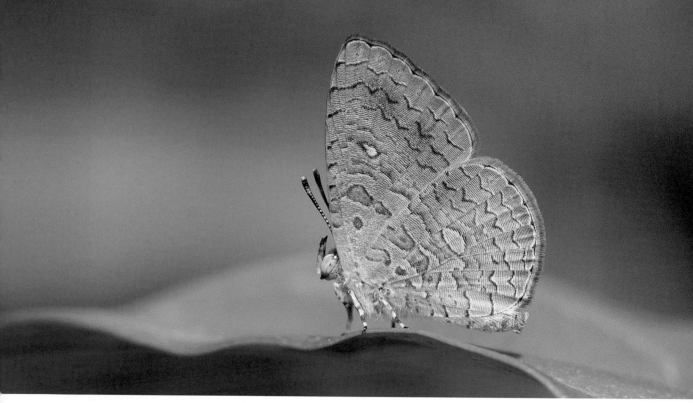

Apefly, *Spalgis epius*, Manas NP, Assam, India.

MILETINAE

The Miletinae are known as Harvesters or Woolly Legs. Oddly, one species, *Feniseca tarquinius*, is found in North America, while the remaining 160 are found either in Africa or the Oriental region. Some taxonomists include Liphyrinae within Miletinae, in which case the total in the subfamily increases to nearly 200 species.

Spalgis epius is fairly typical of the subfamily, with a beautiful striated pattern on the underside, a long thin abdomen, a long proboscis and erect labial palpi. Its common name Apefly refers to the dorsal view of the pupa, which has been likened to the face of a rhesus monkey. The Thai vernacular name Phi Suea Dak Dae Hua Ling literally means 'the butterfly whose pupa resembles a monkey head.'

All members of the Miletinae are involved in complex symbiotic relationships with ants. They are also hemipterophagous, i.e. their larvae feed on Hemiptera – scale insects, treehoppers, plant lice, bugs and aphids. The Apefly, for example, lays its eggs amidst colonies of *Planococcus* mealybugs. Its larvae do not at any stage of their growth eat plant matter. Instead they feed parasitically, or as predators, on eggs, nymphs or adult mealybugs.

Another interesting species is Horsfield's Darkie, *Allotinus horsfieldi*, which inhabits rainforests in Malaya, Sumatra and Borneo. In Mulu National Park I once found an adult *A.horsfieldi* imbibing secretions from female mealybugs. The bugs, which were piercing plant stems to feed on the sap, were also being similarly 'milked' by ants. The butterfly was totally ignored by the ants and bugs, spending several minutes with its proboscis outstretched, imbibing secretions directly from the backs of the bugs.

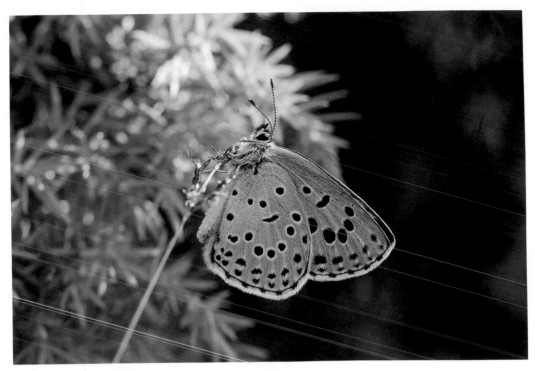

Large Blue, *Phengaris arion*, Saaremaa, Estonia.

POLYOMMATINAE

The 'Weak Blues' are comprised of over 1,500 species worldwide. They are found on all continents and in most habitats, including moors, alpine meadows, grasslands, deserts and open areas within rainforests and cloud forests.

The taxonomy of the Polyommatinae is confused. Currently the subfamily is divided into four tribes – Candalidini, Niphandini, Lycaenesthini and Polyommatini. There are also several genera whose taxonomy is so poorly understood that they have not been assigned to any tribe.

By far the biggest tribe is the Polyommatini. It contains 53 confirmed genera and a further 22 genera whose placement in the tribe is contended. The name Polyommatini means 'many-spotted', and refers to the characteristic pattern of black spots on the under surface of the wings.

The largest European species is the Large Blue, *Phengaris arion*. In the early instars its larva feeds on the flowers of *Thymus* or *Origanum*, but when it reaches the fourth instar it is transported by *Myrmica* ants to their underground nests. Once inside it turns carnivore, feeding on ant grubs until it is ready to pupate.

The genus *Polyommatus* contains 212 species, most of which are native to the Palearctic region. The uppersides of most species are metallic blue in males, while females are generally dark brown and have only a smattering of blue scales at the base of their wings.

The best-known member of the tribe – and one of the most widely distributed butterflies in the entire world – is *Lampides boeticus*. In England, where it is a great rarity, it is known as the

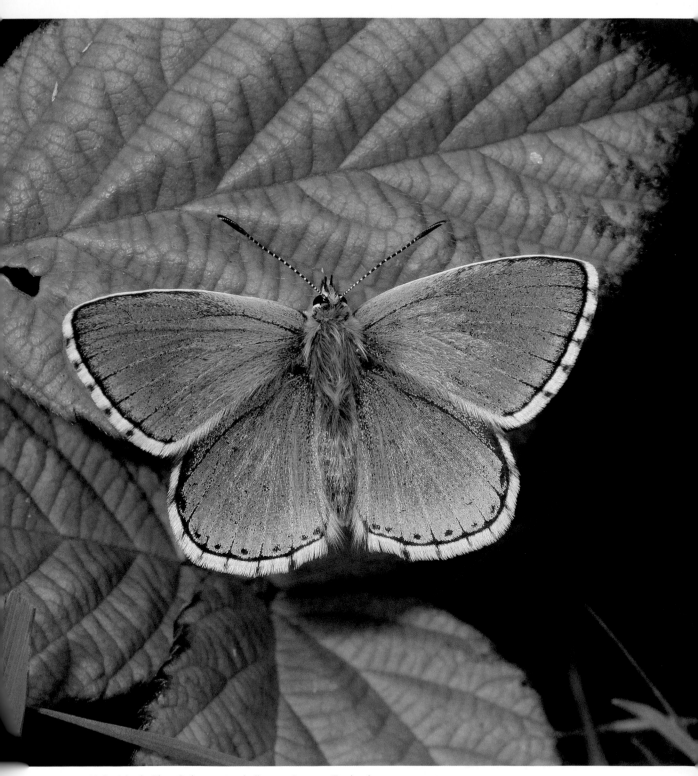

Male Adonis Blue, *Polyommatus bellargus*, Sussex, England.

Pea Blue, *Lampides boeticus*, Sikkim, India.

Long-tailed Blue. Elsewhere it is usually called the Pea Blue, reflecting the fact that its larva, like those of most other polyommatines, feeds on plants in the pea family Fabaceae. It is a species which shows an amazing degree of adaptability to climate and habitat, being found in Europe, Africa, Arabia and temperate/ subtropical regions of India, Malaysia and Indonesia. It has also spread to mountainous regions of Papua and Australia. It reached New Zealand in 1965 and Hawaii in 1882. It has not yet reached the Americas, although it will almost certainly arrive soon, accidentally introduced with an imported plant.

One of the prettiest members of the subfamily is the Common Pierrot, *Castalius rosimon*. It is found in open habitats including forest glades, roadsides and flowery gardens from India to Malaysia, the Philippines and across most of Indonesia. The butterflies are great fun to watch, as they dash frenetically back and forth between low-growing flowers and the tops of small trees, showing complete indecision about their intended landing position.

Common Pierrot, *Castalius rosimon*, Yala NP, Sri Lanka.

The Cyna Blue, *Zizula cyna*, is much overlooked due to its tiny size – it measures only about 20mm (0.8in) across the wings. It is, however, a very beautiful little butterfly. The pattern of black spots on its underside is typical of the Polyommatinae. It is found in disturbed grassy habitats in tropical and subtropical areas from Texas to Bolivia, Paraguay and southern Brazil.

Another tiny and very pretty butterfly, measuring only about 18mm (0.7in) in wingspan, is the Quaker, *Neopithecops zalmora*. It is a widespread and common species in the Oriental region, being found in India, Sri Lanka, Myanmar, Thailand, Malaysia, the Philippines, Sumatra, Borneo, Sulawesi, Bali and Java.

At the opposite extreme, the Tailed Blue Giant Cupid, *Lepidochrysops quassi*, is one of the largest polyommatines in the world, with a wingspan of about 45mm (1.8in). Its lifecycle is very similar to that of *Phengaris*. The butterfly is native to Nigeria, Côte d'Ivoire, Togo and Ghana, where it breeds in disturbed forest-edge habitats.

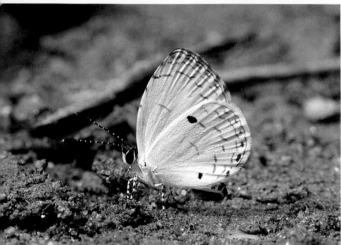

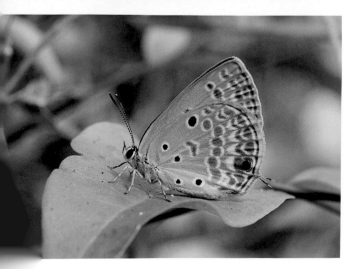

TOP Cyna Blue, *Zizula cyna*, Rio de Janeiro, Brazil.

MIDDLE Quaker, *Neopithecops zalmora*, Chilapata, West Bengal, India.

BOTTOM Tailed Blue Giant Cupid, *Lepidochrysops quassi*, Boabeng-Fiema, Ghana.

PORITIINAE

This subfamily is comprised of 60 Oriental species from 5 genera – *Poriskina*, *Poritia*, *Cyanirioides*, *Deramas* and *Simiskina*. Some taxonomists also include the 560 African Lipteninae species, but unlike these, the larvae of Poritiinae do not possess honey glands and are not known to associate with ants.

Members of the Poritiinae are commonly known as Gems. They are all rare and elusive, spending most of their lives perched on foliage several metres above the ground. Photographs of living butterflies are virtually non-existent, but museum specimens show them to be very beautiful. The uppersides of males have strange irregularly shaped streaks or patches of metallic green or blue on a brown ground colour. Females usually lack metallic scales. They are a paler earthy brown, with patches of bluish-white or light orange, according to species. In the genus *Poritia* the undersides are intricately marbled in shades of light brown. There are black-centred orange ocelli at the tornus of the hindwing, and in some species also on the forewing. In the other genera the markings are more obscure.

THECLINAE

The Theclinae occur on all continents and in all habitats, including moors, grassland, deciduous woodlands and tropical rainforests. Worldwide, about 2,300 species have currently been described, but it is estimated that another 400 or more still await discovery in the Neotropics, where the fauna is particularly complex and understudied. The classification is still in disarray, with some taxonomists recognising only 12 tribes, while others claim the existence of 18 or more. The best-known and most widely accepted tribes include Theclini, Luciini, Arhopalini, Zesiini, Hypotheclini, Horagini, Cheritrini, Remelanini, Eumaeini, Catapaecilmatini, Tomarini and Aphnaeini.

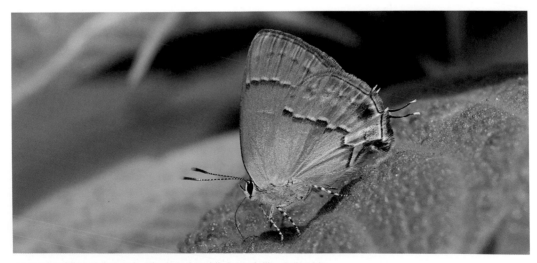

ABOVE Heraldica Hairstreak, *Nicolaea heraldica*, Medellin, Colombia.

OVERLEAF Brazilian Stripestreak, *Arawacus melibeous*, Serra da Bocaina, Brazil.

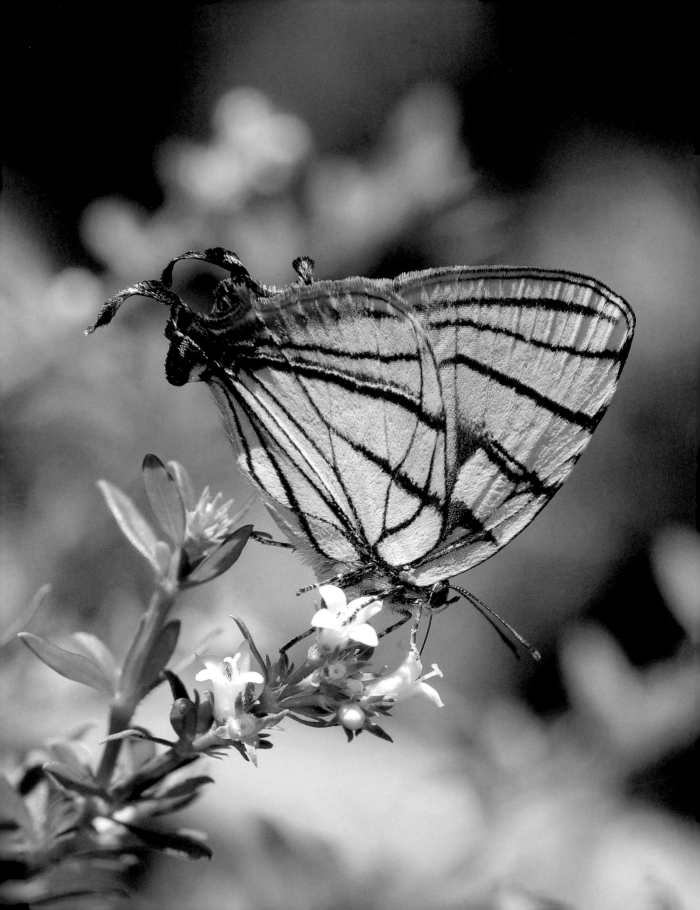

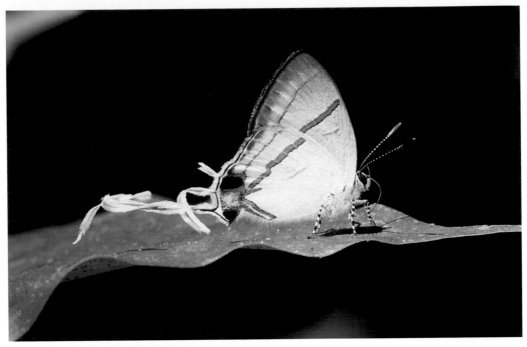

Lebona Fairy Hairstreak, *Hypolycaena lebona*, Wli Falls, Ghana.

Theclini

The tribe Theclini is comprised of about 760 known species and is represented on all continents except South America. Most species inhabit forests and spend long periods high up in the treetops. The 92 genera vary considerably in shape, colour and pattern.

There are 47 *Hypolycaena* species, of which 26 are found in the Afrotropical region, 17 in the Oriental region and 4 in the Australian/Papuan region. The African species are known as Fairy Hairstreaks due to their delicate dancing flight. The individual species can be separated by examining the curvature and alignment of the orange stripe on the underside, the white markings on the upperside hindwings, and the hue of the metallic scales at the basal area of the upperside. The Lebona Fairy Hairstreak, *Hypolycaena lebona*, is distributed from Sierra Leone to north-west Tanzania.

The Common Tit, *Hypolycaena erylus*, is found in India and across South-East Asia to Papua New Guinea. Its underside has a broken orange stripe and there is a conspicuous orange 'false-eye' mark on the hindwing. When the butterfly settles it tilts forward and slowly oscillates its hindwings, causing the antenna-like tails to wriggle. Consequently, it is able to divert the attention of birds away from its body and escape from attack, suffering only superficial damage to its wings.

Common Tit, *Hypolycaena erylus*, Buxa, West Bengal, India.

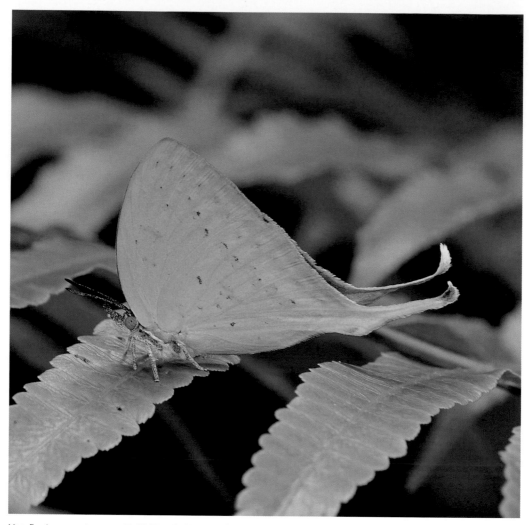
Yamfly, *Loxura atymnus*, Bukit Tapah, West Malaysia.

The Yamfly, *Loxura atymnus*, uses a different defence strategy. It has an unusual wing-shape, with the tornus extended into a long gradually tapering tail. On the upperside its wings are bright orange, but underneath they are yellow, with just a few small brownish markings. The underside colour and wing-shape create the illusion of a dead fallen leaf. Unlike the Common Tit, it remains perfectly still when at rest, relying on its disguise to evade predation.

A close relative of the Yamfly is the Branded Imperial, *Eooxylides tharis*. Males are are often found clustered in groups of three or four on forest saplings, attracted by aphid secretions on the leaf buds. When feeding, they habitually walk around the stems, slowly gyrating, as they probe with their proboscises. On several occasions I have found males head-locked together. Ants are invariably also present, attracted by the same secretions, but they don't attack the butterflies. It is apparent then, that *Eooxylides* are somehow able to appease the ants – perhaps by utilising chemical or vibratory messaging. The Branded Imperial is found from Thailand to Java.

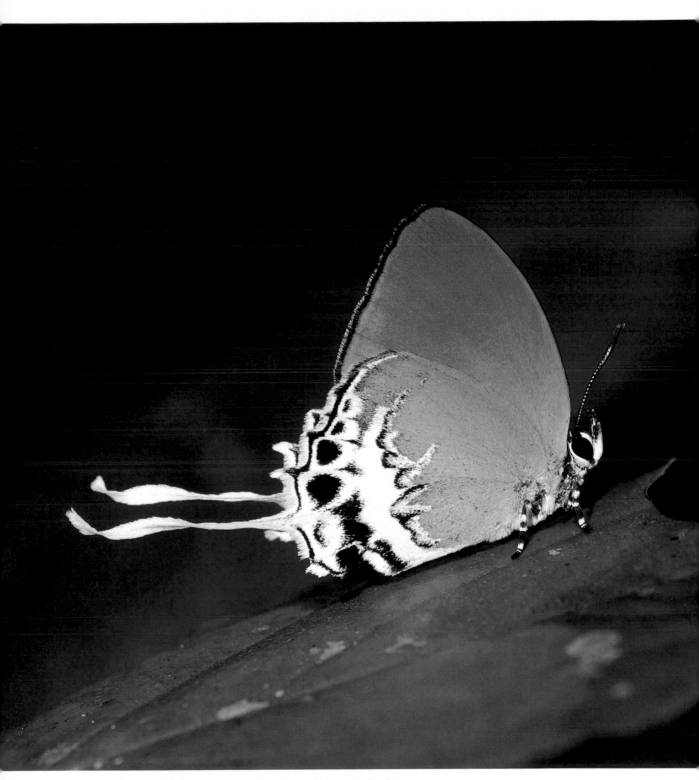

Branded Imperial, *Eooxylides tharis*, Bukit Tapah, West Malaysia.

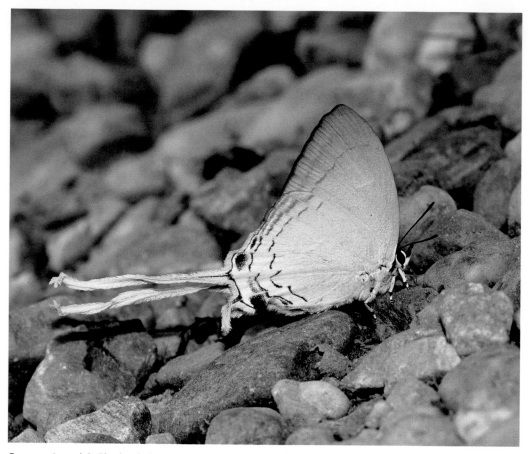

Common Imperial, *Cheritra freja*, Buxa, West Bengal, India.

Cheritrini

The Cheritrini is comprised of six long-tailed Oriental genera – *Drupadia*, *Cowania*, *Ritra*, *Ticherra*, *Cheritrella* and *Cheritra*.

The Common Imperial, *Cheritra freja*, has proportionally among the longest tails of any butterfly in the world, beaten only by the *Lamproptera* dragontails. It is distributed throughout the Oriental region, with the exception of the Philippines. Males are invariably encountered singly; perching on foliage in dappled sunlight, or imbibing mineralised moisture from the ground. Females are normally only seen in flight, skipping from plant to plant in search of oviposition sites.

Arhopalini

This exclusively Oriental tribe contains 255 species in 10 genera. The 210 species in the genus *Arhopala* are commonly known as Oakblues. The name is misleading, as the larvae of many species feed on Combretaceae, Lythraceae or Mimosaceae rather than oaks. Most *Arhopala* species have a deep blue or purple lustre on the upperside, but a few, such as *A.eumolphus*, *A.aurea* and *A.trogon*, are metallic green. All have cryptic undersides, patterned with dark spots and blotches. Most also have a patch of metallic green or blue scales adjacent to the tail.

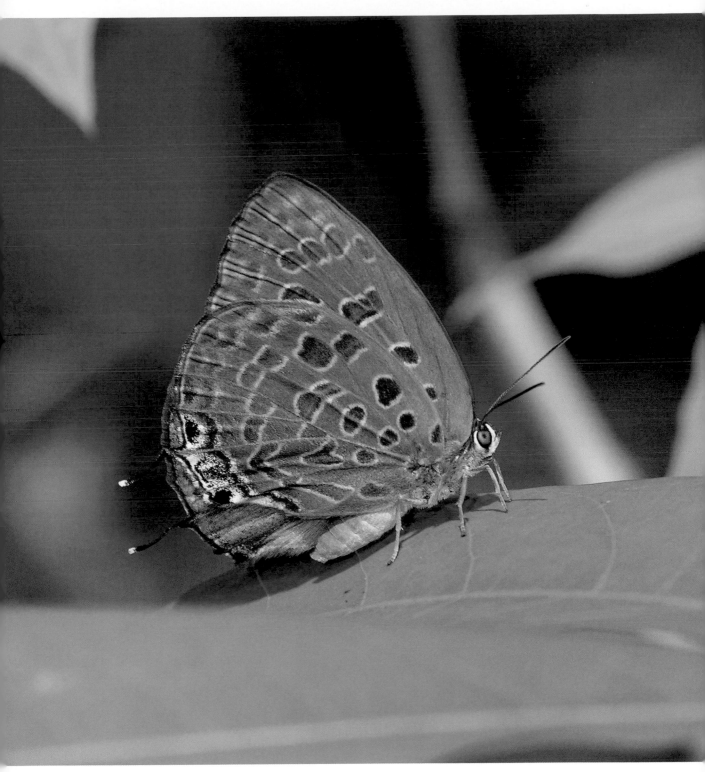

Eumolphus Oakblue, *Arhopala eumolphus*, Bukit Tapah, West Malaysia.

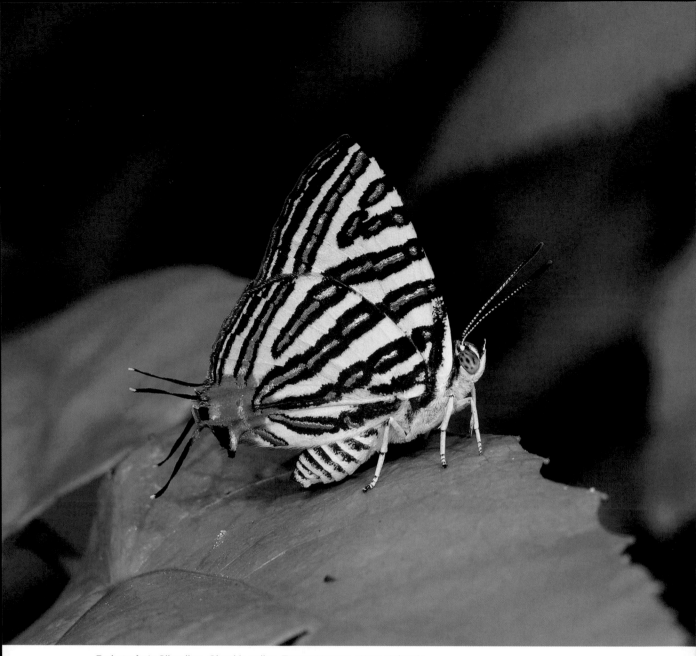

Fruhstorfer's Silverline, *Cigaritis seliga*, Taman Negara, West Malaysia.

Aphnaeini

There are about 300 species in the Aphnaeini. They include 20 *Axiocerces* species from Africa and about 70 *Cigaritis* species, variously distributed across Africa and the Oriental region. Additionally there are eight *Tomares* species. Most are native to the Middle East, but two are found in Morocco, one of which also occurs in Spain.

Fruhstorfer's Silverline, *Cigaritis (Spindasis) seliga*, is typical of the genus. Its pale yellow underside is marked with prominent red-edged silver stripes. These direct the eye towards the tornus of the hindwing, which bears a 'false-head' with long thin antenna-like tails.

Eumaeini

The Eumaeini contains 1,250 known species, of which about 1,070 are confined to the Neotropics. The remainder are Holarctic in distribution. In most species the uppersides of males are gleaming metallic blue, purple or turquoise. However, in *Electrostrymon* they are coppery-orange, and in *Satyrium* and a few other genera they are usually plain brown. Males of all eumaeines have a patch of androconial scales on the forewings. These patches are often large and distinctive. They are one of the primary diagnostic features used to distinguish the various genera.

Eumaeine undersides vary considerably. In *Calycopis*, *Strephonota* and numerous other genera they are greyish or pale brown, with white 'hairstreak' lines, often edged with orange or bright red. Most species have a 'false-head' decoy consisting of a black-centred orange eyespot and a pair of antenna-like tails.

Most eumaeines are small, measuring less than 25mm (1in) in wingspan. However, a few are much bigger – the dazzling azure Cambridge Blue, *Pseudolycaena marsyas*, is one of the largest, measuring about 40mm (1.6in) across the wings.

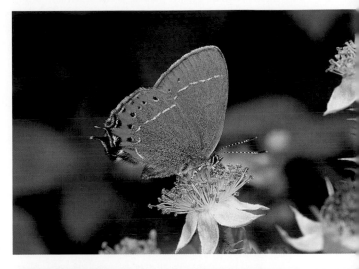

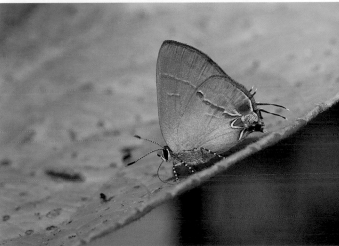

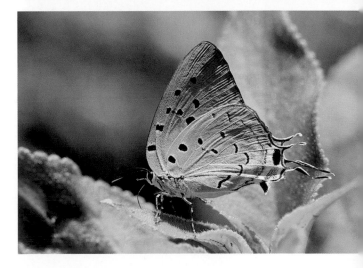

TOP Black Hairstreak, *Satyrium pruni*, Northamptonshire, England.

MIDDLE Atnius Groundstreak, *Calycopis atnius*, Rio Tambo, Peru.

BOTTOM Cambridge Blue, *Pseudolycaena marsyas*, Catarata Bayoz, Peru.

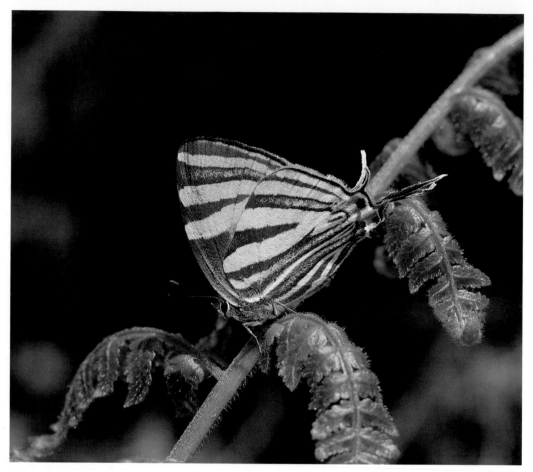

Itatiaia Stripestreak, *Laothus phydela*, Rio de Janeiro, Brazil.

Several genera, including *Laothus*, *Panthiades* and *Arawacus*, have a conspicuous pattern of black stripes on a white ground colour. One example is the Itatiaia Stripestreak, *Laothus phydela*, from south-east Brazil. Like many Neotropical butterflies it has a distinctive character. It spends long periods sitting motionless on a leaf, almost inviting you to photograph it. However, at the last moment, just as you are about to press the button, it plays a little game, slowly but purposefully rotating on its axis to present you with a view of its posterior. The strategy no doubt evolved as a defence to confuse predators, but you can't help feeling that you are being deliberately taunted. A butterfly with a sense of humour!

There are several Neotropical genera with metallic leaf-green undersides. These include the impressive long-tailed *Arcas, Paiwarria, Lamasina* and *Evenus* species; and the smaller and plainer, but still very attractive members of the genera *Erora, Chalybs, Semonina, Trichonis* and *Cyanophrys*. The latter has a sister genus, i.e. *Callophrys*, whose 27 species are found on grasslands, moors and woodlands in the Holarctic region. One of them, for reasons unknown, became known as the Sad Green Hairstreak. Its scientific name is equally mystifying – the genus name *Callophrys* is derived from Greek and means 'beautiful eyebrows', while the species name *miserabilis* is self-explanatory.

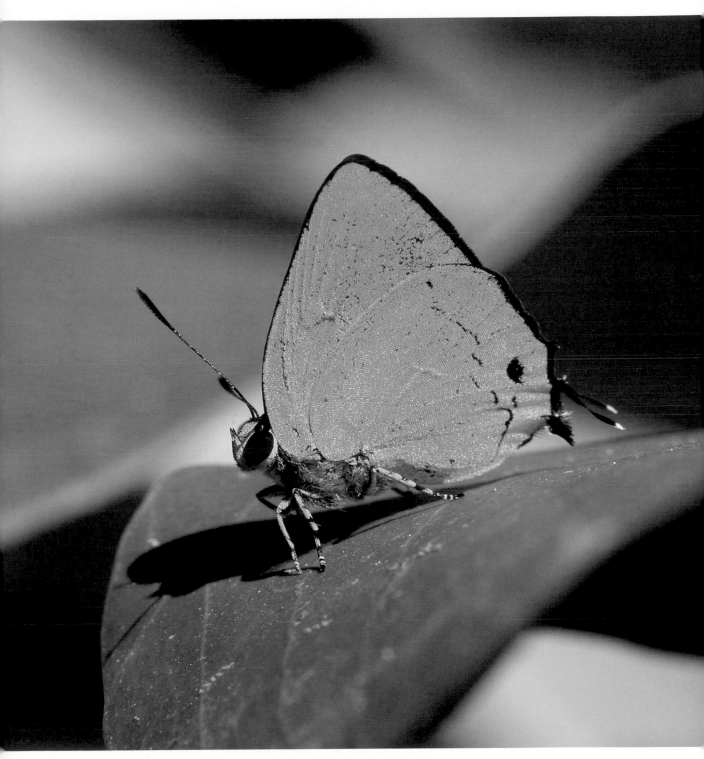

Janais Hairstreak, *Chalybs janais*, Tingo Maria, Peru.

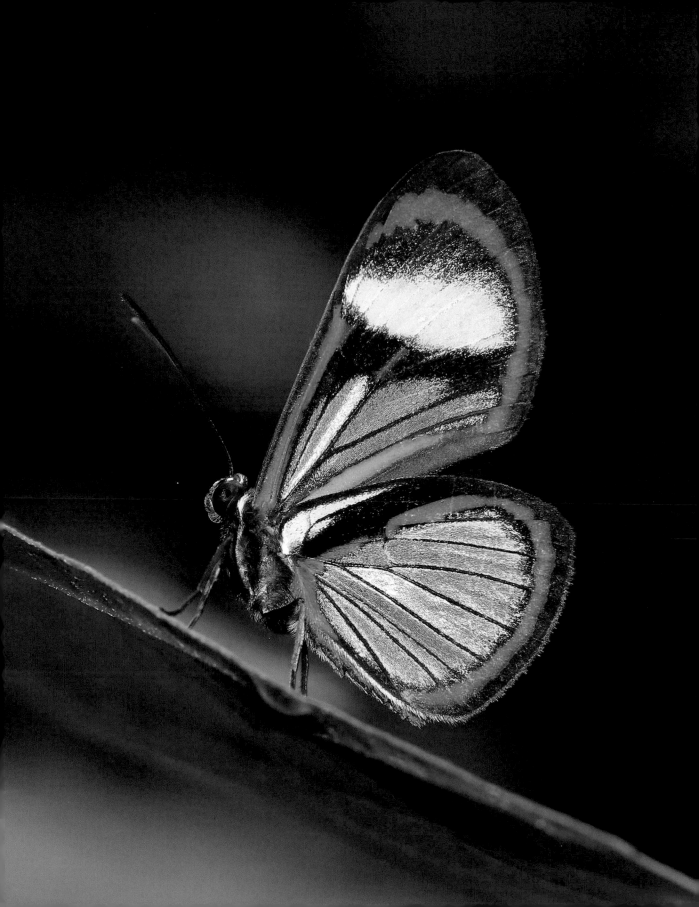

RIODINIDAE

This fascinating family contains about 1,430 species worldwide, of which 1,342 are restricted to the Neotropical region. A few taxonomists still insist on treating them as a subfamily of the Lycaenidae. They do indeed share common ancestors, but in Lycaenidae the forelegs are fully formed in both sexes, while in the Riodinidae those of males are greatly reduced in size. The two families also exhibit differences in the androconia and in the hindwing venation.

The Riodinidae is split into two subfamilies – Euselasiinae and Riodininae. The former are usually simply known as Euselasias. The Riodininae are known as Metalmarks due to the glittering metallic scales found on the wings of most species.

The larval foodplants include numerous trees, shrubs and herbaceous plants from families including Araceae, Asteraceae, Bromeliaceae, Bombacaceae, Clusiaceae, Fabaceae, Cecropiaceae, Euphorbiaceae, Loranthaceae, Myrtaceae, Malpighiaceae, Marantaceae, Melastomataceae, Orchidaceae, Sapindaceae and Zingiberaceae. The larvae of some genera are carnivorous in the later stages of development – the Lagus Metalmark, *Setabis lagus*, for example, is known to be predatory on *Horiola* membracids.

EUSELASIINAE

The Euselasiinae is an exclusively Neotropical subfamily, with about 172 species, assigned to the three tribes Corrachiini, Euselasiini and Stygini. The latter contains just one Peruvian species, *Styx infernalis*. The Corrachiini also has just a single species, *Corrachia leucoplaga*, which is endemic to Costa Rica. The remaining 170 species are all placed in the genus *Euselasia* and assigned to the tribe Euselasiini.

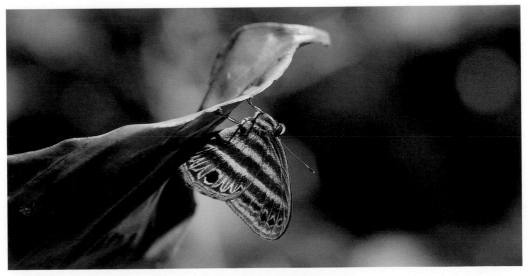

ABOVE Purple-banded Euselasia, *Euselasia orfita*, Pantiacolla, Peru.

OPPOSITE Glasswing Metalmark, *Ithomeis aurantiaca*, Rio Tambo, Peru.

The uppersides of *Euselasia* males are blackish, with patches of metallic orange or blue according to species. Females are dull brown above, with patches of white or pale brown. The undersides of most species are pale brown or silvery-grey, with one or more vertical bands or lines. Most species also have a distinctive ocellus or spot near the hindwing tornus.

Euselasia males spend most of their lives sitting under leaves. A few species, such as *E.pellonia* and *E.angulata*, settle under low vegetation, but most others adopt higher positions, at heights of between about 2–5m (6.6–16.4ft). Although they appear to be resting they are in fact constantly alert, waiting to ambush any other *Euselasia* that flies past. If the interloper is another male, an aerial battle ensues. The trespasser is usually ousted, while the conquering male returns to settle beneath the leaf where he originally perched.

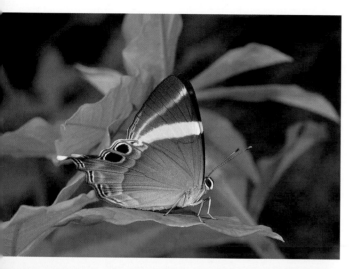

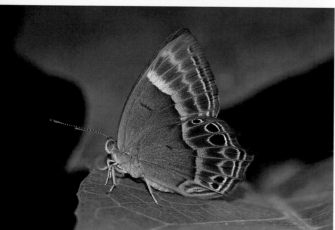

TOP White-banded Judy, *Abisara neophron*, Ringlet, West Malaysia.

BOTTOM Suffused Double-banded Plum Judy, *Abisara bifasciate*, Assam, India.

RIODININAE

The Riodininae is by far the most diverse of all the butterfly subfamilies. The 1,258 known species are incredibly varied in shape, colour and pattern. The Neotropical tribes include Mesosemiini, Eurybiini, Riodinini, Symmachiini, Helicopini, Nymphidiini and Stalachtini. Additionally, there are many '*incertae sedis*' species whose tribal status has not yet been ascertained. The Old World tribes Nemeobiini, Abisarini and Zemerini are sometimes placed in a separate subfamily Nemeobiinae.

Abisarini

There are 60 species in the Abisarini, divided among 7 genera. The largest genus is *Abisara*, consisting of 26 species distributed across Africa, India, Malaysia, China and Indonesia.

Most *Abisara* species have a distinctive stubby or pointed tail on the hindwings, which are adorned with characteristic dark ocelli. The majority, including the lovely White-banded Judy, *A.neophron*, from Malaysia, are earthy brown in ground colour. The Plum Judies, *A.saturata* and *A.bifasciate*, however, have a very attractive reddish hue. They adopt a characteristic posture when at rest, with their wings held half open. In hot weather they become extremely active, zipping back and forth between the treetops and the herb layer.

Orange Harlequin, *Taxila haquinus*, Taman Negara, West Malaysia.

The pretty *Taxila*, *Paralaxita* and *Laxita* Harlequins are variously found from India to Borneo and the Philippines. They are small reddish or orange species, adorned with silver or metallic blue spots on their undersides. Although almost invisible to mammalian or avian eyes in the darkness of the rainforest, these metallic spots reflect a strong ultraviolet pattern that can be detected by other butterflies, and which is probably essential to mate recognition.

The Abisarini also includes the New Guinea genera *Dicallaneura* and *Praetaxila*; and *Stiboges nymphidia* – a species commonly known as the Colombine, which is found from India to China. Its markings are strongly reminiscent of the Neotropical genus *Nymphidium*.

Punchinello, *Zemeros flegyas*, Jorhat, Assam, India.

Zemeriini

The Zemeriini contains only two genera, both confined to the Oriental region. The genus *Dodona* is comprised of 18 species. Most are tailed and are quite hairstreak-like in appearance. There are two *Zemeros* species, *Z.emesoides* from Malaysia and the widespread Punchinello, *Z.flegyas*. When at rest these attractive little butterflies adopt a characteristic posture, holding their wings at an angle of about 60° and canted slightly forward.

Mesosemiini

The tribe Mesosemiini contains just over 150 species, all native to the Neotropics.

The largest genus is *Mesosemia* – a very confusing group of 122 brownish species with distinctive white, black, metallic blue or turquoise bands across their wings. In some species there are several narrow bands, but in others these may all be united to form a single wide band. The forewings of most species feature conspicuous ocelli that almost seem to 'stare' – hence their popular name 'Eyemarks'.

Blue-banded Eyemark, *Mesosemia erynnya*, Rio Madre de Dios, Peru.

Violet-banded Metalmark, *Napaea actoris*, Rio Madre de Dios, Peru.

Male Eyemarks are usually seen singly, but sometimes several can be found flying together in places where trees have fallen and created small glades. They spend much of their time hiding under the leaves of saplings, but will periodically dart out to investigate any passing insect that could potentially be a female of their own species.

Gravid females of some species, such as the White-banded Eyemark, *Mesosemia sirenia*, flit incessantly from leaf to leaf searching for suitable plants on which to lay their eggs. Having located the correct plant, they then walk all over it, gyrating and hopping about in a very amusing manner like robotic clockwork-toys, keeping their wings half open the whole time.

Other genera in the Mesosemiini include *Semomesia*, *Ithomiola*, *Teratophthalma*, *Voltinia*, *Leucochimona* and *Napaea*. The last-named genus is one of the few in which the characteristic eyemark is absent. Most of the 15 *Napaea* species have a similar pattern of pale spots or bands on an earthy brown ground colour. The most beautiful species are *N.heteroea* and *N.actoris*, in which the normal whitish spots are replaced with metallic violet-blue.

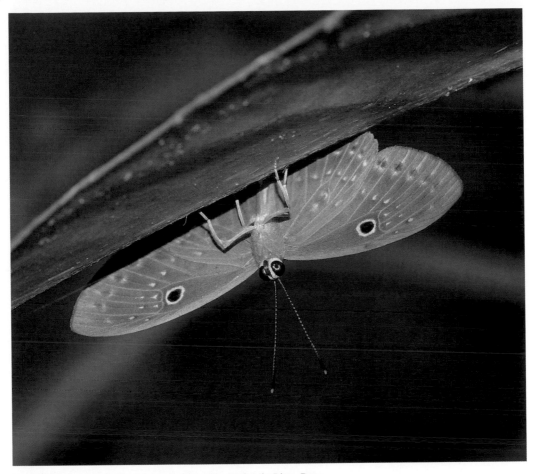

Molochina Underleaf, *Eurybia molochina*, Rio Madre de Dios, Peru.

Eurybiini

The Eurybiini is comprised of two Neotropical genera, *Eurybia* and *Alesa*. The latter contains eight species, the most spectacular being the sexually dimorphic *A.esmeralda* from Colombia. The male of this species has brilliant metallic turquoise wings. The female, on the other hand, is pale brown with dark streaks, and has a series of dark submarginal ocelli on her hindwings.

The genus *Eurybia* is composed of just over 20 species. All have brown uppersides, which in some species, such as *E.molochina* and *E.lycisca*, have a blue iridescence across the hindwings. Almost all species have a prominent orange-ringed ocellus in the discal cell of each forewing, although there are a few 'blind' species including *E.halimede* and the unusual falcate-winged *E.pergaea*. Other *Eurybia* characteristics include metallic green eyes, and an extremely long proboscis that enables them to reach deep into flowers for nectar.

Eurybia adults are very secretive by nature; spending long periods hiding under the leaves of low growing vegetation, with wings outspread, surreptitiously peering out to keep a watchful eye on intruders. Periodically they dash out to investigate other butterflies, then instantly return to settle under another nearby leaf. The speed and agility of their flight is quite amazing to behold, as they dive into the vegetation and instantly flip upside-down to settle under a leaf.

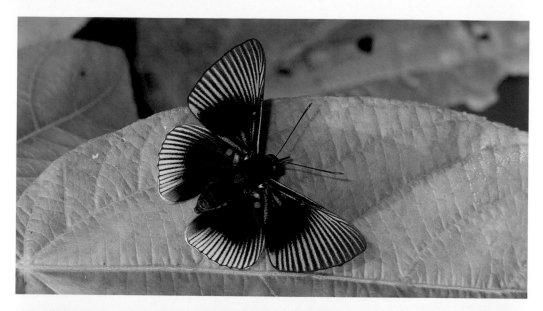

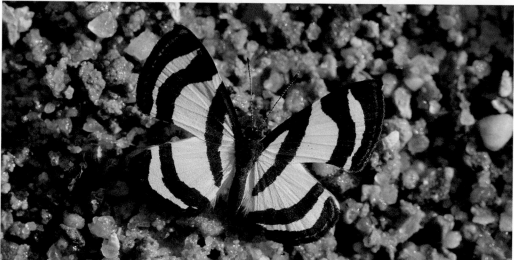

TOP Blue-rayed Metalmark, *Lyropteryx apollonia*, Rio Shima, Peru.

BOTTOM d'Abrera's Pigmy, *Baeotis staudingeri*, Catarata Bayoz, Peru.

Riodinini

This fascinating tribe contains about 280 species in 40 genera, all native to the Neotropics. The adults are extremely varied in appearance. Some have lobed hindwings or spectacular long tails, while others are round-winged and tailless. Many are banded in red or orange and almost all have metallic silver, blue, green or copper markings. Sometimes these markings are confined to one or two narrow bands, but in many species the wings are almost entirely covered in iridescent scales. The butterflies are in fact so varied in colour, pattern and shape that it is difficult to describe any feature they have in common, other than the fact that they are all exquisitely beautiful.

There are eight *Chorinea* species. They are reminiscent of miniature swallowtails, with transparent wings marked with black veins. In all species the thorax is devoid of 'hair' and the palpi are extremely short. All *Chorinea* species have the same basic pattern, but differ in the shape and position of the red markings on the hindwings. The Amazon Angel, *C.amazon*, is found in Guyana, Surinam, Ecuador, Brazil, Peru and Bolivia. It is a rainforest butterfly found at elevations between about 200–1,000m (655–3,280ft), usually in the vicinity of streams.

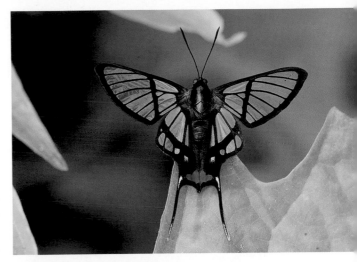

The 14 *Lasaia* species have extremely reflective wings that shimmer in metallic turquoise, sapphire blue or steely grey according to species. The dazzling Cat's-eye Sapphire, *Lasaia arsis*, is commonly found in ones and twos, imbibing mineral-rich moisture from sandbanks or sunlit forest tracks. Its flight is typical of the genus, being erratic, very rapid and close to the ground, with a tendency to flit constantly from spot to spot. It is a cloud forest species, found in Ecuador, Peru and Bolivia.

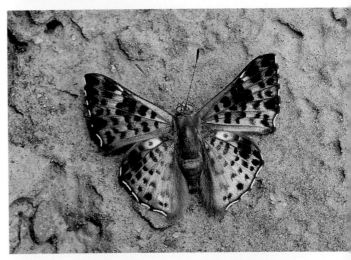

One of the most iconic metalmarks is the Red-barred Starry Night, *Amarynthis meneria*. It is found throughout Amazonia and in the Andes up to an elevation of about 1,000m (3,280ft). It spends much of its time hiding under leaves with its wings fully outspread, but periodically darts out and settles on top of a leaf to bask. Both sexes tend to stay within the forest and are often seen, either singly or in twos or threes, along narrow trails where dappled sunlight penetrates to ground-level.

TOP Amazon Angel, *Chorinea amazon*, Rio Tambo, Peru.

MIDDLE Cat's-eye Sapphire, *Lasaia arsis*, Rio Shima, Peru.

BOTTOM Red-barred Starry Night, *Amarynthis meneria*, Pantiacolla, Peru.

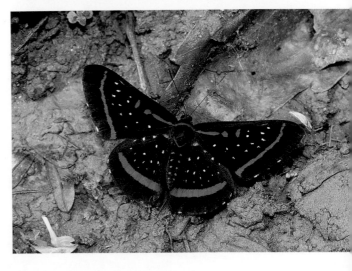

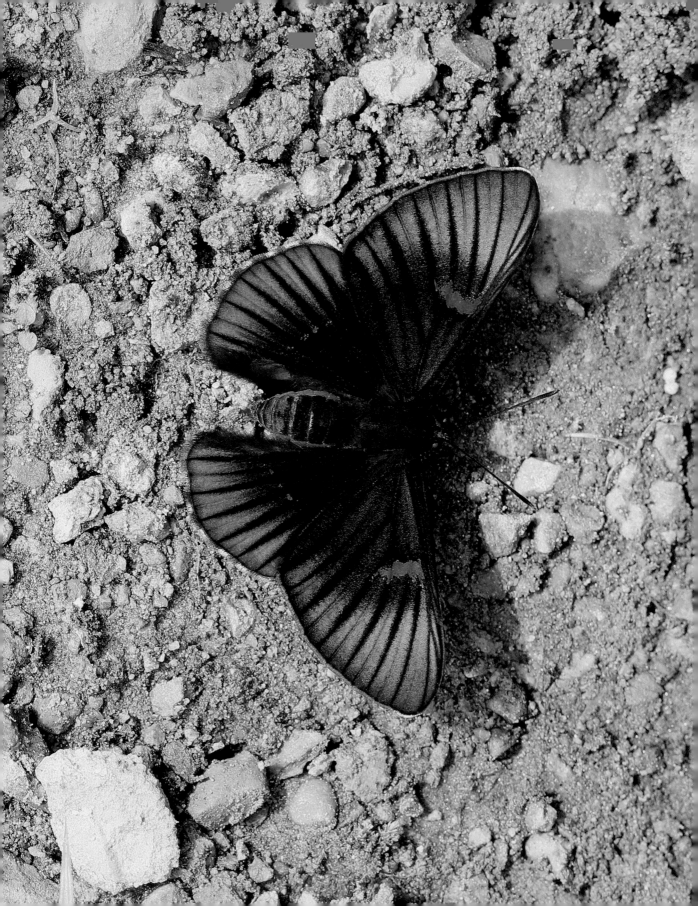

There are three *Necyria* species, namely *N.duellona*, *N.ingaretha* and *N.bellona*. The last-named is found along the eastern slopes of the Andes from Colombia to Peru, at elevations between about 500–1,800m (1,640–5,905ft). Nine subspecies are recognised, some so dissimilar that one could be forgiven for believing they were distinct species. Nevertheless, analysis of genitalia, larval morphology and other aspects of their biology has confirmed that they all are subspecies of *N.bellona*. The race illustrated here – *N.b.whitelyiana* – is native to southern Peru.

The genus *Caria* contains 14 very beautiful and elusive species. Once seen, these glittering jewels are never forgotten. They have an extremely rapid and erratic flight and it can be incredibly frustrating to lose sight of one and be unable to relocate it. Most species are confined to the foothills of the eastern Andes and the Upper Amazon, but there are two which are endemic to Mexico and one that has a range which encompasses Mexico and Texas.

Rhetus butterflies are noted for their long tails and for the beautiful blue sheen on the upper surface of their wings. The Blue Doctor, *R.periander*, is a lowland species in which the post-discal area of the forewings is black. The Sword-tailed Doctor, *R.arcius*, can be found at altitudes between about 200–800m (655–2,620ft), where its range overlaps with that of the Cloudforest Doctor, *R.dysonii*. All three species tend to be found close to small streams or ditches and favour dappled sunlight rather than full sunshine.

OPPOSITE Bellona Metalmark, *Necyria bellona whitelyiana*, Rio Kosnipata, Peru.

RIGHT TOP Green Mantle, *Caria mantinea*, Rio Cristalino, Mato Grosso, Brazil.

RIGHT MIDDLE Harmonia Mantle, *Caria rhacotis*, Rio Shima, Peru.

RIGHT BOTTOM Blue-bordered Mantle, *Caria chrysame*, Rio Kosnipata, Peru.

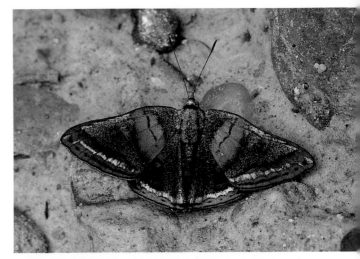

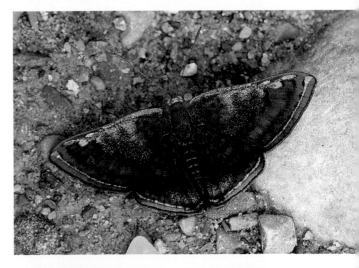

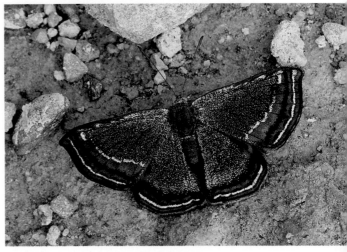

TOP Cloudforest Doctor, *Rhetus dysonii*, Antioquoia, Colombia.
BOTTOM Sword-tailed Doctor, *Rhetus arcius*, Pauti, Peru.

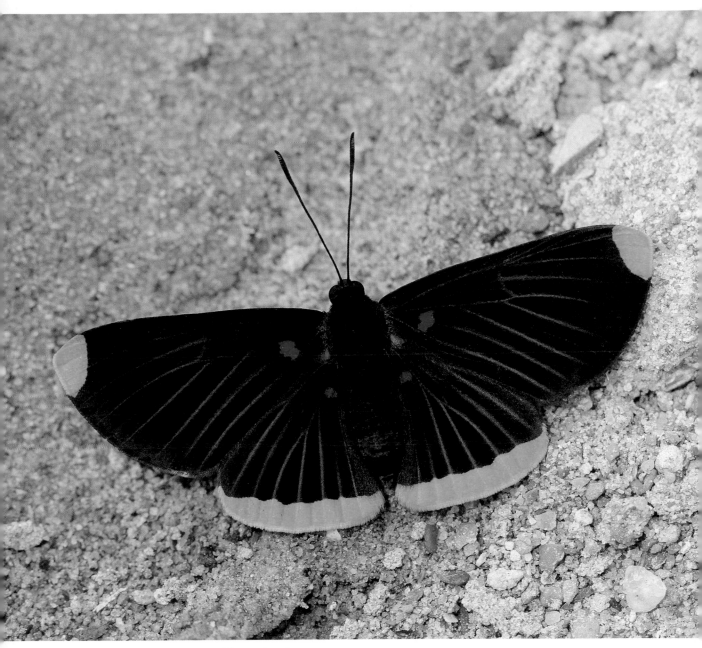

Smith's Pixie, *Melanis smithiae*, Satipo, Peru.

The 27 *Melanis* species are commonly known as Pixies. The genus name refers to the melanic pigment of the scales covering their distinctively shaped wings. Many species have orange borders and wing tips; and most have conspicuous red spots at the base of the wings. Smith's Pixie, *Melanis smithiae*, is distributed from Peru to Paraguay. Males can often be found imbibing moisture from sandy river beaches and are reputed to fly around the canopy of *Samanea* trees in search of females.

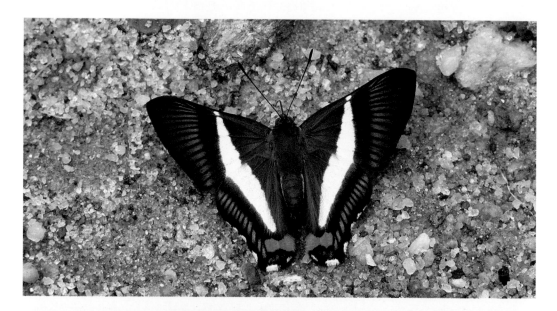

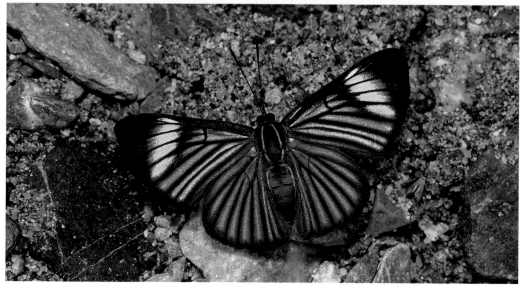

TOP Orange-spot Duke, *Siseme pallas*, Antioquoia, Colombia.

BOTTOM White-rayed Metalmark, *Brachyglenis esthema*, San Ramon, Peru.

The eight species in the genus *Siseme* are all similar in pattern, with the exception of *S.militaris*, which is greyish-brown with a broad orange streak along the costa of the hindwings. The other *Siseme* species are also grey, but have conspicuous white bands or patches. In several species the wings have pale rays between the veins. All species except *S.militaris* have one or two orange-red spots at the tornus of the hindwings.

The Orange-spot Duke, *Siseme pallas*, is found in Colombia, Venezuela, Ecuador and Peru. It is normally encountered in cloud forest in the vicinity of streams or other watercourses, at elevations between about 1,400–2,000m (4,595–6,560ft).

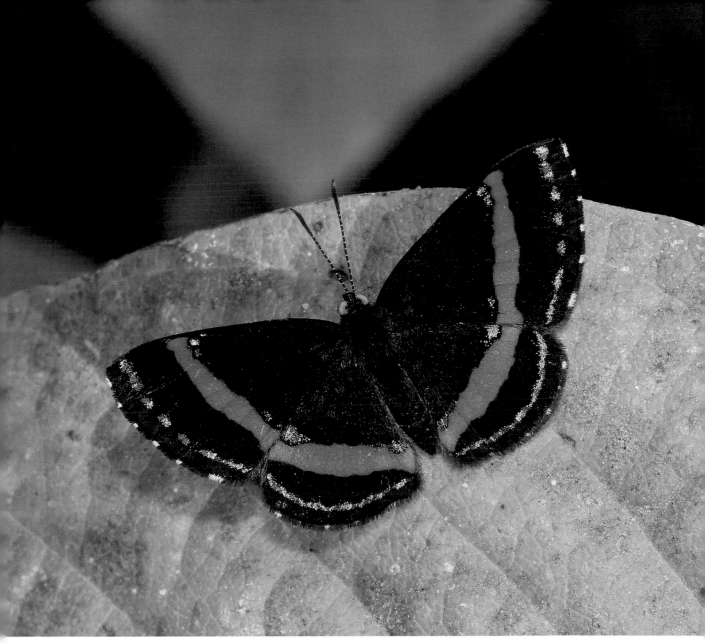

Orange-banded Gem, *Crocozona coecias*, Pozuzo, Peru.

The genus *Crocozona* consists of four tiny and exquisite butterflies, each featuring a similar colour scheme of orange bands and metallic silver sub-marginal lines on a dark brown ground colour. Like many other Metalmarks, they have conspicuous green eyes and short forward-pointing antennae. *Crocozona coecias* is the most widespread species, being found in Colombia, Venezuela, Ecuador, Peru and Brazil.

Chinese Lantern, *Symmachia rubina*, Rio Shima, Peru.

Symmachiini

There are 136 species in this tribe, divided among 13 genera. The butterflies are all fairly consistent in shape and size, but are quite variable in colour and pattern. The genus *Mesene*, for example, consists of tiny bright red, orange or yellow butterflies, often with black margins. On the other hand, the wings of most *Esthemopsis* and *Xynias* species are translucent, except for the apexes and veins, which are black. *Chimastrum* are almost entirely white. Most *Xenandra* species are black with red patches, but in the rare Peruvian species *X. poliotactis* the wings are entirely blue.

The Chinese Lantern, *Symmachia rubina*, in common with several other members of its genus, is beautifully marked in orange, black and cream. It has a characteristic bowed costa on its forewings. It is a scarce butterfly, but can sometimes be found at rest on foliage. It habitually holds its forewings swept back so that they almost obscure the hindwings.

Tailed Jewelmark, *Sarota chrysus*, Rio Claro, Colombia.

Helicopini

This tribe contains four genera – *Helicopis*, *Ourocnemis*, *Anteros* and *Sarota* – which are noted for their attractive underside patterns and their very furry legs.

There are 20 *Sarota* species, distributed variously from Mexico to Bolivia, with the highest concentration in Ecuador. They are tiny butterflies, measuring only about 20–30mm (0.8–1.2in) in wingspan. In all species the uppersides are blackish. The undersides are red or orange, marked with metallic silver streaks and lines, small black spots and golden margins. Most have rounded hindwings, an exception being the exquisite Tailed Jewelmark, *Sarota chrysus*.

Formosus Jewelmark, *Anteros formosus*, Medellin, Colombia.

The 16 *Anteros* species are closely related to *Sarota*. In common with them they have furry legs and silver markings on their wings. Their patterns are generally much simpler than those of *Sarota*, but are nevertheless very beautiful. *Anteros* are elusive butterflies which often spend long periods at rest on the under surface of leaves. They are very sedentary in behaviour, but if deliberately disturbed they are capable of high-speed aerobatics. The lovely Formosus Jewelmark, *Anteros formosus*, is a cloud forest species, distributed from Honduras to Bolivia.

Broad-bordered Nymphidium, *Nymphidium plinthobaphis*, Rio Madre de Dios, Peru.

Nymphidiini

Most members of this tribe have a wing-shape similar to that of the *Nymphidium* species illustrated here. There are, however, several notable exceptions, including Godman's Metalmark, *Behemothia godmani*, which has very falcate forewings; and the astonishing Flag-tailed Metalmark, *Rodinia calphurina*, which has broad scythe-shaped tails, striped in red, white and blue.

The 300 or so species in the Nymphidiini vary greatly in colour and pattern. Most *Theope* species, for example, are metallic blue above and bright yellow beneath. In contrast, *Zelotea phasma* is white with black veins, while *Synargis phliasus* has an *Adelpha*-like pattern of orange and white bands on a brown ground colour.

Several genera, including *Juditha*, *Mycastor*, *Nymphidium* and most of the *Synargis* and *Thisbe* species, have very similar patterns with large white patches and narrow orange submarginal bands.

There are 33 *Nymphidium* species, distributed variously from Belize to Bolivia. The Broad-bordered Nymphidium, *N.plinthobaphis*, is typical of the genus. It is a delicate little butterfly that spends long periods at rest beneath leaves with its wings fully outspread. Females are sometimes seen visiting *Alibertia*, *Croton* or *Cordia* flowers.

Stalachtini

The Stalachtini is comprised of a single genus, *Stalachtis*, which contains six species. Most have tiger-striped patterns in black, orange and white, similar to those of noxious ithomiines.

Incertae sedis

This is a diverse group of genera whose taxonomy is poorly studied. Consequently they have not yet been assigned to tribes. It consists of about 140 Neotropical species from 20 different genera; and a single Old World species, *Hamearis lucina*.

Probably the most commonly encountered genus is *Emesis*, which contains about 40 species. All are similar in shape and pattern, but vary in colour from reddish-orange to brown, grey or dark olive. The Variable Emesis, *E.mandana*, is typical of the genus. Males are often encountered on hot sunny days as singletons amidst aggregations of butterflies mud-puddling on river beaches or beside streams.

The Duke of Burgundy, *Hamearis lucina*, is the sole European representative of the Riodinidae. It occurs at sheltered grassland and woodland sites, where its larvae feed on *Primula*. Males divide their time fairly equally between basking, flying and perching on bushes. At woodland sites these territorial perches are usually located at the junctions of trails, or at the edges of sheltered clearings, as such locations maximise their chances of intercepting passing females.

TOP Variable Emesis, *Emesis mandana*, Rio Napo, Ecuador.

MIDDLE Primrose Metalmark, *Astraeodes areuta*, Rio Tambo, Peru.

BOTTOM Duke of Burgundy, *Hamearis lucina*, Hampshire, England.

Apollo, *Parnassius apollo siciliae*, Sicily, Italy.

PAPILIONIDAE

The Papilionidae contains about 580 species worldwide, and includes such diverse species as the *Parnassius* Apollos of the Holarctic region, the *Parides* Cattlehearts of the Neotropics, the transparent *Lamproptera* Dragontails of the Oriental region and the widespread *Papilio* Swallowtails.

In the majority of species, veins 1a and 1c on the forewing are greatly reduced. All six legs are fully functional in both sexes.

BARONIINAE

This subfamily houses just one species, *Baronia brevicornis*, a name that translates as 'Short-horned Baron'. The genus name refers to a Mr. Baron, who collected the first known specimen. The species name is a reference to its very short antennae. The butterfly has rounded dark brown wings marked with yellow bars and spots. It is the most basal member of the Papilionidae and shares several features with the extinct species *Praepapilio colorado* and *P. gracilis*, both of which were described from single fossils found in the Middle Eocene deposits of Colorado, USA. *Baronia brevicornis* is endemic to the Sierra Madre mountain range in Mexico.

PARNASSIINAE

The Parnassiinae contains 74 species. As with many subfamilies, its taxonomy is in a state of flux. The butterflies are currently divided among the three tribes Parnassiini, Zerynthini and Luehdorfiini. All are native to the northern hemisphere and almost all of them are high elevation species.

Parnassiini

The largest tribe, Parnassiini, is made up of two genera. The Desert Apollo, *Hypermnestra helios*, is the sole member of its genus. It is found in Iran, Afghanistan, Uzbekistan, Turkmenistan and Kazakhstan. The true Apollos, genus *Parnassius*, consist of 52 species distributed across Europe, temperate Asia and North America.

The Apollo, *Parnassius apollo*, is typical of the genus, having translucent rounded wings adorned with conspicuous white-centred red ocelli. The very stiff wings make a distinctive rustling sound as the butterfly soars effortlessly across mountain slopes. In warm sunny conditions both sexes fly actively from flower to flower. In cooler weather they bask low down on rocks or boulders, maintaining a tenacious grip, even in very blustery conditions.

Apollos have not evolved a courtship ritual – females are intercepted in flight and are instantly forced to the ground, where copulation occurs without further ado. During copulation they develop a chitinous structure called a sphragis, which seals the genital opening, preventing them from mating with other males.

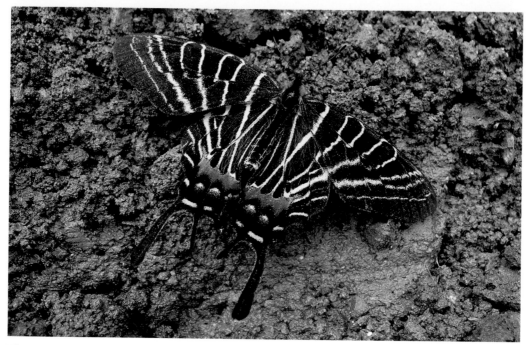

Tibetan Glory, *Bhutanitis thaidina*, Sichuan, China.

Zerynthini

Under current classification this tribe includes 13 species, split among 4 genera – *Bhutanitis*, *Sericinus*, *Allancastria* and *Zerynthia*. Members of the last two genera are known as Festoons. They are pretty pale yellow butterflies, marked with black and red, found in mountainous regions of Europe and the Middle East.

The genus *Sericinus* contains just a single species, *S.montela*, known as the Dragon Swallowtail. The male is a very delicate-looking pale yellow butterfly, marked with black and pink. In the female, the pink markings are enlarged and the black spots united to form a series of narrow suffused vertical bands. Both sexes have a single long thin tail on each hindwing. *S.montela* is found in China, Korea and north-eastern Russia.

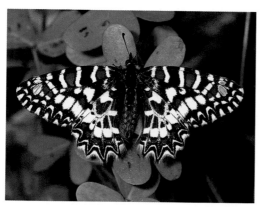

Spanish Festoon, *Zerynthia rumina*, Andalucia, Spain.

Bhutanitis are large, magnificent butterflies, native to the forests of the Himalayas and the Tibetan plateau. They are very distinctive, with black wings thinly striped with yellow. The hindwings have large red patches, prominent blue ocelli and a set of three spatulate tails of varying lengths. The best-known species is the Bhutan Glory, *B.lidderdalii*, which is distributed from Sikkim in India to central China. The illustrated species *B.thaidina* has a more northerly range – it is native to Tibet and the Sichuan province of China.

Luehdorfiini

This tribe consists of two genera – *Archon* and *Luehdorfia*.

The three *Archon* species are known as False Apollos. They are native to the Middle East. As their name suggests they are reminiscent of the true Apollos, but are devoid of ocelli.

The five very pretty species in the genus *Luehdorfia* are early spring butterflies that fly in temperate forests in China, Taiwan and Japan. They are strikingly marked with black stripes on a primrose yellow ground colour. Their tailed hindwings have a red patch at the tornus and a row of blue-centred ocelli near the outer margin.

PAPILIONINAE

Most of the 500 species in this subfamily are tropical or subtropical in distribution, although 74 occur in North America and 4 are found in Europe. The butterflies are widely known as Swallowtails because many have pointed tails on the hindwings that are reminiscent of the forked tails of swallows. However, there are also many untailed species. The legs are long and stilt-like and the antennal clubs are strongly recurved in most species. The Papilioninae is divided into three tribes – Leptocircini, Papilionini and Troidini.

Leptocircini

There are 74 species in this tribe, placed within 10 genera – *Eurytides, Mimoides, Lamproptera, Teinopalpus, Meandrusa, Iphiclides, Protesilaus, Protographium, Graphium* and *Neographium*.

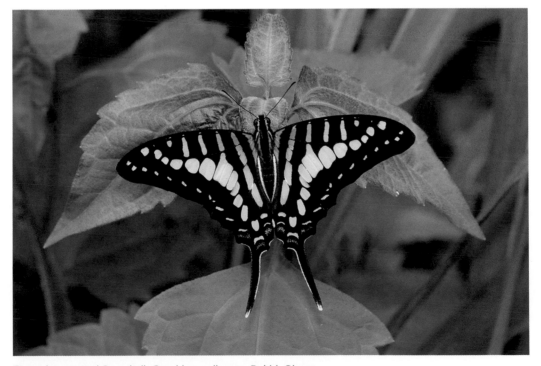

Turquoise-spotted Swordtail, *Graphium policenes*, Bobiri, Ghana.

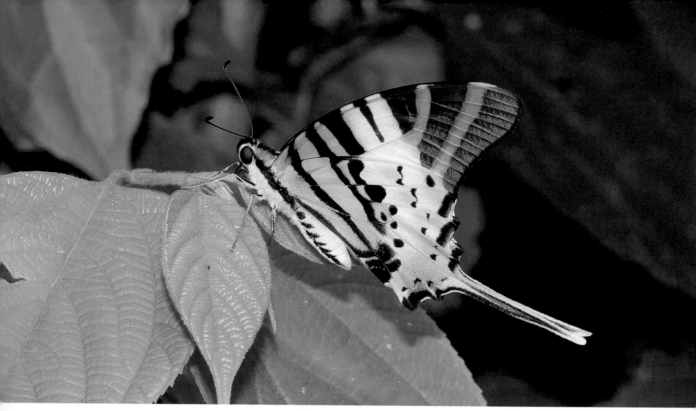

Five-bar Swordtail, *Graphium antiphates*, Ultapani, Assam, India.

Graphium are represented throughout the Old World tropics. The genus contains 104 species, many of which are dark brown with translucent turquoise or lime green 'windows' in their wings. Arguably the most beautiful and unusual of these is *G.weiskei* from Papua New Guinea, which additionally has patches of iridescent purplish-pink on the forewings.

Many *Graphium* species, including *G.agamemnon* and *G.sarpedon*, are devoid of tails. Instead, they have extended or lobed hindwings. Others, such as *G.policenes* and the Five-bar Swordtail, *G.antiphates*, go to the opposite extreme, having long, curved, sword-like tails.

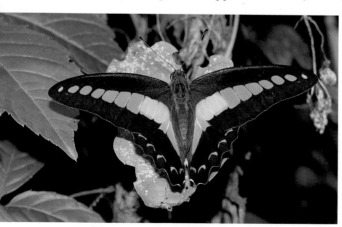

Common Bluebottle, *Graphium sarpedon*, Ultapani, Assam, India.

The gorgeous Common Bluebottle, *Graphium sarpedon*, is among the most familiar butterflies in the Oriental region. Prior to mating, both sexes can be seen circling around the tops of trees, which they use as assembly points where courtship takes place. After mating, males imbibe dissolved minerals from damp sand to replace those lost during sperm transfer. In common with many other species they filter-feed, using their long proboscises to continually suck up water, from which they extract sodium and other chemicals. It is common in some areas to find groups of up to 40 gathered together on the ground. The wing-shape, translucent

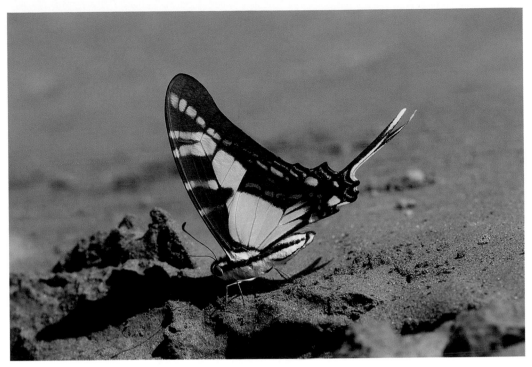

Great Kite Swallowtail, *Neographium thyastes*, Rio Madre de Dios, Peru.

'windows' and posture of the aggregating butterflies conjures up an image of a flotilla of tiny green sailboards.

The *Lamproptera* Dragontails are much smaller in size than other Papilionidae and are unique among them, having completely transparent windows in the wings and very long tails. There are only two species, *L.meges* and *L.curius*. Both are found across southern Asia, from India to the Philippines and Malaysia.

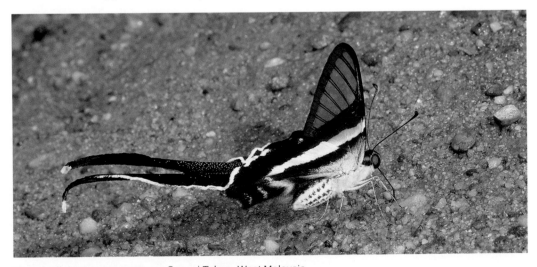

Dragontail, *Lamproptera meges*, Sungai Tahan, West Malaysia.

Lamproptera meges is found in tropical forests, always close to rivers, streams or waterfalls. It has a rapid darting flight and uses its long tails as a rudder, allowing it to suddenly stop in mid-air and make swift changes of direction. Dragontails can easily be mistaken in flight for dragonflies. The resemblance is unlikely to be coincidental. Dragonfly mimicry would be a highly advantageous defence strategy, enabling *Lamproptera* butterflies to live alongside their aggressive models without being attacked by them.

The four *Meandrusa* species are all Oriental in distribution. The best-known is the Yellow Gorgon, *Meandrusa payeni*. This rare yellow and brown butterfly has strongly falcate forewings and its hindwings have broad curvaceous tails.

Papilionini

Some taxonomists classify all 200 members of the Papilionini within a single genus – *Papilio*; but here I retain the traditional format, in which the Holarctic, Oriental, African and Australian species are placed in *Papilio*, while most of the Neotropical species are assigned to *Heraclides* or *Pterourus*.

The Swallowtail, *Papilio machaon*, is found across most of the northern hemisphere, where it produces no less than 42 recognised subspecies. Throughout most of its range it has adapted to a wide range of habitats including prairies, woodlands, dry canyons, subalpine hay meadows, riverbanks, fens, marshes and farmland. Its adaptability extends also to its choice of foodplants. In North America the larvae usually feed on Compositae, while in Europe Rutaceae and Umbelliferae are used instead. Both sexes fly freely about their habitat, pausing regularly to nectar, usually favouring pink flowers such as knapweeds and thistles. When nectaring, Swallowtails keep their wings fluttering constantly – a behaviour typical of Papilionini worldwide.

The Lime butterfly, *Papilio demoleus*, is found across the Oriental region from India and Sri Lanka to Vietnam and the Philippines. Its range continues south through peninsular Malaysia

Swallowtail, *Papilio machaon gorganus*, Auvergne, France.

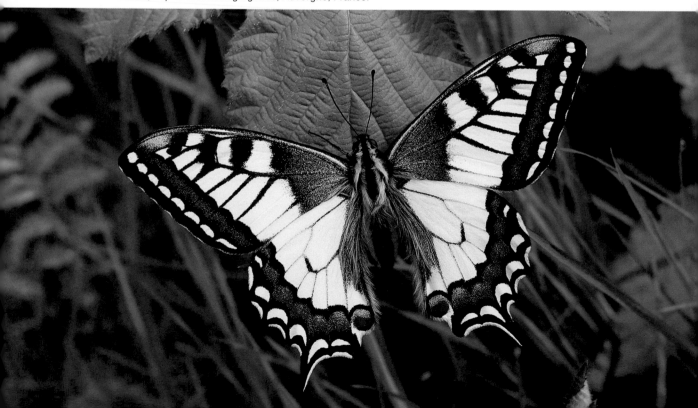

to Borneo, Sulawesi, Java, Irian Jaya, Papua New Guinea and Australia. It has also been introduced to Central America and the Caribbean, where it is a pest of *Citrus*. The butterfly bears a remarkable resemblance to the African Citrus Swallowtail, *Papilio demodocus*, but the two species are not as closely related as their appearance would seem to indicate.

The stunning Green-banded Peacock, *Papilio palinurus*, is a member of the subgenus *Achillades*, which includes 19 species native to the Oriental region. All have black wings, speckled with thousands of glittering green scales, endowing them with a mossy appearance. Some species, such as *P.buddha*, *P.blumei* and *P.palinurus*, also have broad metallic green bands; while *P.paris*, *P.polyctor* and *P.krishna* have large pools of metallic turquoise on their hindwings. Also included in *Achillades* are *P.montrouzieri* and *P.ulysses*, which are found in New Caledonia and Australia/New Guinea respectively. Both lack the green peppering found in the rest of the subgenus, but instead have the entire basal half of their wings covered densely with metallic blue scales.

Black wings, white patches, red crescents and spatulate tails are a common theme among Papilionidae in the Oriental region, but the Tailed Redbreast, *Papilio bootes*, can easily be distinguished from other similar species by the red streaks that run along the inner margin of its underside hindwings. *P.bootes* is a powerful but very graceful butterfly which sails effortlessly across wide rivers and up and down mountainsides in the Himalayan foothills. It is found in India, Bhutan, Myanmar, Tibet and western China.

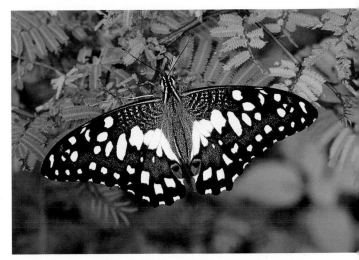

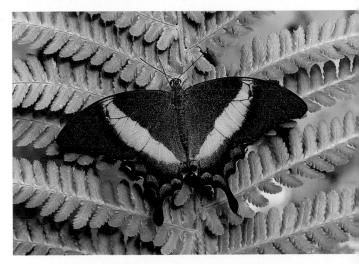

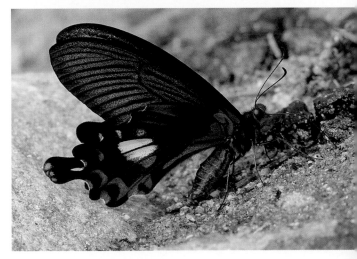

TOP Lime butterfly, *Papilio demoleus*, Yala NP, Sri Lanka.

MIDDLE Green-banded Peacock, *Papilio palinurus*, Poring, Sabah, Borneo, Malaysia.

BOTTOM Tailed Redbreast, *Papilio bootes*, Sikkim, India.

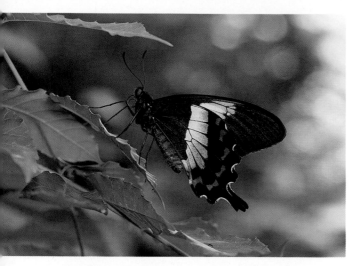

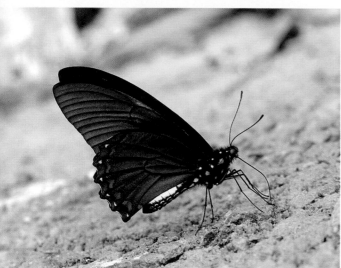

Troidini

The larvae of all Troidini species feed on *Aristolochia* vines; plants that confer them with toxic qualities which protect them and the ensuing adults from predation. There are about 140 species worldwide, including the *Pachliopta* and *Atrophaneura* Roses and Windmills of the Oriental region, and the *Battus* Pipevine Swallowtails and *Parides* Cattlehearts of the Neotropics. All of these species are predominantly black, with red or yellow spots on the sides of the thorax and pink or red crescents or spots on the hindwings.

The most famous members of the Troidini of course are the *Troides*, *Trogonoptera* and *Ornithoptera* Birdwings. The genus *Ornithoptera* is comprised of 13 enormous and majestic butterflies with golden bodies. Males have vast black wings that are adorned with broad swathes of iridescent blue, green, gold or orange. Females are even larger than the males, but not as colourful, generally being earthy brown with whitish markings.

The genus includes the dazzling Cairns Birdwing, *O.euphorion*, from Queensland, and 12 more species found on New Guinea or the surrounding islands. Among them are the Paradise Birdwing, *O.paradisea*, a unique species with elegant curved tails; and the fiery orange Wallace's Golden Birdwing, *O.croesus* – the butterfly that inspired its discoverer to write the enchanting passage quoted in the dedication at the front of this book.

TOP Cramer's Tailed Cattleheart, *Parides ascanius*, Rio de Janeiro, Brazil.

BOTTOM Belus Swallowtail, *Battus belus*, Satipo, Peru.

The title of largest butterfly in the world also goes to a member of this genus – the gorgeous Queen Alexandra's Birdwing, *O.alexandrae*, a truly gargantuan creature from Papua New Guinea. Males of *O.alexandrae* are black, with swathes of metallic turquoise, and measure up to 26cm (10.2in) in wingspan. Females are much less colourful, being dull brown with pale yellowish-white markings, but are even more enormous, sometimes measuring over 30cm (12in) across the outspread wings.

The majestic Rajah Brooke's Birdwing, *Trogonoptera brookiana*, is found in West Malaysia, Borneo, Sumatra and Palawan. In a few areas it is locally abundant, but populations everywhere are threatened by the horrendous oil palm plantations that have transformed the formerly glorious rainforests of Malaysia and Indonesia into an ecological hell on Earth.

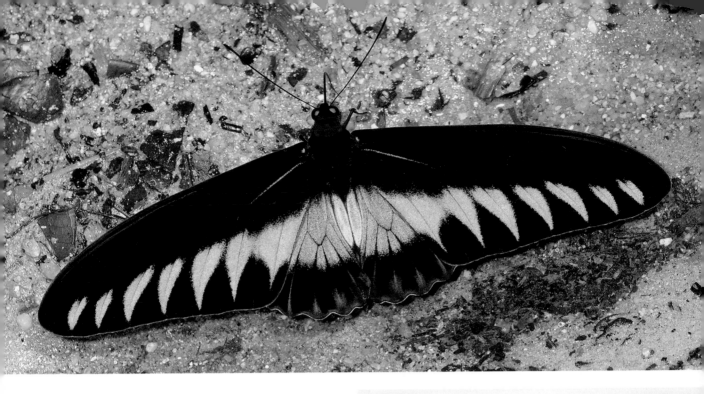

Rajah Brooke's Birdwings are powerful flyers, capable of travelling from one side of a river to the other with no more than three or four wing-beats. Males congregate at hot sulphur springs, seepages and other sources of minerals.

In May 2009 in Perak I came across one of the most stunning butterfly spectacles I have ever seen – a massive group of over 100 pristine *T.brookiana* settled on a small patch of ground on a quiet forest track. No photograph or words can begin to do justice to the beauty of these creatures; and to see such a huge aggregation was a sight guaranteed to blow the mind of even the most experienced entomologist. Try to imagine a quivering mass of 100 iridescent green butterflies, each measuring about 16cm (6.3in) across, crammed tightly together on a

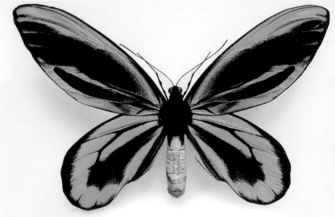

TOP Rajah Brooke's Birdwing, *Trogonoptera brookiana*, West Malaysia.

BOTTOM Queen Alexandra's Birdwing, *Ornithoptera alexandrae*, New Guinea.

patch of ground the size of a small dining table. Then try to imagine the thrill of being so close that you could reach down and touch them. After taking a few photographs you edge gently away but the whole group erupts into flight and you are surrounded by a swirling mass of glittering green wings. You freeze on the spot, hoping not to scare them away; and they respond by gliding closely around you. One by one they resettle on the ground until they encircle you. After a couple of minutes they relax and outspread their glorious wings. You are utterly mesmerised. The huge privilege of such an experience is something you never forget.

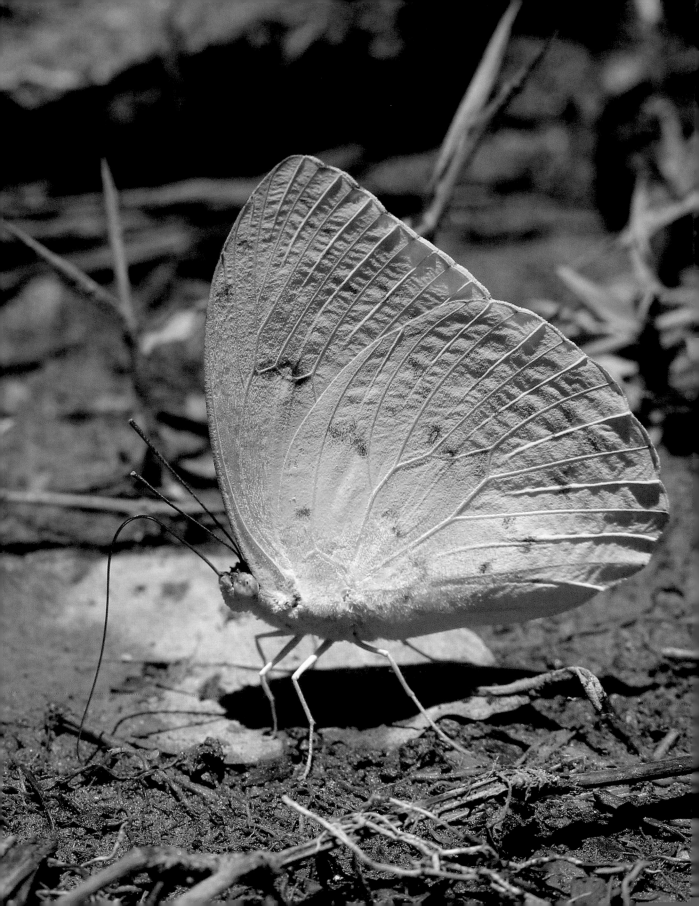

PIERIDAE

The Pieridae contains about 2,000 species worldwide. The majority are primarily white or yellow, usually with black wing-margins. Some genera however, including *Delias*, *Prioneris*, *Anthocharis* and *Hebomoia*, have patches of red or orange. There are also a few genera such as *Pareronia* that are marked with pale blue; and one unusual Neotropical species, *Patia orise*, that has large transparent windows on its wings.

All legs are fully functional in both sexes. The eyes are hairless but the labial palpi are hairy and project upwards at an angle of about 45°.

The family is split into four subfamilies – Coliadinae, Dismorphiinae, Pierinae and Pseudopontinae.

COLIADINAE

The subfamily Coliadinae is represented in all regions of the world. It houses 226 species, split between 15 genera, among which are *Anteos*, *Aphrissa*, *Catopsilia*, *Colias*, *Eurema*, *Gonepteryx* and *Phoebis*.

Most species in this subfamily have bright yellow wings; hence popular names such as Grass Yellows, Clouded Yellows, Sulphurs and Brimstones. The great majority of species are migratory or nomadic in behaviour. Consequently, genetic interchange is frequent and only a very small number of subspecies have evolved. Several species however, such as *Catopsilia pomona*, exhibit a variety of colour forms attributable to seasonal dimorphism or polymorphism.

The Lemon Emigrant, *Catopsilia pomona*, is found throughout the Oriental region, the South Pacific islands and Australia. It produces several different morphs whose development is linked to day length and temperatures experienced during the larval stage. These various morphs were originally thought to be distinct species, but captive-breeding experiments proved otherwise. The *pomona* morphs all have a pair of silvery spots on the underside, in the cell of the hindwing. They also often have dark patches, these being most pronounced in *catilla*. In morphs such as *crocale*, *alcmeone* and *jugurtha*, the wings are unmarked on the underside.

The genus *Colias* contains 83 species and is represented virtually worldwide. The butterflies are commonly known as Clouded Yellows. This name was first applied to the European species *C.crocea* in the 18th century, and may well have been derived from the expression 'cloud of yellows', as the butterfly

ABOVE Lemon Emigrant, *Catopsilia pomona*, morph *catilla*, West Malaysia.

OPPOSITE Cloudless Sulphur, *Phoebis sennae marcellina*, Itatiaia, Brazil.

migrates in vast swarms to Europe from North Africa. There is a famous account by Harrison, who in 1868, at the age of 11, sat on a cliff at Marazion on the south coast of Britain and observed 'a yellow patch out at sea, which as it came nearer showed itself to be composed of thousands of Clouded Yellows, which approached flying close over the water, rising and falling over every wave till they reached the cliffs.'

There are only two species in the genus *Gandaca*, i.e. *G.butyrosa*, which occurs in the Philippines, Sulawesi and New Guinea; and the Tree Yellow *G.harina*, which is distributed from India to Vietnam, Malaysia, Sumatra and Borneo. Males of the latter sometimes aggregate with other Pierids, but are usually encountered singly, imbibing dissolved minerals from wet ground. Females tend to spend most of their lives in the treetops, but occasionally descend to nectar at *Lantana* flowers.

The *Eurema* Grass Yellows are small butterflies, easily recognised by their bright yellow wings. The name is derived from the fact that most species are inhabitants of disturbed grassy habitats, although the larvae feed on Fabaceae, Mimosaceae, Caesalpinaceae and Simaroubaceae, rather than grasses. *Eurema* are among the most familiar and abundant of tropical butterflies. There are 70 known species worldwide, of which 36 are found in the Neotropical region, 13 in North America, 10 in Africa, 25 in the Oriental region and 10 in Australia/Papua New Guinea.

TOP Clouded Yellow, *Colias crocea*, West Sussex, England.

MIDDLE Tree Yellow, *Gandaca harina*, Chilapata, West Bengal, India.

BOTTOM Tropical Grass Yellow, *Eurema xantochlora*, Rio Kosnipata, Peru.

Amazon Snowflake, *Leucidia brephos*, Rio Pindayo, Brazil.

One of the most unusual members of the Coliadinae is the aptly named Amazon Snowflake, *Leucidia brephos*. This tiny rainforest butterfly has a slow, dawdling but very persistent flight, fluttering aimlessly and apparently going nowhere. It gently wafts along, often for half an hour or more without settling, but never progresses more than a few metres away from its starting point. When it does eventually settle, it adopts a strange ballerina-like posture.

Wood White, *Leptidea sinapis*, Saaremaa, Estonia.

DISMORPHIINAE

This subfamily contains about 60 species. Most are native to the Neotropics, the exceptions being the seven species in the genus *Leptidea*, which are native to Europe and temperate Asia.

Nehemia Mimic White, *Pseudopieris nehemia*, Junin, Peru.

In mainland Europe, the Wood White, *Leptidea sinapis*, breeds in a diverse range of habitats including alpine meadows, woodlands, roadsides and moors. However, in Britain, at the edge of its range, it is limited to only about 20 tiny declining populations in sheltered sites in woodlands and undercliff habitats. Nevertheless on sunny mornings in May it can still be found daintily fluttering along trails, pausing here and there to nectar at trefoils and orchids. It makes a very pretty sight as sunlight shines through its delicate white wings. Overnight or in dull weather, Wood Whites go to roost, often in groups of two or three, on white flowers such as stitchwort.

ABOVE Hewitson's Mimic White, *Dismorphia lygdamis*, Rio Kosnipata, Peru.

OVERLEAF Sisamnus Dart White, *Catasticta sisamnus*, San Ramon, Peru.

The 30 Neotropical *Dismorphia* species are characterised by having almost elliptical forewings and disproportionately large hindwings. They all appear to be Batesian mimics of various noxious ithomiines, heliconiines or pierines. Males and females sometimes mimic different species. The male of *Dismorphia laja*, for example, is black with cream bands and is a mimic of *Heliconius wallacei*; while the female is patterned in orange, yellow and black and mimics tiger-complex ithomiines. In the case of *Dismorphia theucharila* both sexes are very convincing mimics of glasswing ithomiines. The beautiful Andean species *Dismorphia lygdamis* is unusual because it mimics *Catasticta* Dart Whites. Males of both genera can be found in the vicinity of cloud forest streams, where they drink at the water's edge.

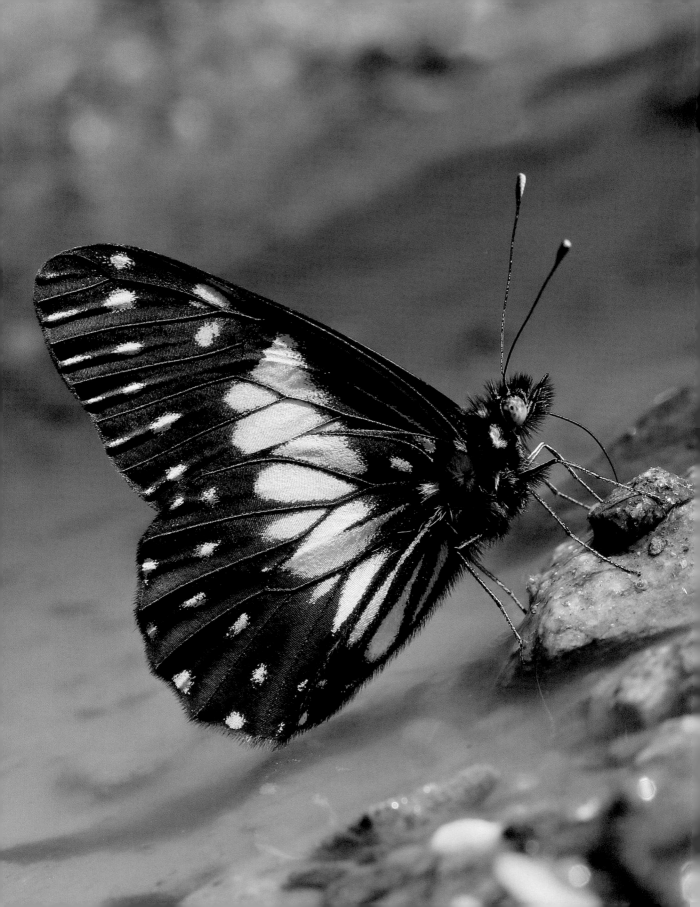

PIERINAE

Worldwide, there are 866 species of Pierinae, housed within 56 genera. They are represented in almost all habitats including deserts, savannahs, rainforests and alpine meadows. They are collectively known as Whites; and indeed most of them are primarily white, with just a few simple black markings. However, many such as *Delias*, *Prioneris* and *Perrhybris* have colourful patterns incorporating orange, red and/or yellow spots or streaks.

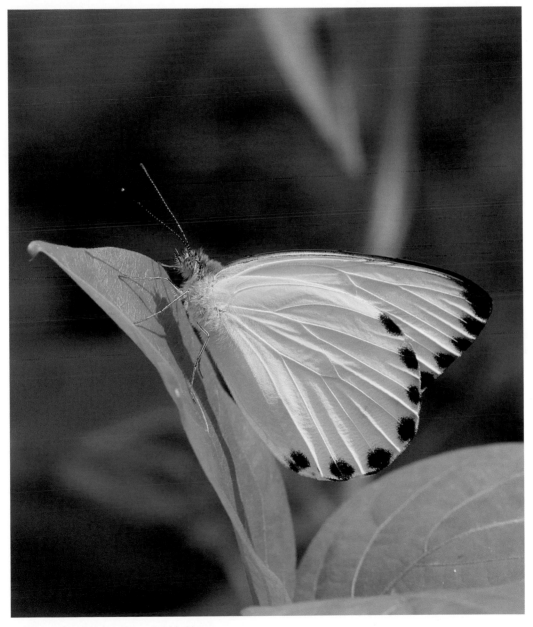

Cebron White, *Dixeia cebron*, Bobiri, Ghana.

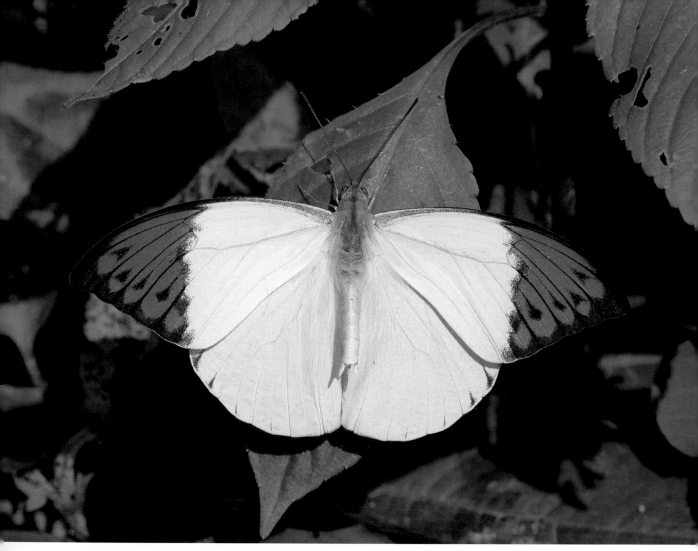

Great Orange-tip, *Hebomoia glaucippe*, Ultapani, Assam, India.

Colotini

The tribe Colotini contains 74 species within 6 genera. The *Nepheronia* and *Eronia* Vagrants and the genus *Calopieris* are Afrotropical in distribution. The majority of the 50 *Colotis* Lesser Orange-tips are also African, although eight species occur on the Indian subcontinent. The Oriental region is also home to two *Hebomoia* species and to the *Pareronia* Wanderers, which are Batesian mimics of *Tirumala* Blue Tigers.

The Great Orange-tip, *Hebomoia glaucippe*, is found throughout the Oriental region. It is primarily a lowland species that occurs in a wide variety of habitats including rainforests, deciduous forests, *Acacia* thorn scrub and farmland. Males spend long periods resting on the ground, where their cryptic 'dead-leaf' underside pattern affords them excellent camouflage. They take flight periodically, patrolling back and forth in search of females. During the midday heat they often aggregate in groups of up to 30 to imbibe moisture from patches of damp ground. Later in the day, when temperatures are lower, they sometimes bask on foliage with their wings half open or fully outspread.

Pierini

The largest tribe is the Pierini. Its 44 genera include the *Catasticta* Dart Whites, *Melete* Flags and *Pereute* Ravens of the Neotropics; the *Belenois* Caper Whites and *Mylothris* Dotted Borders of Africa and the gaudy *Delias* Jezebels and *Ixias* Orange-tips of the Oriental region. It also includes the ubiquitous *Pieris* Whites, the *Aporia* Black-veined Whites of the Palearctic, and the pantropic *Appias* Albatrosses.

Cabbage Whites, as they are popularly known, belong to the genus *Pieris*. There are 33 species. Most are entirely innocuous, but two of them, *P.rapae* and *P.brassicae*, have become pests of commercial *Brassica* crops around the world. The species that causes the most damage is the Small White, *P.rapae*. It occurs naturally throughout the Palearctic region, but has been inadvertantly introduced to many other regions including North America, Australia and New Zealand.

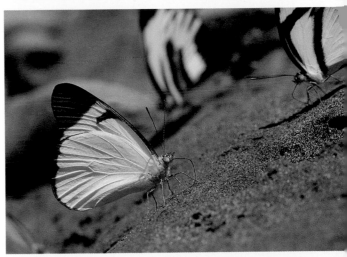

The six *Melete* species are characterised by having a yellow spot at the base of each hindwing, on the underside. The forewings of most species have a black apex and often a dark bar at the end of the discal cell. The ground colour of *M.leucanthe* is white, but in other species is quite variable. In *M.lycimnia*, for example, it ranges between pure white and deep primrose yellow according to subspecies.

There are three *Itaballia* species. The prettiest is the common Orange-bordered White, *Itaballia pandosia*. It has four subspecies, distributed from Mexico to Peru and Brazil. Males are usually encountered singly, mud-puddling with other pierines on river beaches, while females are

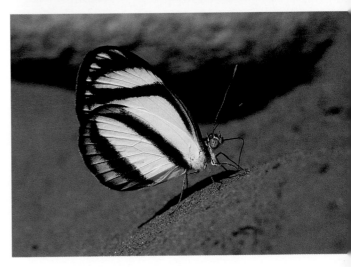

TOP Chocolate Albatross, *Appias lyncida*, Bukit Tapah, West Malaysia.

MIDDLE White Flag, *Melete lycimnia*, Rio Madre de Dios, Peru.

BOTTOM Orange-bordered White, *Itaballia pandosia pisonis*, Rio Napo, Ecuador.

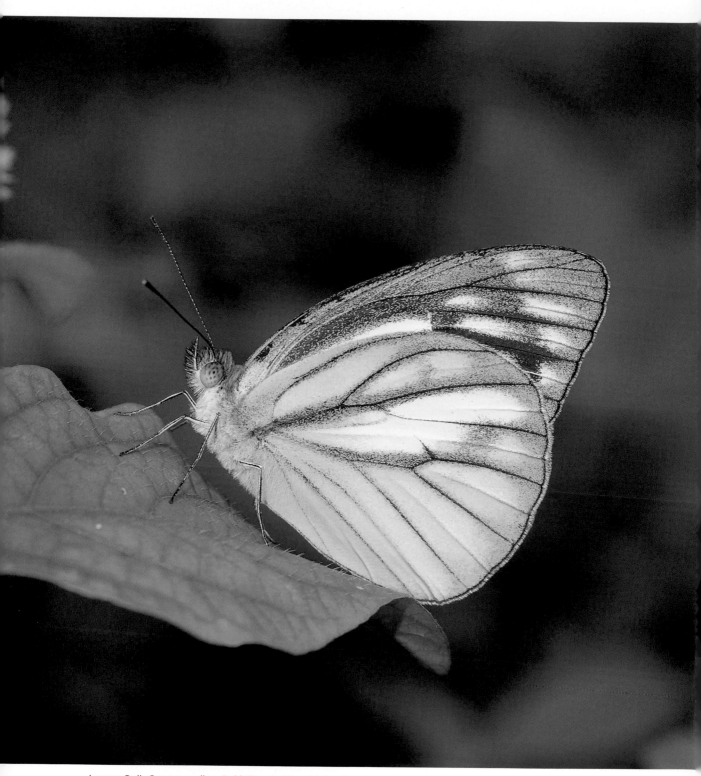

Lesser Gull, *Cepora nadina*, Bukit Tapah, West Malaysia.

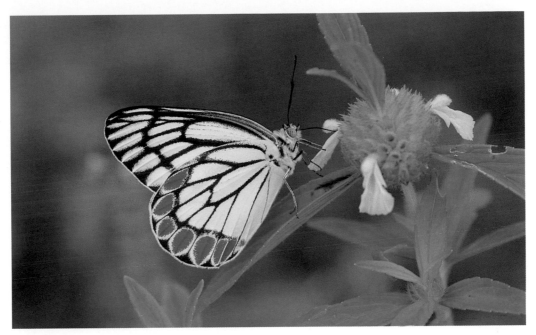

Common Jezebel, *Delias eucharis*, Yala NP, Sri Lanka.

generally seen fluttering along rainforest trails in search of oviposition sites.

Caper Whites, from the genus *Belenois*, are named after their foodplant, caper or *Capparis*. There are 29 species. The pure white wings of males have well-defined black markings, while in females these are browner and more suffused. By far the most abundant species is the Common Caper White or Pioneer, *Belenois aurota*. During its annual migrations, swarms of plague proportions sweep across the plains of Africa, Arabia and India; with hundreds of thousands gathering to mud-puddle along forest roads.

The most widespread of the 17 *Cepora* species are *C.nerissa* and *C.nadina*, both being found throughout the Oriental region. The Lesser Gull, *Cepora nadina*, is seasonally dimorphic. The gorgeous deep yellow on the underside is only present in the wet season. The dry season form is a plainer but still very attractive butterfly with a more greenish hue. Females often visit *Lantana* flowers. Males are attracted to patches of urine and to sources of lime, where they often aggregate with *Appias*, *Graphium* and *Hebomoia* species. Gulls are nervous butterflies and take flight at the least disturbance. Afterwards, they generally resettle nearby on foliage, but delay returning to their feeding places until long after any threat of danger has passed.

A white ground colour with dark veins, red spots and splashes of bright yellow, are the trademarks of the 238 *Delias* Jezebel species. The colours advertise their toxic properties, as a warning to avian predators. Many of the species are exceedingly localised, being endemic to particular islands or mountains, although a few are far more widespread. The latter group includes the Common Jezebel, *Delias eucharis*, which is found in lowland areas of India, Burma and Sri Lanka. Both sexes spend much of their lives in the treetops where their larval foodplant *Loranthus* grows as a parasite. Periodically, however, they descend to embark on a 'nectaring run', fluttering hastily from place to place, pausing here and there for a moment to sip the nectar of *Lantana*, *Mentha* and other flowers.

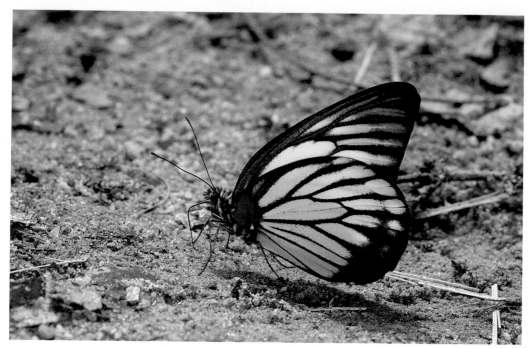

Red-spot Sawtooth, *Prioneris philonome*, Perak, West Malaysia.

Quite similar in appearance to the Jezebels are the *Prioneris* Sawtooth butterflies. Both genera are unpalatable to birds, so are probably Müllerian mimics. Males of the Red-spot Sawtooth, *Prioneris philonome*, tend to be seen singly, typically when imbibing moisture from damp sand. If they are disturbed, they instantly dash off, resettling a few metres away. Further pursuit causes them to immediately return to their original feeding place. This game of cat and mouse can go on for a long time, so when attempting to photograph *Prioneris*, sore knees and elbows are inevitable and much patience is required. In this genus, the leading edge of the forewings, when examined under high magnification, can be seen to be strongly serrated – hence the common name Sawtooth.

Anthocharidini

The Anthocharidini contains 70 species within 6 genera – *Leptosia*, *Eroessa*, *Zeagris*, *Anthocharis*, *Euchloe* and *Hesperocharis*.

Hesperocharis comprises of 12 creamy-white Neotropical butterflies, attractively patterned with dark veins and submarginal chevrons. One anomalous member of the genus, *H.hirlanda*, has suffused dark streaks and a narrow orange border to the underside hindwings. It was previously placed in the monotypic genus *Cunizza*, but was recently reassigned to *Hesperocharis*. The only other Neotropical genus is *Eroessa*, which is composed of a single species *E.chiliensis*. It is white, marked with black and orange, resembling the Holarctic *Anthocharis* Orange-tips.

In Europe, the Orange-tip, *Anthocharis cardamines*, is one of the first butterflies to emerge in early spring. The orange patches on the male's forewings are purported to be aposematic, acting as a warning to birds that the butterflies contain noxious mustard oils derived from the larval foodplants.

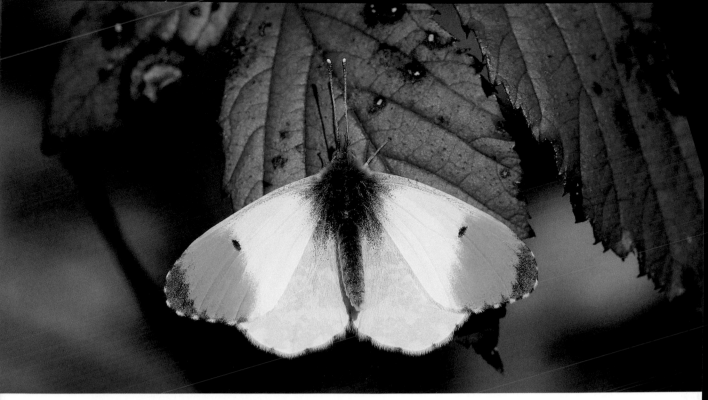

Orange-tip, *Anthocharis cardamines*, Hampshire, England.

Members of the genus *Leptosia* have very rounded white wings with a conspicuous black spot on each forewing. The seven African species are known as Wood Whites or Flip-Flops, the latter name referring to the characteristic incessant bobbing flight.

The Oriental species *Leptosia nina* is known as the Psyche. According to ancient Roman mythology, Psyche was a beautiful girl who was visited each night in the darkness by Cupid. He told her she must not try to see him, but she ignored his request and cast her eyes on him as he slept. While doing so she accidentally spilled hot oil from her lamp on him. After Psyche had been subjected to many harsh punishments by Cupid's mother Venus, Jupiter made her immortal, and she and Cupid were married. Her name Psyche is Greek for both 'soul' and 'butterfly'. The Psyche is also known by the delightful name Wandering Snowflake.

PSEUDOPONTIINAE

For many years it was thought that the tribe Pseudopontiinae contained only a single species, *Pseudopontia paradoxa*. Recently however, taxonomists discovered that there are actually five very similar species. They can be distinguished genetically and by differences in wing venation. All are inhabitants of African rainforests. They are small butterflies with rounded semi-transparent wings. Paradoxically, despite being 'true' butterflies, their antennae are not clubbed at the tips. An even greater paradox is found in the next family – Hedylidae.

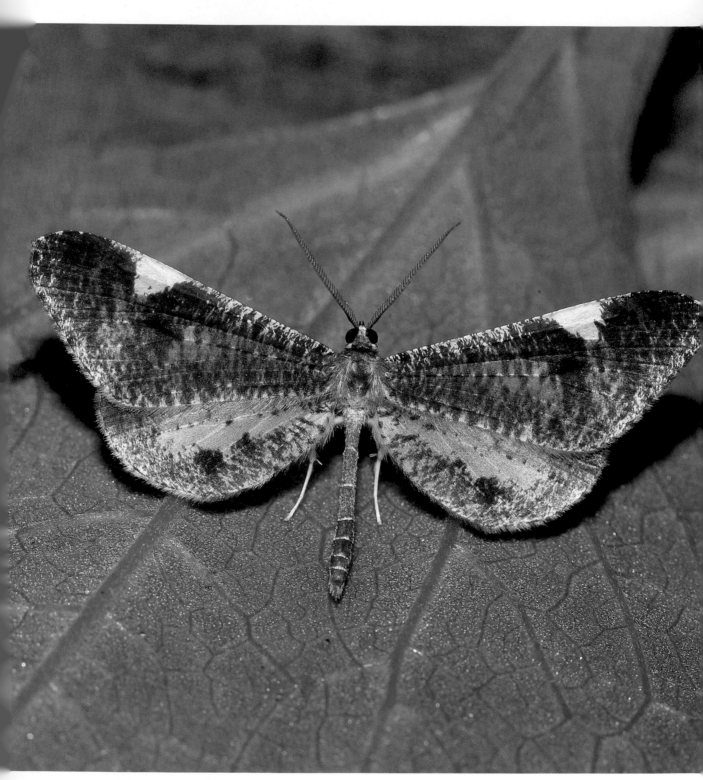

Mottled Macrosoma, *Macrosoma heliconaria*, Rio Tambo, Peru.

HEDYLIDAE

The Hedylidae were originally considered to be moths, but studies of early stage morphology caused scientists to change their minds. Scoble and Aiello published a paper in 1990 which concluded that the insects had more in common with the five traditional butterfly families than with any of the moth families. Consequently they were transferred to the Papilionoidea and the 36 known Hedylidae species are now regarded as butterflies.

All members of the family are currently placed in the genus *Macrosoma*. They are distributed variously from Mexico to Bolivia, with the greatest diversity in Peru, where at least 26 species occur.

The Hedylidae are nocturnal in behaviour and decidedly moth-like in appearance. Anatomically they have many of the characteristics of moths, including unclubbed antennae and a frenulum linking the elongated fore and hindwings during flight. However, microscopic examination of their legs, wing venation, internal organs and genitalia provides clues to their affinity to butterflies.

The early stages feature many butterfly-like characteristics. The eggs, for example, are spindle-shaped and bear vertical ribbing, so are structurally closer to those of Pieridae than to moth eggs. The larvae have antler-like appendages similar to those of the Apaturinae and a bifid tail as found in Satyrinae. They also have secondary setae as found in Pieridae and an anal 'comb' – a feature otherwise restricted to the Hesperiinae. Likewise, the pupae are structurally similar to those of swallowtail butterflies. Furthermore, they are secured to the substrate with a cremaster and silk girdle, as is the case with the pupae of Pieridae and Papilionidae.

HABITATS AND CONSERVATION

The human race has radically altered the environment of the Earth, while showing little concern for the millions of other species that have an equal right to exist on it. As a direct consequence of our own success as a species, wild habitats around the world are being destroyed or degraded to the point where thousands of other species are being annihilated, with many in imminent danger of extinction.

The changing environment

Some changes are so dramatic that they can't be missed. The wholesale clearance of vast swathes of former rainforest in Malaysia and Indonesia, the ploughing up of ancient grasslands in Europe, and increasingly rapid urban expansion in Brazil and Peru, are just a few examples of environmental catastrophes that are obvious to even the most casual observer.

We can all see the havoc wreaked by road building and the urban development that inevitably follows it, which results in the loss of thousands of hectares of wild habitat across the world every day. However, many of the detrimental changes to our environment are less obvious. They take place more slowly but gradually erode wild habitats, leaving future generations with a much poorer world.

Changes in forest management and agricultural policies, for example, have had a devastating impact on butterfly populations in Europe. Conifer plantations simply can't provide the sunlit conditions or the variety of habitat niches that can be found in a natural broad-leaved forest. Hay meadows have disappeared from the UK and are becoming increasingly scarce throughout Europe.

Drainage schemes have virtually eliminated marshes, bogs and damp grasslands across much of the developed world, with devastating effect on butterflies and other insects, not to mention the insectivorous birds and other creatures higher up in the food chain.

Farmers have to make a living, but modern arable pastures, with just a few species of grass and hardly any wild flowers, are incapable of supporting even a tiny number of butterflies.

Gardening, both at landscape level and at household level, has been transformed. The human race has recently developed an unfortunate compulsion with neatness that has resulted in the 'tidying up' of the landscape. Beautiful wild flowers that are vital to butterflies and bees are mown down or eliminated with herbicides, to be replaced by sterile lawns.

Our modern approach to gardening, based on an obsession with the importation of alien plants, wreaks immense damage on indigenous wildlife. A small handful of butterfly species will nectar at alien plants, but they are far from ideal. Butterflies have evolved to recognise the colours, shapes and scents of indigenous wild flowers. Furthermore, they can only survive if they have the correct indigenous plants for their caterpillars to feed on.

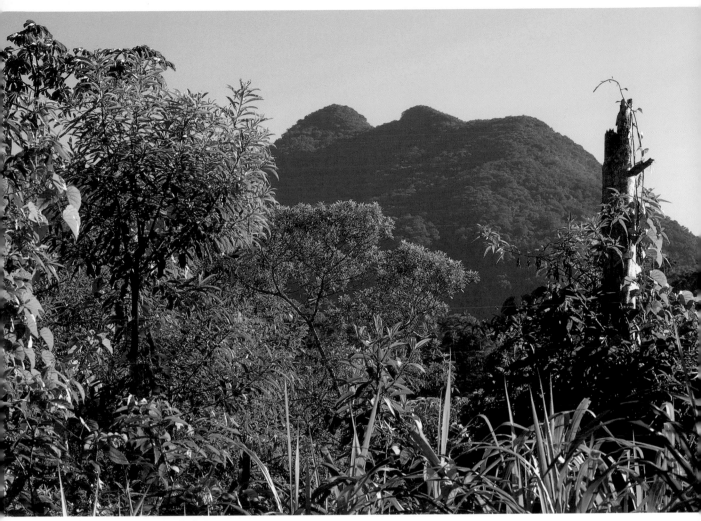
Critically endangered Atlantic rainforest, Itatiaia, Brazil.

Even plants which at first glance appear to be harmless can be very destructive to butterfly populations. In Australia, for example, the larvae of the Giant Birdwings *Ornithoptera priamus*, *O.richmondia* and *O.euphorion* all feed on native *Aristolochia* and *Pararistolochia* vines, but the closely related Dutchman's Pipevine *Aristolochia elegans* that is imported and planted in so many Australian gardens is fatal to them.

Habitat loss and degradation

Centuries ago, when the human population was smaller and less affluent, we occupied less land and consumed far less of the Earth's resources. Enough wild habitats existed to ensure that butterflies thrived, and could move easily between their breeding sites. Since then our population has exploded. Urban expansion, and the surrender of vast expanses of land for crops and oil palm plantations, has already caused the destruction of millions of hectares of wild habitats across the world.

Those habitats that remain are now highly fragmented, so gene flow between the butterfly populations is limited, and in many cases non-existent. A consequence of this reduced genetic diversity is that butterflies lose their adaptability and become increasingly dependent on localised and specialised habitats. Take for example, the English subspecies of the Swallowtail, *Papilio machaon*, which now survives at only a handful of tiny specialised fenland habitats in Norfolk, where its larvae feed almost exclusively on milk parsley, *Peucedanum palustre*. Compare this with mainland Europe or North America, where the same species has an active gene flow. The correspondingly high genetic diversity enables it to remain hardy and adaptable, so it can use a vast array of larval foodplants and thrive in a wide range of habitats that include everything from deserts to mountain peaks.

THE DESTRUCTION OF THE RAINFORESTS

Rainforests and cloud forests are wonderful, utterly irreplaceable habitats. They are places of immense beauty and support millions of mammals, amphibians, reptiles, birds, butterflies and plants that can survive nowhere else. They have survived for millions of years, but they are now being wantonly destroyed, burnt down and replaced with lifeless and sterile soybean and oil palm plantations to satisfy the fashionable vegetarian and health food markets, and to provide biofuel for our vehicles.

Vast swathes of forest are also cleared annually to make way for cattle ranches to supply the fast food industry. The bounty is short-lived however. The resulting pastures are poor in nutrients, and only capable of supporting cattle at very low densities. The pastures are burned annually to promote new grass growth and to destroy cattle parasites. The fires rage uncontrolled, devastating vast areas of forest and annihilating wildlife.

Piecemeal destruction by slash and burn farming also continues at a frightening rate. It occurs on a smaller scale, as it is carried out by local farming communities rather than by multinational companies, but nevertheless it accounts for the destruction or severe degradation of many thousands of hectares of rainforest every year.

The fragmented forest, surrounded by much hotter and drier agricultural land, itself becomes hot and dries out because the average temperature of the entire region rises and the humidity falls dramatically. This causes major changes in the vegetation structure of the remaining areas of forest, so even if they are protected from logging they change in character and their biodiversity is greatly reduced.

An independent 160 page report* published in 2014 revealed that 'about five football fields of tropical forest were cleared every minute between 2000 and 2012,' with consumer demand for timber, beef, leather, soy and palm oil in Europe and the US being the driving force. It argues that 49 per cent of that tropical deforestation was due to illegal conversion to commercial agriculture. In Brazil an incredible 30.6 million hectares (75.6 million acres) was deforested in the first 12 years of the century. The worst offenders of all were revealed to be Malaysia and Indonesia, which deforested 4.7 million hectares (11.6 million acres) and 15.5 million hectares (38.3 million acres) of their land respectively, representing the greatest destruction in terms of percentage.

This would seem to be an appropriate point to plea to the readers of this book to drastically rethink their approach to consumerism, fast food and vegetarianism, these being the primary drivers of rainforest destruction and the root causes of the ongoing annihilation of butterflies and other tropical wildlife. The future is in your hands.

The future of butterflies

Butterflies have been present on this planet for at least 190 million years. During this period they have adapted and evolved to meet the challenge of many climatic and environmental changes including ice ages, periods of high volcanic activity, and shifting continents. Indeed it is these very changes that have instigated speciation and allowed the evolution of over 17,500 butterfly species and possibly as many as half a million species of moths.

In the past however, such changes have taken place over periods of geological time, giving each species thousands or tens of thousands of years to adapt and evolve. The arrival of humans, and in particular our incredibly high rate of population growth, has changed the future of butterflies. It is no exaggeration to say that a great tragedy awaits them, comparable to the mass extinction of dinosaurs.

Most biologists now believe that within a few decades habitat loss will result in massive losses in butterfly diversity. In the foreseeable future a tipping point will be reached beyond which there is no possibility of recovery, and by the end of the 21st century it is quite possible that butterfly diversity will be measures in terms of only a few hundred species worldwide.

In the short term the influence of conservation organisations on governmental and commercial policies can slow down the rate of decline, and I most strongly urge every reader of this book to become actively involved in conservation.

You can make a very important contribution simply by signing a few of the many on-line petitions organised by www.rainforestportal.org, www.rainforest-rescue.org and other conservation NGOs. These are of immense value in applying pressure on governments to clamp down on the illegal logging and unauthorised development that causes so much devastation in the Amazon, the Andes, Africa, Malaysia and Indonesia.

There are many other ways you can help. Donations, no matter how small, enable NGOs such as the World Land Trust and the Amazon Conservation Organisation to purchase and protect vital tracts of forest that act as biological corridors between national parks and other major wildlife refuges.

Ecotourism gives you the chance to see butterflies and experience the wonders of the rainforest. It is also a very important conservation tool. By participating in ecotourism you are helping to provide employment for local people, and you are sending a very direct message to governments that preserving rainforests is good for their economies.

*Lawson, S. *et al.* 2012. *Consumer Goods and Deforestation: An Analysis of the Extent and Nature of Illegality in Forest Conversion for Agriculture and Timber Plantations.* Forest Trends.

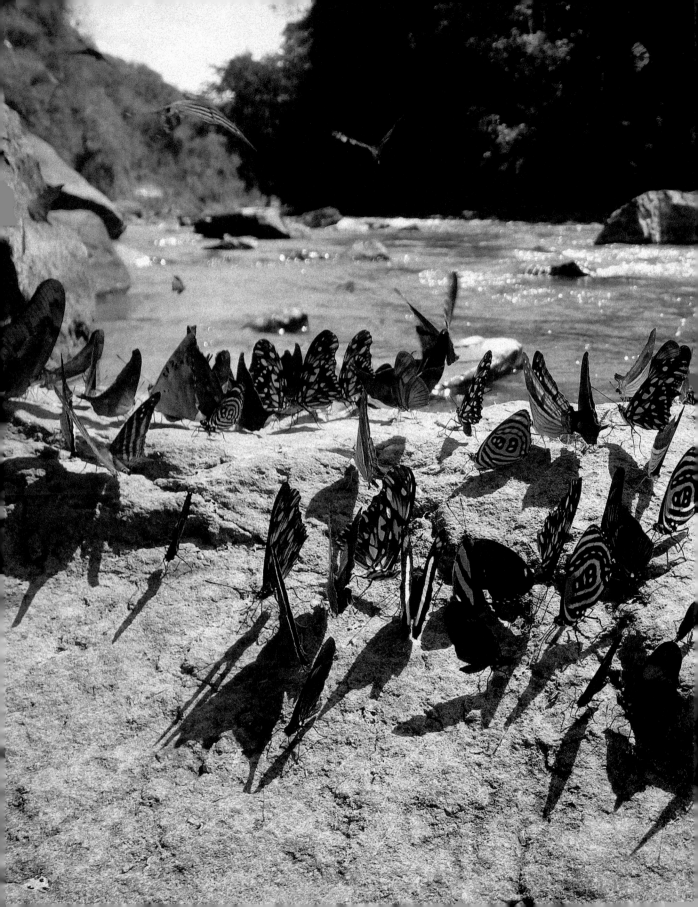

GLOSSARY

Technical terms relating to the study of Lepidoptera.

abdomen The segmented part of the body behind the thorax, containing the respiratory, digestive and reproductive organs.

aberration An individual with abnormal appearance, usually caused by climatic extremes, pathogens, or genetic mutation.

aestivation A state of diapause during periods of heat or drought, such as the dry season in tropical regions. The opposite of hibernation.

anatomy The study of the internal and external structure of animals.

androconia Specialised wing scales in male butterflies, from which pheromones are disseminated to attract or convey chemical messages to females.

antennae The pair of segmented sensory organs arising from the heads of insects, used to detect pheromones.

apex The tip of the forewing, where the costa and outer margin meet.

aposematic Warning colouration, for example bright yellow, orange or red, often in association with a black ground colour. Examples include the yellow and black bands on the abdomen of wasps and hornets, and the fiery orange colour of toxic butterflies such as the Monarch, *Danaus plexippus*.

aphytophagous Carnivorous on homopterans – as with some Lycaenidae caterpillars that feed on aphids, coccids, psyllids or membracids.

basal (a) The area of the wings that is closest to the thorax.
(b) Primitive, close to the ancestral form.

bivoltine Having two generations per year.

brood A single generation of a population. Hence double-brooded refers to a species having two generations per year.

calcareous Alkaline soils and rocks, for example chalk, limestone.

camouflage A form of concealment in which the subject is similar in colour and pattern to the surface on which it rests.

cell The areas of the wings that are enclosed between veins.

chitin The tough matter which forms the outer casing of the head, thorax, abdomen, legs, antennae etc. of an insect.

chrysalis The third stage of the lifecycle of a butterfly, in which the metamorphosis from caterpillar to adult butterfly takes place.

circadian clock A biological clock employing rhythms of biochemical, physiological or behavioural processes that control time-based behaviour.

cladistics A diagrammatic system of taxonomy based on quantitative analysis of comparative morphological and behavioural data, foodplant usage, DNA analysis, etc. This is used to construct tree diagrams (cladograms) that deduce and illustrate relationships between taxa.

cline A progressive change in visible characteristics apparent over the range of a species. The two extremes of appearance are linked by a series of intermediates.

colony A locally isolated population of any given subspecies, the result of fragmented distribution in species with critical habitat requirements.

costa The leading edge of the forewing or hindwing.

costal fold A fold in the leading edge of the forewing, which contains androconia. Found in the males of certain Pyrgines, for example *Erynnis tages*.

cremaster Tiny hooks at the tip of the abdomen of a pupa, used to secure the pupa to a silk pad spun by the caterpillar.

crepuscular The habit of becoming active in the half light of dusk or dawn, and being quiescent during bright daylight and total darkness.

cryptic Colouration and patterning which conceals an insect from predators. Examples include camouflage, disguise and disruptive patterning.

desertification The gradual conversion of forested land into arid grassland and finally into desert, as a result of climate change and/or destructive use of land.

desiccation Excessive loss of water from plant or animal tissues.

diematic　　Patterning or posture that simulates the appearance of a predatory or harmful creature, for example the 'snake-head' marking on the forewing of an *Attacus* Atlas moth or the 'owl-eyes' on the wings of *Automeris* moths.

diapause　　Suspension of activity and development, usually as the result of climatic influence. Examples include hibernation and aestivation.

dimorphism　　The occurrence of two distinct forms of a species in a given population. Examples include sexual dimorphism (male and female being markedly different) and seasonal dimorphism (dry season and wet season forms being markedly different).

discal　　The enclosed basal cell of the forewing or hindwing.

disguise　　A form of concealment in which the subject strongly resembles a naturally occurring object. Examples include the Comma, *Polygonia c-album*, which when its wings are closed, resembles a dead leaf, and the Buff-tip moth, *Phalera bucephala*, which resembles a broken twig.

dispersal　　Extension of the range of a butterfly beyond its local breeding area, caused when females stray away from existing colonies.

disruptive colouration　　The breaking up of wing outlines by mottling, marbling or bands of contrasting colours. Birds tend to target butterflies by shape, so any pattern that breaks up the shape into irregular sections will assist the butterfly in evading attention.

diurnal　　The habit of becoming active during daylight hours.

DNA　　Deoxyribonucleic acid – the molecules from which chromosomes and genes are constructed.

dorsal　　The back of the body, or the upper (recto) surface of the wings.

ecology　　The study of relationships and dependencies of animals and plants with each other and the environment.

endemic　　The restriction of a taxon to within a limited and well defined area such as an island, mountain range or country beyond which it is absent.

evolution　　The theoretical ability, as postulated by Darwin and others, of a species developing by degrees into a genetically and physically different organism, by a process known as natural selection.

falcate	Hooked, as in the apex of a Brimstone butterfly's forewing.
family	An assemblage of closely related genera.
fauna	The entire range of animal species within a geographical region.
form	An ecological, seasonal or sexually dimorphic variety of a species or subspecies, for example the form *valesina* is an ecological variety of the female of the Silver-washed Fritillary – *Argynnis paphia f. valesina*.
genitalia	The sexual organs. The male equivalent of a penis is called an *aedeagus*, the female organ is called a *bursa copulatrix*.
genus (plural genera)	An assemblage of species that are more closely related to each other than to species in any other genus. In the case of butterflies and moths, all the species within a given genus will share identical wing venation and various other characteristics.
girdle	A silk thread around the waist of a chrysalis, supporting its weight.
gynandromorph	A sterile individual which possesses both male and female characteristics. Only obvious in sexually dimorphic species.
habitat	A type of environment or life-zone with particular characteristics that have a limiting effect on the biodiversity of the fauna. Examples include calcareous grassland, sub-alpine meadows, and tropical dry forest.
hair pencil	A tuft of androconial scales found at the tip of the abdomen of male danaines and certain moth families.
hibernaculum	A 'nest' made by larvae, within which they overwinter. Made up of a tent of leaves held together with strands of silk, or of a more substantial communal web within which a brood of larvae shelter in the early instars.
hibernation	The dormant stage of the lifecycle in which a species passes the winter months. Depending on the species, hibernation can occur in the egg, caterpillar, chrysalis or adult stage of the lifecycle.
honey dew	A sugary by-product expelled by aphids as they suck protein-rich fluids from foliage. Vast quantities of this substance coat the leaves of trees in mid-summer, and are used as an adult food source by many butterfly species, and also by ants.
hyaline	Translucent or transparent 'windows' that form part of the pattern of a

butterfly's wings. Occurs mainly in tropical ithomiines (Glasswings) and satyrines (*Cithaerias, Dulcedo, Haetera*, etc.).

hybrid The sterile progeny that results from the cross-fertilisation of two species.

imago The final adult stage of an insect.

instar The stage of a caterpillar's development between moults. Depending on the species, a caterpillar can have four, five, or six instars.

instinct Inherited behaviours and responses, as opposed to those that are learnt by individuals during their own lifetimes. Courtship rituals can appear to be intelligent but are merely a series of instinctive responses to specific stimuli. A female, for example, might settle if showered with pheromones by a male, and the male then has to respond in a particular way which signals the female to initiate the next phase of the ritual, and so on.

intelligence The ability of a species to reason and learn, to understand, and profit from experience. Avian predators exhibit intelligence, but there is no evidence that true intelligence occurs in any insect species.

larva The second stage in the lifecycle of a butterfly or moth. Also known as a caterpillar. Examples include silkworms, loopers and woolly bears.

lunule A crescent-shaped mark, typically found in a series around the wing-margins of Polyommatinae (Blues), Melitaeini (Fritillaries), etc.

margin The outer border of the wings.

melanism Increased development of black pigments on the wings, prevalent when pupae are subjected to abnormally cold climatic conditions. The higher percentage of blackness on the wings increases heat absorption and enables the butterflies to remain active in colder conditions.

metamorphosis The transformation of a caterpillar into a chrysalis, and the development of the adult butterfly within the chrysalis.

metapopulation A population comprised of a semi-permanent core colony, surrounded by a number of smaller marginal colonies that wax and wane in size, often periodically collapsing, to be later recolonised from the core colony.

microhabitat A small and well-defined sub-habitat, for example the forest floor within a mid-elevation transitional wet rainforest, or a damp gully at a particular elevation on a grassy mountainside.

migration	The spontaneous dispersal of a species over long distances in order to seek suitable breeding sites, for example the Clouded Yellow migrates from North Africa, across Europe and northwards into Britain. Migration is probably triggered by climatic conditions, length of day, habitat overcrowding, habitat degradation and other unknown factors.
mimicry	The close visual and behavioural resemblance of one species to another, presumed to be an evolutionary development.
mimicry, Batesian	Similarity of appearance between an unpalatable or noxious species (the model) and an unrelated palatable species (the mimic).
mimicry, Müllerian	Similarity of appearance among a group of related or unrelated species that are all unpalatable or toxic to predators. Avian predators associate the patterning of the whole group with the unpleasant experience of tasting just one or two butterflies.
monocotyledon	Any flowering plant whose first sprout from the seed has only one leaf, for example grasses, sedges, rushes, orchids, palms, bamboo. These are used as larval foodplants of Hesperiinae, Morphinae and Satyrinae.
morphology	The study of development and change of structure and form.
mud-puddling	The act of imbibing dissolved mineral salts from damp ground. Almost exclusively confined to male butterflies, which need to replace salts lost during copulation. In some species it may even be necessary for males to acquire these salts prior to copulation.
myrmecophile	A species that lives in a dependent, mutually beneficial, or symbiotic relationship with one or more species of ant.
natural selection	'Survival of the fittest'. An evolutionary process whereby individuals that exhibit beneficial anatomical or behavioural adaptations pass on their characteristics genetically to subsequent generations. At the same time, less desirable characteristics are gradually eliminated from populations as a result of heavier predation and other environmental factors.
nectaring	The act of feeding on the nectar of flowering herbs, bushes or trees.
Neotropics	Mexico and all of the countries of Central America and South America.
Newcomer's gland	A gland on the backs of Lycaenid larvae which secretes a sugary substance that is attractive to certain ant species that form symbiotic relationships with the relevant butterfly species.

nocturnal The habit of becoming active during night time.

nomenclature The assignment of scientific names to families, genera and species.

ocellus A rounded spot or marking on the wings, effectively a 'false-eye' that may temporarily startle a predator, or divert attack away from the body of the butterfly.

osmaterium A fleshy forked eversible organ located behind the head of caterpillars in the family Papilionidae. It secretes a noxious fluid which deters attacks by parasitic and predatory wasps, ants, and birds.

oviposit To lay eggs, either singly or in batches.

ovum (plural ova) Egg. The first stage in the lifecycle of a butterfly.

Palearctic The zoogeographical region that is comprised of Europe, North Africa, and the temperate and sub-arctic areas of Asia.

palpi The pair of sensory organs that project from between the antennae of adult butterflies. Used to detect pheromones.

parasite An organism which feeds and develops on or within another species, but does not bring about its death. An example is *Trombidium breei*, a mite which parasitizes Common Blue butterflies.

parasitoid An organism which feeds and develops within another species, ultimately leading to its death, for example the wasp *Apanteles glomeratus*, whose grubs kill vast numbers of larvae of the Large White, *Pieris brassica*e.

patrolling Flying back and forth over a fixed area. Used to describe the flight of males when actively searching for females.

perching Mate location whereby a male waits on a protruding leaf or twig, darting out to intercept and investigate passing insects to seek females. The male nearly always returns to the perch afterwards, and defends the territory by ejecting other males.

pheromone An airborne chemical substance disseminated by male butterflies that induces receptiveness or passiveness in females of the same species. Related substances are used by female moths, for example Saturniidae and Lasiocampidae, to attract male moths from a considerable distance.

phylogenetics The science of using comparative data regarding morphological,

ecological and behavioural characteristics, and molecular DNA analysis, to illustrate presumed evolutionary relationships. The results are usually output as cladistic diagrams (phylogenetic trees)

pigment A chemical which in the case of butterflies is derived from the caterpillar's food plants, and which produces the base colour of individual wing scales.

plantation Secondary forest which has been planted with plots of a single species of tree, typically oak, beech or spruce. The trees are allowed to reach maturity and then felled en masse.

polymorphism The occurrence of two or more forms of a given species within the same population, as in the Mocker Swallowtail, *Papilio dardanus*.

polyphagous Describing a species whose larvae feed on a wide range of different plant species from different genera or families. Such highly adaptable species tend to be much more widespread and abundant than those which specialise on particular larval foodplants.

polyvoltine Having several generations per year. Also univoltine, bivoltine, trivoltine, meaning having one, two or three generations per year.

population Members of a species that live together in the same area, and whose subsequent generations maintain uniform genetic character.

proboscis The tube through which adult butterflies suck liquid foods, and which is coiled between the labial palpi when not in use.

pupa
(plural pupae) The third stage in the lifecycle of a butterfly in which the bodily tissues are broken down and reform as an adult butterfly. Also known as a chrysalis.

race A distinctive population which is visually separable from other races of the same species, but which is not sufficiently different to be regarded as a subspecies.

range The entire area within which a species naturally occurs. The distribution of a species within its range is often patchy, but in the more adaptable species can be contiguous.

recessive Suppressed by a corresponding dominant gene, so that the recessive form, which is normally different in appearance, occurs less frequently in the population than the dominant form.

reflectance basking	Basking with the wings held half open, so as to reflect sunlight falling on the wings of whites, blues and coppers onto the thorax and abdomen, to facilitate rapid warming.
reticulation	A network pattern.
scales	Microscopic plates which arise from individual cells on the wings, body and legs of butterflies and moths. The wing scales overlap like the tiles on a roof, and are easily dislodged, appearing as coloured dust on the fingers when butterfly wings are handled. The scales on the body and legs are long and thin, giving the appearance of fur or hair.
setae	The 'hairs' on caterpillars, and on the pupae of certain species.
species	A group of individuals that interbreeds, producing and maintaining genetically identical fertile healthy offspring over a period of millions of generations. By definition a species cannot interbreed with another taxon to produce fertile offspring.
sphragis	A plug or structure which seals the genital opening of fertilised females of certain species, for example *Parnassius apollo* or *Euphydryas aurinia*, physically preventing further copulation.
spiracles	A series of breathing holes arranged in a row on each side of the abdominal part of larvae, pupae and adult butterflies.
subgenual	Under the knee.
submarginal	The area slightly inboard of the margins on the wings, often marked with lunules, ocelli or chevrons.
subspecies	A population with distinctive physical characteristics, which evolved at a time when it was geographically isolated from other populations. It is possible for two or more subspecies to be sympatric if climatic changes cause formerly isolated populations to expand and overlap, but ultimately they will converge to become a single subspecies.
symbiosis	The co-existence and inter-dependence of two organisms, such that one or both of the organisms is incapable of surviving without the cooperation of the other. The Large Blue, *Maculinea arion*, for example, is incapable of surviving unless it feeds during its larval stage on the grubs of the ant *Myrmica sabuleti*. The ant benefits from having the larva in its nest, but can survive without it.

sympatric	Occurring in the same area.
synonym	Duplicated scientific names applied to the same taxon. The first published species name is valid. Others are called junior or invalid synonyms. When taxonomists revise the classification of a species it is often transferred to a newly created genus, for example the Meadow Brown was originally given the name *Papilio jurtina*, but is now called *Maniola jurtina*.
taxon (plural taxa)	Any scientifically defined biological unit, for example the class Insecta, the family Nymphalidae, the genus *Apatura*, or the species *iris*.
taxonomy	The scientific classification of organising animals and plants into groups as defined by presumed relationships. Patterns of wing venation for example, are commonly used to assign species into appropriate genera.
territory	A fixed area defended by the male of a species, often centred on a perching place such as a particular leaf, which is used as a lookout post from which to survey passing females.
thorax	The muscular middle section of an insect's body, which acts as an anchor for the legs, wings, head and abdomen.
transect	A regular weekly walk that follows a fixed route through a butterfly habitat. The route is divided into sections, each representing a different sub-habitat. The butterflies seen in each section are counted, and the figures compared to those obtained in other sections; or from the same section in previous years. The figures are analysed to determine the management factors that affect butterfly populations.
tubercles	Wart-like nodules which are formed in bands on the abdominal segments of certain species of caterpillar. In some subfamilies, for example Nymphalinae, the tubercles are greatly enlarged and extended to form rows of branched spines along the back and sides.
univoltine	Having a single generation per year.
vein	A tubular blood vessel, particularly in reference to the tubes supporting the membrane of butterfly wings.
venation	The pattern and arrangement of veins on the wings.

INDEX

Genera and species

A

Abananote 172
Abantis 105
abbreviata 97, 98
Abisara 248
abyla 177
Acerbas 123
acesas 201
Achillades 273
achine 210
Achlyodes 103
Acleros 123
Acraea 27, 79, 172
Actinote 172, 173, 203
actorion 94, 95
actoris 252
Adelpha 30, 53, 129, 176, 177, 264
adippe 36
Aeropetes 208
Aethilla 103
agamemnon 270
Agathymus 127
Aglais 21, 38, 56, 57, 84
agnosia 85, 161
agondas 205
Agraulis 78, 163
Agrias 149
Aguna 115
albicans 226
alciope 172
alciphron 227
alcyone 69
Aldania 175
alecto 74
Alenia 106

Alera 123
Alesa 253
Aletis 181
alexandrae 274, 275
aliphera 21, 78
Allancastria 268
Allora 117
Allotinus 41, 230
Altinote 71, 172, 173
amandus 30
Amarynthis 255
amathea 196
Amauris 79
amazon 70, 255
ambata 97
Amblyscirtes 120
Amnosia 204
amphinome 36, 135
amphione 156
amydon 149
Anaeomorpha 149
Anaphaeis 35
Anartia 196
Anastrus 100
anchises 62, 63
androcles 228
angulata 248
Anisochoria 97
anna 151
annulata 193
anteas 173, 203
Anteos 277
Anteros 263
Anthanassa 201
Antheraea 73
Anthocharis 36, 39, 44, 46, 55, 81, 277, 288, 289

Anthoptus 119
Antigonis 142
Antigonus 98
Antillea 201
antilope 195
antiphates 270
Antirrhea 187
Apatura 45, 50, 87, 129, 131
apaustus 45
Apaustus 120
Aphrissa 277
apollo 56, 266, 267, 305
apollonia 254
Aporia 26, 56, 58, 285
Appias 285, 287
apries 41
Apyrrothrix 108
Araschnia 36, 79, 80
Arawacus 74, 236, 244
araxes 108
Arcas 244
Archaeolepis 13
Archaeoprepona 149, 150
archidona 151, 152
Archon 269
arcius 257, 258
areuta 265
argante 34
argentata 212
arginussa 151
argus 16
Argynnis 168
Arhopala 240, 241

Ariadne 132
arion 231, 305
aristolochiae 79
aristoteles 99, 100
arizonensis 176
arja 50, 51
Aroma 118
arsalte 97
arsis 255
arthemis 176
Artines 120
ascanius 274
Ascia 59
Aslauga 223
aspidos 226
aspila 179
Aspitha 109
assaricus 109
Asterocampa 131
Asterope 137, 139, 141, 149
Astraeodes 265
Astraptes 45
astyanax 176
Atarnes 103
atalanta 52, 53, 191
Aterica 185
athena 186
Athyma 177, 178
Atlantea 201
atlantis 135
atnius 243
Atrophaneura 79, 274
Attacus 299
atymnus 238
aurantiaca 246
aurea 240
aurina 125

aurinia 35, 36, 38, 63, 203, 305
aurorula 5
aurota 35, 287
austenia 179
Automeris 73, 299
Auzakia 177, 178
Axiocerces 242
Azonax 109

B

Badamia 117
badra 117
Baeotis 254
Baeotus 190
bamba 97
Baronia 267
batea 188
Batesia 135
bathildis 74
Battus 176, 274
Bebearia 175, 183
Behemothia 264
Belenois 35, 285, 287
belladonna 135
bellargus 232
bellona 257
belus 274
berania 85, 128, 154
Bhagadatta 179
Bhutanitis 268
Bia 94, 95, 188
Bibasis 116
biblis 167
Biblis 132
bicolor 225
Bicyclus 73

bifasciate 248
Blepolenis 188
blumei 273
boeticus 86, 231, 233
Bolboneura 137
boliviana 137
Bolla 99
bootes 273
Brachyglenis 260
brahma 228
brassicae 64, 285,
 303
brassolis 41, 224
Brenthis 15, 168
brephos 279
brevicornis 267
brigitta 88
brookiana 48, 274,
 275
buddha 273
Bungalotis 115
butyrosa 278
Byblia 132

C
Caerois 187
cajus 100
c-album 79, 81, 191,
 299
Caligo 23, 63, 188,
 189
Calinaga 145
Calisto 218, 219
Callicore 49, 142,
 143, 144
Callimormus 120
Callophrys 32, 244
Calopieris 284
calphurina 264
Calycopis 38, 243
cama 101
camilla 79
camillus 155
Camptopleura 100,
 101
Caprona 105

Carcharodus 99
cardamines 36, 39,
 44, 46, 55, 81,
 288, 289
cardui 86, 191
Caria 257
carias 133, 134
carinenta 87, 174
Carrhenes 97
Carterocephalus 127
Carystus 19, 118,
 123
cassioides 66
Castalius 233
Castilia 173, 201
castnia 224
Catacore 142
Catacroptera 199
Catasticta 281, 282,
 285
catilla 277
Catonephele 133
catops 205
Catopsilia 277
cebron 283
Celaenorrhinus 106,
 107
celtis 174
centaurus 151
Cephise 45
Cepora 286, 287
Ceratrichia 123
ceraunia 226
Cerautola 226
Cethosia 163, 166,
 167
chalcis 185
Chalybs 244, 245
Chamunda 105
chandra 129, 130
Charaxes 60, 87,
 146-148
Charidia 102
charithonia 166
Cheritra 240
Cheritrella 240

Chersonesia 153, 155
chiliensis 288
Chimastrum 262
Chioides 115
Chiomara 100
chiron 153, 154
Chloreuptychia 73,
 214, 216, 217
Chlosyne 201
Choaspes 117
Chondrolepis 123
Chorinea 70, 255
chrysame 257
chrysippus 17, 79,
 205
Chrysiridia 27
chrysogone 214
chrysus 263
Cigaritis 244
Cirrochroa 170
Cissia 73, 214, 216
Cithaerias 27, 70,
 205, 301
claudina 201
clisithera 142
Clossiana 86, 168,
 201
clymena 143
clysonymus 164
clytemnestra 67, 151
clytia 157
coecias 261
Coeliades 117
Coelites 208
Coenonympha 61,
 209
Coenophlebia 151,
 152
coenus 141
Coladenia 105
Colias 32, 277, 278
Colobura 193
colorado 267
confusa 23
Consul 39, 67, 68,
 151

contubernalis 102
Copaeodes 124
Corades 218, 221
core 157, 209
coridon 36, 62, 81
corinna 153, 154
corita 153
Corrachia 247
cothon 220
Cowania 240
crataegi 56, 58
crocea 8, 277, 278
Crocozona 261
croesus 274
Cunizza 288
Cupha 170
Curetis 222, 223
curius 271
cutteri 183
cyane 53
Cyanirioides 235
Cyanophrys 12, 13,
 66, 244
Cybdelis 133
Cycloglypha 100, 101
Cyclosemia 99
cydno 16
Cyllogenes 207
Cymaenes 120
Cymothoe 180
cyna 234
cypris 186
Cyrestis 153-155
cytherea 177
cytora 194, 195

D
Dagon 201
Dalla 127
damippe 112
dan 106
Danaus 17, 22, 51,
 56, 79, 89, 158,
 205, 297
danava 177, 178
danforthi 14

dardanus 79, 304
darlissa 209
Dasyophthalma 188
datis 75, 203
davidis 145
decora 204
deidamia 187
dejone 170
Delias 277, 283,
 285, 287
delphis 148
demodocus 273
demoleus 272, 273
dentata 222
Deramas 235
Detritivora 38
deucalion 190
dia 151
diademoides 209
Diaethria 142, 143
Diaeus 97
dicaeus 71, 172, 173
Dicallaneura 249
Dichorragia 204
dido 166
dione 192
Dione 21, 49, 78,
 163
dirce 193
Dismorphia 156, 281
dispar 48, 225
Dixeia 283
Dodona 251
dohertyi 105
Doleschallia 199
doto 162
Doxocopa 27-29, 50,
 53, 87, 129-131
dramba 14
Drupadia 240
Dryadula 163
Dryas 21, 50, 78,
 163
duellona 257
Dulcedo 70, 205,
 301

durbani 40
Dymasia 201
Dynamine 141
dyonis 141
Dyscophellus 115
dysonii 257, 258

E

Eagris 105
Eantis 103
Ebrietas 100
Ectima 135
edessa 161
edwardsi 183
egesta 180
Flbella 113
Electrostrymon 243
elegans 208
Elymnias 30. 205
Elzunia 76
emalea 170
Emesis 265
emesoides 251
enega 101
Entheus 114
enyo 221
Eooxylides 238, 239
epaphus 197
epicles 228, 229
epictetus 119
epimachia 109
epimenes 137
Epiphile 137, 138
Episcada 26, 162
epistrophus 186
Epitola 224-226
Epitolina 225
epius 230
erato 76, 164, 165, 203
Erebia 53, 66, 209
Eresia 75, 77, 156, 173, 201, 203
Eresiomera 225
Eretis 106
Eretris 218

eriopis 137, 138
Erites 208
Eroessa 288
Eronia 284
Erora 244
erosus 98
erylus 237
Erynnis 81-83, 100, 101, 298
erynnya 251
esmeralda 253
esthema 260
Esthemopsis 262
ethemides 124
ethilla 166
Ethope 209
eucharis 287
Euchloe 288
Eueides 20, 21, 77, 78, 156, 163, 203
eulalia 177
Euliphyra 40, 224
eumolphus 240, 241
Eumorpha 63, 64
Eunica 133, 134
eunice 77, 156, 203
eupale 146, 147
Euphaedra 175, 180-183
euphorion 274, 293
euphrosyne 86
Euphydryas 35, 36, 38, 63, 201-203, 305
Euploea 157, 205, 209
Euptoieta 168
Euptychia 214, 216
Eurema 88, 277, 278
Euripus 131
europa 212
euryanassa 156, 159
Eurybia 31, 253
Euryphura 185
Eurytela 132
Eurytides 269

Euschemon 118
Euselasia 247, 248
Euthalia 180
Evenus 244

F

fabius 39, 67-69, 151
fasciatus 63, 64
Faunis 190
Favonia 36
februa 25, 66, 135
Feniseca 230
feronia 135
ferruginosa 220
Flacilla 120
flegyas 250, 251
flesus 105
formosus 263
fornax 135
forreri 151
Forsterinaria 214
Fountainea 151
freja 240
Fresna 123
furcula 89, 154

G

galathea 34, 81, 83, 210
galena 185
galenus 106, 107
Gandaca 278
Gangara 123
genoveva 195
genutia 51
Gerosis 105
gesta 100, 101
Gesta 100
Gindanes 102
glaucippe 50, 284
glycerion 61
Gnatotriche 201
Gnophodes 207
godmani 264
Godyris 50

Gonepteryx 35, 56, 84,,86, 277
Gorgopas 99
gracilis 120, 267
Grais 100
grandis 137, 224
Granila 109
Graphium 269, 270, 287
Greta 29
gyges 115

H

Haematera 142
Haemeactis 103
Haetera 70, 205, 301
halia 77, 156
halimede 253
Hamadryas 25, 31, 36, 66, 135
Hamearis 265
haquinus 249
harina 278
harmonia 77
harpalyce 183
Hasora 117
Hebomoia 50, 277, 284, 287
hecale 165
hector 79
helcita 181
helena 226
helenor 31
Helias 100, 101
heliconaria 290
Heliconius 16, 31, 35, 44, 45, 51, 71, 75-77, 163-166, 203, 281
Helicopis 263
Heliopetes 97
Heliophorus 228, 229
helios 267
Heodes 227
Heraclides 62, 272

heraldica 235
hercyna 207
Hermeuptychia 214
hermosa 137
herophile 219
Hesperia 121
Hesperocharis 288
Hestina 157
Heteronympha 213
Heterosais 161
hewitsoni 40
Higginsius 201
Hipparchia 31, 32, 56, 69, 209-211
hirlanda 288
hirsti 13
Historis 190
horsfieldi 230
hosta 104
Hovala 127
humboldt 76
humboldtii 142
Hyalothyrus 81
hymenaea 26
Hypanartia 192
hyperia 132
hypermnestra 205
Hypermnestra 267
Hypna 67, 151
Hypoleria 70
Hypolimnas 30, 195
Hypolycaena 237
Hyposmocoma 13
Hypothyris 85

I

Iambrix 123
iblis 137
Idea 157, 205
ilione 78, 156, 157
Inachis 25, 38, 72, 73, 85, 191
inachus 199, 200
infernalis 223, 247
ingaretha 257
ino 15, 168

io 25, 38, 72, 73, 85, 191
Iphiclides 87, 269
iris 50, 87, 306
isabella 77, 156, 203
ismenius 164
isodora 67
issoria 172
Issoria 168
Itaballia 285
Ithomeis 247
Ithomia 27, 29, 70, 85, 159-161
Ithomiola 252
iulia 21, 50, 78

J
Jamides 74
janais 245
Janatella 201
janetta 181
jasius 146, 147
java 35
Jemadia 113, 114
jesia 216
jucunda 198
Juditha 264
Junea 50
juno 21, 78
Junonia 195

K
kahruba 147
Kallima 199, 200
Kallimoides 190
Katreus 106
kingi 151
kuenstleri 205

L
Lachnocnema 40
lagus 247
laja 281
Lamasina 244
lamia 207
Lampides 86, 231,

233
Lamproptera 27, 70, 267, 269-272
laodamia 135
laothoe 139
Laothus 244
lapitha 177
Laringa 132
Larinopoda 226
laronia 122
Lasaia 255
Lasiophila 50, 218
Lasippa 175
lathonia 168
latifasciata 100
laufella 123
laura 151
laure 129
laurentia 28, 29
Laxita 249
lebona 237
leda 47, 207
Lento 120
Lepidochrysops 40, 234
leppa 99
leprieuri 140, 141
Leptidea 56, 280
Leptosia 288, 289
Lerodea 120
lethe 192
Lethe 207, 209, 212, 213
Leucidia 279
Leucochimona 252
Leucochitonea 105
leuconoe 205
leucoplaga 247
levana 79, 80
libentina 224
Libythea 22, 174
Libytheana 87, 174
licomedes 150
lidderdalii 268
lilaea 193
Limenitis 79, 176

linda 130
Liphyra 41, 224
Liptena 224, 226
lobelia 216, 217
Lobocla 114
longula 66
Lonomia 43
Lopinga 210
lowii 209
Loxolexis 106
Loxura 238
loxus 97
lucina 265
Lucinia 137
Ludens 120
Luehdorfia 269
Lycaena 27, 48, 227, 228
Lycas 19, 123
Lychnuchus 118
lycimnia 285
lycisca 253
Lycorea 77, 78, 156, 157
lygdamis 281
Lymanopoda 50, 218, 220
lympharis 186
Lyropteryx 254
lysimnia 77, 156

M
mabillei 180
machaon 16-19, 26, 52, 86, 272, 294
Macrosoma 290, 291
Magneuptychia 214, 216
Mallika 199
Manataria 207
mandana 265
mane 13
Maniola 31, 306
mantinea 257
marcella 153
Marpesia 49, 78, 85,

89, 128, 153, 154
marshalli 207
marsyas 243
Matapa 19, 123
Mazia 201
Meandrusa 269, 272
Mechanitis 29, 77, 156, 203
medon 181, 182
Megaleas 118
Megathymus 127
meges 70, 271
Melanargia 34, 81, 83, 209, 210
Melanis 259
Melanitis 47, 207
Melanocyma 190
Melete 285
melibeous 235
Melinaea 43, 85
Melitaea 53, 201
melpomene 16, 45, 76, 164, 203
Memphis 50, 87, 151
meneria 255
merope 213
Mesene 262
mesentina 177
Mesosemia 251
Mesotaenia 142
Mesoxantha 196, 132
Metamorpha 196
Methona 23, 78, 156
Metisella 127
metrodorus 114
Microtia 201
Milanion 102
militaris 260
Mimeresia 224
Mimoides 269
Mimoniades 108, 112
miserabilis 244
Moduza 177
molochina 253
Monca 120
montela 268

montrouzieri 273
monuste 59
Mooreana 105
Morpho 31, 53, 75, 186, 187
Morvina 99
motva 174
mulciber 157, 205
Muschampia 99
Mycalesis 73
Mycastor 264
mylitta 73
Mylon 100
Mylothris 285
Myrinia 99
myrrha 22, 174
Mysarbia 111
Myscelia 133
Myscelus 109, 110

N
nadina 287
nama 157
Napaea 252
Napeocles 196, 198
Narope 188
narycus 102
Nascus 115
Nastra 120
Necyria 256, 257
negra 172
nehemia 280
neleus 81, 83
Neographium 269, 271
neophron 248
Neopithecops 234
Neorina 209
nephelus 209
Nepheronia 284
Neptidopsis 132
Neptis 175
nerissa 287
Neruda 163
nesimachus 204
Nessaea 133

nesseus 204
nessus 151
Netrobalane 105
niavius 79
Nica 137
Nicolaea 235
nina 289
nobilis 151
nolkeni 103
Noreppa 149
Notocrypta 123
numata 76, 164
numilia 133
nurscia 108
nuspesez 45
nyctelius 131
Nyctus 118
Nymphalis 32, 85
nymphidia 249
Nymphidium 249, 264

O

Oarisma 121
obliqua 43
Ocella 99
Ochlodes 28, 121
octavia 195
Odina 105
odius 190
Odontoptilum 105
Olafia 108
Oleria 162
orcus 97
orea 137, 138
Oressinoma 31, 214, 216, 218
orfita 247
orise 78, 277
Ornithoptera 4, 274, 275, 293
Orophila 142
Orses 123
Ortilia 201
Osmodes 122, 123
Ouleus 102

Ourocnemis 263
Oxeoschistus 218, 220
oxione 183
Oxynetra 108

P

Paches 97
Pachliopta 274
pagasis 109
Paiwarria 244
Palaeochrysophanus 227
palinurus 273
pallas 260
pallida 103
Panacea 135, 136
pandosia 285
pang 228
Panoquina 118
Panthiades 74, 244
Pantoporia 175, 193
paphia 34, 168, 169, 300
Papilio 16, 18, 19, 26, 30, 37, 53, 79, 86, 94, 157, 209, 267, 272, 273, 294, 306
paradisea 274
paradoxa 157, 289
Paralaxita 249
Paramimus 102
Parantica 51, 157, 209
Parantirrhoea 207
Pararge 31
Parasarpa 177
Pardaleodes 123
pardalina 109, 110
pardalinus 77
Parelbella 113
Pareronia 277, 284
Pareuptychia 214
Parides 43, 62, 63, 267, 274
Parnassius 27, 56,

266, 267, 305
Parphorus 120
parrhassus 195
Parthenos 179
paseas 109
Passova 109
Patia 78, 277
Paulogramma 142
pausia 219
pavonia 73
payeni 272
Peba 120
Pedaliodes 218, 219
pedaliodina 97
pellonia 248
penelea 214
penelope 216
Penthema 209
Pereute 285
pergaea 253
Peria 137
periander 50, 257
Perichares 125
Perisama 142
perissodora 109
perius 178
Perrhybris 283
perseis 181
peruda 219
petreus 78
phaedima 203
Phaedyma 175
Phalanta 170
phalantha 170
phantasina 183
Phanus 114
Phareus 114
pharsalus 172
phasma 264
Pheraeus 120
Phengaris 231, 243, 305
Philaethria 163, 166
philenor 176
philoctetes 187
philonome 288

philumena 151
philyra 175
phlaeas 228
Phlebodes 120
Phocides 114
phocus 115
Phoebis 34, 49, 277
phoronis 109
Phycioides 201
phydela 244
Phystis 201
piera 70
Pierella 205-207
Pieris 62, 64, 285, 303
Pintara 105
Placidina 156, 159
Plebejus 16
plexippus 22, 56, 89, 158, 297
plinthobaphis 264
podalirius 87
Podotrichia 163
poggei 79
Poladryas 201
policenes 269, 270
poliotactis 262
polychloros 85
Polygonia 36, 79, 81, 191, 299
polymnia 203
Polyommatus 29, 30, 36, 53, 61, 81, 231, 232
polytes 79
Polythrix 115
Polyura 50, 51, 146, 148
polyxo 151
pomona 277
populi 176
Poriskina 235
Poritia 235
Porphyrogenes 115
posthumus 224
Posttaygetis 214

postverta 141
Potomanaxas 100
Praepapilio 267
Praetaxila 249
praxithea 219
Precis 195
Prepona 149
priamus 293
Prioneris 277, 283, 288
prola 135, 136
Pronophila 218
proserpina 151
Protesilaus 269
Protogoniomorpha 194, 195
Protographium 269
pruni 243
Pseudergolis 204
Pseudocoladenia 106
Pseudodebis 209
pseudognetus 113
Pseudohaetera 205
Pseudolycaena 243
Pseudophilotes 40
Pseudopieris 280
Pseudopontia 289
Pteronymia 64, 70
Pteroteinon 123
Pterourus 77, 272
Pycina 190
pygas 144
Pyrgus 53, 97
Pyronia 28, 73
Pyrrhiades 117
Pyrrhochalcia 117
Pyrrhopyge 108, 111
pyrrhus 148
Pythonides 102

Q

Quadrus 102
quassi 234
quercus 36
quintina 162

R

Radiatus 120
rafflesia 118
rahria 155
rapae 62, 285
rhacotis 257
rhamni 35, 56, 84, 86
rhetenor 75, 186
Rhetus 50, 257, 258
Rhinopalpa 190
rhipheus 27
Rhyniognatha 13
richmondia 293
Ritra 240
Rodinia 264
rosimon 233
rubina 262
rubrofasciata 176
rumina 268
rusina 188
ryphea 151

S

Sacrator 118
Saliana 118
sallei 103
Sallya 132
sangaris 180
sanguinalis 103
Sarangesa 106
Sarbia 108, 112
sarcoptera 181
Sarmientoia 115
Sarota 263
sarpedon 270
Sasakia 131
saturata 248
Saturnia 73
Satyrium 35, 38, 243
Sea 133
sejanus 111
seliga 242
semele 56, 211
semihyalina 108

semirufa 224
Semomesia 252
Semonina 244
sena 116
sennae 277
septentrionis 29
Sericinus 268
serpa 177
Seseria 105
Setabis 247
Siculodes 5
Simiskina 235
simplex 220
sinapis 56, 280
Siproeta 69, 166, 196, 197
sirenia 252
sisamnus 281
Siseme 260
smithiae 259
Sophista 99, 100
sophus 185
Sostrata 100
Spalgis 230
Speyeria 201
spica 127
Spindasis 242
Spioniades 97, 98
splendens 181
Stalachtis 265
Stallingsia 127
Staphylus 99
staudingeri 254
stelenes 69, 166, 197
Steremnia 218
Stibochiona 204
Stiboges 249
Strephonota 243
Styx 223, 247
Sumalia 177
sylvanus 121
sylvestris 124
sylvia 179
Symbrenthia 193
Symmachia 262

symmomus 126
Synale 118
Synargis 264

T

Taenaris 190, 205
tages 81-83, 298
Tagiades 105
Talides 123
Tanaecia 180
tarquinius 230
Taxila 249
Taygetis 73, 80, 214, 215
Tegosa 201
Teinopalpus 269
telassa 111
telassina 111
Telenassa 201
Telipna 224
Tellervo 156, 163
Temenis 137, 139
tentyris 183, 185
Teratophthalma 252
terena 174
Terinos 170, 171
terpander 171
teucer 189
Texola 201
thaidina 268
thamyra 215
tharis 238, 239
Theagenes 101
Thecla 35
themis 181
Theope 264
thericles 108
Thersamonia 227
Thespeius 124
Thisbe 264
thoas 62
Thracides 118
thyastes 271
Thymelicus 28, 124
thyodamas 155

Thyridia 78, 156
Ticherra 240
tiessa 216
tigrina 179
Tirumala 29, 51, 157, 209, 284
Tisias 19, 118
Tisiphone 73
Tisona 201
tithonus 28, 73
Tithorea 77
tolumnia 216, 217
Tomares 242
Trapezites 126
triaria 219
Trichonis 244
trogon 240
Trogonoptera 48, 274, 275
Troides 274
Tromba 118
tryxus 97
tulbaghia 208
typhaon 109
typhla 216, 218

U

ulema 221
ulysses 273
Urbanus 115
urticae 21, 38, 56, 57, 84

V

valentina 209
Vanessa 52, 53, 61, 86, 191
Vanessula 190
vanillae 78, 163
variegata 97
varna 97
Vehilius 120
velutina 135
Venas 120
verma 212, 213

versicolor 112
Vettius 120
vicrama 40
Vindula 170
Virga 120
virgilia 80
Voltinia 14, 252

W

w-album 38
wallacei 281
weiskei 270
wellingi 151
whitelyiana 256, 257

X

xanthocles 71
xanthomelas 32
xanthostola 224
xantochlora 278
Xenandra 262
Xenophanes 97
Xynias 262

Y

Ypthima 73
yuccae 127

Z

zagreus 77
zalmora 234
Zaretis 67, 151
Zariaspes 120
zavaleta 50
Zeagris 288
Zelotea 264
Zemeros 250, 251
Zera 103, 104
zerynthia 154
Zerynthia 268
Zeuxidia 190
zitenius 207
Zizula 234
zoilus 163